TWO NON-BRAIN-DAMAGED
ECONOMISTS IN A SINGLE HOUSE-
HOLD...

¡YIPPEEE!!!

—L.P.J./2017

Minding the Public Purse

The Fiscal Crisis, Political Trade-offs, and Canada's Future

JANICE MacKINNON

McGill-Queen's University Press
Montreal & Kingston • London • Ithaca

Legal deposit second quarter 2003
Bibliothèque nationale du Québec

Printed in Canada on acid-free paper.

This book has been published with support from the University of
Saskatchewan Publication Fund.

McGill-Queen's University Press acknowledges the support of the
Canada Council for the Arts for our publishing program. We also
acknowledge the financial support of the Government of Canada
through the Book Publishing Industry Development Program (BPIDP)
for our publishing activities.

National Library of Canada Cataloguing in Publication

MacKinnon (Potter, Potter-MacKinnon), Janice
 Minding the public purse : the fiscal crisis, political trade-offs, and
 Canada's future / Janice MacKinnon

 Includes bibliographical references and index.
 ISBN 0–7735–2554–8

 1. Fiscal policy—Canada. 2. Debts, Public—Canada.
 3. Expenditures, Public—Canada. I. Title.

HJ8513.M32 2003 339.5′2′0971 C2002–906111–3

Typeset in 10/13 Palatino by True to Type

To William, Alan, and Peter

Contents

Preface

Like many Canadians, my eyes used to glaze over when I heard the words "deficit," "debt," or "public finances." These were topics for bankers, economists, and politicians, not for academics like me, who were more concerned in the 1980s about what the Free Trade Agreement meant for Canada. By the 1990s, however, deficits and debts were no longer mere abstractions but were affecting the pocketbooks of all Canadians. In my case, in 1993 after a mere fourteen months in politics, I became Canada's first female finance minister, responsible for the finances of a province on the brink of bankruptcy; and debt, which had seemed so abstract a few years earlier, became all too real.

While the main features of the fiscal crisis of the 1990s have been documented, what is not on the public record is what happened behind closed doors. Provinces such as Saskatchewan, which were so indebted that they could not even borrow money in Canada, were at the mercy of international credit raters who dictated the terms under which the billions of dollars needed to pay for essential public services could be borrowed. With financiers threatening to cut off their money supply, these provinces had to slash programs and raise taxes to get their fiscal houses in order, or face the prospect of default.

How did provinces such as Saskatchewan, with a history of sound financial management, get themselves into such a mess? What happens when credit raters squeeze financially troubled governments? What strategies did provinces adopt in the 1990s to steer their financial ships back on course? Although all provinces had a fiscal problem, they did not all make the same strategic choices, since differing approaches marked a dividing line between right- and left-wing governments.

In 1995, just when Saskatchewan and Alberta were balancing their budgets, they were drawn into the vortex of the rapidly deteriorating federal fiscal situation. The scramble at the provincial level was often more desperate

in the early 1990s, but the stakes were higher as federal Finance Minister Paul Martin prepared for his landmark 1995 budget.

At a time when the prime minister met only occasionally with the premiers, federal and provincial finance ministers, including three future premiers, met regularly to debate, argue, and agonize about the future of Canada. Although the fiscal crisis was front and centre by 1995, the ties that bind Canadians and the wedges that drive them apart came to the fore in controversies about such issues as the GST. The deeply rooted regional divisions and the dramatic changes in position of Canada's two largest provinces, Quebec and Ontario, were played out in heated and sometimes angry exchanges behind closed doors. Despite our differences, in the end we were all embattled finance ministers, working in a common cause, and we all sensed that we were part of a major turning point in Canadian history.

The 1995 budget was a watershed in Canada's history. Years of wrangling at constitutional tables had not changed federal-provincial fiscal relations as dramatically as this one budget did. While constitutional proposals had been the subject of intense debate, and even of a referendum, the wholesale changes made in 1995 were unilateral decisions, made with no national debate, except in the private discussions of the finance ministers. The Canada of the past, in which a strong federal government funded and set national standards for health and social programs, was swept aside in favour of a more decentralized federation, in which the provinces became the main guardians of the programs most Canadians cherished.

Were there alternatives to these unilateral choices? What did these changes mean for the future of Canada? Although I was among Martin's harshest critics in 1995, I must admit that the choices he made have weathered well. Rather than merely turning more power over to the provinces, the federal government repositioned itself to meet the challenges of the twenty-first century. The 1995 budget meant major changes for the provinces in that their responsibilities increased while their funding did not. How, then, did the provinces respond to the new Canadian reality created by Martin in 1995?

This is a book about the deficit era of the 1990s, described by Martin as "a rare period in history, similar to World War II, when the government and the people were completely at one on a major national undertaking."[1] Canadians in the 1990s supported the cuts to government programs and increases in taxes that were unprecedented in peacetime. The astonishing level of support for such actions was revealed in 1995 when a caller to an open-line program chastised Martin for the cuts and he responded by asking, "What you are saying is that we should take care of you and forget about your kids?" The phone lines lit up with caller after caller repeating the theme that Canadians were prepared to make sacrifices in order to balance the budget so that

they would not be saddling their children with a massive debt.[2] In exchanges like these, Canadians exhibited their resolve, and they emerged from the decade more resilient and confident about the future.[3]

This is also a book about politics, both in the public eye and behind the scenes, and about the New Democratic Party. As Roy Romanow's NDP government wrestled Saskatchewan's ballooning deficit to the ground, the most taxing conflicts were internal ones. Politics involves more divisions within the ranks than is often apparent from the outside. But the conflicts also reflected the struggle within the NDP to come to grips with deficit reduction and the global economy. The NDP believes in government and spending, and in the 1990s we had to cut both. In an exercise that can only be described as gut wrenching, we had to cut and even eliminate programs that our party had created in the 1970s. Our choices were made only after a lot of soul searching. With ongoing internal divisions and public support at an all-time low, the NDP continues to stumble on the road to confronting the new fiscal and economic world of the twenty-first century.

This book is also about governing during a crisis. All of the warning signs that Canada was drifting toward the fiscal brink were there for years while we focused on other issues. Only when the situation reached crisis proportions was action taken. Decision making in a crisis is not good decision making: choices are limited, debate is curtailed if not dispensed with altogether, and sober reflection is sacrificed on the altar of the urgency to act quickly and decisively. No one who has governed during a crisis would ever want Canada to wander down that road again. Yet I fear that it may.

The skyrocketing costs of health care and the reluctance of Canadians to accept fundamental changes in the system are nudging us closer and closer to another crisis. Like the deficit in the 1980s, the cost of health care is taking on a life of its own and spiralling beyond the fiscal capacity of the provinces. If not addressed, these rapidly rising costs could take Canadians once again down the road of more deficits and increasing debt.

Equally alarming is the fact that we may repeat the 1980s scenario, when many of us were worrying that free trade might compromise our sovereignty; but as it turned out, it was the fiscal crisis that put us on our knees before New York bankers. Today, Canadians are focusing on health care and giving short shrift to other clouds on the horizon. The emerging shortages of highly skilled and educated people and our lagging productivity do not capture the public attention as health care does. But if not addressed, these issues will, in the near future, plunge us into another crisis.

The unique contribution of this book is the perspective from which it is written. While it takes advantage of the excellent scholarly work done on deficit and debt, the political challenges of the 1990s, and the nature of politics and public policy formation, it is written from the vantage point of an

insider. My status as a Saskatchewan cabinet minister from 1991 to 2001 meant that I was a player in provincial and federal-provincial decision making for almost the entire decade of the 1990s. My role as Saskatchewan's finance minister from 1993 to 1997 took me into the boardrooms of the credit raters, who in many ways called the fiscal shots in the 1990s. And my political connections have allowed me access to former and current premiers, former finance ministers such as Paul Martin and Don Mazankowski, and a host of civil servants, all of whom were generous in sharing their intimate knowledge of what happens behind the scenes. It is this combination of a scholarly approach and first-hand experience that sets the book apart.

My goal has been to write a book that is substantive and as objective as possible in its content but very readable in style. Public policy debates should not be considered the preserve of politicians, civil servants, or academics, but should be familiar territory to all concerned Canadians. In the end, political decisions are not abstractions. As this book shows, minding the public purse is about making the right policy choices and using our hard-earned tax dollars wisely. It's a job in which we should all take an interest.

Acknowledgments

I am greatly indebted to William MacKinnon, currently a third-year political science student at the University of Saskatchewan, who spent the summer of 2001 at Waskesiu summarizing primary material, choosing juicy quotes, and breaking the back of the task of reviewing my ten years in government. My husband Peter and our older son Alan also read the manuscript and provided wise advice and support, just as they did during my political career. David MacKinnon, my brother-in-law currently living in Ontario, shared with me his wisdom from years of experience in the public, private, and health-care sectors and kindly read the manuscript.

I am enormously grateful to the University of Saskatchewan academics who gave generously of their time to review the manuscript at each stage of its evolution. Jim Miller, Canada research chair in Canadian history, read the manuscript thoroughly and was very influential in helping me refine my arguments and correct errors. John Courtney, one of Canada's most distinguished political scientists, also provided excellent advice and brought the insight of his discipline to the work. Michael Hayden, another history professor and a former editor, helped me focus my arguments and asked the very difficult but necessary questions that had to be addressed. Ken Coates, acting provost and dean of arts and science, not only read the material but also worked assiduously to help me get it published. His enthusiasm and boundless energy were inspiring.

Bob Mitchell also read the manuscript and helped me with the chronology of events. Con Hnatiuk provided valuable insights from his experience of four decades in the civil service and from his current work in the health-care field. Steve Orsini of the Ontario Hospitals' Association was generous in sharing his time and research. Paul Boothe, a professor of economics at the University of Alberta and former Saskatchewan deputy minister of finance, offered excellent advice and shared research. I also want to thank Dr Sam Shortt, director of the Centre for Health Services and Policy Research at Queen's University, for his advice.

The staff at the Saskatchewan Legislative Library were extremely helpful, particularly Michele Howland, Jane Blackett, Leslie Polsom, Tim Prince, and Maria Swarbrick. I was also helped enormously by the reference staff at the University of Saskatchewan, especially Gail Bunt. Other students and staff of the history department also helped with the manuscript, including Ingrid McGregor, Jack Coggins, Rob Angove, and Michael Thome.

At McGill-Queen's University Press, Aurèle Parisien, editor, was key in embracing the manuscript and moving it quickly through the various stages. Carlotta Lemieux took an extraordinary interest in the manuscript and has been a superb copy editor. Joan McGilvray, coordinating editor, has been attentive and helpful throughout the editing process.

I also want to acknowledge the support of the Social Sciences and Humanities Research Council (SSHRC). When journalists ask what SSHRC does, the answer is that it helps projects like this see the light of day.

"When the PCs came to office in 1982, Saskatchewan had balanced budgets, a strong economy, and a bright future.

Today we are deep in debt, our economy is unable to generate enough jobs and opportunities, and the future is uncertain for many.

Working together we can turn Saskatchewan around, and rekindle the spirit of community that built this province. The values of cooperation, compassion, and fairness can help build a future of hope and opportunity for everyone in Saskatchewan. I'm proud to have Janice MacKinnon as part of our New Democrat team. Together we can do it . . . the Saskatchewan way!"

Roy Romanow

New Democrats

The 1991 election campaign
(courtesy Committee to Elect Janice MacKinnon)

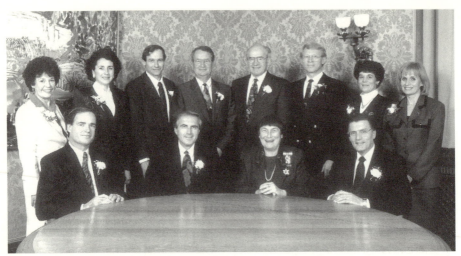

The war cabinet (*front, right to left*): Ed Tchorzewski, finance minister; Sylvia Fedoruk, lieutenant governor; Roy Romanow, premier; Dwain Lingenfelter, minister of economic development; (*back, right to left*) Janice MacKinnon, minister of social services; Carol Carson, minister of municipal government; Bernie Wiens, minister of agriculture; John Penner, minister of energy; Bob Mitchell, minister of justice; Darrel Cunningham, minister of rural development; Louise Simard, minister of health; Carol Teichrob, minister of education (Legislative Photographic Services, Regina)

We would not have made it through the deficit crisis without the advice of experienced career civil servants such as John Wright, deputy minister of finance until 1995.

In rural Saskatchewan, with Walter Jess, one of my strongest allies
in caucus. The support of caucus was key to the success of the
1993 budget. (Compliments of Irene Attrux)

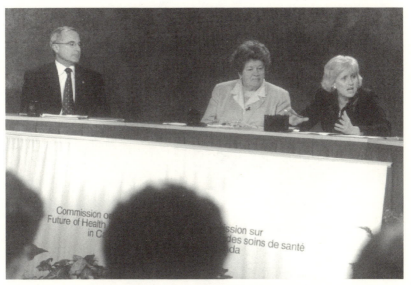

Debating health care at the Romanow Commission on the Future of
Health Care. *Left to right*: Peter Barrett, former president of the Canadian
Medical Association; Monique Bégin, health minister in the Trudeau
government who was responsible for the Canada Health Act; Janice
MacKinnon (Danielle Fortosky, Saskatchewan Communications Network
[SCN], 2002)

"...NEVER PROMISED YOU A ROSE GARDEN!"

Saskatoon *Star Phoenix*

Enjoying a joke with Paul Martin

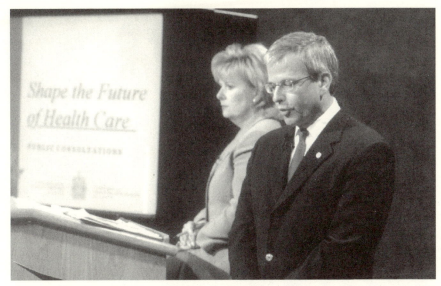

Pamela Wallin, moderator, with Peter MacKinnon, president of the University of Saskatchewan and my husband, at the Romanow Commission on the Future of Health Care (Danielle Fortosky, SCN)

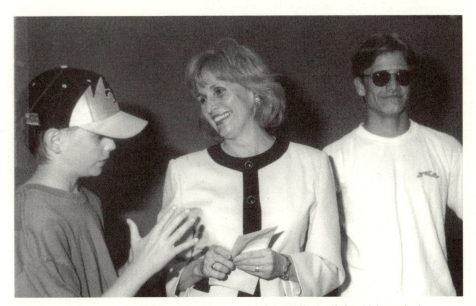

Election night 1995, with Alan MacKinnon (*right*), William (*left*). Although the government won, two rural war cabinet ministers went down to defeat. (Saskatoon *Star Phoenix*)

PART ONE

The Origins of the Fiscal Crisis: Canary in the Coal Mine

I only wish that those who wrote about the deficit and debt crisis as a right-wing conspiracy had been present in the Saskatchewan cabinet room in the spring of 1993 as Premier Roy Romanow and I, along with other key players in our NDP government, waited anxiously for word from New York. We had just been told that the bonds we had recently issued to finance the daily operations of our government were not selling. Whether we liked it or not, our fate lay in the hands of the New York bankers. Our high deficit and debt and our BBB credit rating meant that we could not borrow money in Canada – even municipalities within our own province could not take the risk of buying Government of Saskatchewan bonds. The gravity of the situation was reflected in a call that evening from Don Mazankowski, who phoned me at home to find out "if things had settled down and we were okay." As federal finance minister, he knew that the default of one province would reflect on all of Canada and that in the deficit and debt crisis of the 1990s, Saskatchewan was a canary in the coal mine.

The Federal Origins of the Fiscal Crisis

In January 1995, when the *Wall Street Journal*, "the bible of the U.S. business community," published an editorial entitled "Bankrupt Canada?" that referred to Canada as "an honorary member of the Third World in the unmanageability of its debt problem" and raised the prospect that it could "hit the debt wall," even the most laid-back Canadian taxpayer had to take notice. The debate over deficit and debt had moved beyond the corporate boardrooms and academic ivory towers into people's living rooms, as newspaper headlines – "Bank Rate Climbs, Dollar Sinks," "Dollar's Battering Continues," "Bank Rates Soar to Defend Dollar" – told Canadians in no uncertain terms that their country's financial problems were threatening their standard of living.[1] Even in Saskatchewan, which was just emerging from its own battle with the deficit monster, many people were shocked by the magnitude of the problem. This, after all, was Canada, one of the G7 countries, not some "frozen banana republic."

In both Canada and Saskatchewan, it is surprising how easily we had moved down the path of rising deficits, despite the warning signs that there was a financial problem in the 1970s, a major challenge in the 1980s, and a crisis by the 1990s. The problem began in the 1970s when the Liberal Party, which had established itself as Canada's governing party, lost the balance between compassion and sound management, which had been the secret of its political success. Like the New Democratic Party (NDP) in Saskatchewan, and its forerunner the Co-operative Commonwealth Federation (CCF), the Liberal Party of Canada prided itself as being the party of compassion, the architect of our most deeply cherished social programs. Medicare began in Saskatchewan and it was expanded at the national level by the Liberals, who also created other key parts of our social safety net: old age security, unemployment insurance, the family allowance, and social assistance. While introducing social programs in the 1950s and 1960s, the Liberals in Ottawa and the CCF-NDP in Saskatchewan had balanced their budgets and

closely guarded their hard-earned reputation for sound management of the economy.

The 1970s, however, was an expansive time of big government, when fiscal and economic concerns were eclipsed by other affairs, including bilingualism and biculturalism, constitutional issues, and federal-provincial controversies. Some parts of the agenda of Prime Minister Pierre Trudeau were expensive. The goal of creating a "just society" involved enriching social programs and indexing them to inflation – which meant that as inflation took off, so did the cost of these previously affordable entitlements. Creating equality of opportunity for Canadians from all parts of Canada involved pouring billions of dollars into less developed regions. Reasserting the role of the federal government led to new programs in areas of provincial jurisdiction, such as housing and urban affairs.[2]

At the same time as the government was embarking on this ambitious spending agenda, it was grappling with new and very difficult economic challenges: skyrocketing energy prices and the combination of high inflation, high unemployment, and slower growth. Thus, the new spending was financed by running deficits, and for the first time in its history, Canada was borrowing huge sums of money not just for major one-time capital projects but to finance the ongoing operations of its government. Trudeau's many finance ministers failed to deal with the mounting deficits and ignored the advice of more business-minded Liberals, like Paul Martin, who tried to persuade the Trudeau government in its last term to focus on the economy, not the constitution. Thus, when Trudeau left office in 1984, Canada had racked up a $38.5 billion annual deficit – almost $200 billion in debt – and "the Liberals, the party of managerial competence, left office with their reputation for sound economic stewardship in ruins."[3]

The Trudeau era was also a defining time for the NDP in both Canada and Saskatchewan; ideas popularized by the NDP in the 1970s became the mantra for the leftist critique of deficit reduction in the 1980s and 1990s. The quip by Mackenzie King that the CCF – now the New Democrats – were merely Liberals in a hurry seemed apt in the 1970s as Liberal minority governments relied on NDP support to stay in power. The Liberals expanded social programs, created a crown corporation, Petro Canada, to be a public presence in the oil industry, and established the Foreign Investment Review Agency to screen foreign investment. In the long term, the 1972 election campaign, in which the NDP very successfully zeroed in on "corporate welfare bums" (corporations that were taking advantage of tax loopholes to avoid paying their fair share of taxes), became fixed in the minds of many leftists, who returned again and again to the theme that Canada's fiscal problems could be solved by simply closing tax loopholes and taxing corporations.

The prominence of the NDP in the 1970s was most evident in Saskatchewan, where the government of Allan Blakeney was in power for most of the decade – which was one of the most prosperous in the province's history. The high energy prices that caused problems for many Canadians were a boon to an energy-producing province like Saskatchewan, which used the money from high royalties on oil and potash to finance an ever-expanding array of health and social programs. Here again, leftists returned to the 1970s model to solve the problems of the 1980s and 1990s: if governments were short of cash, all they had to do was increase royalties on potash, oil, and other resources. It had worked in the 1970s, so why wouldn't it work in the 1990s?

Although the Blakeney government, unlike its federal counterpart, balanced its budgets and provided sound management, it contributed to the fiscal problems of the 1990s by expanding Saskatchewan's infrastructure and programs beyond what was sustainable and by fostering, as Trudeau did, unrealistically high expectations. "Our economy can no longer support the public-sector infrastructure that we have built to serve the quality of life and the standard of living that we have come to expect" was the telling assessment of the Saskatchewan Financial Management Review Commission, established in 1991 by Roy Romanow's NDP government to assess the province's desperate financial straits.[4] Granted, much of that infrastructure was built in the early part of the century when farms were smaller, travelling times between communities were longer, and technology was less advanced. Nonetheless, a lot of it dated back to the 1970s when cash was pouring into the treasury, when cabinet ministers were pondering not how to save but how to spend money, and when the size of government was not a concern. The overbuilt infrastructure of the province haunted our government in the 1990s. Two examples were especially troubling.

Saskatchewan is the birthplace of medicare, and much of the spending in the 1970s involved enhancements to health care: a children's dental program, a publicly funded drug plan, the addition of new services, and the construction of many new hospitals. There used to be an adage in Saskatchewan politics: "Close a hospital and lose a riding." Opening new hospitals, on the other hand, was good politics. A hospital was associated with security (knowing that medical treatment was at one's doorstep), employment (many good off-farm jobs for spouses were at the local hospital), and survival (once a community lost its hospital, usually the school, the credit union, and the co-op left shortly afterward). Thus the Blakeney government opened new hospitals, many in small communities. The 1980 budget, for example, boasted about the new hospitals in the towns of Lampman (population 720), Borden (population 195), Nokomis (population 535), Kamsack (population 2,726), and Paradise Hill (population 395), and in its last

budget the government announced funding for another four new hospitals.[5] But how in the long term could Saskatchewan – which was heavily dependent on federal transfer payments to finance its programs and which had the most volatile economy in Canada – afford to lead the nation in the number of hospital beds per capita?

Expensive infrastructure and unrealistically high expectations were created not only in health care but also in education. It is said that when the province was created in 1905, Regina got the government, Saskatoon the university, Prince Albert the penitentiary, and North Battleford the mental institution – and the problem is that, for years, people have been sent to the wrong places. The truth in the humour is that although Regina was made the capital, the University of Saskatchewan was opened in 1907 in Saskatoon as the province's main institution of postsecondary education. By the 1970s, it had a medical school, professional colleges, a good national reputation, and a Regina campus. In 1974 the government decided to make the Regina campus of the University of Saskatchewan a separate university; but it did not explain that the main full-scale university was to be the University of Saskatchewan and that its Regina counterpart would be a smaller, more targeted liberal arts college. Moreover, the funding formula did not take account of the more expensive programs offered at the University of Saskatchewan, which meant that the larger university was chronically underfunded.[6] Besides being a constant source of friction between the two cities, especially under the NDP, which always did well in Regina, the handling of the issue allowed the Regina academic and business community to harbour expectations that their university could in time grow to become another version of University of Saskatchewan. How a province of one million people could afford two major universities was a question asked by many outside the capital city.

The overbuilt infrastructure and high expectations created by Blakeney paled in comparison to the major fiscal problems that Trudeau passed on to the Conservative government of Brian Mulroney in 1984. Unlike Trudeau, Mulroney and his finance minister, Michael Wilson, acted quickly to address the federal deficit in their first budget by, among other measures, partially de-indexing old age pensions. The response from seniors was swift and furious. One group of protesters corralled the prime minister himself in what was described as "one of the most important confrontations of his short parliamentary career."[7] As he was leaving the Parliament Buildings, Mulroney was accosted by Solange Denis, who assailed him with the much publicized line, "You lied to us ... you made us vote for you, then, Goodbye Charlie Brown." When Mulroney tried to soothe her by saying, "I'm listening to you madame," her tart response was, "Well madame is damned angry." Madame's anger abated eight days later when the government made a "humiliating retreat" from its pension cut.[8]

The about-face on the pension issue showed up the weakness in Mulroney's approach to deficit fighting. Although he and Wilson talked a lot about the fiscal problem and the need to address it, they had not informed Canadians effectively enough about the size of the problem and the kinds of solution required. Polls showed that Canadians were concerned about the deficit and supported cuts. The catch was what they were prepared to see cut. A 1983 poll showed public support for reducing the number of people working for the government, access to unemployment insurance, and funding of the CBC; and it showed strong opposition to reducing access to health care, family allowance payments, and postsecondary education.[9] But only cuts to major programs such as health care would provide the savings needed to solve the fiscal problem. Canadians were still of the mindset that someone else – federal public servants, those on unemployment insurance, or CBC employees – should make the sacrifices. They still had to be convinced that their standard of living was on the line, that dramatic sacrifices from them were required, and that there would be some long-term benefit from the short-term pain.

The other problem was revealed by Michael Wilson when he confessed, "If I had to do it all over again, I'd have attacked [Liberal finance minister Marc] Lalonde's deficit from the start. I could never get the support I needed in cabinet to get it under control, and I'm sorry for it."[10] The support of a determined and united team was essential to tackling the deficit. Not only did Wilson not have his cabinet colleagues on side, but the prime minister himself had shown in the pension controversy that he would run for the political hills when opposition to unpopular cuts mounted.[11] His caving in to an irate senior told the members of every other major interest group that if they screamed loud enough they too would be spared the tough medicine. Thus, while the Mulroney government tried to contain spending, it also responded to pressure to finance megaprojects.

As time passed, other issues overtook the deficit on centre stage. The 1988 election was fought on the issue of free trade with the United States. As so often occurs in Canadian politics, energy and time were absorbed by the constitutional issue, this time the Meech Lake and Charlottetown accords. And introducing the goods and services tax (GST) was a major political battle for the Conservatives. Governments, like armies, can only fight on a certain number of fronts at the same time. The Mulroney government lacked the unity, focus, and determination to take on a battle over the deficit that would have drained all its energy and used up much of its political capital.

After shying away from major spending cuts, Mulroney, like his counterparts in Saskatchewan, Ontario, and other provinces, increased taxes. The Conservatives implemented forty-three tax increases, including eliminating exemptions, broadening the base of existing taxes, introducing surtaxes,

and, of course, imposing the GST. The average person felt the pinch as personal income taxes rose from being 13 percent of household spending in 1969 to 20 percent of it by the 1990s. Canada "hit the spending wall under Trudeau, meaning that subsequent governments could not contemplate major new social programs." Under Mulroney, we "hit the tax wall," meaning that future governments could not increase taxes.[12]

The Conservatives were beginning to control the growth of the deficit by raising taxes, watching spending, and shifting program costs to the provinces – a practice called offloading. Then along came John Crow. As governor of the Bank of Canada, Crow, like other central bankers in the developed world, launched a crusade against inflation that meant raising interest rates dramatically. Setting interest rates is a balancing act. Lower interest rates promote growth in the economy and job creation, and generally benefit the "have nots" who do not have access to credit. Higher interest rates control inflation and benefit creditors. Under Crow the bank's exclusive focus on inflation fighting benefited creditors and hurt those seeking employment."[13] The result was disastrous for many ordinary Canadians as the economy slowed, jobs were lost, and a recession began.

But the recession and higher interest rates also spelled disaster for Canadian governments.[14] In 1990 federal Finance Minister Don Mazankowski unveiled a two-year deficit-reduction plan. It was one of many financial plans released during the 1980s and 1990s by federal and provincial governments. But this one was the centrepiece of the federal budget, and it included spending restraint that would have brought the deficit under control. The recession and high interest rates blew Mazankowski's plan out of the water. As the economy slowed, monies from corporate and personal taxes declined, while unemployment led to higher costs for unemployment insurance and welfare. As another Canadian deficit-reduction plan bit the dust, it took along with it Canadian credibility. Credit-rating agencies and bankers had seen too many financial plans that quickly went off track. In future, plans, projections, and good intentions meant little; only cash on the dash – cuts already achieved and pain inflicted – mattered.

Recession and high interest rates in the early 1990s propelled Canada toward a fiscal crisis as we entered a vicious circle, with the deficit, the debt, and interest payments growing relentlessly like a snowball rolling downhill. By the 1990s, interest on the debt was growing by more than $100 million a day, 365 days a year, which meant that the deficit was $100 million higher each day, and $100 million more in tax dollars had to be collected just to pay the interest on the debt. But the debt was also growing at $100 million a day, which meant that the interest costs increased further, pushing up the deficit and debt, fuelling the worsening cycle.

Even as Canada veered toward a fiscal crisis, there were some economists

and left-wing writers who tried to persuade Canadians that dramatic spending cuts were not warranted; it was high interest rates and the recession, they argued, not excessive spending that had caused our deficit problems.[15] The idea that Canada was facing a fiscal crisis was even portrayed as a right-wing conspiracy; the business community, complicit governments, and naïve media, it was claimed, had persuaded the public that we had a major fiscal crisis, their aim being to soften up people for major cuts in cherished social programs.[16] By the 1990s, arguing over the causes of the problem seemed irrelevant; it was action that was required. Leftists, however, contended that rather than tough medicine for average Canadians, our financial problems could be solved by closing tax loopholes, taxing corporations, and lowering interest rates.[17]

The failure of the left to acknowledge and provide solutions to the emerging deficit/debt crisis mystified and disappointed me as a member of an NDP government. Surely, as more and more of our tax dollars went to pay interest on our debts and the gap between what was collected in taxes and spent on programs widened, the arguments of the right wing became more appealing to the average Canadian. What Joe or Jane Canadian knew was that they were paying governments more and getting less, which constituted for them a bad deal. Maybe it was better, as the right wing claimed, to minimize the role of government and leave more money in Joe or Jane's pocket, in the form of tax cuts, so that they could spend it more wisely.

Equally disturbing was the fact that the standard left-wing critique provided no concrete solutions. Sure, closing tax loopholes is generally a good idea. But as David Perry, senior research associate with the Canadian Tax Foundation, pointed out, by the 1990s tax shelters had been under attack since 1982, and the most lucrative had been eliminated. Ending tax shelters wasn't going to come close to dealing with the deficit challenge.[18] Similarly, in the 1990s it was not as easy to increase corporate taxes as it had been in the 1970s. Free trade and the global economy meant that corporations could move their finances and investments wherever the cost of doing business was the most attractive. Whether we liked it or not, our tax rates in a global economy had to be competitive. Did I like it? No. Did I think it was a fact of life? Yes.

Most troubling, however, was that the left-wing critique failed to consider the implications of the fact that Canada led all the developed countries in the level of its foreign indebtedness, with Canadian governments owing foreigners more than $300 billion. Our governments borrowed too much money for them to find financing in Canada. But as the various governments borrowed more abroad, more than $30 billion left Canada every year to pay interest costs.[19] The level of foreign indebtedness also left Canada vulnerable to the whims of international markets. Just as money poured into

the country when times were good, it could be pulled out just as quickly when Canada appeared to be in trouble. Worst of all was the fact that it was international financiers, not Canadians, who made the fateful decisions.

Tremors warning of a coming financial earthquake abounded in the early 1990s. International credit ratings for Canadian governments were revised downward, and several European and Japanese investors announced that they would no longer buy Canadian government bonds.[20] In the fall of 1992 the financial publication *Euromoney* reported that "foreigners started looking at Canada because of the referendum [on the Charlottetown Accord] and ended up getting terrified about the economy ... What they found was a low-growth economy so constrained by debt that it is unable to stimulate recovery without sparking a currency crisis."[21] High-level International Monetary Fund (IMF) officials spent long hours in Ottawa talking to officials in the Department of Finance and to the governor of the Bank of Canada.[22] Economists warned that Canada was perilously close to a full-blown fiscal crisis. As one financier put it, the country was living "on the brink of a volcano and is very close to falling in."[23]

The currency quake came in late 1994, and although it was Mexico that went through the crisis, Canada felt the aftershock. In December the Mexican peso was devalued, investors panicked, and the Government of Mexico watched helplessly as the international markets drove the peso into a free fall. The Mexican crisis showed, in the words of one of Paul Martin's advisers, "just how fickle offshore, short-term money is ... It was a great object lesson in the psychology of the run."[24] Nervous international investors, spooked by the Mexican currency crisis, looked around for safe places for their investments. For far too many, Canada did not make the grade. As they sold their Canadian holdings, the dollar fell and the Bank of Canada raised interest rates to prop up the dollar and keep that absolutely essential foreign money in Canada. It was every finance minister's nightmare – potentially the early stages of a currency crisis that could take Canada down the road that Mexico had just travelled. One person who was not surprised was Paul Martin. After the 1994 budget, he had visited financial capitals around the world and concluded that if the 1995 budget did not tackle the deficit head on, interest rates would go through the roof and Canada would be thrown into a major fiscal crisis.[25] Time had run out on Canada.

Action was needed. Remarkably, by 1995 Canadian voters were even demanding action at the federal level. They had learned their lesson well on the provincial scene in the early 1990s as the debts of the provinces approached $200 billion and credit-rating agencies asserted their authority. Successive downgrades in provincial credit ratings in the late 1980s and early 1990s were Wall Street's way of signalling that there was a limit to the amount of debt that was sustainable. If credit-rating downgrades were

warning signals, access to credit was the rating agencies' ultimate weapon. As provinces such as Saskatchewan veered perilously close to a full-blown fiscal crisis, with their ability to borrow hanging in the balance, dramatic budgets with massive cuts and tax increases followed suit. After enduring wave after wave of tough provincial budgets, Canadians were psychologically prepared for what Martin had to deliver. By 1995, they knew that skyrocketing deficits and ever higher debts were a cancer on the body politic that required tough medicine. Provincial governments had laid the groundwork for the difficult choices that Martin had to make.

Before considering the deficit and debt-taming battles begun in the provinces in the early 1990s, it is necessary to answer a fundamentally important question: How did Saskatchewan and other provinces with a record of fiscal responsibility get themselves into such a quagmire by the beginning of the 1990s? In some parts of the world, governments end up on the financial brink because of bribery, corruption, and the use of public resources for private ends. Not in Canada. The politicians who racked up the provincial deficits and debts in the 1980s and 1990s were generally well-meaning people who were interested in helping people – and, of course, in winning elections. If they were spending a lot, it was mainly because Canadian voters expected a lot from their governments. Understanding how well-meaning people drove a province to the brink of bankruptcy is the best tonic for preventing similar folly in future.

Helping People and Winning Elections: Spend, Spend, Spend

The urge to spend, spend, spend in the name of helping people and winning elections knew no ideological bounds in the 1980s. Whether it was David Peterson's Liberals, who governed Ontario from 1985 to 1990, or the Conservative regime of Don Getty, in power in Alberta from 1985 to 1992, or the Conservatives in Saskatchewan under Grant Devine between 1982 and 1991, the pattern was the same. Notions of fiscal prudence were cast to the wind as government coffers were opened in response to voters' expectations that governments could solve their problems.

Ontario Treasurer Robert Nixon reflected the mood of his province when he declared that the prospect of a downgrade in the province's credit rating should not worry voters, since "having a triple-A credit rating does not provide needed jobs for young people, nor improve access to affordable housing, nor improve the quality of and availability of health care."[1] Between 1985 and 1988, Ontario's spending increased by double digits, with the amount going to agriculture rising by 86 percent and spending on health care going up by 84 percent. How did Ontario pay for its excessive spending in the late 1980s? A booming economy helped fill government coffers. Taxes were increased – in its six budgets, the Peterson government implemented twenty-eight tax increases. Even with tax increases and a booming economy, there was still a widening gap between the money coming into the treasury and spending. Hence, the government ran deficits. By the early 1990s, Ontario was running a deficit of more than $3 billion a year, carrying a debt more than ten times that size, and the booming economy that had underpinned the growth in spending was a distant memory as the province was mired in recession.[2]

The story was similar in Alberta in the late 1980s and early 1990s. The problem there started with revenue from oil and gas that financed almost half of Alberta's spending by the mid–1980s. In 1985 the price of oil plummeted from $30 to $15 a barrel, drastically reducing government revenue,

but government spending was not cut to reflect the changed fiscal reality. Instead, government spending continued to grow by 5 percent a year, and the province ran deficits. Optimistic forecasts for the price of oil masked the size of the problem; for example, in one budget, spending was based on an estimated price of $23 per barrel for oil when in fact oil was only at $9 per barrel.[3] Helping people and winning elections was the theme for much of the spending. In 1989, as the Getty government prepared to meet its makers at the polls, families were losing their homes because of record high interest rates. In response, the Getty government promised to subsidize mortgage rates and, for good measure, committed to spend more on highways and to replace rural party lines with private telephone lines. When the election was over, another $800 million in new spending was fuelling Alberta's growing deficit.[4] By the time Ralph Klein replaced Getty as leader in December 1992, Alberta had a ballooning deficit of more than $3 billion, which was projected to reach $6 billion by the mid–1990s, and an escalating debt.[5]

By the end of the 1980s all provinces had financial problems similar to those in Alberta and Ontario, but Saskatchewan had become a canary in the coal mine of deficit and debt. All governments thought they could use government largesse to solve people's problems, but in Saskatchewan in the 1980s this notion was taken to extremes. Pouring tax dollars into megaprojects and picking economic winners and losers occurred elsewhere, but not with the reckless abandon displayed in Saskatchewan. The Devine government, described by *Globe and Mail* columnist Jeffrey Simpson as "one of the worst provincial governments in recent history,"[6] racked up more than $10 billion in debt in less than a decade – $10,000 in debt for every man, woman, and child in the province. How could a province with only two small deficits before 1982 find itself in such terrible financial straits? How could a right-wing government committed to downsizing government and lowering taxes end up increasing taxes and raising government spending to unprecedented heights? The story of how Saskatchewan racked up more than $10 billion in debt in less than a decade is fascinating, and it is worth telling, since it serves as an object lesson of how easily and quickly things can go so badly wrong.

The story begins with the neo-conservatism of the 1980s. In 1979 Great Britain elected Prime Minister Margaret Thatcher, in 1980 Americans chose Ronald Reagan as president, and in 1982 Grant Devine and the Conservatives took Saskatchewan by storm. While Devine had to soften his rhetoric in deference to the history of Saskatchewan as the birthplace of medicare and many of Canada's co-operatives and crown corporations, his election did mark a turn to the right. Key Thatcher advisers such as Oliver Letwin came to Saskatchewan to impart their wisdom on privatization, and Devine shared the fundamental neo-conservative belief that "government is not the

solution to the problem. It is the problem."[7] Rather than believing that higher taxes meant better social programs, Devine championed tax cuts so that "the people could invest more of their own money to better advantage themselves, creating jobs and building the province."[8] Rather than seeing government as a positive force that improved people's lives and helped the economy grow, Devine viewed it as a negative that constrained the potential and dynamism of individuals and led to the creation of bureaucratic empires and red tape.[9] More than anything else, the all-consuming distrust of government, its institutions, traditions, and public servants explains both Devine's rise to power and the Conservatives' downfall as a government.

Grant Devine was the perfect missionary for the new right in Saskatchewan. A populist, a booster, and a man determined to transform the province, he inspired people with his vision of a new Saskatchewan. Raised on a farm, he spoke the language of rural people. "Don't say whoa in a mud hole" and "Give 'er snooze Bruce" were among his many folksy expressions. But he also had a PH D, was a professor at the University of Saskatchewan, and was a devout Christian and upstanding family man with four children and an attractive wife, Chantal. Devine was a dreamer. "Like all builders, he sees beyond obstacles. He finds opportunities" was how an admirer described him, while a critic said that Devine "only saw the opportunity or hope, not the problems or consequences; he saw the dream and never lived on the ground."[10] His enthusiasm was infectious. He had a simplicity and sincerity that was captivating and "a speaking style that came right from the heart, that caught the emotions of people. The crowds came to cry with him and to laugh with him."[11] Devine's "unabashed optimism" was depicted by political columnist Murray Mandryk: "Had he been cruise director of the Titanic, he would have spent his final hours bragging about how many good swimmers there were aboard."[12] Devine's appeal helps explain the Conservatives' victory in 1982.

Weeks before the 1982 election, a confident senior political adviser told me that the upcoming election would see one of the biggest victories in Saskatchewan history. The good news for this chap was that his prediction proved to be correct: the election on Monday, 26 April 1982, was a landslide; the bad news for him was that it was for the wrong party. In what became known as "the Monday night massacre," Grant Devine and the Conservatives won 55 of the legislature's 64 seats and captured 54 percent of the popular vote. The result shocked the New Democrats; even the general public had assumed before the election that the NDP would coast to victory.

The CCF-NDP was Saskatchewan's natural governing party – holding power for thirty-one of the thirty-eight years between 1944 and 1982 because it provided strong leadership and sound management while at the same time tapping into the social democratic history of the province. Social

democratic ideas had come to Saskatchewan in the early twentieth century with British immigrants who had been members of the Labour Party and trade unions. Also, the hardships of the wheat economy fostered prairie radicalism. Wheat farmers – who felt victimized by eastern-based grain merchants, banks, and middlemen, and were vulnerable to the whims of the weather, grasshoppers, and international grain prices – came to believe that the "old line parties" did not represent their interests, and they sought alternatives. The Co-operative Commonwealth Federation emerged as one of several grassroots protest parties. Meanwhile, Saskatchewan people developed co-operatives and crown corporations as a way for communities to provide themselves with affordable and effective goods and services. Similarly, social gospel ideals of showing compassion for the less fortunate and the desire of ordinary people to provide security against illness and misfortune led to the creation of health and social services.[13]

Equally important was the CCF-NDP's hard-headed commitment to sound financial management and efficient government. Everyone has heard of Tommy Douglas, the charismatic premier of the province (1944–61), but just as important to the CCF's electoral success was Clarence Fines, Douglas's tight-fisted and very powerful finance minister. Debt was anathema to Fines, who hated paying interest to the banks. In its thirty-one years in power the CCF-NDP brought in one small deficit budget and thirty surpluses.[14] The CCF also openly avowed a mixed economy, in which crown corporations provided utility services such as power, while key sectors of the economy, notably oil and potash, were developed by the private sector. As an activist party, the CCF-NDP believed in affordable and effective government and quickly developed one of Canada' finest public services.[15]

The defeat of the CCF in 1964 was a defining moment in Saskatchewan's history, which etched in stone the province's reputation for partisanship. Although there were many reasons why the government lost – it was old and tired, and Tommy Douglas had left for federal politics – legend had it that the government died on the battleground of medicare. [16] When the CCF moved in the early 1960s to implement a universal, publicly funded healthcare system, the doctors went on strike and the province was bitterly polarized between supporters of the doctors and the government. "Never forget" is a fitting epitaph for the strike, in that years later people still recall on which side one lined up in 1962. The new Liberal premier, Ross Thatcher (a former CCFer), privatized some government operations, cut taxes, and made labour legislation more pro-business. However, his right-wing bark was worse than his bite. The major crown corporations survived; most of the civil servants who left did so voluntarily; and in the case of medicare, Thatcher's only bold move was to impose deterrent fees, which were so ineffective and unpopular that they contributed to his defeat in 1971.

When the NDP returned to power under Allan Blakeney in 1971, the party continued its tradition of compassion, sound financial management, and effective government. But it also moved, like the Government of Alberta, to diversify the economy and to assert provincial control over the province's increasingly lucrative natural resources: oil, potash, and uranium. In both Saskatchewan and Alberta, the governments battled Ottawa to assert provincial control over natural resources; they broadened their economies well beyond agriculture into resources, services, and even manufacturing; and they created Heritage Funds to set aside some of the windfall resource profits for economic ventures to benefit future generations. In both provinces the 1970s was a period of prosperity and optimism, a time when government played an active role in creating new social programs and managing the economy.[17]

If the 1970s in general was the era of big government in Canada, then Saskatchewan was the trailblazer. There didn't seem to be a problem that government couldn't solve. When farmers were having trouble transferring their land from one generation to the next, the solution was to create a government agency, the Land Bank, to which retiring farmers could sell their land so that it could be leased to tenants until they could afford to buy it. The long-standing problem of underdevelopment in northern Saskatchewan was addressed by creating a whole new Department of Northern Saskatchewan, complete with its own bureaucracy in La Ronge. To ensure that local people controlled and benefited from natural resource development, more crown corporations were created. Crown corporations in uranium, oil, and other sectors meant that the profits from these industries remained in the province, as did the good high end jobs that went with keeping the companies' head offices in Saskatchewan. And when potash companies balked at paying their fair share of royalties and threatened court action to challenge provincial control, the answer was to nationalize them and create another crown corporation. Expanded well beyond their initial mandate to provide utility services, crown corporations became major engines of economic development in the 1970s.[18] Although some measures made good sense, the impression was of an almost omnipresent government, and there was legitimate concern about the effects of such an approach on the long-term growth of the province.

Although at the time I supported the Blakeney approach to economic development, including the nationalization of potash, I can in retrospect see that high taxes, an oversized crown sector, and a strong government presence in the economy were not good strategies in the long term. Whatever the rationale for taking over the potash mines, investors would be wary of a place known throughout North America for having nationalized a key industry. High royalties on scarce resources may have worked in the 1970s,

but not in the 1980s as resource prices fell and globalization meant that companies sought out the most tax-competitive place in which to do business. As crown corporations sprang up to carry the provincial torch for economic development in Saskatchewan, they crowded out the private sector, while in Alberta private-sector businesses led the way and an entrepreneurial culture was created. During one of the greatest booms in Saskatchewan's history, there was no strategy to capitalize on the immense opportunities and translate them into long-term expansion of the private sector and the development of a non-agricultural entrepreneurial culture.[19] Thus, even in its heyday, the province hovered around a million people with a volatile economy that was dependent on the ups and downs of commodity prices, external markets, and capital investment. When the down cycle came, what would become of the rich array of social programs and hospitals built in the heady days of the 1970s?

The size of government concerned members of the business community; key deputy ministers feared the government's main focus was "the development of a form of state capitalism," and increasing bureaucratization resulted in government decisions that unnecessarily irritated people.[20] For instance, SaskTel insisted that telephones could be bought only from the crown-owned monopoly, and Saskatchewan Government Insurance refused to allow people to purchase the customized license plates available in other provinces. When glitzy ads praising "Saskatchewan's Family of Crown Corporations" played before feature films in local theatres, they were greeted with a chorus of boos while cabinet ministers in the audience cringed. Expansion of the resource sector led to fears that social spending was suffering. Even Allan Blakeney now concedes that "we did not carry the people" on the benefits of more crown corporations and that in the case of the resource sector, government ownership was not "the wave of the future."[21]

Although Blakeney was personally respected and his government was regarded as a good manager, the tell-tale rumblings of a looming defeat were apparent as even New Democrats whispered that the government was isolated, had lost touch with voters, was not listening, and had lost its drive and focus. Blakeney and Roy Romanow, his deputy premier, were preoccupied by the constitution; Premier Ross Thatcher used to say that on a list of 100 priorities for Saskatchewan, constitutional change was 101.[22] Symptoms of an old government into its third term also appeared as interest groups drove decision making, as money was thrown at problems, and as the government tried to be all things to all people. Within government, power was increasingly centralized in the Department of Finance and the Executive Council, robbing departments and ministers of opportunities to innovate, and leaving the premier more isolated and more dependent on his staff.[23]

Slowly but surely, sound management was being transformed into bureaucracy; it was becoming an end in itself rather than the means to an end. Instead of being the vehicle to make the best political decisions, good management came to mean running a well-tuned bureaucracy which made sound policy decisions that had an internal logic to them but which left voters feeling alienated and abandoned. Civil servants and cabinet ministers were, in the words of one of them, "losing sight of the average guy on the street whom we supposedly served."

A turning point for the NDP was the budget of 19 March 1982 which boasted that the province was leading Canada in economic growth, "with the finest array of health, social and education programs in Canada" and "a future" that was "second to none." At the same time, interest rates of over 20 percent meant that young families were "threatened with losing their homes" and pensioners were struggling to "live on fixed incomes" while inflation soared and "small businesses were facing bankruptcy." As if the obvious disconnect between the problems of people and the success of the government was not enough, there was a meagre $20 million of interest rate relief, targeted to people with incomes of $35,000 or less, while $2 billion – one hundred times as much – was being spent "in job-creating capital investment through crown corporations and government agencies." The budget also failed to mention that with resource prices declining, the province was moving into stormy economic waters. The Conservatives would later allege that the budget relied on inflated revenue estimates to mask a deficit. Blakeney, while adamant that the 1982 budget was balanced, concedes now that the 1983 and 1984 budgets would have been very difficult to balance without tough action. However, heading into an election, the government was not about to "burst the bubble of optimism" that had engulfed the province since the mid 1970s.[24] The chasm between the government's knowledge about a less than rosy picture for the province's future and the public sense that the boom times of the 1970s were continuing left the door open to extravagant Conservative election promises to help people and win votes.

With the help of expert out-of-province pollsters such as Allan Gregg, the Conservatives were transformed in the early months of 1982 from a "loosely knit group" that had only recently challenged Devine's leadership into populists who connected with the public mood.[25] The NDP boast that the government was "tested and trusted" was countered by Devine's claim that in fact it was "rusted and busted". In response to government ads celebrating the "family of crown corporations," Devine said that while the family of crown corporations was doing well, Saskatchewan families were suffering. In a bold and unexpected stroke, the Conservatives promised that all homeowners, not just those with incomes below $35,000, would get mortgage

relief; the Land Bank would be dismantled in favour of financial assistance to allow farmers to buy their land instead of renting it; the gas tax would be eliminated immediately, and sales and income taxes would be cut.

Devine also projected a vision of a better and bolder future when he talked about "there is so much more that we can be" and advocated a coalition of common sense against the socialists. The prosperity and confidence of the 1970s and early 1980s rekindled the hope that Saskatchewan could close the gap with Alberta. Before the Second World War, Saskatchewan had been home to about 25 percent of the prairie population; but with the discovery of oil in the late 1940s, Alberta had boomed, eclipsing its eastern neighbour, so that by the 1980s Saskatchewan had only 10 percent of the West's population.[26]

For many business people and right-of-centre politicians, it was the socialists in Regina as much as the oil in Alberta that had held the province back. In the 1960s Liberal Premier Thatcher quipped, "There is nothing wrong with socialism except it doesn't work."[27] A decade later the Conservative leader Dick Collver referred to Saskatchewan's tremendous economic potential when he called it "a sleeping giant ... chained by the dogmatic idiots in the NDP."[28] And Ross Thatcher's son Colin, who left the Liberals to join Devine, declared that the CCF-NDP had been "a curse on the province of Saskatchewan and have unquestionably retarded our economic development, for which our grandchildren will pay."[29] By adopting a pro-business agenda, intimated Devine, Saskatchewan would be propelled forward into the big leagues to regain its rightful place alongside Alberta.

As the Conservatives captured the limelight, the NDP was caught in its own contradictions and plagued by internal divisions. With the 1982 budget extolling the province's rosy future, the NDP could not convince voters that Conservative election promises were unaffordable. The decision halfway through the campaign to shift gears and make expensive promises of its own merely confused NDP supporters. This abrupt shift in message divided New Democrats, as did the decision to order CUPE health-care workers back to work on the eve of the election. For some New Democrats, making rash promises midway through the campaign smacked of cynical vote buying, while others vented their wrath at the finance department for holding the purse strings so tightly as the government headed to the polls. These divisions persisted into the 1990s and haunted our government.

When the dust settled, Saskatchewan had taken a turn to the right. The CCF-NDP view that the benefits of high taxes were high-quality public services had been less persuasive than the Conservative idea that hard-pressed taxpayers needed more money in their pockets in the form of tax cuts. The CCF-NDP approach of targeting assistance to the less fortunate or those in need had been rejected by the middle class, which supported the need to

help all taxpayers struggling with high interest rates. For better or worse, the Devine Conservatives had irrevocably committed themselves to loosening government purse strings to provide universal help to Saskatchewan people. Swept away by the heady optimism of the 1970s oil boom, the Conservatives assumed that the economy and government revenues would continue to grow dramatically. What would happen when they discovered that the boom times were over in Saskatchewan?

The optimism that swept the province in the April 1982 election was reflected soon after, when the first speech by a Conservative from the government benches in almost fifty years was delivered by a twenty-six-year-old MLA, Grant Hodgins, Devine's personal choice for the honour. Hodgins remembers fondly the pride he felt, decked out in his new blue suit adorned by the rose given him by his brother, as he declared in his powerful auctioneer's voice that Saskatchewan's time had finally arrived, while fifty-four enthusiastic Conservative MLAS applauded wildly.

Less than a decade later the same Grant Hodgins, now government house leader, rose from the front benches of the legislature to drop a political bombshell. Hodgins recalls the overwhelming sadness he felt as he mumbled, "I'm sorry, Grant," to the premier, who sat next to him but had no idea that his protégé was to announce his resignation from cabinet and the moving of his chair "to the opposite side [to sit] as an independent member."[30] Soon afterwards the government ended the legislative session without even passing its budget, and it governed by special warrants until October, when its five-year mandate expired. The government that had stormed to power in 1982 was unceremoniously swept from office in 1991, and by the end of the decade the name Conservative was in such bad odour that it was replaced by the Saskatchewan Party, a coalition of former Conservatives, Liberals, and Reformers.

The Conservatives' troubles began within weeks of assuming office when Finance Minister Bob Andrew, after a careful review of the finance department's fiscal forecasts, informed Premier Devine that the province could not afford to eliminate the gas tax. The response was a barrage of polls, by the same pollsters who had fashioned the Conservatives' electoral sweep, showing that the public was in no mood to hear about fiscal restraint and would never forgive a party that broke a promise so critical in its election victory. The pollsters' message was reinforced by memories of the defeat in 1980 of the short-lived Conservative government of Joe Clark, which had promised voters "short-term pain for long-term gain" to deal with the federal deficit. Politics trumped sound public policy when the Devine government opted to live up to its election commitment to eliminate the gas tax, provide mortgage relief, and replace the Land Bank by taking the province down the road of deficit financing.

Andrew's predicament shows why right-wing governments, like the Reagan administration in the United States, amassed such huge deficits in the 1980s. The idea that tax cuts would trigger economic growth and therefore pay for themselves proved to be simplistic in an increasingly global economy where so many other variables, beyond the control of governments, affected growth. Moreover, the flip side of tax reduction was cutting government spending – a feat more easily achieved from the comfortable pew of the opposition benches. Andrew recalls how Conservative MLAs who had been experts at cutting spending while in opposition were transformed, after winning the election, into cabinet ministers with turf to protect or backbenchers who wanted roads, schools, or other spending in their ridings.[31]

Despite their rhetoric about downsizing government, the Conservatives had ridden to power on their promise to cut taxes and help families deal with high interest rates. The initial impulse to open government coffers expanded in scope as other hardships hit Saskatchewan people in the troubled decade of the 1980s. Throughout, the theme was loosening government purse strings in order to protect people. Andrew's successor as minister of finance, Gary Lane, declared in his 1989 budget: "When escalating living costs eroded seniors' incomes," the government introduced the $40-million-a-year Senior Citizen's Heritage Program. The theme continued with Lane's successor, Lorne Hepworth, who provided a novel definition of what constituted "sound financial management." According to Hepworth, "In times of high interest rates, it means protecting families and their homes, farms and businesses. In times of drought, international trade wars and low grain prices it means protecting farm families and communities."[32] Rather than controlling spending and balancing budgets, sound financial management in the 1980s was equated with spending money to help people weather troubled times.

Shielding voters from the ups and downs of economic life in a resource-based province proved to be a costly undertaking. The most striking example of spending tax dollars to protect Saskatchewanians was the billions spent by the Devine Conservatives to preserve the rural way of life and prop up a threatened agricultural sector. By the 1980s, diversification of the economy into resources, services, and even manufacturing meant that agriculture represented a smaller piece of the economy, but the heart and social ethos of the province were still rooted in the family farm, especially for the Conservatives. If there was one overriding dream that united the Conservative caucus, it was saving rural Saskatchewan and preserving the family farm and the values of hard work and community spirit that it represented.

By the 1980s, changes in technology, world trade, and government policy had combined to put the family farm on the list of endangered species. Bigger and better farm equipment enhanced the productivity of prairie

farmers, but at the same time fewer and fewer people were needed to farm the same amount of land, and bigger and bigger farms were required to finance the costly new equipment. Bigger farms meant a decline in rural population, which in turn threatened rural services such as schools and hospitals. Larger farms also caused railways to abandon branch lines and led to the closure of rural elevators, which meant that farmers had to truck their grain farther and farther each year. The result was higher costs for transportation. At the same time the costs of other inputs, such as fertilizer, were increasing and the higher costs were not matched by better prices. Farming was transformed from being a way of life to becoming a business in which only the largest and most efficient would survive.

The pressure of global competition and the market economy also took their toll. Over the years, an impressive array of bulwarks to protect the family farm had been created. They included the Crow benefit, established in 1897 and updated in the 1920s, guaranteeing low freight rates for the transportation of prairie grains; marketing boards, regulating production and setting prices for many agricultural products; and the Canadian Wheat Board, created in the 1930s as the sole agency for marketing grain. By the 1980s, as the global economy eroded national boundaries, these bastions of the family farm came under attack. Marketing boards found it harder to guarantee a fair return to producers in an increasingly open economy in which prairie farmers had to compete with farmers around the world. Despite all the rhetoric about free trade, the United States and the European Union subsidized their farmers, leaving Canadian farmers to compete on a playing field that was uneven. On top of these fundamental changes, the 1980s brought drought, low commodity prices, and infestations of grasshoppers. Rural Saskatchewan was clearly in serious trouble, and the Conservatives sallied forth to save agriculture and the rural way of life.

In the 1980s the Conservatives poured literally billions into agriculture and rural Saskatchewan. There were one-time payments from the province and the federal government to offset European and American subsidies or to combat natural disasters like droughts. There were low interest loans to young farmers to encourage them to begin farming. A host of agricultural inputs, including farm fuels, were exempted from taxation. There were cash advances and loans on very open-ended terms to tide farmers over difficult times. In 1986, for instance, $1 billion was spent on low interest loans that allowed all farmers, irrespective of their need or ability to repay, to borrow $25 an acre at exceedingly low interest rates. At the same time, hundreds of millions were poured into services in the hope of making rural Saskatchewan an attractive place in which to live. Ten new hospitals were built, there was special financial support for community facilities such as curling rinks, and more than $500 million was spent bringing natural gas

and individual telephone lines to rural households.[33] Devine cabinet ministers, including Colin Thatcher, who was minister of energy in the early 1980s, were committed to preserving a cherished way of life and bailing out a troubled sector of the economy. What, in the end, was the result of all of the government spending?

As Colin Thatcher travelled through the Saskatchewan countryside in 2001 for the first time in fifteen years, he was overwhelmed by emotion when he saw the abandoned homesteads, dismantled elevators, and shrinking towns, and his first thought was that the Devine government, whose heart and soul had been in rural Saskatchewan, had failed the farmers. He reflected on all of the money poured into schools, hospitals, rinks, phone and gas lines, and the federal-provincial bailouts, and realized that although the Devine government's heart had been in the right place, the policies adopted obviously had not.[34]

Too often in politics, what we cherish most we inadvertently destroy by believing that protecting it means freezing it in time, when in fact protecting something may require changing it dramatically – just like raising children, for instance, where protecting them means encouraging them to grow and adapt to the world in which they have to live. The Devine government demonstrated its commitment to rural Saskatchewan not by thinking about what changes were required to equip rural people to meet the new world of the future, but by doing what had been done for generations. It did not, for example, deal with the problem that rural Saskatchewan has hundreds of local governments – more local governments per capita than in any other Canadian province – which choke off potential investment in a tangle of red tape. Instead, the government continued the time-worn tack of building more infrastructure, without the population to support it, and funnelling cash payments or loans (which often could not be repaid) to cash-strapped farmers.

No amount of money could stop the tidal wave of forces that led to larger farms and rural depopulation. In fact, the consolidation of farmland into fewer hands was actually accelerated in the 1980s by government programs that based assistance on the number of acres farmed. An assessment of these programs concluded that one-third of the farmers were actually helped by the programs, another third were in such bad shape that the money did not help, and the final third, often big farmers, did not need the money but used it to buy out their financially troubled neighbours. Ironically, legislation restricting the ownership of farmland by outsiders was beside the point when the family farm was being gobbled up from within by fellow farmers. At the same time, in order to convince the federal government to continue investing billions in agriculture, the province agreed to a change in the funding for agricultural programs. Whereas in the past the federal government

had paid 100 percent of the cost of such programs, by the end of the 1980s the provinces had to come up with 35 percent of any new agricultural funding. For Saskatchewan, which had the largest amount of agricultural land of any province but only about 3 percent of the country's taxpayers, this change was devastating and made pressuring the federal government for agricultural assistance an expensive proposition.

At the same time as the Conservatives were spending literally billions to protect farmers and other Saskatchewan people from the ups and downs of the economy, these same ups and downs were ravaging the provincial treasury. No doubt the Conservatives had some bad luck. They came to power just as the resource bubble was bursting. Rather than benefiting from record prices for oil, potash, and uranium, as in the 1970s, prices for resources and agricultural products fluctuated, often tumbling to historic lows. The problem was simple enough: the government was spending much more, taking in less, and financing the shortfall with deficits. With only two small deficits in their entire history, the people of Saskatchewan were not vigilant enough about the Conservatives, who did not balance even one of their budgets but instead delivered ten straight deficit budgets.

It was beguiling how easily the Conservatives explained away the deficits. The first one was blamed on the NDP government which, as Andrew put it, had "jiggered" the numbers in its own 1982 budget. The second deficit was justified on the basis that "most of the additional burden caused by falling oil revenues should be carried by the government not be imposed on the people of Saskatchewan"; Andrew assumed a curious division between the people and their government, as if the people, as taxpayers, would not in the end have to pay for the deficits of the government. Particularly disarming was the Conservatives' admission that deficits had to be eliminated; for example, in 1984 Andrew was adamant that deficits had to be reduced and that "failure to accomplish this will force harsh penalties on our children" – by which he meant "reductions in government services and tax increases." All the while, the government continued to introduce both new programs and new rationales for deficit financing: running deficits in bad times was fine as long as the budget was balanced in good times; the budget might not be balanced in a specific year but it would be balanced over the life of the government; and every other government was running deficits.[35]

Changes in accounting also masked the deficits. Canadians have paid dearly over the years for the fact that when accounting changes are mentioned, taxpayers' eyes glaze over, as the Saskatchewan example shows. In 1986, rather than paying for new capital projects such as schools or hospitals in one year, as had been standard practice, the cost was spread out over many years. Also, publicly owned farmland was sold to a new government corporation,

allowing the government to take the money from the sale and spend it.[36] Spending was also moved over to the crown side of government. The Department of Supply and Services, a government department, became the Saskatchewan Property Management Corporation (SPMC), a crown corporation, which meant that rather than government offices and equipment being paid for out of the current year's money, the equipment was booked as assets and financed by borrowing; by 1991 SPMC had racked up more than $700 million in debt.[37] Another of the many examples of fancy bookkeeping was the financing of the environmental and recreational activities associated with the building of the Rafferty and Alameda dams in southern Saskatchewan. Rather than paying for these costs upfront, the government created a crown corporation and had it borrow the money; by 1991 this crown corporation had $115 million in debt.[38] All of this debt had to be repaid. Simply put, rather than paying its bills as it went along, the government was spending money to protect today's taxpayers and leaving the bills to be paid by their children.

Andrew also deftly changed the Heritage Fund – created in the 1970s to provide investment for future generations – by playing on popular concern that, under Blakeney, money had been spent on crown corporations rather than on people. Instead of lending the more than $1 billion in the Heritage Fund to crown corporations (for instance to Sask Oil so that it could "buy other oil companies"), Andrew said that the money should be spent on "services and tax cuts for people."[39] And here lay the problem. When the Heritage Fund had been used to buy assets, it was being invested; but when Andrew removed the restrictions on the use of Heritage Fund money in 1983 and began moving the money into government revenue, he was spending the $1 billion. It was like selling a section of land to pay your bills for this year without pondering how you will pay the same bills next year now that both the land and the money received from selling it are gone.

The provincial auditor, whose job it was to review the government's books and report to the public, warned again and again that proper accounting practices were not being followed and that the true level of public debt was unknown. His 1991 report said:

These financial statements do not follow accounting principles appropriate for government financial statements. The financial statements do not include all the organizations owned or controlled by the Government. Also, the financial statements do not include sufficient information to provide a clear and full understanding of the financial position of the Government. If appropriate accounting principles were followed, the financial statements would be materially different.[40]

Changes in accounting hid from voters the true extent of the province's financial problems and allowed the Conservatives to be narrowly re-elected

in 1986, even though the province had already racked up some $2 billion in debt and had had its credit rating downgraded.

Despite the fact that the Conservative government and the NDP opposition knew that the province was in serious financial trouble by 1986, both had election platforms full of expensive promises. While the Conservatives offered homeowners 9¾ percent mortgages, $10,000 home improvement loans at 6 percent and $3,000 for first-time home buyers, the NDP's platform was 7–7–7: $7,000 grants for first-time home buyers, $7,000 renovation grants, and 7 percent mortgage rates. During the 1986 election, when I campaigned with Roy Romanow, who was making a political comeback after his defeat in 1982, door knocking was like talking to comparison shoppers. Voters calculated the money that they would get from one party's promises and then tried to compare these with what was being offered by the opposing party. Liberal ads boldly declared, "Don't sell the farm! Last election the Tories bought votes with billions of dollars in promises. This time, the NDP are promising billions more. Before you go for the goodies, wouldn't you like to know the cost?"[41] Apparently not many did. The Liberals elected only their leader. Most voters, it seemed, did not want cold water poured on the great Saskatchewan barbecue.

Even the federal government was dragged into the 1986 spending spree. Grant Devine broke with the Saskatchewan tradition of always running against the federal government. He had a close relationship with Brian Mulroney and supported some of Mulroney's most contentious moves: the Free Trade Agreement, the Meech Lake Accord, and the goods and services tax (GST). In return, Mulroney financed megaprojects in Saskatchewan, found federal positions for retiring provincial cabinet ministers, and responded to a telephone call from a Saskatchewan motel room midway through the 1986 election, when Devine pleaded for a $1 billion support package for Saskatchewan farmers.

The 1986 election taught me a lot about politics. Although Allan Blakeney took full responsibility for the campaign, anyone familiar with him knew that he was following the advice of his pollsters rather than his own instincts when he catered to the voters' appetite for government aid by making extravagant promises that could only be financed by running deficits. Immediately after the election, I attended an NDP council meeting and witnessed the tragic spectacle of a great leader being crucified by his own activists for abandoning his principles. The lesson was: Do the right thing in politics and use pollsters to help sell the message, not to design the policies; even if you go down, you'll leave with your head held high. Political advisers also did an image makeover of Blakeney. An intellectual, dignified, reserved man, he was dressed up to look more like Devine. It was sad to see him awkwardly strolling around trying to look folksy in ill-suited plaid

shirts. Later, when I was in politics, and my own advisers hinted that I was too aloof for Saskatchewan voters and dressed too fancily for the NDP, the image of the plaid shirts would flash into my mind and I would think to myself, "I am who I am and I dress as I do." In politics, the only person you can be is yourself.

Soon after the election, it became clear that Saskatchewan was blazing a trail, but it was not the trail the Conservatives had promised. By 1987, "while the deficit for the other nine provinces averaged $201 per capita, Saskatchewan's was $691 per capita," and while the rest of Canada had a per capita debt of $5,658, Saskatchewan's was $10,172. Ironically, the party that had come to power to shrink government had increased government spending beyond Blakeney's wildest dreams. In the 1970s government spending had been about 20 percent of the provincial economy (GDP), barely above the national average. By 1987 government spending in Saskatchewan was almost 35 percent of GDP, while spending for the rest of Canada had grown to only 22 percent.[42] Action had to be taken.

Beginning with the 1987 budget, the Conservatives started down the dreary road of dismantling the programs they had created and raising the taxes they had promised to cut. The Conservatives' replacement for the Land Bank, the Farm Purchase Program, aptly described as the "centrepiece of provincial agriculture policy for the last five years," was scrapped in the 1987 budget.[43] The gas tax, eliminated with such fanfare in 1982, was reinstated in 1987, but rebates were given to consumers. By 1990 the rebates were gone and the gas tax fully reinstated. Elected on a promise to cut the sales tax, the Conservatives raised it from 5 to 7 percent, and in 1991 it was harmonized with the GST. Rather than decreasing income taxes as promised, the Conservatives raised them and introduced a flat tax, which was increased twice. Marching side by side with their federal cousins, the Saskatchewan Conservatives introduced thirty increases in personal and corporate taxes so that by 1990 the province's "personal and corporate marginal tax rates," according to an economist of the day, were "already among the highest in the country."[44]

Although the Devine Conservatives raised taxes, cut programs, and introduced plan after plan to reduce the deficit, they never tamed the monster. After a big spending election budget in 1986, the 1987 and 1988 budgets were focused on restraint, but when the finance minister lost his fight to have another tough budget in 1989, the province's fate was sealed. After 1989, increased spending was worsened by high interest rates and federal offloading as the debt, deficit, and interest payments took on lives of their own and spiralled out of control. In Saskatchewan, the great barbecue was over and the bills for the wild spending were coming due.

The Devine government's spending can in part be explained by the challenging times for governments in the 1980s. The steady march of the global

economy meant that governments, unable to extend their reach beyond their borders, had less capacity to control economic forces such as unemployment, interest rates, and commodity prices. At the same time, these very forces wreaked havoc with people's lives, and they instinctively turned to government for help. Economic realities may have been increasingly global in the 1980s, but political attitudes had not followed suit. Still caught in the traditional Canadian view that government could and should play a major role in improving people's lives, politicians opened government coffers to help people without realizing that there were some forces that no amount of money could stop. Although the Devine regime had advocated cuts in government, it had in fact increased government spending to record levels because it succumbed to the enticing view that if enough money was spent, it could protect Saskatchewan people from the vicissitudes of global economic forces.

The fiscal calamities of the 1980s also resulted from the unwillingness of politicians to level with voters. Aware of the high public expectations of government, politicians of all stripes courted voters with new spending rather than laying out the hard, cold fiscal facts in any systematic way. Thus, public expectations were not curbed. But how could voters temper their expectations of governments if political leaders did not present a compelling case about the nature of the problem? The situation was especially acute in health care, where the costs were skyrocketing. As Saskatchewan's health minister in the late 1980s explained, "Provincial health ministers were never able to communicate to the public the financial stresses facing governments due to the rising costs of health care."[45] Instead, every time a service was cut, there was a storm of public protest, egged on by opposition politicians, who were sowing their own seeds of inflated public expectations, which would plague them when it was their turn to govern. The cycle of avoiding fiscal realities was only broken when the situation reached a crisis and there was no choice but to cut spending.

A Bad Combination: Attacking the Civil Service and Signing Megaprojects

A paradox apparent in many right-wing governments in the 1980s was the rhetoric in praise of the private sector and the ease with which the same politicians poured billions of public dollars into privately controlled projects. Saskatchewan was not alone in latching onto megaprojects – major economic development initiatives that relied heavily on large-scale investments – as a cure for the unemployment ills of the 1980s. What made Saskatchewan distinctive was the reckless abandon with which Devine signed development ventures that exposed taxpayers to huge risks. Devine's commitment to expanding the province at all costs became dangerous when it was combined with his government's assault on the civil service, the very people who could have saved him from making such irresponsible commitments. Disdainful of the advice of professionals but desperate to sign deals, the Devine government made some of the most outrageous economic development decisions of any government in Canada.

The roots of these one-sided ventures lay in the right-wing attitudes toward the public service in the 1980s. The almost slavish admiration for the private sector, which was at the heart of the new right ideology of British Prime Minister Margaret Thatcher and American President Ronald Reagan, not only prompted governments to privatize crown assets but also led to a decline in respect for the public sector and its public servants. In the 1980s it was commonplace for governments in Canada to downsize the civil service, to talk in terms of ending bureaucratic red tape and streamlining government operations. But in Saskatchewan the antipathy went beyond the buzzwords of "downsizing" or "streamlining" to entail an all-out assault on the very notion of an independent, professional civil service. The Saskatchewan situation shows what happens when distrust of the public sector crosses the line to become disdain for the procedures, processes, and professional advice that constitute good government.

When such attitudes form the baggage that politicians carry with them into decision making, the results are catastrophic. Understanding how Devine's megaprojects came to be signed begins with his government's treatment of the civil service – a brutal and senseless assault on one of the foundations of our British parliamentary system of government.

Who could blame Con Hnatiuk for slamming the door on a government official who came to his home on a blustery February evening to get him to sign his letter of resignation as deputy minister of social services? As a professional civil servant whose career in Saskatchewan dated back to 1968, Hnatiuk had tried to work with the new government, and the Conservatives had promoted him to deputy minister. But by 1986 his minister, Grant Schmidt, wanted him out and the alternative to resigning was to become part of the macabre firing ritual. Senior civil servants, who lived "in constant fear of the dreaded Wednesday phone call when they [were] summoned to the minister's office to receive their road map and golden handshake," would see his name on a list of bureaucrats fired at a Wednesday cabinet meeting.[1] More junior people would find out when the "employee bulletin" came out on Fridays and clutches of civil servants hovered around bulletin boards to read the roll call of their colleagues who had fallen in action. The definition of an optimist, according to a joke in Regina in the 1980s, was a civil servant who took his or her lunch to work. Con Hnatiuk was a casualty in what an academic study called "a heavy-handed and vigorous purge of the public service" that transformed one of Canada's finest public services into – in the words of a fired civil servant – "a pack of discontented individuals constantly worried about their jobs," who worked in an atmosphere where "mistrust and suspicion reign supreme."[2]

Why the Devine Conservatives went further than other governments in the 1980s in their assault on the civil service can be explained by their inexperience, their antigovernment philosophy, and the personality of Devine and those he chose as advisers. Devine and those closest to him had never been in government and had no interest in learning how to run one. According to his minister of energy, Colin Thatcher, Devine "loved politics and public relations but did not enjoy the drudgery of administration." Devine's days, according to Paul Jackson, a journalist who enthusiastically supported him, "were a whirlwind of activity, going to meetings, developing policies, traveling to the United States to fight for wheat farmers ... But that frenzy of activity left Devine little time to manage his own government." Much of his precious government time was spent placating the horde of MLAS elected in the 1982 sweep, especially since just before the election their discontent had almost led to a revolt against his leadership. "Matters sent to his office for his approval or authorization were usually never seen or heard of

again," said Thatcher, "I recall sending him a memo in which I asked if he was satisfied with the level of information I was providing. He did not reply."[3]

Devine might still have been a good premier if he had compensated for his own shortcomings by carefully selecting his staff and his deputy premier. He did neither. "No provincial premier in Canada can be surrounded by as many nits, twits, dimwits, and halfwits as Donald Grant Devine," wrote Jackson. "Incapable of hiring good staff and firing bad staff," Devine was advised to appoint his wife, Chantal. "A woman of finesse with a successful business background, she wouldn't be afraid to crack a much-needed whip and unlike some of his lackluster aides, she really would have his best interests at heart."[4] A few months after the election a group of cabinet ministers were so concerned about the quality of the premier's staff that they went to him and offered him any of the qualified staff in their offices; the offer was ignored. Loyal to his staff, uncomfortable with making difficult choices, Devine soon "was withdrawing more and more into his small circle and becoming increasingly inaccessible on government matters."[5]

The quality of appointed people was crucial, since under Devine a whole roster of chiefs of staff, aides, and executive assistants were hired as power shifted away from the professional civil service and into the hands of these hand-picked political appointees. The combination of Devine's lack of interest in running the government and the weakness of his staff meant that there was a vacuum at the centre, which resulted in a lack of direction that allowed ministers to run their own fiefdoms. No one, in the end, was really minding the store.[6]

For deputy premier, Devine did not choose a person who possessed the administrative skills he lacked. Instead, he followed the Mulroney adage of "dancing with the one that brung you" and selected Eric Berntson, a key player in Devine's election as leader and premier. As Grant Hodgins put it, "Devine was a salesman who desperately needed an administrator to run the ship of state; in Berntson all he got was a bigger salesman." A huge, ruddy farmer known for his colourful language and intimidating presence, Berntson was politically astute and decisive. However, his lack of administrative competence and good judgment was illustrated when, as minister of economic development, he invested more than $5 million in GigaText, a company that promised to develop computers to translate Saskatchewan laws into French. When the dust settled, GigaText had folded, no laws had been translated, Saskatchewan government money had made its way into Bermuda bank accounts, and the government had paid $2.9 million for computers valued at only $39,000. According to the Gass Commission, set up to review the province's finances, the "analysis and recommendations [for

GigaText] were prepared by a Cabinet Minister and a member of the Board, with little or no involvement of the staff." The Commission found that while millions of tax dollars had been given to the company, the government had not received regular financial reports; instead, the monitoring had been left to the GigaText board of directors, and sole cheque signing authority had been given to the project's promoter.[7] In 1990 Berntson was appointed as one of Mulroney's GST senators,[8] but he had to resign when he was sentenced to a jail term for defrauding Saskatchewan taxpayers of more than $40,000.[9]

Berntson epitomized the Conservatives' deep distrust of government When he called crown corporation employees "political has-beens" and "rejects" of the NDP government, he was voicing a common Conservative view that the civil service was not independent but was filled with New Democrats. "Bureaucrat" to many Conservatives conjured up the image of a well-heeled middle-class urbanite who worked short hours for big pay and built empires and proliferated red tape; worse, this powerful elite lorded it over local people. As Berntson said, "Central planners and political appointments made in the bureaucracy know better than the people of Saskatchewan what is good for them and their communities, their schools and their hospitals."[10] Thus, there was a populist dimension to taking on the civil service: power and decision making would be taken out of the hands of "the suits" in Regina and returned to average local folks. The lack of respect for professionals led to a blurring of the distinction between seeking public input and the need to have professional advice. Ordinary people have an important role to play in politics in helping governments make strategic choices. But while wise politicians seek public input on a range of choices, they leave the task of mapping out the options and implementing the policies to professional civil servants.

In their zeal to clean house, the Conservatives showed no understanding of the value of the first-class public service that had been built in Saskatchewan over many years. When Tommy Douglas created the Public Service Commission in 1947, the bureaucracy was "transformed" from a "patronage-based machine ... to a meritocracy ... a highly professional and respected corps that had helped to devise and implement a whole series of innovative programs, some of them subsequently adopted by other provinces and by the federal government."[11] Before Douglas, Liberal governments had "always assumed the civil service to be an extension of the party." As an independent MLA quipped during the 1925 election, "If all government employees working in the campaign for the Liberals had been forced to wear a uniform, it would have appeared that Saskatchewan groaned under an occupying army."[12] Douglas ended such

direct patronage, although orders-in-council were used by all governments to circumvent the Public Service Commission's hiring, and government supporters were placed strategically in crown corporations, agencies, and boards. Under Douglas and Blakeney, educated and talented people from across North America made their way to Saskatchewan to be part of a civil service that was on the cutting edge of new ideas and prided itself in excellence. Bob Mitchell, a deputy minister in the 1970s, remembers the excitement, the esprit de corps, and sense of pride in being a Saskatchewan civil servant. In fact, when Ross Thatcher came to power, a group of them left for Ottawa, where they were dubbed the "Saskatchewan Mafia" because of the power they wielded (Al Johnson became president of the CBC and Tommy Shoyama became the deputy minister of finance).[13]

Saskatchewan's intense partisanship led to constant pressure from the grass roots of all parties to politicize the public service; the difference lay in the response of the leadership. In the 1940s, when CCF party resolutions complained about the "supporters of the old line political parties" in the bureaucracy and demanded the firing of "reactionary departmental heads" and the hiring of "persons who are sympathetic to the CCF," a cabinet minister explained: "I would have been lost if not for the old members of my staff. I'm only a beginner in this work, [but the deputy minister] has been at it for twenty years." Another standard response was, "It's easier to teach an engineer to be a socialist than a socialist to be an engineer."[14] In contrast, when Grant Schmidt, admittedly one of Devine's most outspoken ministers, called his deputy minister for the first time, he said, "Just to let you know I can run this department with a telephone and a stick."[15] Although there was some patronage and partisanship under the CCF-NDP, it was balanced by the belief in a strong, activist government and in a professional civil service that could design and deliver programs effectively.

The Devine Conservatives' goal was to politicize the public service. From their point of view, the Blakeney civil service had been partisan, and they took heart from journalists who claimed that by the end of the Blakeney regime, "individuals with direct political links to the party in power were slotted into middle-management positions throughout the civil service and in crown corporations."[16] Rather than waiting for vacancies to open and for qualified people to come forward, the Conservatives opted for an immediate changing of the guard. Their rationale was simple: the NDP had run an effective government because it had the support of the civil service; therefore, if they wanted to get control of the government, they had to replace the New Democrats with Conservatives. Timing was also an important factor; Joe Clark's short-lived government in Ottawa had just fallen, and many

Conservatives thought its downfall was related to its failure to take on what was believed to be a pro-Liberal federal civil service. For other Conservatives, unfamiliar with a professional civil service but accustomed to running their own farm or small business, the change of government simply meant that it was their turn to hire the help.

Lost on these folk was the distinction between the legitimate practice, followed by governments across Canada, of moving or replacing very senior people such as deputy ministers but leaving untouched the vast majority of junior and middle-ranking public servants. The Conservatives also failed to realize that although some civil servants were partisan New Democrats and others wielded far too much power, the vast majority were professionals committed to working under the direction of whatever government was in office.

The case of Colin Thatcher illustrates nicely the Conservative goal of politicizing the public service and the problems inherent in the approach. When Devine made Thatcher his energy minister, Thatcher assumed, like his Conservative colleagues, that he would fire all the bureaucrats he had inherited from the "reds." However, unlike the rest of the cabinet, Thatcher had some experience with government. His father had been premier, and he knew that running a good ship of state required able people. His first plan was to entice the best and brightest from Alberta; but after finding that Albertans in the oil industry were uninterested in coming to Saskatchewan because of concern about the return of an NDP government and high royalties, his eyes turned to the local scene and to his deputy minister, Don Moroz. As Thatcher put it, "I like to think of myself as a decent judge of horseflesh, as they say in the cattle business," and he came to see that Moroz was an able nonpartisan public servant who could work for any government. As his respect for Moroz grew into trust, Thatcher found out that there were "some very bright people sitting around Executive Council waiting to be fired," and he worked with Moroz to hire them into his own department.[17]

As Thatcher hired former Blakeney civil servants, he had "heart-to-heart" chats with them, which reflected the extent to which he had come to see the value of a professional civil service. His message to one very qualified public servant was typical: "I can't imagine how someone as bright as you could ever have made yourself as vulnerable as you did in driving New Democrats to the polls on election day. I expect you to be a lot smarter than that when you do this job. I don't care how you vote, but I don't expect the opposition to be getting brown envelopes from you. I'll treat you like a professional and I expect you to act like one." Thatcher was unique, however, not only because of his understanding of government but also because he realized that in order to implement the major changes he wanted, he needed

"good bureaucrats." As he said, "I came to have a lot more respect for the top ranks of the civil service as a minister who wanted to get things done than I ever had in opposition."[18]

Thatcher, Bob Andrew, Gary Lane, Gordon Dirks, and others who retained former NDP civil servants were a minority, and the criticism from fellow Conservative ministers reveals the mentality of the majority. When Thatcher refused to fire "his bureaucrats," he was told by cabinet and caucus members, "You've been captured by your deputy on the first day; you should have just fired him" ... "You shouldn't have gotten to know him; you should have just fired him." There was almost a macho quality to the idea of going into government and gunning down bureaucrats. As Thatcher recalls, "I took some awful needling that I had gone over the hill and been captured by the bureaucracy, that I was becoming soft."[19] Such comments reveal the extent to which most in the Devine government responded to the grass roots' call for a purge of the socialists. Ridding the bureaucracy of the "reds" had the added advantage of making government largesse available to the Conservatives' supporters.

The Conservatives believed in the adage "To the victors go the spoils" – and since in 1982 there were a lot of victors, they would need lots of spoils. Exuberant and cocky from a landslide victory after almost fifty years out of power, party supporters and new-found friends rushed to reap the rewards. "The lineup at the political trough was incredible," Thatcher recalls. "People I had never heard of were writing and phoning ... New staff were appearing out of thin air bringing down resumés of people they wanted hired." Members were "hovering in the corridors like wolves in search of prey," pestering ministers to find jobs, appointments, and contracts for supporters. Cabinet meetings were bogged down by discussions about how to keep the members happy and about the political affiliation of employees, down to the level of secretaries. Astonishing to Thatcher was the lack of concern about the qualifications of the appointees. "Patronage is necessary in matters like this and even makes the system work a little better, but the Devine government brought it to a new edge," he lamented. "The question of ability or competency seemed to be of no consideration in an appointment, only whether the person in question was a Tory and a friend of the right minister."[20] Desperate to reward supporters and determined to weed out the socialists, the Conservatives had set the scene for the onslaught.

"They hunted people" was how one civil servant who survived the onslaught remembers the 1980s. Soon after the election, Premier Devine informed public servants that they could not belong to political parties – although he was forced to change his tune publicly after being told that this was contrary to the Charter of Rights and Freedoms. However, behind

closed doors, legions of long-time civil servants were fired because of their politics. Everyone, it seemed, had lists: members of the transition team, the cabinet, the caucus, staff, friends – they all had lists of supposedly known NDP supporters, and if your name was on a list and there was no one to vouch for you, you were in line to be fired. "We are now in the midst of a full-scale purge of the civil service," political columnist Dale Eisler wrote in May 1982, "one that is shaking the bureaucracy to its core and filling the hallways of government with fear and that has all but ground the process of administration to a halt."[21]

As well as NDP lists, the government had lists of 1,200 employees appointed by order-in-council (in other words, by cabinet), and as Berntson put it, "If you live by the order-in-council, you die by the order-in-council."[22] Not all of these employees were political appointees, as can be seen from the public letter of Harvey Abells, who was fired from his post as director of government purchasing. As Abells explained, he had been appointed after a public competition with six other candidates; his job had always been an order-in-council position, and "since my appointment, [I have] scrupulously avoided any overt political activity." How did the minister, whom he had never met or even talked to, evaluate his performance? "Was it on information given by my executive director?" he asked (his job performance had been excellent). "Was her judgment based on the paperwork I have submitted?" (the minister had signed, with no changes, the Cabinet Decision Item he had just submitted). If his performance was in any way unsatisfactory, "Why was I never so advised?" he asked. He pointed out that his agency had often been a model for other provinces because of "our nationwide reputation for fair and honest dealing and consistent protection of the taxpayer." Abells spoke for many other civil servants in saying, "My loyalty on the job has been to Saskatchewan taxpayers and not to any political party."[23]

Rather than being an orderly, planned process, the firings appear to have been hit-and-miss operations. Mistaken identity was a common problem, as the case of Ralph Smith illustrates. To renew the contracts of temporary government employees, senior civil servants needed the approval of a transition committee – which Con Hnatiuk did not get when he went to renew Ralph Smith's position; he was told that Smith was on an NDP list. When Hnatiuk argued that Smith was vital to the department and pleaded on his behalf, he was allowed to renew Smith's contract, but was told: "If you're wrong and he is an NDP activist, we're going to fire you instead." There were, in fact, three Ralph Smiths in the government, and the one in Hnatiuk's department was not an NDP supporter.

As well as being random, the process reached right into the bowels of the bureaucracy. A junior analyst described the "Spanish Inquisition" he

endured. He was summoned to a room in which there were some MLAs and political appointees – "hacks and flaks," as they were called. This made him especially nervous, because it was rumoured that "the people in the back rooms often did the shooting." Surrounded by these men, the civil servant was subjected to hours of interrogation about his portfolio and his experience, and then he was dismissed. Although he lived to fight another day, he never forgot the intimidating and bizarre experience.

The extent to which junior employees came under fire for disagreeing with the government was shown in the case of Harry Van Mulligen. At a fateful meeting of Regina City Council in November 1982, Van Mulligen – an elected councillor who was also a middle-ranking provincial civil servant – opposed the city's endorsement of provincial wage-restraint policies. For his actions, Van Mulligen was transferred to Prince Albert on the grounds that he could not effectively work for the government and oppose its policies.[24] It took a court injunction to get the government to cancel the transfer. But the "hunting" continued. Van Mulligen was stripped of most of his duties and left with only clerical work, and his desk was moved from his private office into the general office with the secretaries. By May 1983, "boredom and frustration" had taken their toll and Van Mulligen quit.[25]

Like Van Mulligen, Con Hnatiuk felt hunted. As a professional civil servant who had worked for both Thatcher and Blakeney, Hnatiuk's inclination was to accommodate the new Devine government. In the early 1980s he worked as a senior administrator for Social Services Minister Pat Smith and was promoted to be deputy minister by Smith's successor, Gordon Dirks, who was diligent in following proper processes and in seeking and listening carefully to advice from civil servants, even if he decided not to accept it. Hnatiuk's relationship with the government began to sour in April 1986 when the Regina press leaked a story that the deputy premier, Eric Berntson, was being investigated by the police for allegations made by his adopted teenage daughter, who had been involved with the department because she was a young offender. To silence the swirl of speculation, Berntson made an impassioned appeal in the legislature for public understanding of his family's problems.

In his speech, Berntson clearly blamed civil servants, especially those in the Department of Social Services. He told the legislature that the department had notified the police of the allegations made against him by his daughter (which in fact was standard practice), without any attempt to verify them. "The allegations," he speculated, had been made "probably with the help of the social workers." He painted himself and his family as "victims of the system" and wondered aloud about "certain professionals acting less than professionally, perhaps even unethically." The fact, he said, that

"the file relating to me and my family was apparently treated like a news-
letter and leaked to the press and others, leads me, Mr. Speaker, to no other
conclusion than that people, the people handling this file, acted very unpro-
fessionally or unethically or both."[26] Social Services Minister Dirks investi-
gated Berntson's allegations against his department and reported in August
that there had been "no improper conduct by members of the department
relating to confidential files."[27] Public servants, however, believed that
despite the support of Dirks, others in the government remained convinced
that the department had leaked Berntson's file to discredit the deputy pre-
mier and were biding their time.

Their time came after the long-awaited October election, in which Dirks
was defeated and replaced by Grant Schmidt, who assumed that in the
social services department of "2,200 employees 1,500 were my political
enemies."[28] While Hnatiuk and other department officials assumed that
their successful working relationship with two previous Conservative
ministers – Pat Smith and Gordon Dirks – demonstrated that they were
professional public servants, Schmidt's belief was that the department was
full of social activists who undoubtedly were NDP supporters. Thus, his
mission was to "de-politicize the department and restore its competence."
To achieve the latter, rather than following the established practice of
working through the deputy minister, Schmidt himself interviewed four-
teen of the department's top managers and decided that eleven had to be
replaced because they were incompetent. "De-politicizing" the civil ser-
vice – a process outlined in a document leaked in 1991 called "Political
Patronage in the Hiring Process" – involved having 123 department
employees take early retirement and, in the words of political columnist
Murray Mandyrk, applying "a political litmus test to potential govern-
ment employees." Schmidt explained that the department "spent money
like drunken sailors. It was partisan, political, socialist. I don't apologize
for making it non-partisan," he declared. Even one of his predecessors, Pat
Smith, publicly shot back that social services was not like other depart-
ments, where "monthly expenditures are mapped out according to a for-
mula."[29] Schmidt was also determined to fire his deputy minister, prefer-
ably for cause, in order to save the costs of severance.[30] After an
unsuccessful attempt to transfer Hnatiuk to a position vaguely defined as
working with defeated MLAS, Schmidt made it known that he wanted his
deputy gone, and the issue became a nasty public affair.

"Hnatiuk Did Sask Favor by Resigning: Schmidt" was the headline in the
story announcing the end of a career in the Saskatchewan public service that
had spanned almost twenty years and three different administrations.
Schmidt had minced no words when he stated that the government "no

longer had confidence" in Hnatiuk, who he said had cost taxpayers "his weight in gold." With the publicity surrounding Hnatiuk's departure, his three young children were taunted by fellow students about their father being a socialist who had been fired, and Hnatiuk had to take them out of school. When he took a job as deputy minister in Manitoba, Schmidt's parting comments were ominous. Asked how long Hnatiuk had worked for the Saskatchewan government, Schmidt replied "too long" and added, "How long will he serve in Manitoba? Too long."[31] Sure enough, after a change of government in Manitoba, the new Conservative government fired Hnatiuk. But he received several job offers, one of which was from the Alberta minister of family and social services, John Oldring. At the interview, Hnatiuk asked Oldring, "Why would I work for another Conservative government when I've already been fired by two?" But Oldring persisted and asked what he could do to persuade Hnatiuk. The reply was simple, "Get Grant Schmidt off my back." At that, Oldring picked up the phone, got Schmidt on the line and could be heard saying "Grant, I'm going to hire Con Hnatiuk and I know you won't interfere with the decision ... Thanks Grant, goodbye." Finally, Con Hnatiuk was safe from the hunt.[32]

For many civil servants the hunt was never over. There had been the initial firings in 1982, which Devine said "increased productivity" and boosted "optimism" in the civil service.[33] Then in 1987 with government restraint, more than two thousand civil service jobs went. As reporters watched through the windows, four hundred people, mostly women, who worked in the children's dental program were herded into a hotel room and told that they were being fired. And in 1990 came Fair Share, a bizarre and politically motivated scheme to move civil service jobs from Regina to rural Saskatchewan, the Conservatives' stronghold.

"Now is the time to share the assets of government business," was how Devine explained Fair Share in a film accompanying kits sent to communities inviting them to bid on more than a hundred government departments and agencies. The largesse of government was again being doled out, this time to local communities, which scrambled over each other to lure the well-paying jobs. "This plan," according to a Prince Albert columnist, was the Conservatives' "municipal version of homeowner grants ... and just as those programs appealed to the baser instincts of people – Give me my money, I don't care if the province can afford it or not – so does Fair Share." Even the city of Regina got into the act; after complaining about how devastating the loss of more than ten thousand jobs would be to the capital, Regina business people went on to eye federal jobs that could be moved from other parts of Canada and research jobs that could be taken from Saskatoon. Throughout, there was no pretence that the "fair sharing of jobs"

to smaller communities had anything to do with more effective or efficient public services. On the contrary, the criteria were community need, available infrastructure, and community support for the new jobs, and even the government conceded the cost was in the millions.[34]

It was hard to take what one writer called the "loony decentralization" seriously. One suggestion was using the Academy Awards format for the announcements: "And the winner of the agriculture department is ... Yorkton." The University of Saskatchewan professor Don Cochrane had an overwhelming response to his front-page confidential memo to Premier Devine suggesting that university colleges could also be moved around the province: geology would go to Rockglen, religious studies to Galilee, mathematics to Divide, medicine to Livelong, surgery to Cut Knife, and administration to Surprise. Similarly, "A Letter to Prince Devine from Machiavelli" heaped ridicule on Devine's plan:

With few ducats left in the treasury to slush upon your cherished rural rump, you threw in the civil service itself – more than a thousand jobs, banished to forlorn pockets of the province where the grain elevators outnumber the people. I admit you have shown that there is more than one way to buy a vote. And clearly you have re-read my chapter "Becoming Princes by Evil Means" ... Mind you, it is always fun to torture the government employees [sic] union. In the regrettable absence of the rack and the red-hot pincers, marooning them in Biggar and Hudson Bay affords at least some satisfaction. Having savored the nightlife in the new postings, their resignations will create vacancies in a government for the folks you trust ... An unemployed enemy is a dead New Democrat.[35]

The humour was lost on government employees, who felt as if they were being "auctioned off" and once again found their lives in turmoil. After learning from the media about being moved to Humboldt, a weeping woman said, "It's my life someone is playing with." Deanne Montbriand called the move "sick" and "disgusting" and anguished for her daughter, who at the tender age of ten would have to choose between living with her mother in Humboldt or her father in Regina. Margaret Neal, a secretary, was destined for Shaunavon, while husband Allen, a draftsman, was being sent two hundred kilometres away to Maple Creek.

In a moving public letter to Devine, the wife of a civil servant described the pain being inflicted on her family. Her teenage daughter was so stressed by the situation that the prospect of her committing suicide "haunts me every day, every hour," said this woman. She worried whether her young son's stuttering problem would be worsened by the move, which might make him more "nervous and insecure." But if she remained in Regina, would "separation from his dad make him anxious and afraid?" She was

concerned about her husband's health under the weight of the decisions, and confessed: "At the moment I am not a good wife or mother. Tension, stress and fear invade my thoughts and distract me." She spoke for many others in saying, "I am frightened for my husband, for my children, for myself and for Saskatchewan."[36] The Conservatives' disdain for the ideal of a professional civil service had reached an all-time low, and the hardship being experienced by people like this woman was merely the visible sign of a much deeper problem.

As well as wreaking havoc with people's lives, the Conservatives' treatment of the civil service wreaked havoc with the administration of government and the province's finances. With no firm hand at the centre, ministers were free either to protect able people in their departments – as Dirks, Thatcher, Andrew, Lane, and Hepworth did – or to conduct their own witch hunts. Also, the Devine government relied less on advice from experienced professionals in the civil service and more from political appointees or those with "outside experience," who often revealed their contempt for professional public servants. For instance, a political appointee said in a friendly way to a career civil servant, "You're a bright and able guy, why don't you get a real job making real money?" In turn, a saying among professional civil servants as the inexperienced newcomers floundered was "The smart guys are in charge; let's watch them." Working in an atmosphere of suspicion and fear, the civil service became emasculated. Rather than offering independent advice with confidence, many adopted the safer approach of "Keep your head down." With the firings, the resignations, and the difficulty of attracting qualified new professionals, the once proud Saskatchewan civil service degenerated into a demoralized lot, who by the time we took over in 1991 had almost forgotten what it meant to run a good ship of state.

The attack on the civil service reflected the arrogance of right-wing antigovernment thinking. Politicians, after all, are the board of directors of the government whose job it is to set overall policy, while it is up to the civil servants to implement these policies and advise the government, based on their years of experience. The purge of the civil service was like a new and totally inexperienced board of directors taking over an oil company and firing the key managers and employees who knew the oil industry, replacing them with friends or newcomers who were just as inexperienced in running an oil company as the board. The Conservatives' inability to see that running a government requires just as much experience and savvy as running an oil company was their most disastrous blind spot.

Accompanying the attack on the civil service was a growing disregard for the rules and procedures fundamental to running a good government. Special warrants passed by cabinet but not approved by the legislature were increasingly used to spend taxpayers' dollars. The government ignored

federal regulations requiring an environmental assessment of a major dam project in the south of the province, until it was stopped by a court injunction. And in 1988, when the provincial auditor criticized the government's accounting, he was subjected to a personal attack by Bob Andrew, who called auditors "people who bump against reality once a year ... live in that jungle-zoo and call themselves bureaucrats." The auditor's fundamental concern – that he did not have access to enough information to evaluate the province's finances properly – was picked up by the *Globe and Mail*: "The Saskatchewan government appears to regard the province's auditor as a kind of Peeping Tom, a prowler in the backyard of its fiscal business and a rude intruder on its private affairs."[37]

Widely publicized battles like these were merely the tip of the iceberg; behind closed doors the fundamentals of good decision making were breaking down. Basic to successful governing is the need for politicians to make decisions based on a thorough analysis and after considering advice from the professional civil service. The Gass Commission found "transactions" in which "members of the Cabinet were involved directly in the negotiations and did not appear to have received (or to have requested) detailed analyses of the alternatives that were being discussed." The commission also found "several examples where the Government entered into transactions or commitments without having undertaken a full and complete financial analysis."[38]

The lack of financial analysis was related to the declining role of the treasury board as the internal watchdog of government spending. A committee of cabinet, the treasury board (chaired by the finance minister and including five other ministers) has the all-important job of developing the budget, after months of deliberation, and of evaluating and then either approving or denying spending. It epitomizes the discipline of power. In our government, it was an iron-clad rule that no spending could proceed to cabinet without going first to the treasury board – indeed, the cabinet secretary would simply refuse to put an item on the agenda without sign-off by the deputy minister of finance – and it was rare for a treasury board decision to be overturned by cabinet.

The extent to which the Conservatives lacked the discipline of power was reflected by their behaviour at treasury board. Finance public servants were unnerved by the first Conservative treasury board meetings, at which ministers, revealing their deep distrust of the bureaucracy, neither questioned nor debated issues but merely sat there staring at the officials. Rather than lengthy, informed debates, as had been customary under previous governments, there was either silence or in some cases irrelevant discussions; for example, during a review of the $300 million social services budget, the conversation focused on why welfare recipients could afford

cabs. Treasury board decisions were often overturned by the cabinet or the premier. When the board denied a program that the minister of health particularly wanted, he simply announced the program anyway and proceeded to spend the money. Such flagrant disregard for treasury board decisions occurred without consequences. The lack of power of treasury board was also reflected in attendance. By the end of the 1980s, it was not uncommon for the minister of finance to be sitting at a treasury board meeting, alone with officials, trying to explain away the fact that none of his cabinet colleagues had bothered to attend. By the time of the last budget, the process had disintegrated completely. The budget was not reviewed by treasury board; it did not go to cabinet; and the premier merely asked to see a one-page summary of its main themes. That is how more than $4 billion of taxpayers' money was spent.

The Conservatives' failure to follow due process and heed the counsel of professionals also created major problems in the structuring and financing of megaprojects. Economic development initiatives, many worthy in principle, were badly structured in practice because of inadequate financial analysis and the willingness of politicians to ignore, overrule, or circumvent the sound advice of their civil servants and advisers. Three such megaprojects – the NewGrade and Husky heavy oil upgraders and Crown Life – exposed Saskatchewan taxpayers to more than $1 billion in debt and were cited by rating agencies as major factors in the downgrading of the province's credit rating.

Megaprojects were the craze of the 1980s, and they epitomized Canadian governments' schizophrenic view of the role of government in economic development. While politicians lauded the private sector, their actions showed government money being funnelled into private-sector deals. For instance, in Alberta's economic development strategy, analysts found an "ambivalence" that "comes in the recognition ... of the dangers of enlarging the scope of government and, on the other hand, proposing, at every turn, an expansion of government activity." By 1984, spending on economic development in Alberta had risen to $3 billion, three to five times higher than in other provinces, and in Saskatchewan it had increased more than 30 percent.[39] Thus, Saskatchewan was typical of other governments of the day in declaring its ideological commitment to private enterprise at the same time as millions of tax dollars were being invested in risky ventures.

Megaprojects were embraced by politicians in the 1980s as a quick fix to the daunting problem of unemployment and as a last-ditch way of exerting some control over economies increasingly beyond the reach of political leaders. Jean Chrétien's 1993 election victory with the slogan "Jobs, jobs, jobs" showed the extent to which unemployment levels of 10 percent or more had

made jobs the main preoccupation of Canadian voters. Politicians eager to please their electors found they had few levers to pull to turn around the stubbornly high levels of unemployment. In Saskatchewan, for example, the Devine government declared the province open for business; it made its labour legislation more pro-business, and it cut taxes. Yet little changed. Whatever benefits flowed from these initiatives were outweighed by the stark reality that as a resource-dependent economy, Saskatchewan's fortunes depended on commodity prices, investment decisions, interest rates, and exchanges rates – all of which were decided beyond the borders of the province. But one lever that governments did have was the power to persuade companies to come to Saskatchewan by offering public investment on terms too good to refuse.

Megaprojects were also great politics. If a megaproject could not generate at least three or four ribbon cuttings with smiling politicians, there was something wrong with the government's communications staff. The photo opportunities were great and the speeches even better. Politicians, facing record levels of unemployment, delighted in rhyming off the thousands of man-years of employment that the would come with the construction phase, the hundreds of spinoff jobs, and the scores of permanent jobs for those running the facility. The costs of investing in the project, on the other hand, could easily be explained by recounting the thousands of dollars in new tax revenue that would come from all the economic activity. Selling megaprojects involved boosterism, and it was hard to find a more exuberant booster than Grant Devine.

Saskatchewan would become the "oil capital of Canada" and be "on a plane with Toronto, Montreal, Chicago and other centers with the capacity to manufacture," boasted Premier Devine as he joined Bill McKnight, Saskatchewan's federal cabinet minister, and Vern Leland, president of Federated Co-ops, in October 1985 to officially turn the sod for the NewGrade upgrader, which would process Saskatchewan's significant heavy oil reserves into light sweet crude. The announcement was followed by a flurry of activity and hype as a project manager was hired and a Californian company selected to provide the technology. The "enormous job creation potential" was celebrated, as was the "miles and miles of pipe" that would be purchased for the upgrader from the Regina-based steel company, ipsco. "This announcement," according to a journalist, " finally puts some flesh on the bones of Devine's statement, there's so much more we can be."[40] Lost in all the hoopla was the fact that although all the ribbons had been cut and tens of millions of tax dollars had been spent, neither the project agreement nor operating agreement had been signed. In short, who would run and pay for the upgrader was still to be negotiated at the time the project was publicly launched.

The upgrader exemplified Devine's approach to economic development. It symbolized his goals to build up Saskatchewan at all costs and to lessen its vulnerability to the ups and downs of a resource-based economy through diversification and more processing of its resources. Noble as the goals may have been, the road to achieving them was often fatally flawed. One problem was Devine's personality. Although in no sense a hands-on premier, he did get directly involved in many of the megaprojects. His approach was described well by political columnist Mandryk in 1990: "Grant Devine lives by the gut reaction ... He is fueled by a powerful mixture of adrenalin, emotionalism and moral convictions. His tank seldom empties. He sets his sights on a goal, looks straight ahead and – pedal to the floor – races towards it. To suggest he has no capacity for thoughtful assessment is unfair and wrong. It's just that he often puts more stock in his own intuitive thought than the analytical skills of others."[41] Ignoring the advice of civil servants and other professionals and impatient with the niceties of process and financial analysis, Devine all too often told his ministers that they "were going to need a megaproject to create employment ... and he wanted all the stops pulled out to get one."[42] The political imperative to get the deal at all costs in effect meant relinquishing the government's bargaining power. Once the announcements had been made and the government was on the hook, the results of the negotiations about the details were almost a foregone conclusion; in the case of NewGrade, the Co-op would get to run the upgrader, while it was left to the government to pay the bills.

The mentality of the Devine government was captured nicely by an adviser who dubbed the Conservatives a band of buccaneers. At their best, buccaneers can be daring entrepreneurs who, after appropriate analysis, look beyond the short-term measures of costs and benefits and established practices to venture into new territory, trying bold strokes and taking risks. Bold buccaneers act more like entrepreneurs and less like accountants. Thus, in 1983 Colin Thatcher, after analysis by his Department of Energy, reversed Blakeney's high royalty policies and dramatically reduced oil royalties to breathe new life into a stagnating oil sector.[43] Gary Lane, after his Department of Finance studied the options, created an employee-owned company, Greystone Managed Investments, which began with a $3 billion portfolio to manage Saskatchewan government pension funds, and by 2001 it had expanded to become a $12 billion investment company with clients across Canada. In crown corporations there was a more entrepreneurial approach, so that lucrative contracts to supply machinery and equipment were used to entice international companies such as Hitachi and Babcock and Wilcocks to build facilities in the province.

The same boldness was apparent in the privatization of some non-utility crown corporations. For instance, Saskatchewan Mining and Development

Corporation (SMDC) and Eldorado Nuclear, a federal crown corporation, were combined to create the uranium giant Cameco, while the American corporate giant Weyerhaeuser was lured to the province with the sale, at a greatly discounted price, of the Prince Albert Pulp Company. There was also a strategy to entice average folk into the investment world by selling crown corporation bonds, which could later be converted into shares, on very attractive terms. And there were some imaginative examples of employee and community ownership, notably the creation of NorSask Forest Products from the sale of government-owned sawmills to employees and to the Meadow Lake Tribal Council, a federation representing ten First Nations bands.

Even some of the megaprojects were soundly structured and brought long-term benefits to the province. Saskferco, a joint venture between the American corporate giant Cargill and the Saskatchewan government, was, according to the Gass Commission, "handled in a very business-like manner" by professional civil servants and outside experts.[44] The result was a major manufacturing facility producing nitrogen-based fertilizer that was financially sound and was expanded several times during the 1990s to create jobs and other benefits for Saskatchewan people.

However, the bold spirit of a buccaneer, when combined with a basic distrust of government and a disregard for sound analysis, can degenerate into reckless spending and the use of tax dollars as a source of largesse. For example, after receiving more than $500,000 from the government to manufacture barbecue briquettes in Devine's Estevan riding, Char Inc. folded after three weeks, leaving behind only a few employees making kitty litter. Similarly, Supercart's scheme to produce plastic shopping carts – described by Devine as a "perfect example" of economic development – foundered after the company received more than one million dollars from federal, provincial, and municipal governments. Such deals were part of a more general pattern as the number of lobbyists and consultants in Regina grew from a mere four in 1982 to 178 by 1990. "Millions of dollars were poured into pet projects in cabinet ministers' ridings, ... [and] hundreds of untendered contracts were up for grabs, everything from legal work to advertising to decorating government offices."[45]

A glimpse into the decision making that led to these deals was provided by the Gass Commission, which noted there was "an orientation" in the Devine government "towards avoiding public disclosure." The lack of public disclosure and accountability was exemplified by the Saskatchewan Diversification Corporation. Created as a subsidiary of a crown corporation, it was a vehicle for cabinet ministers to dole out millions of dollars on projects without scrutiny by the legislature, the auditor, or the finance department.[46] Gass also documented the failure to seek or heed professional

advice: the government investment in Canapharm, a pharmaceutical company in Health Minister Graham Taylor's riding, was "approved by cabinet, after SEDCO's [Saskatchewan Economic Development Corporation's] management did not provide recommendations in support of such actions," even though in the end SEDCO had to take a $4 million loss on the venture. In the case of Hunter Manufacturing Ltd, the government rejected the recommendation from its own management to deny the investment, and the minister simply directed, with no supporting analysis, that the investment be made.[47]

Gass also analysed the sale of the Potash Corporation of Saskatchewan (PCS). In explaining his government's financial troubles, Devine alleged that the NDP bought high ... The NDP bought a lot of real estate, a lot of dirt and a high risk for the taxpayer. And to get rid of it we had to take the write-down." The biggest write-down taken by the Devine government was on the sale of PCS, which it did not sell when the professionals advised it to do so. In Gass's words, "We were unable to find any documentation to support the Government's reasons for overriding the recommendations of its advisors."[48] If Devine had sold when potash prices were high, not low, the government would have made millions instead of losing them.

One reason for selling PCS and other crown corporations was the government's obvious financial troubles after 1987, which led to greater reliance on equity investments, loans, and loan guarantees. According to the Gass Commission, "The increased use of loan guarantees appears to be a consequence of the Province's current financial situation. Other forms of direct assistance, such as grants and advances, affect the deficit and further reduce the Government's cash position."[49] In other words, while tax cuts or grants had to be paid for out of the current year's budget, equity investments and loan guarantees seemed costless and were not even reported to the public for months or even years. When the finance department officials cautioned Devine about using such financing, he accused them of lacking vision, by which he meant his vision of the jobs and economic activity that would come with the megaprojects. But the officials had visions too, visions of what would happen if the projects failed and the loans and guarantees had to be paid by Saskatchewan taxpayers.

It is against this backdrop that the negotiations for the NewGrade upgrader have to be seen. Soon after being elected, Devine's government pursued the idea, which dated back to Blakeney's time, of upgrading Saskatchewan's heavy oil, and it approached Federated Co-ops (FCL) about building an upgrader next to its Regina refinery. In 1983 the province, the federal government, and FCL signed an agreement to study the project's feasibility, and in the ensuing negotiations the province was ably represented by Jack McPhee, who had extensive upgrader experience, and Philip

Gordon, formerly senior vice-president of Shell Canada, along with other experts. However, their wise advice was often disregarded by a premier convinced that the project "was so important and so good for Saskatchewan that it was worth doing at virtually any cost." Of like mind were key cabinet ministers, afraid of "the political clout of FCL [which represented hundreds of retail co-ops across the province] should the project be cancelled in an atmosphere of animosity between the parties."[50] Although FCL stood to gain from the project – its outdated refinery would be modernized and its supply of the increasingly scarce Alberta light sweet crude would be secure – it took the firm position that it would share none of the risks or costs; and it clearly understood the vulnerability of the government, especially after the project had been officially announced, after $100 million had been invested in it, and the upgrader was the centrepiece of the Conservatives' 1986 bid for re-election.

The first of many stumbling blocks in the negotiations was FCL's insistence that the refinery be "kept whole"; that is, if there were problems with the upgrader, the refinery had to be compensated for any losses it incurred. Unable to secure what it needed at the table, FCL in June 1984 circumvented the negotiators and wrote directly to ministers complaining about members of the government team. As a result, the government dropped one of its negotiators and FCL won its point.[51]

A key controversy in 1985 was the government negotiators' position that the upgrader had to be a separate entity with its own employees and board of directors, while FCL was adamant that employees of the refinery had to run both the refinery and the upgrader. Government officials were concerned that in an integrated facility with money passing back and forth between the refinery and upgrader, separate accountability was essential to ensure that tax dollars were being spent only on the government-owned upgrader and not on FCL's refinery. Again, FCL went around the negotiators to the politicians and threatened to abandon the project: "Despite strong recommendations to the contrary [from senior government officials] the FCL demands were agreed to by the ministers acting under the premier's directive not to lose the deal."[52]

The decisions made in 1985 were a "massive surrender, directed from the ministerial level, from positions previously strongly defended and thought to be sacred by the Saskatchewan negotiation team."[53] As well as caving in to FCL's demand to run the whole facility, financial concessions were made, the most notable being the government's commitment to pay FCL's share of money for the project, even though FCL would continue to receive 50 percent of the profits. These concessions were made over the written objections of officials and without analysis about the financial implications.[54]

Negotiations stalled in 1986, and after FCL threatened during the election campaign to abandon the project, the government's two key negotiators – McPhee and Gordon – were dropped. Two days before Christmas the final agreements were signed, and it was the government that was playing Santa Claus. The only real cash invested in the project came from the Saskatchewan government – $158 million. The other $635 million was debt guaranteed by the governments of Canada (43.3 percent) and Saskatchewan (56.7 percent). FCL's position was that the cost of the upgrader was less because it was integrated with the refinery, which was its contribution. However, FCL retained sole ownership of the refinery while Saskatchewan taxpayers were potentially on the hook for more than half a billion dollars. And that was only the beginning.

The practical implications of the concessions made by the government were documented in a 1991 report to the Devine government by its own appointees to the NewGrade board. According to the report, NewGrade had "no manager" or "group of employees to look to who have undivided accountability for NewGrade operations"; instead, the refinery management had sole decision-making power for the whole facility and had "the exclusive cheque writing authority for NewGrade and as such authorizes and signs NewGrade cheques payable to itself for tens of millions of dollars." Attempts by government members to separate accountability for the upgrader from the refinery were rejected by FCL, whose members controlled half of the board of directors, and could block any motion by government appointees. The one independent report, done in 1987, concluded that "in excess of $4 million of costs" assigned by refinery management to the upgrader – and paid by taxpayers – should in fact have been paid for by the refinery. Government representatives also expressed concern about FCL's policy of "promotion from within," which was "a serious impediment when a radical technological change, such as the introduction of the sophisticated upgrader units, calls for experienced talent from outside the organization."[55]

As well, there were major accidents in the first two years – fires, explosions, and the emission of oil droplets over a residential part of Regina. In assessing the causes, the government board members believed that the "lack of experience " and "inadequate training" of refinery employees were "a contributing factor." An independent consultant agreed "that the incidents were either caused or seriously worsened by operating decisions."[56] Despite these views that refinery operators were in part responsible for the accidents, the refinery paid none of the costs. In fact, the guarantee that the refinery be "kept whole" meant that the government, through Newgrade, had to pay the refinery $30 million to cover its costs for the disruptions caused by the accidents.[57]

The start-up problems in the first three years also led to losses and raised the question of who would pay for them. The Canadian government took the position that it had merely guaranteed loans and was not an equity partner eligible to share profits, so it refused to contribute. FCL had consistently refused to contribute cash and had the iron-clad guarantee that if default occurred, the refinery would be restored to its original state. The upgrader could not even be sold to another party on site but would have to be dismantled and moved from the property (creditors had wondered about the resale value of an upgrader on wheels). This left the Saskatchewan government with the choice of either paying for the $75 million in losses or allowing default, in which case taxpayers would have to pay $400 million in loan guarantees (on top of losing the $158 initially invested). The government paid the $75 million. Ominously, the government board members warned, "NewGrade is and always has been over-leveraged."[58] With 80 percent debt financing, the interest payments were crippling, and when the principal payments began in 1992, NewGrade would not be able to pay its bills. The government would again have to pay – either for the losses or for the loan guarantees that would come due if the upgrader went bankrupt.

By the early 1990s there were similar problems with the province's other upgrader, the Bi-Provincial in Lloydminster, a joint project of the Saskatchewan, Canadian, and Alberta governments and Husky, Saskatchewan's largest producer of heavy oil. The similarities between the two projects were striking. A sure sign of an election in Lloydminster was the almost ritualistic announcement that an upgrader was on its way. The final announcement, at the time of the 1988 federal election marked the eighth time that the project had been unveiled. As with NewGrade, all the hype put pressure on the government. According to energy minister Thatcher, Husky "knew the politics of the upgrader" better than the government. They "fully understood the political ramifications for us if we failed to deliver," said Thatcher. "They knew they could be tough and push us a long way." In case they forgot their leverage, Devine reminded them of it. When negotiations bogged down, he helpfully chimed in that he would pursue the project "with as much vigour as it takes," and Alberta's Premier Don Getty added that he would pay more to get the deal. As with NewGrade, construction had begun and more than $200 million was spent before the key agreements had even been negotiated.[59]

Bi-Provincial was plagued by structural and financial problems similar to those of NewGrade. The part-time board of directors, supported only by a few consultants, had problems supervising management, especially since Husky, like FCL, was given sole authority to run the facility. Husky's responsibility for supplying the feedstock, constructing and operating the upgrad-

er, and marketing the end product meant that there were ample opportunities to offload costs from other parts of Husky's operations onto the upgrader and onto taxpayers.[60]

The financing of the project, according to a senior government adviser, was "bordering on crazy in terms of risk and potential cost."[61] In fact, in the early 1980s Thatcher had become so convinced that the Husky upgrader would be far too expensive that he had begun working secretly but aggressively on an alternative megaproject – a nuclear power plant to upgrade the province's uranium. However, Thatcher was soon gone, and with him went the caution about the financing of the upgrader. Thus the government, as well as investing $232 million, forgave royalty payments on the condition that Husky would significantly increase its exploration and development. While the language for the royalty concessions was clear and binding, the commitments to exploration were vague and unenforceable; so while the costs of the royalty concessions are estimated to be approximately $140 million, the benefits as of 1991 were $34 million.[62] Added to the initial costs were the cost overruns. By August 1991 the project was $175 million over budget and more cash had to be contributed. Looming on the horizon was the prospect of more cash shortfalls and of the Auditor telling the government that its investment had declined in value – both of which meant more money from Saskatchewan taxpayers and more concern by credit-rating agencies.

As well as citing the upgraders, credit raters were concerned about Crown Life. The idea of luring Crown Life, one of Canada's oldest and largest insurance companies, to Saskatchewan began with a group of Regina businessmen who soon captured the imagination of politicians, including Devine. In exchange for investing $355 million in the company, Crown Life's head office would be moved to Regina, and when combined with the Co-operators Insurance, which also had a head office in the city, Regina would become a major insurance centre. The prospect of more than a thousand head office jobs and an equal number of indirect jobs was a great tonic for a province suffering in 1991 from low agricultural and resource prices, and it seemed like a lifeline to a desperate government heading into an election.[63] Money was to be raised in the long term by selling shares; in the short term, a $355 million loan was needed.

It's too bad that the Devine Conservatives did not consult New Brunswick Premier Frank McKenna's Liberal government, which also had been offered the Crown Life deal, with a lower price tag. Just before September 1991, Crown Life, according to McKenna, offered to move 1, 200 jobs from Toronto to New Brunswick "in exchange for a $250-million loan guarantee" – $105 million less than Saskatchewan paid. The concerns raised by McKenna echoed those raised by the bureaucracy in Saskatchewan. "We

didn't like the risk, we didn't like the dollar amounts and we didn't like the principle," McKenna said. He explained, "We like to minimize the risk to our people in New Brunswick, and we don't like the corporations to actually benefit themselves from it [the deal]."[64] Saskatchewan finance officials also worried about the problems of the insurance sector, which was losing money on its sizable investments in real estate, especially in the United States, and of Crown Life, whose large real estate portfolio had already been noted by credit raters. But financial questions took a back seat in a deal driven by politics. The extent to which politics was involved was shown when Crown Life's request to consider moving the company to Saskatoon instead of Regina was firmly denied.[65] There is a saying in government that the finance department always protects its minister. It is ominous that when the documents had to be signed for the government to guarantee up to $305 million – as well as providing $50 million for relocation costs – to Crown Life, the minister of finance was conveniently away.

The enthusiasm and hoopla associated with attracting a thousand jobs from Toronto began to fade in government circles by November, when Crown Life's results for the first nine months of 1991 showed a loss of $145 million and its credit rating was downgraded by Standard and Poor's, one of several downgrades. Crown Life's losses made a public share offering problematic, and the back-up plan in the agreement signed regarding Crown Life was for the government to convert its guarantee into a loan. The government's "temporary" involvement in the project now looked more permanent. As the *Globe and Mail* pointed out, the government had "exposed taxpayers to a quarter-billion dollar risk by backing a local businessman in the purchase of a Toronto-based insurance company." By late 1991, credit raters shifted their gaze from Crown Life to the government.[66]

The stories of Crown Life and the upgraders show the folly of governments investing directly in the economy. In their zeal to soothe voters' anxieties about high unemployment levels, politicians in the 1980s pursued megaprojects whose economic benefits were far outweighed by their costs. At the heart of the problem was the source of the decision making. Direct investment decisions are made at the cabinet table, and as soon as a decision reaches the cabinet table, politics is involved. When politics is involved, immediate benefits are more likely to overshadow concerns about long-term costs. Although few governments are as reckless as the Devine Conservatives were, the experience of the 1980s shows that when governments invest in economic development initiatives, they risk taxpayers' dollars, and the costs can be enormous. Governments, I firmly believe, should not be risking taxpayers' dollars by picking economic winners and

losers, especially since the record shows that governments of all stripes pick their share of losers.

In 1991, Crown Life's problems were overshadowed by the stunning announcement on 17 June that government house leader Grant Hodgins was leaving the government over Fair Share. "Public servants," Hodgins said, had been "particularly loyal" to him during his career and "the professionalism, courtesy and dedication that they have extended to me has impacted upon me greatly." Fair Share, he lamented, was divisive, setting one community against another; it was costly for a province "on the verge of bankruptcy," and was motivated by "politics to a degree that I am not only uncomfortable with, but that I find personally unacceptable." Hodgins's move was the last straw for a government that had so angered the public service that its members stormed the legislature.

The Devine Conservatives were in line for a punishing defeat by Saskatchewan voters; and, unfortunately for them, there was more bad news to come – the RCMP was investigating Project Fiddle, a Conservative fraud scheme that tarnished their badly tattered reputation even further. In the mid–1980s a handful of Conservative MLAS and their caucus research director had begun to divert government funds paid for research and administration into a fund used for political purposes. Although only a few were directly involved in Project Fiddle, the RCMP uncovered other wrongdoing; for instance, the New Democrat MLA Murray Koskie was convicted of a separate fraud, and former cabinet minister Joan Duncan, who "pleaded guilty of defrauding taxpayers of $12,405," admitted that in a fit of anger over being dropped from Devine's cabinet in 1989 she had used government money to pay for a holiday in Hawaii.[67] The investigation also caught in its net those who might otherwise be considered to have acted carelessly or used bad judgment; for instance, Bob Andrew pleaded guilty to using $4,500 to pay his constituency secretary's severance, and Grant Hodgins was found guilty of fraud for using $3,645 for computer software for his constituency office. The investigation took a tragic turn when Jack Wolfe, a veterinarian and former Conservative minister known for his scrupulous honesty, was under investigation for using caucus money to buy a computer. Wolfe wrote a note to his pregnant wife saying that he loved her and their three young children "too much to have you bear the pain of having my name and reputation destroyed." He then shot himself.

Wolfe's suicide and Hodgins's resignation reflect the tragedy of the Devine regime. Amid all the excessive spending and reckless disregard for process and professional advice, there were some ministers who worked hard in their portfolios and treated their officials fairly. Hodgins, for example, was a backbench MLA when the assault on the civil service occurred.

Not only did he not participate in it, but he did not agree with it. However, in a government lacking strength and direction at the centre, the able and conscientious ministers were overshadowed by the more powerful ministers, who treated government as a source of largesse – jobs to be given to friends, vote-getting grants to entice taxpayers, government departments to be auctioned off to local communities, and sweetheart deals to be signed with promoters. Without well-defined and strictly adhered-to processes for decision making, there was no mechanism to rein in those inclined to abuse their power. And sometimes, because all too often no cabinet decisions were taken, ministers knew little about the actions of fellow ministers.

The role played by the ministers of finance was especially difficult. All three protected civil servants in the finance department, so there was a corporate memory at the centre of government; and all were regarded as conscientious ministers who took their department's analyses seriously. Bob Andrew made consistent albeit futile efforts to cut spending. Gary Lane fought hard for a third tough budget in 1989 to break the back of the deficit, and when he lost he left the finance portfolio. Lorne Hepworth strove to limit the government's commitments to the megaprojects. But in the end, their fate was sealed by a government willing to disregard financial controls and accountability and for whom political polls were more important than sound public policy. Once treasury board became just another committee whose advice could easily be accepted, rejected, or simply disregarded, any sense of the discipline of power was gone. A minister of finance can only keep a government on track fiscally if he or she has the consistent support of the cabinet and the almost unwavering backing of the premier. None of Devine's finance ministers had either.

Both Hodgins and Thatcher criticized the Devine government for being excessively political. Politics is based on emotion, reacting quickly to a problem and pleasing people, while good government requires sound analysis and sober second thought. Pleasing people in politics is most easily achieved by avoiding difficult decisions and putting money in voters' pockets, and Devine's government was a perfect example of this all-too-common political problem. Also, in the Devine regime, decisions were made on impulse to solve immediate political problems, rather than putting political impulses through the sieve of good management. Any sense of long-term planning would have shown the Conservatives the folly of taking on the civil service. No organization can run effectively with demoralized and hostile employees. Sound financial analysis and decision making would have forced the government to weigh the long-term costs against the immediate appeal of excessive government spending. And a respect for professionals and their advice would have changed dramatically the terms of many

megaprojects. But with politics driving the agenda, good government took a back seat.

Although administratively they were much worse than other governments, the Devine Conservatives were merely a more reckless and extreme model of what was happening elsewhere in the 1980s. In reflecting on that decade from the vantage point of the 1990s, Alberta Premier Ralph Klein said of his government's role in the Bi-Provincial Upgrader, "We [the three governments] were all stupid together." The Saskatchewan government may have been especially irresponsible in its handling of the megaprojects, but in two of the worst deals its partners were other governments. Similarly, its desire to appease taxpayers was excessive; yet all governments raised taxes and ran up deficits trying to shield voters from unemployment, low commodity prices, and other hardships. Politicians in the 1980s fuelled the traditional idea that government could and should solve problems, rather than working to rein in public expectations. And the Devine Conservatives confused other Canadian governments' legitimate practice of downsizing the public service with a foolhardy disdain for the procedures, rules, and professional advice essential to sound administration. Their arrogant assumption that they could run an effective government without the support and advice of a competent and committed public service proved to be their undoing and was the major reason why they racked up such huge deficits and debt.

Tragically for the Conservatives, their anti-government attitudes meant that their alternative vision for Saskatchewan was never really tested. In 1982 the public was open to an alternative to the Blakeney approach of relying heavily on crown corporations to develop the province and of targeting government aid to those most in need. The Conservatives did have an alternative vision, based on streamlining government, encouraging the growth of an entrepreneurial class and culture, and expanding the province. But political goals, like destinations, can only be reached with a road map outlining the route. The Conservatives' failure to see the need for the road map meant that they never reached their destination, so whether or not they were headed in the right direction remains an open question.

Devine, to all outward appearances, walked away from his government's debacle unscathed. By the time the fraud trials were over, more than a dozen Conservative MLAs had pleaded guilty or been convicted of fraud. There were more suicides. And the Saskatchewan Conservative party was in ruins. But the RCMP "didn't uncover any evidence that indicated that the former premier had broken the law or even knew about the fraud scheme operating in his caucus office." Oblivious of what was happening in his own government, Devine said in a 1995 interview that he felt "betrayed" and that he

had "trusted individuals." The taxpayers of Saskatchewan might well say the same of Premier Donald Grant Devine.[68]

The legacy Devine left has become legendary. A province that was once a model of sound financial management had been driven to the brink of bank-ruptcy. Billions of taxpayers' dollars had been risked on megaprojects. A civil service, respected for years in other parts of Canada for its competence and innovation, was almost in ruins. On 1 November 1991, when the Romanow government took office, it inherited a province on its knees.

PART TWO

Managing the Fiscal Crisis: The Provincial Scene

It was a sobering moment when Premier Roy Romanow told the three cabinet ministers in his office late one night in February 1993 that after only sixteen months in government he was going to call an election. Although clearly angry, he explained in a calm and matter-of-fact voice that his NDP government had been elected to govern the province, not to hand it over to creditors or the federal government. He was furious because for the second time in a month a group in his cabinet had refused to support the proposed 1993 budget and instead wanted the province to default on its debt and allow the federal government or creditors to take responsibility for the politically unpopular choices that had to be made. This time, however, the dissenters had been joined by a senior cabinet minister, who was now sitting in the premier's office apologizing and trying to reverse course. Undeterred, Romanow turned to the now sheepish minister and assigned him the task of being campaign manager in the threatened election. As we were leaving the office to ponder the fate of our government, the premier's parting shot to the minister who had supported default was, "By the way, campaign manager, how do you think we'll do in the upcoming election?"

The New Economy and the New Fights

"I need to speak to Finance Minister Don Mazankowski today and it's an emergency," was the message I left with the federal minister's staff at 8:30 on a Monday morning in January 1993. When Mazankowski returned the call that evening, I introduced myself as the recently appointed Saskatchewan finance minister and went right to the point: "Our government cannot put together a budget that meets the targets of the credit-rating agencies. Do you know what that means?" The reply was equally succinct and direct: "Yes. Fly to Ottawa and meet me at the finance department rather than on Parliament Hill. Bring only your deputy minister. Let us know in advance what files we might help you with and don't let anyone but your premier know you're coming."

The conversation reflected the fiscal reality in Canada described colourfully in a 1992 financial report as follows: "The Canadian fiscal situation ranges from painful in Quebec, to ghastly in Ontario, to terrifying in Saskatchewan."[1] The assessment would have been even worse if the financial analyst knew the tight box that our government was in by early 1993. On the one side were credit-rating agencies demanding dramatic, even draconian, action quickly to get our financial house in order so that we could continue to borrow money; on the other side were some members of our cabinet who resisted, to the point of supporting default, the tough medicine prescribed as the cure to our financial ills. My call to Mazankowski was a desperate attempt to get our government out of its box and to restore both the province's finances and the unity of our government.

The tight jam that the Saskatchewan government found itself in was a product of the economic and fiscal challenges facing provinces in the early 1990s, the realities of partisan politics, and divisions within the NDP. The 1990s were a major turning point in Canadian history because it was in this decade that the full force of the global economy hit Canada and the consequences of decades of overspending came home to roost. The increasingly

competitive economy of the 1980s had brought hardship for many Canadians. Unemployment, the decline of the prairie family farm, downsizing, and job losses prompted Canadians to turn to governments for help; and politicians, anxious to accommodate voters, responded by spending money in an effort to solve people's problems. By the 1990s, however, the jig was up. The cupboard was bare, as years of deficit financing caught up with provinces across Canada. At the same time, governments came to understand that many problems were beyond their capacity to fix. The combination of grappling with the fiscal crisis and accepting the new realities of the global economy made the 1990s a period of unprecedented change and adjustment.

Politicians had to reshape Canadians' expectations of government. No longer able to be all things to all people, governments, like other organizations, had to be strategic and make choices. Running deficits to protect people from today's hardships was merely handing the bills on to future generations. Governments were pressured to focus their efforts and resources not only by the fiscal crisis but also by the dramatic changes required for success in an increasingly competitive, open, private-sector-dominated economy. The signing of the North America Free Trade Agreement (NAFTA) in the early 1990s reflected the fact that corporations no longer were constrained by national boundaries, and the revolution in information technology was truly transforming the world into a global village. The ramparts that had been erected in the past to protect Canadians from external forces and allow them to build a unique society and political culture were being torn down by forces beyond their control. The message that leaders had to deliver was not easy: no jurisdiction – whether a country or a province – could be an island unto itself, with barricades to keep out foreign competitors. The global world was here to stay, and we had to learn to compete and excel in that tough, demanding world or we would be left by the wayside. Navigating the fiscal crisis and the implications of the new economic world order, though not easy, were essential to Canada's success in the twenty-first century.

The challenge of redefining the role of government was especially troublesome in Saskatchewan. As well as a massive debt and ballooning deficit, the province by the early 1990s had more than a billion dollars at stake in risky megaprojects, and as some of them veered toward bankruptcy, bold action was required. To make matters worse, key sectors of the economy – agriculture, for instance – faced the traumatic adjustment from being heavily dependent on government-supported programs to operating in a more market-oriented economy. And in a province that relied so much on government and harboured vestiges of distrust for business, the shift to a more private-sector world was a special challenge.

As well as the daunting issues of the decade, the drama that unfolded at

the highest levels of the Saskatchewan government in the early 1990s reflect-ed the internecine rivalries that are part and parcel of politics. The façade of unity that governing parties put on for the public masks the extent to which there are often intense divisions brewing just beneath the surface. The quest for power, prominence, and public approval are all potent factors in fuelling rivalries and factionalism, and they reared their ugly heads in an especially menacing fashion in the 1990s when the stakes were so high.

The divisions within our ranks also reflected the struggles within the NDP to come to grips with the new world of the 1990s. The victory of the market economy, the need for Saskatchewan to compete in an open economy that was beyond the control of government, and the hardships caused by gov-ernment cutbacks all challenged long-held and deeply cherished NDP beliefs. The Romanow government quickly dashed some New Democrats' hopes that the NDP would pick up where Blakeney left off in 1982 by using high taxes on corporations to finance programs for people. Beyond the pub-lic eye, there was serious dissension within the ranks that at times threat-ened to jeopardize the government's capacity to make the decisions neces-sary to keep the province from sliding into bankruptcy.

The demands of the fiscal crisis, the new economy, and a devastated civil service became apparent soon after our 1991 election victory. Managing the transition and trying to revitalize the civil service were the first orders of business. But equally pressing was the need to breathe new life into a stag-nant economy, deal with the ongoing agricultural crisis, and rescue megaprojects on the brink of collapse. All these issues led to fights – some internal, others with powerful interest groups. In retrospect, it is surprising how oblivious members of the new government were to the severity of the crisis looming on the horizon. Ours was not a planned script with a known ending. It was a drama that unfolded as the demands of the situation quick-ly forced us to choose and to act.

On 1 November 1991, as the eleven smiling faces in the new Romanow cabinet posed for a picture around the cabinet table used by Tommy Dou-glas, none of them knew the extent to which Saskatchewan was truly at a crossroads. They were still feeling the glow of the landslide election victo-ry, in which the NDP had won 55 of the legislature's 66 seats and taken 51 percent of the vote. Fresh in their minds was the jubilation and hope that pulsated through the auditorium on election night as long-time New Democrats and new supporters flocked to hear a hoarse Roy Romanow declare to thunderous applause, "Let the word go forth from every corner of our province tonight that Saskatchewan is back."[2] Many of the same peo-ple were at the swearing-in, proud of their hard-earned victory and confi-dent in the expectation that the NDP government would implement its elec-tion platform to improve the province's new agricultural Gross Revenue

Insurance Program (GRIP), "revive the school-based dental program," "improve prescription drug plan benefits," and "eliminate the need for food banks"[3]

The small war cabinet chosen by Romanow was the first hint of what kind of government he would lead. Cabinet making is one of the most difficult yet defining times, when a premier reveals his hand and gives his government and its intentions a human face. Described by Romanow as being "lean, keen and somewhat green," the cabinet was a blend of veterans and new faces, charged with the task of managing the transition and getting "the province back on its feet." Of the veterans, Romanow was the best known, having attained a national reputation for his role in the 1982 constitutional changes, and he was the most experienced, having served as Blakeney's deputy premier throughout the 1970s. The deputy premier and finance minister, Ed Tchorzewski, had held many portfolios in the Blakeney cabinet, including finance, and had a tremendous knowledge of government and a reputation as a solid New Democratic Party man. Our best "street smart" politician, next to Romanow himself, was another former Blakeney minister, Dwain Lingenfelter, who was house leader and minister of economic development. Lingenfelter was also an entrepreneur to whom business people easily related. Two able lawyers, elected in 1986, were Bob Mitchell, who had also been a deputy minister in Blakeney's government, and Louise Simard, who had extensive experience working with government agencies and was given the punishing task of being minister of health.

Many of the six newcomers had been recruited by Romanow himself and reflected the changing cycle of politics; while a party in decline has trouble attracting high profile candidates, a party that is positioned to win an election can attract experienced and respected people as the NDP could in 1991. The new minister of energy, John Penner, a former principal and businessman from Swift Current, was described by a Calgary oil executive as being "a bright man ... [who would] make an excellent minister." Penner signalled a break with the high royalties of the Blakeney era when he said, literally within minutes of being appointed, "The message I would give to the industry is just carry on with your business." Similarly, when Berny Wiens, a farmer with a master's degree and former national president of the school trustees, was appointed minister of agriculture, the leader of the right-wing Western Canadian Wheat Growers stated, "We can expect responsible policies and a sensible, pragmatic approach." Two experienced women in the cabinet were Carol Teichrob, former municipal politician, farm leader, and business person, and Carol Carson, who had been mayor of the city of Melfort. Darrel Cunningham, a farmer with a degree in agricultural economics, hid his powerful intellect behind the guise of being a plain-talking guy from small-town Saskatchewan. Legend

has it that I barely made it into the cabinet. Romanow now admits with a chuckle that he wondered if I was tough enough. So he put me into cabinet but gave me the touchy social services portfolio to test my mettle and see whether or not I was a "keeper."

The face put on the government with the new cabinet was, in the words of political commentators, "new look," "moderate and non-ideological," and "pragmatic, down to earth, level-headed types, genuinely concerned about fiscal responsibility and economic development."[4] Romanow said he wanted to set aside ideology and even geography – since most ministers were from the two major cities – and to "tackle the problems of the 1990s with fresh eyes." The fresh eyes included a record number of women (a full 40 percent of Romanow's first choices were women), an unprecedented level of higher education (the eleven cabinet members shared sixteen university degrees) and a dominance of baby boomers (although four were over fifty, the rest were all in their forties). The 40 percent of the cabinet who were veterans provided invaluable experience in both politics and government. They knew both how to keep us out of political trouble and how to run a competent and fiscally responsible government. Of the 60 percent who were new, none were career politicians. Drawn to politics with the goal of ending the Devine era and shifting the direction of the province, they were important agents of change in a government less concerned with merely transacting the people's business and more interested in transforming the face of the province.

Behind the eleven men and women filing into the legislative chamber to be sworn in as cabinet ministers were eighteen veterans who had been part of Her Majesty's Loyal Opposition but had been left out of the cabinet. Most were very gracious in setting aside whatever disappointment they may have felt, and they eagerly pitched in to help the newcomers. Although Bob Pringle, a Saskatoon social worker, had good reason to believe that he would be the new minister of social services, he quickly took me under his wing and helped me find a new deputy minister. Similarly, Myron Kowalsky may have wondered why there was no cabinet minister from his riding in Prince Albert, yet he never displayed anything but enthusiasm for the task of getting on with government. And if Ned Shillington, a lawyer and veteran of Blakeney's cabinet, ever wondered about Romanow's first choices, he never showed it. Shillington, like the other Regina area MLAs Harry Van Mulligen and Suzanne Murray, was still basking in his constituents' delight at having Devine gone, Fair Share set aside, and Regina once again the undisputed capital of the province.

Beneath the surface there were important differences between the members of the war cabinet and the veterans in the caucus. While none of the newcomers were career politicians, many of the veterans would still be there

long after the class of 1991 had left the field. Most of the veterans had been elected in 1986, before the Free Trade Agreement was even signed, and their formative political experiences predated both the fiscal crisis and the advent of the global economy. When they entered the legislature they brought with them traditional NDP goals – enhancing social programs, preserving the family farm, and making the tax system more progressive – and their experience in opposition reinforced their views. While the rookies from the class of 1991 had been pursuing careers in the rapidly changing world of the late 1980s, the class of 1986 had spent hours in the legislature attacking Devine's government on the basis of traditional NDP ideas. The Conservatives had been berated by them for the inadequate funding of health and education, for tearing gaping holes in Saskatchewan's social safety net, and for increasing taxes for people while allowing corporations a free ride. The 1989 budget, for example, had been condemned for its tax "increases for people and a reduction of two percent for large corporations," and a 1991 pamphlet claimed that while the average family was paying $2,800 more a year in taxes, the corporate share of income tax had "fallen to only 16 cents for every dollar you pay."[5]

The veterans of 1986 had been shaped by five long, gruelling years in opposition. The New Democrats had expected to win the 1986 election and had been profoundly disappointed when they won the popular vote but the Conservatives stayed in power. Worse yet, it was after 1986 that the Conservatives revealed their true right-wing stripes. Despite bitter and protracted fights in the legislature, the NDP MLAS could not stop Devine from privatizing the jewels of the NDP's resource crowns – Sask Oil, SMDC (uranium), and the Potash Corporation of Saskatchewan. They watched helplessly as the children's dental program created by the NDP in the 1970s was gutted and the technicians fired. And they raged in vain about the waste and mismanagement of the Tories. Through long and tumultuous legislative sessions which they dragged right through the summer, the New Democrats became first-class politicians. In their single-minded attack on the Tories, which was more like political warfare than parliamentary opposition, their focus was on politics; the politically smart position to take in the short run was the question foremost in their minds. At the same time, the luxury of opposition is the latitude to be all things to all people and not to have to reconcile the inconsistencies or long-term implications of promising to spend more, tax less, and still balance the budget. Thus, in 1991, when still opposition leader, Romanow claimed that he could balance the budget in the first term and eliminate the debt in fifteen years by "attacking waste and mismanagement, implementing a system of fair taxation, rejuvenating the economy, standing behind farmers and improving our quality of life."[6]

At the federal level, differences between the veterans and the Liberals first elected in 1993 surfaced in their reactions to Paul Martin's tough 1995 budget. The newcomers, according to authors Edward Greenspon and Anthony Wilson-Smith, were much more likely than the veterans to support the dramatic changes which the budget represented. As the authors explained, while the veterans had been "isolated in the time capsule of Parliament Hill," the newcomers of 1993 "could draw upon their recent experiences in the private sector or municipal government or in almost any other institution in understanding the way ahead for Ottawa." Pursuing careers during the rapidly changing late 1980s, they had been forced to confront the realities of both fiscal restraint and the new global economy. They "had lived the reality of doing more with less. They understood that global competition had rendered the old rules obsolete." [7]

Similarly, the new MLAs in Saskatchewan were more pragmatic and more comfortable about being architects of dramatic change, while the veterans in the caucus were more concerned about the politics of the changes and the extent to which they were at odds with traditional NDP positions. As well as the differences in the career paths of the two groups, the newcomers were unencumbered by having been in opposition. Romanow used to say, "If only I hadn't made those speeches with those wonderful promises while I was in opposition." With nothing on the record, the new people were freer to chart their own course. Also, as the saying goes, "Ignorance is bliss." When having to make very difficult choices, being unaware of the full implications of a decision can sometimes be a blessing. The new treasurer of Alberta, Jim Dinning, put it well in 1993 when he said, "Being new to the job, I had one major advantage. I simply didn't know what can't be done."[8]

The difference between our two groups would play themselves out as the fiscal problem unfolded, but what was immediately apparent in November 1991 was that a few New Democrats did not share the public's enthusiasm about the new cabinet. As the local press put it, "The NDP's old guard is probably still having heart palpitations" at the cabinet choices. One such group was the "liquor cabinet," a collection of hard-drinking, big-talking MLAs who met regularly in Murray Koskie's office at the east end of the basement in the legislature. Self-styled experts on politics and tactics, they disdained policy "wonks" and made life difficult for high-minded leaders such as Allan Blakeney. They tended to prefer a political ace like Lingenfelter for leader, though as one MLA said, "As the night wore on and the booze flowed almost any one of them might emerge as the new leader." As the 1991 election approached, many felt they had a personal commitment from Romanow that they would be in the cabinet, and their late-night talk turned to dividing up the cabinet posts. Imagine their shock and anger,

after spending five gruelling years in the trenches bringing down the Devine government, when they found that not one of them was rewarded with a cabinet job. Instead, the cabinet was full of neophytes with no political experience, people who would certainly trip and stumble. And some of us soon proved them right.

I was one of the neophytes who revealed my political inexperience with some early gaffes, the most notorious being my lecture to a group of First Nations leaders on a reserve that had just voted solidly NDP. The case was about a young girl who, because of allegations of abuse, had been removed from Beardy's reserve and placed by the Department of Social Services in a non-aboriginal foster home. When the chief publicly used the case as an example of the principle that First Nations' children should not be placed in white foster homes but should remain in homes on the reserve, as minister of social services I sympathized and phoned to say that I would stop by the reserve on a trip to Prince Albert. Within hours, I was horrified to find that the chief was telling the press that I was coming to the reserve to sign an agreement to give the band control over foster care. Outraged that I was being set up and that the misfortunes of a child were being used for political ends, I drove onto the reserve, marched into the band office, confronted an all-male group of band leaders, and gave them a piece of my mind. The press was soon full of stories about my arrogant, condescending lecture.[9] Although the local MLA, Walter Jess, was a prince on the issue and the premier quipped that at least I'd passed the test of showing backbone, the rumblings from a few veteran MLAs were thunderous, and the more jaded even talked about the cabinet job that would soon be open for one of the political pros to fill.

Another problem was the left wing of the NDP. The moderation of the war cabinet, which resonated with the public, angered some members of the far left. The day after the cabinet was announced, a prominent Saskatoon party member publicly registered her concern that the rookies did not have "to wait for their time" but took cabinet jobs that should have gone to political veterans.[10] In a party with strong trade union connections, the notions of seniority, paying one's dues, and waiting one's turn were deeply ingrained. Just as troubling were suspicions about the NDP credentials of some of the new ministers. Carol Carson, it was alleged, had supported Grant Hodgins in Melfort in 1982 and voted for the Devine Conservatives. Carol Teichrob, in her capacity as a Saskatoon area reeve, had openly criticized the Blakeney government's plan to create an urban park – the Meewasin Valley Authority – in Saskatoon. And many New Democrats harboured suspicions that Romanow himself was a closet Liberal. Never known as a party man or a union guy, Romanow dressed well and spoke moderately – further causes for suspicion by some on the left.

The hostility of the far left to our shiny new cabinet was revealed in the left wing magazine *Briarpatch,* which featured a scathing article, "Who's New in Cabinet." I was their first candidate for dissection. Rather than fitting the image of a compassionate, humble NDP minister of social services, I was described as being "impeccably dressed," with high heels that banged on the "cold marble" floors of the legislature, and as having "an abrupt style," a "steely approach," "little experience ... with poverty issues," and a belief that "having a hard nose is part of the job description." Equally unflattering was the picture of Carol Carson, who was called "a small-town civic booster." She was criticized as an "extremely weak" choice for environment minister since she was "very much in favor of development in the broadest sense" and had not participated in the intense NDP battles to halt uranium mining in the province. The reason Romanow made such poor choices, according to the article, was that he had no commitment to traditional NDP goals, such as enhancing social programs, so he chose new ministers who had "more loyalty to the premier who led them to victory than to the party's long standing ideals." In any future expansion of the cabinet, the premier was advised to appoint "experienced, savvy men and women who can raise the right moral questions when decisions are made."[11]

From the beginning, then, there were cracks in the unity of our team and a chasm between the views of the public and some party stalwarts. The war cabinet combined both the experience of veterans and the pragmatism and momentum for change of the newcomers, and the public, it seemed, applauded this refreshing combination. But, clearly, some caucus members felt betrayed. Bridging the divisions and soothing the egos was a taxing task and in the early months our cabinet was too preoccupied with the other issues on its plate to give the matter the attention it deserved.

The agenda that we inherited in 1991 was overwhelming, as might be expected for a province on its knees. As well as the deepening financial problem, the economy was languishing, the province was mired in an agricultural crisis, and several of the megaprojects were on the verge of collapse. Immediately, we needed a legislative session in December in order to pass the Conservatives' budget (since the province was being governed through special warrants) and to carry through on our own election promises to repeal the harmonization of the sales tax with the GST and establish a Code of Ethics and Conflict of Interest guidelines, the key features of our democratic reform election package. As well as inheriting a budget that had not even been passed by the legislature, we were bequeathed outrageously expensive contracts that Devine and company had entered into in their dying days, giving generous severance packages to some of their appointees. Unable to face the politics of cutting services to people while well-paid public servants got a golden handshake, we

introduced legislation to nullify the agreements. The politics was great, but the practice of using the legislature to break contracts was troubling. To say that we were preoccupied with other issues besides the unity of our caucus would be an understatement.

After 1 November the Legislative Building was often lit up like a Christmas tree at midnight as cabinet ministers and their staff worked literally around the clock at breakneck speed to get a handle on the government and come to terms with the civil service. It's exhilarating to be part of a transition to a new government and to be a cabinet minister for the first time. One of the last bastions of true hierarchy, the Marble Palace, as the Legislative Building was often called, responds to power. On the morning of 1 November I walked through the building unnoticed. By the evening I was being addressed as the Honourable Minister, I had my own late-model car, a political staff of six within my office, and people willing to bend over backwards to accommodate my every wish. Thoughts about how ill prepared I was for the responsibility were quickly set aside as the government machine sprang into action with a precision that only long experience in public administration can bring. The tone of the regime was set quickly as ministers dispensed as summarily as possible with the handshaking at the tea party following the swearing-in ceremony and hurried to the first cabinet meeting.

The transition was organized and efficient, directed by experienced people from the Blakeney era. At our first cabinet meeting we got what was known as "the speech," told that we as cabinet ministers were policy makers not administrators; our job was to set priorities and seek advice and options from the civil servants, whose task it was to actually run the government. Woe betide a minister caught running the department. We were also told that uploading problems to the minister was a way for the civil service to avoid accountability; how could a minister chastise a deputy for a policy that did not work if the policy had been designed by the minister?

After "the speech," we were given an impressive checklist for the transition. Our first task was to consult the party platform to see what commitments had been made in our portfolios. As minister of social services I was unnerved to realize that the major promise in my area was to eliminate food banks. Next was a meeting with the NDP member who had been the opposition critic for our area and with a special adviser assigned to each minister. The special adviser brought briefing books and a checklist of other information to be requested from the department, including annual and long-term plan and budget, organization chart with names, salaries, qualifications, and job evaluations, current problems and major contracts, as well as lists of lawyers, advertising agencies, and other avenues through which governments traditionally distribute patronage. In dealing with the civil

service, all firing and hiring had to be approved by a coordinating committee. We were also given a list of civil servants in our department that went two levels below the deputy or head. The list had three kinds of markings: a plus for "keep the employee"; a question mark for "uncertain"; and a cross with the notation that this did not necessarily mean firing, it just meant that these people were not appropriate for their current position. Only after being armed with all of this material were we actually to meet face to face with the civil service. As I prepared for my first meeting with the department, I was unnerved by the number of crosses on the personnel chart.

As minister of social services I did not inherit a department like finance, justice, and energy, which had virtually escaped the firings of the Devine years. I inherited a devastated department that had been run by Grant Schmidt. The shredders in the legislature had been working overtime in the days between Devine's defeat and the transition to the new government. When I entered the minister's office, I was shocked to find no files, no corporate memory – the office had been stripped bare. All that had been left was an obscene message written on a large piece of paper. As I scanned the organization chart, it was obvious that political appointees with no professional qualifications had been placed throughout the department. This impression was confirmed in a report from my special adviser, which concluded that "patronage" was "rampant" in the department, most of the hiring having been done "out of the former ministers' offices." The former ministers, the report stated, had intervened so often and so deeply into the decision making of the civil service that the department had been reduced to a "dysfunctional family."[12] Literally within hours of taking office, I saw evidence of the dysfunction as I was asked by the department whom to hire or fire and which adoptions to approve or reject. Rather than the department being run by social workers, it was run by the equivalent of accountants, uninterested in dealing with poverty and more concerned with weeding out welfare fraud – an impression confirmed by our discovery of cameras and other surveillance equipment used by the department to spy on welfare recipients. Although I dutifully followed my checklist and asked all the questions about long-term goals and vision, I got no answers from a civil service that was so emasculated and demoralized that it had lost its policy-making capacity.

I also inherited one of the few agencies that had been moved out of Regina as part of the Fair Share program. New Careers, an agency that employed welfare recipients on capital projects, had been moved to Kamsack, a small community in eastern Saskatchewan. Reading about the move was a wonderful insight into Fair Share. Of the nine employees transferred, only two actually moved; the rest commuted. As well as paying for a lease in Regina and $1 million for a new building in Kamsack, the agency's costs

for transportation and telephones increased by more than $200,000 a year. I also had a bird's-eye view of the centralized decision making that had led to Fair Share. A report done by the president of New Careers concluded that "neither management, nor the board of directors not even the Progressive Conservative minister in charge of New Careers at the time supported the move." Within days of the public announcement that New Careers was moving back to Regina, the former Conservative minister, Beattie Martin, admitted, "I argued rather vehemently with the group [which made the Fair Share decisions]. I just didn't like the idea of uprooting people." His sentiments were shared by Don Racette, a member of the New Careers board of directors and a Conservative candidate in the October election, who said of the decision to move the corporation, "It was a shock because they [the Devine government] didn't give us a chance to discuss the whole idea – they just went ahead and did it."[13] If only my other problems could be solved so easily.

The extent to which the weakness of my department would be my undoing was reflected in my lecture to the Beardy's First Nations, which occurred less than two weeks after my appointment, and in two other incidents, which fortunately never became public. On a bitterly cold day in late November 1991 my chief of staff, Jonathan Wilkinson, came gingerly into my office with that "I've got bad news" look on his face. A woman had phoned our office trying to locate her severely disabled aunt, a ward of the department and a permanent resident of one of the department's facilities. When asked about the aunt's whereabouts, the acting deputy minister replied that the department did not know where she was; somehow, they had lost track of her. For two days Jonathan and I waited in anguish, concerned not only about the woman herself but also about what would happen if, on top of the Beardy's story, the press caught wind of this situation. Luckily, the woman was found safe and sound; but the level of incompetence that the incident revealed was terrifying.

The second incident involved a briefing note, which in government is supposed to outline a problem and then, under the heading "Recommended Response," provide the solution or answer for the minister. As Jonathan and I were speeding to meet a group in Moose Jaw that was irate about how slowly we were going down the road to eliminate food banks, I was reading the briefing note outlining the specific problem about which the group wanted to meet. After a page-long description of the problem, I got to the "Recommended Response," where there was only one word: "None." By now so overwhelmed by the chaos around us, we burst out laughing, imagining the scenarios for the meeting: after the group outlined its horrific problem, I would simply stare blankly at them; or I could say firmly, "No response"; or I could pronounce, "Be assured that for your major problem,

I have absolutely no solution." In fact, at the meeting all that I could do was listen carefully and promise to look into the group's concerns, which fortunately the group chalked up as attentiveness rather than ignorance. The premier had told me that being minister of social services would be a test of my mettle, and I realized that if I did not get help soon, I was going to fail the test.

The cry for help took the form of two telephone calls to men whom I had never met but who changed the course of my career. Before the election, a friend mentioned that he knew an experienced senior civil servant who would be willing to give me confidential advice. My friend gave me the civil servant's private telephone number and said that he would mention that I might call. In a desperate moment, I made the call and spoke to Mr X, confessing that I was at my wits' end and needed help. In a thirty-minute conversation, he reviewed my department for me, told me whom I could trust and whom I needed to watch carefully, and mapped out a game plan. When I put the game plan into a memo and took it down to Wes Bolstad, the acting cabinet secretary, who had held a similar position under Blakeney, he smiled broadly and said proudly, "What a great plan for your department; you are certainly learning quickly how to be a good cabinet minister." Mr X was obviously a gold mine.

There is no shortage of advice available in government, but the catch is that almost everyone who provides it has some interest to protect. Departments are the main source of valuable and informed advice, but departments have their own decided views about how the world should unfold. Other ministers are often very helpful, but they too have to consider the interests of their own departments and their own careers. Ministers ignore the premier's views at their peril; however, the sooner a minister realizes that a premier may have to sacrifice a particular minister in the interests of the broader government as a whole, the better off that minister will be. What Mr X provided me with over the years was advice from a disinterested perspective, advice that most often began with the phrase, "Minister, what is in *your* best long-term interests is ... "

What Mr X also brought was the accumulated wisdom of the civil service. He epitomized the professional civil servant, sitting silently at meeting after meeting over the years, listening and observing so much and hiding the knowledge behind an expressionless face until asked for advice – when the face lights up and the wisdom pours forth. For example, when I called Mr X about a new policy direction that I was considering, often the response was an analysis of what had happened the last time an enterprising minister had tried that approach. For ten years, I never made a major decision without consulting Mr X, who also called me, with his cheery, "Just a heads up, Minister, but here's what's coming your way ... "

– warnings that are invaluable in the shark-infested waters of government and politics.

My second call, on the advice of Mr X and others, was to Con Hnatiuk in Edmonton, whom I begged to return to Saskatchewan to be my deputy minister. I had learned the value of good management as president of the Saskatoon Co-op, when the board of directors decided to dispense with our usual practice of hiring our managers from Federated Co-op, which had a reputation for training excellent managers. Instead, we wanted a manager who shared our philosophy, so we hired someone from outside the system. Our new manager, though a great philosopher, was so bad at managing that my husband said to me, "Maybe you could get him to bag groceries. At least you'd get some value out of him." Sound management, a good sense of policy, and invaluable experience as a career civil servant was what Hnatiuk brought with him.

Hnatiuk, like almost all of my other deputy ministers, had extensive experience in government that was crucial in compensating for my own inexperience. I knew none of the tricks of the trade, but my deputy ministers knew all of them. Over the years they passed on their knowledge, so that I came to understand how to drive initiatives through the complicated labyrinth of government, a skill that is essential in achieving anything in politics. Also, after ten years I had built up a network in the bureaucracy. In an environment where information is power, I had access to information and had an early-warning system about trouble on the horizon. My key contacts in the civil service looked out for me, and I looked out for them. Their watchful eyes and sound advice help explain why, of the original war cabinet, I was the one who survived longest.

Watching a career civil servant like Hnatiuk begin to rebuild our corner of the bureaucracy was enlightening. He reviewed the crosses on the personnel chart, changed some to plusses, added crosses of his own, and began to "houseclean" the department. His sound advice was, "Minister, don't sully yourself with this task. It's mine and I can do it with no bad publicity." Only once did I ask what was going to happen to a particularly obnoxious person. When the reply was, "He's being transferred to Saskatoon," I naively asked, "But isn't that just moving the problem around." The matter-of-fact answer was, "Next month I'm abolishing that position in Saskatoon."

While thirty-five people were being quietly moved out, the public attitude to the department changed from stories about the minister lecturing First Nations to headlines applauding the new "hands-off hiring policy." Hnatiuk said that if I wanted to achieve anything worthwhile, I had to gain the confidence of the department. So I began a tour of the province, speaking to social workers and promising that hiring would no longer be done through the minister's office. "Hiring will be done through the proper chan-

nels" I told them, and would be based on merit. As well, there was a com-
mitment to restore confidence and professionalism, and to give "social
workers the discretion they need to do their jobs"; and words that the down-
hearted public service needed to hear: "We need to trust them."[14] As the
months passed, it was rewarding to see the growing competence, confi-
dence, and policy-making capacity of what had been one of the govern-
ment's worst departments starting down the road to becoming one of its
best.

Hnatiuk's hiring, however, revealed a much darker side of the transition
because, before he was hired, word got out of my plan to bring him back to
Saskatchewan, and although Bob Pringle and several other members of cau-
cus actually recommended his appointment, some others argued vehement-
ly against it. Their criticism was that I was hiring a Tory, who had worked
for Grant Schmidt and implemented some of his obnoxious work-for-wel-
fare schemes. Lost in the rhetoric was the reality that Hnatiuk had served
under Thatcher and Blakeney, been forced out under Devine, and fired by
the Manitoba Conservatives; but he was suspect because, while a deputy
minister for the Conservatives, he had carried out some of their policies. The
concept of an independent and professional civil service had been under-
mined by the right and was now being called into question by some on the
left.

Although the Romanow government was wedded to the concept of a pro-
fessional and independent civil service, and although the firings were limit-
ed and well managed, the government never really connected with the civil
service as it had in the Blakeney era. This was partly because there was a
barrier of mistrust. Devine's firings were a watershed for many New
Democrats who had been in opposition between 1986 and 1991. Friends,
party members, and many competent people had lost their jobs, and
vengeance was part of the mix in 1991. Also, in the highly charged, totally
partisan legislature of the late 1980s, there had been no middle ground; if
civil servants were helping a Tory minister with answers during estimates,
then that civil servant was regarded by caucus members as being on the
other team. Estimates in the 1980s could be tumultuous and nasty – one
Conservative minister was reduced to tears during a grilling by the opposi-
tion – and NDP members could be heard yelling across the floor to the civil
servants advising Conservative ministers that after the election, they would
be gone. The venom continued after the election. At virtually every NDP
council meeting that I attended, at least one or two party members would
go to the microphone and lambaste the government for not getting rid of the
Tories in the civil service.

My view was straightforward. I was the first minister to fire my deputy,
not because of incompetence but because the government needed a

complete change in direction in social services, and the only legitimate way to achieve that goal was to replace the deputy. After that I fired nobody. I gave Hnatiuk the lists with the crosses on them; I told him my impressions and concerns, and then left him to build the professional civil service. The key relationship is between the minister and the deputy. Confidence in the deputy means allowing him or her to make the choices and build the team. There is no other way to have an independent, professional, and highly motivated civil service.

The adage "Sometimes you don't want to get what you wished for" applied perfectly to the government's early plan to fire the senior people in the Department of Finance. The reasoning was that the finance officials had advised Devine as he racked up a huge debt, so how could a new government keep the same advisers? Ironically, the finance civil servants had virtually to a person been hired by Blakeney's government, and then all three of Devine's finance ministers had taken enormous flak from their fellow Conservatives for protecting them because of their competence; and now the New Democrats were going to fire them for surviving! In the end, replacements could not be found. But although the officials remained, so did a lingering mistrust. At a social event, there was a telling war of words between the premier and a senior finance official, who said, "Either trust us or fire us." To which the premier replied that they should have quit if their advice to Devine's government was being ignored completely. As I listened to the exchange, I made a fundamental decision that I communicated to the premier: "Officials need not quit if governments don't accept their advice, but be assured that as a minister I will quit the day that I can no longer support the overall direction of the government." Without the corporate memory and competence of the Department of Finance, we probably would not have turned the corner on the province's finances. Little did I know in 1992, as the future of finance officials hung in the balance, what their continued employment would mean to my own future. What a relief it was when I became minister of finance of an almost bankrupt province after only fourteen months in government, to hear my new deputy minister, John Wright – who at forty-two was already a veteran civil servant – say with great authority, "Don't worry, Minister, I've been in government all of my working life and I've never lost a minister"!

At the same time as we were handling the transition and the civil service, we had to tackle the recession, whose effects were devastating for Saskatchewan. Between 1987 and 1992 the province's economy had grown by a puny 1.5 percent, and in two of those years it actually shrank. The recession caused job losses and other hardships and left governments with increased costs for welfare and decreased income from taxation. Boosting the economy was imperative, and this took us straight to a partnership with

the business community that was unprecedented in its scope in NDP governments.

Forging a partnership with business challenged both the practice of Blakeney, who in the 1970s had relied heavily on the crown sector for economic development, and the rhetoric of Romanow in opposition in the late 1980s, when he heralded the mixed economy, with the emphasis on the public and co-operative sectors. By the 1990s, however, the world had changed. The public sector had been pared back by Devine's privatizations of non-utility crown corporations, and immediately after our election we made it clear that we had no intention of reversing these decisions.[15] Saskatchewan, it is true, is home to some of Canada's largest co-operatives, notably the Saskatchewan Wheat Pool, Federated Co-operatives, and Credit Union Central. By the 1990s the major co-operatives – although still committed to the principle of one member, one vote – operated more like well-run, customer-oriented businesses, a shift that was symbolized by the decision of the Saskatchewan Wheat Pool to sell shares on the stock exchange. The reality in Saskatchewan as elsewhere in the 1990s was that growth was driven primarily by private-sector business people, and turning the economy around meant inspiring their confidence and encouraging them to invest.

In late April 1992 there was a historic two-day meeting, co-chaired by Romanow and his long-time friend, corporate lawyer Harold MacKay, with key cabinet ministers and the leaders of the business community. Gaining the confidence of the business community, I learned from the frank discussions at the meeting, required a combination of attitude and game plan. In terms of attitude, business people needed to be reassured that we would not return to the 1970s, with its high royalties and big government, but would create the right climate for investment. Equally important was the need for a game plan. Business, I have found from my experience in politics, will play by a variety of rules, but the rules need to be clear and consistent. Our economic development strategy, Partnership for Renewal, reflected both the game plan and the attitude.

The shift in the role of government in our 1990s strategy was revealed when the economic development minister, Dwain Lingenfelter, declared, "The era of megaprojects is over ... Small business is the key to the province's economic recovery."[16] This signalled a major departure from the NDP approach in the 1970s, when direct government investment in the economy was commonplace. In the 1990s the role of government in the knowledge-based global economy involved creating a competitive tax regime, reducing red tape, educating and training a quality workforce, and financing infrastructure, from roads to research facilities. There were also innovative public-private partnerships, such as the Tourism Authority and the Saskatchewan Trade and Export Partnership, whereby government

provided the money and overall mandate for trade and tourism develop-
ment, but private-sector boards made the ongoing strategic decisions. By
the mid–1990s, polling showed that the public accepted the idea that the
role of government in the economy should shift away from direct grants or
investments and toward the idea of creating the right climate for invest-
ment and growth.

Balancing the budget was also important in stimulating the economy. Ris-
ing deficits meant to business the probability of future tax increases, while
balanced budgets symbolized both current stability and predictability and
the prospect of reduced tax rates in future. Strengthening the economy
would help us balance the budget, and balancing the budget would help us
strengthen the economy. From the beginning, then, the goals of economic
development and balancing the budget were inextricably linked – and both
led to divisions within our ranks.

Symbolic of the new working partnership with business was the decision
in early 1992 to set up an industry-government committee to revise energy
royalty rates. Saskatchewan is the second-largest producer of oil in Canada;
thus, expansion of this sector would significantly boost jobs and economic
activity to help the economy grow. And since oil delivered nearly $200 mil-
lion annually into government coffers, the growth of the oil industry would
mean more money for the beleaguered treasury. The terms of reference for
the committee were a perfect example of our new partnership approach to
business: although the government had to recoup the same revenue from
oil, the royalty regime could be restructured to encourage more investment
in exploration and production. The win-win logic was inescapable.

The decision to revise oil royalties was part of the larger government plan
to use targeted tax cuts for business as a tool to promote economic growth
and job creation. As economic barriers came down, companies did their own
comparison shopping about tax rates in different jurisdictions before decid-
ing where to invest. Similarly, managers, professionals, and other highly
qualified people looked carefully at income tax rates before choosing where
they would work and pay taxes. In a province that could not afford across-
the-board tax cuts (indeed, in 1992 and 1993 the province had to raise some
taxes), targeted tax cuts for potentially high-growth sectors were both
affordable and effective. Thus, in the 1990s, taxes for small business – the
backbone of the economy – were cut by 20 percent; taxes were cut to encour-
age manufacturing and processing; the sales tax on 1–800 telephone num-
bers was removed to attract call centres; and there were new tax credits to
encourage research and development.[17] The business community applaud-
ed the tax changes as effective incentives to invest, and as finance minister
(as I was by then), I consistently told business people that tax cuts to busi-
ness had to show results for people: every time business taxes were cut, tax-

payers needed to be persuaded that the result was more jobs for people and more revenue for the treasury. Internal polling showed that the public supported business tax cuts if they resulted in jobs and economic growth.

However, there was not unanimous support within our own ranks, especially when the issue of revising oil royalties was raised. The oil industry epitomized big business, and for some there was an instinctive animus to the sector. Just as important, when in opposition the NDP had hammered the Conservatives for lowering royalties for oil companies and increasing taxes for people.[18] How, then, could an NDP government move toward a policy that smacked more of Colin Thatcher, Devine's minister of energy, who dropped royalty rates to promote economic growth, than of Allan Blakeney, who raised royalties to finance social programs for people? Symptomatic of what was to come was an early exchange between Energy Minister Penner and a left-wing caucus member. When the caucus member said, "I want those oil companies to squeal like pigs from higher royalty rates," Penner quipped that the only squealing that would come from higher royalties would be the "squeal you'll hear from the tires of the cars as they leave the province."[19]

The opposition in caucus was reinforced by criticism from party supporters and left-wing writers outside caucus. In meeting after meeting we were told by the party faithful that just as Blakeney had raised royalties on resources to pay for social programs, we could do the same if only we had the courage and vision. An especially vitriolic example of left-wing thinking was a letter by University of Regina Professor John Conway. After accusing our government of engaging in "business think and market speak" and conforming "religiously to the corporate neo-conservative agenda," Conway asserted that "the revenues are there to be had if the provincial government had the political courage and imagination to go after them." He claimed that significant new money could be collected through "tax reforms designed to dismantle Devine's pro-corporate, pro-rich tax changes in the 1980s ... [and] in capturing a fair rent for the province's natural resources." By raising our royalties to 1970s levels, he argued, the government would gain hundreds of millions of dollars for social programs. Conway graciously concluded that if we did not agree that more money could be collected by raising royalties and corporate taxes, we were "either liars or fools."[20] A more polite version of the same argument was made by Howard Leeson, a former deputy minister in Blakeney's government. After urging higher royalties for potash, Leeson went on to argue that more money could be collected if corporations and people who invested more than $1,000 in RRSPs were required to buy Saskatchewan Savings Bonds at below market interest rates.[21]

Saskatchewan's left-wing proponents of higher corporate taxes and higher royalties were part of a Canadian movement in the 1990s that churned out

publications designed to persuade taxpayers that corporations should be paying more in taxation. The Ontario Federation of Labour and the Ontario Coalition for Social Justice, for instance, distributed *Unfair Shares*, which listed profitable corporations that paid little or no taxes. Another document, distributed by the Canadian Union of Public Employees, contended that tax breaks to corporations "are so numerous that they constitute a parallel, but little-known, system of social programs aimed mainly at business and the rich. Call it 'wealthfare.'" The message in all was the same: raising tax levels for corporations would provide the money necessary to fund Canadian social programs. The notion that corporate taxes needed to be competitive to keep and attract investment was dismissed; as one writer said, those who threaten "to reduce their investments, evade taxes, or move to the U.S. or Mexico unless their taxes are lowered are in effect resorting to the moral equivalent of blackmail and extortion. They should be ashamed of themselves."[22]

The idea that a lot more money for government programs could be found by raising corporate taxes was much more than an academic debate; it filtered through to NDP party members, for whom such ideas were orthodoxy, and they were constantly on our case for not acting like true New Democrats. Long-time party activist Howard Brown wrote a public letter about "whose snouts are really stuck in the Romanow government trough." The answer was businesses benefiting from targeted tax reductions and "the petroleum industry [which] feasts on the same royalty concessions doled out by the Tories." The conclusion was: "The NDP government has abandoned the party's natural base of support, the working people and farmers who elected it, in favor of a partnership with the business establishment."[23] Just as typical of what we heard again and again from party members, was the following letter: "We would very much like to see this government more of a people's government than business for a change. Your gvt. acts more like a conservative than N.D.P. It's time we got a break, the little guy. Surely Devine's tax and royalty structures should be changed instead of leaning on the people of this province."[24] The arguments of the left wing made our task very difficult because they persuaded some of our own members that there was an easy, painless, very traditional NDP answer to our fiscal problems.

In more meetings and letters than I can count, the practical problems with the arguments about raising royalties and corporate taxes were explained. Resource prices in the 1970s and early 1980s were at an all-time high, the cost of extracting resources had risen, especially since new techniques such as horizontal drilling had to be used to extract newer oil. A corporate capital tax on resource companies introduced by Devine in the 1980s was raised twice in the 1990s, which meant that royalties represented only part of the

revenue gained from resources. And new trade agreements, such as Canadian agreements on internal trade, meant that Saskatchewan citizens and businesses could not be forced to invest in the province.

Facts and figures changed the minds of none of our critics, because at stake was the much-cherished NDP policy of fair and progressive taxation. The notion that from each according to their ability and to each according to their need is a central social democratic ideal, and taxation based on one's ability to pay is at its core. The ideal found expression in the Canadian income tax system based on ability to pay and in Canadian social programs geared to help the less fortunate. The heyday of progressive taxation for the NDP was the 1970s, when the Blakeney government captured high royalties from flush resource companies to pay for social programs, and when the NDP took a record number of seats federally by attacking "corporate welfare bums," – rich corporations that used tax loopholes to avoid paying their fair share. For those New Democrats who constantly sought to return to the taxation ideal of the 1970s, telling them that there was no going back was like telling your children that there is no Santa Claus.

Whether we liked it or not, we had to govern in the real world of the 1990s, where the idea of taxation based on ability to pay had to be tempered by the need to have tax rates that were competitive. Recent trade agreements and the global economy meant that borders were open and corporations were free to invest wherever they pleased; so if they did not like our tax regime, they might easily decide to invest elsewhere. In making their decisions about our royalties, for example, oil companies did not look back to compare our tax rates with Blakeney's; they looked sideways to compare our taxes with our competitors. If the cost of doing business in Saskatchewan was substantially higher than elsewhere, new exploration and production would go elsewhere, and even existing wells might be shut down and rigs moved out of province, just as they had been in the last year of the Blakeney regime. If we wanted to help the province grow, then we had to play by the rules of the game, whether we liked them or not. If we did not care about expanding the province's tax base, then we had to find some tooth fairy to finance the fine array of social programs and infrastructure that had been built over the years. We were not out to attack orthodox NDP beliefs, but it was our responsibility to get the economy moving – to create jobs for people and revenue for the treasury – and in that we succeeded.

It is often forgotten that Saskatchewan balanced its budget earlier than anticipated, and this was partly because it pulled out of the recession of the early 1990s to become one of Canada's fastest-growing economies, heralded by the *Globe and Mail* as the economic "star of the nineties."[25] Although many factors spurred the growth, government policies were important, especially targeted tax cuts and revised royalty rates. Consider the growth

in the oil sector. The introduction of the revised royalty regime in 1993 led to more than $ 1 billion in investment in 1994, along with a 15 percent increase in production and hundreds of new jobs, a trend that continued throughout the 1990s and meant that oil led the way out of the recession.[26] The growth in the economy was mirrored in the gains to the treasury. In 1992 Saskatchewan collected less than $200 million in oil royalties. By 1994 the treasury took in more than twice as much from the oil industry – $460 million – and by 1996 the revenue had more than tripled to almost $700 million.[27] The record-breaking expansion in the oil industry was an important factor in Saskatchewan's economic and fiscal turnaround, but like many of our other victories it was achieved at the cost of dissension within our own ranks.

The new economy also led to new fights over agriculture. If the Devine Conservatives had been deeply committed to agriculture and rural Saskatchewan, New Democrats' heartstrings were attached to the almost mythical family farm. As well as being an economic unit, the family farm was heralded as a way of life in which many Saskatchewan virtues, such as a strong work ethic and the spirit of cooperation, were rooted. The problem was that as the bulwarks traditionally supporting the family farm – marketing boards, subsidized freight rates and federally funded agricultural programs – came down, the only farms that could survive were the huge corporate entities. Despite this inescapable reality, many New Democrats were committed to the traditional family farm and were bent on using government policy to save this historic institution.

The quest to save the family farm was fought on the battleground of the Crow benefit, which guaranteed subsidized freight rates for grain. For New Democrats, the Crow was the foundation for the family farm, which needed low freight rates to survive. Equally fundamental was the NDP belief that the benefit had to continue to be paid to railways, not to individual farmers. This strongly held NDP position had been the centrepiece of the catastrophic 1982 election in which Blakeney's government had been swept from power. The contrary view was that the benefit retarded economic development: by subsidizing the transportation of raw grain while making processed products pay the higher regular freight rates, it consigned Saskatchewan people to the being "hewers of wood and drawers of water" rather than manufacturers and processors. Therefore the benefit should be paid directly to farmers. So while the New Democrats' goal was to protect the family farm, their opponents' aim was to expand and diversify the economy.

Both sides were firmly entrenched in their positions, and the intense partisanship for which Saskatchewan is renowned meant that there was no middle ground. For the right wing, the CCF-NDP had always been the social-

ist party, or the "reds," whose policies retarded the economic development of the province. The left wing saw the world in equally extreme terms, as one of Tommy Douglas's favourite stories revealed. When describing the origins of the CCF, Douglas spoke about mice living under governments run by cats – clearly, the "old line" Liberal and Conservative parties. One day, he said, the mice woke up and realized that the only difference between the cats was their colour – some were black and others were white – so they smartened up and elected a government of mice. A clear message of the story is that there are two distinct sides. The Crow benefit was seen by New Democrats as sacred ground from which there could be no retreat – unless, of course, the mice wanted to commit heresy and join the cats. Lost in all the rhetoric was the reality that rather than fighting over how the benefit was paid, right and left in Saskatchewan should have been uniting around the position that over $300 million a year was being spent by the federal government on transportation in Saskatchewan, a landlocked province that depended more than any other on trade. The middle ground of ensuring continuation of the $300 million in federal funding was unattainable in a province so deeply divided by partisan politics.

I am still haunted by our government's role in the demise of the Crow benefit. In the summer of 1990, at a caucus retreat in Waskesiu, Darrel Cunningham expounded on the Crow in his usual colourful language, with many four-letter words. His message was that the world was changing, and either we had to change with it or be left behind. Cunningham's challenge to the orthodox NDP position on the Crow caused an uproar. One huskily built caucus member looked menacingly at him and said, "If you never say that again, I won't have to wring your neck." The issue of rethinking the NDP position on the Crow was set aside. Less than two years later, as our exuberant new minister of agriculture, Berny Wiens, prepared for his first meeting with his federal and provincial counterparts, discussion in the war cabinet again turned to rethinking the traditional NDP position on the Crow. Although the agriculture minister warned that Saskatchewan was in danger of losing the benefit entirely, the conclusion was that New Democrats were too deeply attached to the traditional position to countenance any compromise. Thus the government held to the orthodox NDP position that the benefit had to be paid to railways. Three years later, when the various groups were still squabbling about the details of how to pay the benefit, a cash-strapped federal government, citing a new trade agreement banning subsidies like the Crow, ended the benefit entirely, and Saskatchewan lost $300 million a year in federal money for transportation. Within four years freight rates tripled and, in the words of historian Gerald Friesen, "the original small homestead in the old grain export system could not survive."[28]

From the ashes of the ending of the Crow benefit arose a new agriculture, foreshadowed in 1993 in our strategy Agriculture 2000. As Friesen says, innovation and Innovation Place were at its core. Farmers diversified, moving beyond wheat to a whole range of specialty crops; they used the advantage of cheap feed, created by the ending of the Crow, to move more heavily into hogs and livestock, and they began to process more of their products before exporting them. They also exported their knowledge, the most stellar symbol of which is Innovation Place, the research and development complex built in the 1970s in Saskatoon next to the University of Saskatchewan and federal research labs, such as the Plant Biotechnology Institute. Recently featured in *Time* magazine, which said that its "roots ... lie in the timeless farmland, but its purpose is all about the future,"[29] Innovation Place has become a world-class centre in biotechnology and other forms of agricultural research. New crops, new vaccines, new agricultural technologies – these will be the growing agricultural exports of the future.

True as it may be that Saskatchewan agriculture is merely going through a transition, the casualties in the process are very real and very human. Some of the most heartbreaking meetings in my ten years in government were with farm families whose lives were being torn apart by changes beyond their control. With an average age well over fifty, many farmers, whose families had farmed for generations, were going bankrupt – not because they had done anything wrong, but because the world they had known was changing before their eyes. As they looked to the government for help, we had no effective answers. The global economy had not only changed the rules of the game in agriculture but it had taken away government's capacity to erect ramparts to ward off the unwanted changes. The hardship of farm families tore at our heartstrings and led to many acrimonious but unproductive caucus meetings as we struggled to find solutions to a problem that we could not solve.

The most immediate problem in November 1991 was to live up to our election commitments: to pressure the federal government for more money for farmers and to improve the new agricultural program, GRIP. Both landed us in terrible trouble. To accomplish the first goal, Romanow headed a delegation of farm leaders and prairie politicians to the nation's capital, which was great politics but did little to improve federal-provincial relations. The provinces' point of view was that the treasuries of the United States and the European Union were subsidizing their farmers, and in order to achieve a level playing field, federal coffers, rather than paltry provincial treasuries had to support Canadian farmers. From the perspective of the federal government, its treasury also was depleted; and as for Saskatchewan, we were the socialists who had just beaten Devine, one of Mulroney's strongest allies. Now, to make matters worse, we were landing

on his doorstep with TV cameras, making him look bad for not supporting Canadian farmers. The last straw was our mission to change the newly minted Conservative agricultural program, GRIP, which the federal government had coerced other provinces into accepting just to please Saskatchewan.[30]

GRIP caused farmers to hang Agriculture Minister Wiens in effigy. It was the focus of a bitter 1992 legislative session, and it was still being talked about in 1999, when the NDP lost almost all of its rural seats. Introduced in the 1990s, GRIP guaranteed an income to farmers based on yield and a fixed price for grain. The problem for the Romanow government was that the program encouraged farmers not to respond to market conditions; more importantly, as structured it was simply too expensive. Thus, GRIP was to be changed, reducing the coverage that farmers could count on from 100 percent to 80 percent. This led to a protracted and nasty battle with the federal government. Changing the program meant going through a complex process – which our officials believed the federal government intentionally delayed – and notifying farmers by 15 March 1992 of the changes to the program. Because of the delays, the province did not have time to inform all farmers in writing but merely issued a press release before the deadline. As a result, a lawsuit was launched. Advised that if the law suit succeeded, the province would be liable for as much as $500 million in damages, the government had little choice but to adopt a draconian solution. The temperature in the legislature in the summer of 1992 increased dramatically as we passed a law to change GRIP, to do so retroactively, and to take away citizens' rights to sue over the issue! To farmers, who had made seeding plans based on the original program, we had changed the rules at the last minute without properly notifying them and had then taken away their legal rights. Within six months the premier had changed both the minister and the deputy minister of agriculture, but many Saskatchewan farmers, for reasons that are understandable, never really trusted us after GRIP.

While both agriculture and the economy required immediate attention, the overriding issue for the new government was the financial crisis, which involved both cutting government spending and restructuring the megaprojects that were teetering on the verge of bankruptcy. I was fortunate enough to be a point person in both endeavours. In September 1992 I was appointed minister of Crown Investments Corporation (CIC), responsible for the megaprojects, and three months later I became finance minister, overseeing government spending. On becoming CIC minister, I was handed the big black binders detailing Devine's megaprojects (the joke was that the binders could not be read anywhere near razor blades, since a smart minister would slit her wrists). The contents of the binders had not escaped the watchful eye of credit-rating agencies. Moody's of New York, for instance,

warned that "the accumulated exposure to numerous Crown and commercial investments" and "loan guarantees" was a major reason why the province's credit rating had been downgraded.[31] Three of the projects alone – Crown Life and the NewGrade and Husky upgraders – exposed the province to almost $1 billion in liabilities. The projects were financial disasters, but they were also economic engines, and the trick was to change the financing while protecting the jobs. Managing, renegotiating, and refinancing the massive projects was like firefighting: just when one part of the fire seemed under control, another burst into flames.

While other governments could afford to sell their troublesome megaprojects and absorb the losses, Saskatchewan was unlucky enough to have a higher debt on a per capita basis and more financially troubled megaprojects. Adding another $1 billion in megaproject losses onto an already huge debt involved risking dramatic credit-rating downgrades that could trigger default. But if unloading the projects at fire-sale prices was not an option, neither was continuing down the dreary road of propping up badly structured deals. We did not have the money to choose this path, and a cursory reading of the black binders made it clear that pouring more money into bad deals was a bottomless pit. Caught between the proverbial rock and hard place, the war cabinet decided on a bold and somewhat dangerous strategy: the megaprojects would have to be restructured and made financially sound before they could be sold. Ironically, while our Liberal and Conservative partners lost more than $1 billion in their scramble to unload their shares of the megaprojects, the Romanow New Democrats acted more like a private-sector company by restructuring government investments to improve their balance sheets so that they could be sold without significant losses.

The political risks, however, were formidable. Business partners had to be persuaded to rewrite legal contracts and in doing so to lessen the financial burden to government and increase their own costs and risks. As if this was not enough, once the projects were refinanced, politically they became ours not Devine's. In the back of all our minds was the unspoken question: Could such badly financed projects really be fixed and made financially sustainable? Our strongest weapon in this strategy was public opinion – to mobilize support for our approach with the taxpayers (who were paying the bills) and then bring the pressure of public opinion to bear on the companies to get them to agree to changes in the contracts. But there was another weapon in our back pocket that we hoped we would never have to use – passing legislation to change contracts unilaterally. Terrible as this choice seemed, if the alternative was risking default of the province, we all knew what we would have to do.

When New Democrats enthusiastically endorsed the election platform to renegotiate the megaprojects, they envisaged taking on the sweetheart

agreements with corporate giants such as Weyerhaeuser. Little did we know that our resolve to refuse to prop up the badly structured megaprojects would lead to cooperation with Weyerhaeuser and major disagreements with the governments of Canada and Alberta, as well as a public brawl with one of the province's largest co-ops and a nerve-racking journey right to the brink of default.

Negotiations with the government's partners in the megaprojects began optimistically, with good news, courtesy of Weyerhaeuser Canada. In a 1986 deal the American forestry giant had purchased existing facilities – a pulp mill, sawmill, and chemical plant – and agreed to build a new $250 million paper mill, with the costs being financed by a government loan that did not have to be repaid until at least 2015. In November 1992, after months of discussions, Weyerhaeuser repaid the province its debt of $150 million – more than twenty years before it was due – and relieved the province of a $45 million loan guarantee. Public opinion played a role in this generous decision. As Weyerhaeuser's Bill Gaynor explained, "We believe that in the long run our license to do business with a public resource such as the forest is public opinion. By responding to the current fiscal situation in the province we are convinced that we are doing the right thing."[32] Whether good corporate citizenship or enlightened self-interest, the decision allowed the government to show credit-rating agencies that progress was being made in restructuring Devine's deals and enabled it to point to Weyerhaeuser as a model for other megaproject partners to follow.

The initial round of Crown Life refinancing also went smoothly, although it did reflect the problem of the government moving from being a critic of a project to taking ownership of it. When it became clear that because of Crown Life's financial problems a public share offering to finance the $355 million investment would not be possible, the private-sector backers of Crown Life proposed that the government issue ten-year bonds that could be converted to shares. This would have meant that if Crown Life's finances improved, bondholders would benefit by converting their bonds into shares on lucrative terms; but if the company floundered, the government would be responsible for paying out the bonds when they came due, at a cost of more than $600 million. So it was a nonstarter for the government. Instead, it replaced the Conservatives' $355 million loan guarantee with a direct government loan of $275 million, and the deal was painted as good news because it reduced the province's obligations by $80 million. The smile pasted on my face at the press conference announcing the new Crown Life financing masked my discomfort with using government money to lure a company from one province to another. Also, although I could see the logic of building upgraders to process Saskatchewan's heavy oil reserves, I never caught the dream of Regina becoming the insurance capital of Canada.

Wishful thinking was also reflected in my comment: "This [improvement] shows clearly the commitment of the government to get the taxpayer out of this deal as quickly as possible." And my praise for the backers of Crown Life for their "cooperation" and their "willingness to be part of the solution rather than part of the problem"[33] was designed as a message to our partners in the upgraders. Although Crown Life would return to haunt us, at least one of the shaky megaprojects had been stabilized.

Neither stability nor cooperation characterized the two upgraders. By 1991 the government had already lost $232 million on the NewGrade upgrader, and there was another loss of $75 million for the current year, plus projections for more losses into the future. If, however, the government did not pay the endless stream of losses, the result would be default, leaving the government on the hook for $334 million in loan guarantees. The bi-provincial Husky upgrader story was similar. The government had already lost $63 million of its investment, and in August 1991 the project was $175 million over budget, forcing the government to pay its share of the cost overruns. Within six months the corporate hat was being passed again, asking all the partners to pony up for another cost overrun of $190 million, with the implicit threat that failure to comply would mean the collapse of the project, leaving the government on the hook for another $252 million.

Ned Shillington, Saskatchewan's CIC minister, was certainly the skunk at the garden party at a meeting in Edmonton, on 28 May 1992, when he told federal Finance Minister and Deputy Prime Minister Don Mazankowski, Alberta treasurer Dick Johnson, and Husky President Art Price that he had bought lots of black paint so that Saskatchewan could paint the Bi-Provincial Upgrader black and mothball it. Shillington later said, "In politics as in poker, it's sometimes better to be underestimated, and you could tell the others thought that I was one of those Saskatchewan socialists who was just crazy enough to actually shut down a project that employed hundreds of people in my own province."[34] The decision Shillington was communicating was the Saskatchewan government's resolve to no longer pay for cost overruns. If this meant, as was being suggested, that the project would collapse, so be it. Months earlier, Saskatchewan had tried unsuccessfully to link any Saskatchewan contribution to the Bi-Provincial project to federal cooperation in dealing with NewGrade. But by May 1992 the government's position was that if the other partners wanted to continue paying for cost overruns, that was fine, but they could count Saskatchewan out.

Saskatchewan's position put the Bi-Provincial partners in a quandary. Legally there was no obligation for any partners to contribute beyond a $50 million limit that had already been reached. More to the point, the Romanow government was the only one of the partners that had not been party to the original agreement. What this meant in political terms was that

all the rest had been at the many ribbon cuttings, smiling broadly and shaking hands. There's nothing like a ribbon cutting to tie a politician to a project, especially considering that the pesky media have a habit of reporting on the closing of a facility with footage from ministers praising the project at its opening. In the end, the other partners paid Saskatchewan's share but diluted its equity, making it clear that when the project was sold, Saskatchewan's share would be lessened, a provision full of irony in light of what the future held.

With the other Bi-Provincial partners committed to covering Saskatchewan's share of what turned out to be two more cost overruns, this project was stabilized and our government could turn its attention to the even worse mess with the NewGrade upgrader. The project had been financed with 80 percent debt – $635 million guaranteed by the governments of Saskatchewan and Canada. Since they were high interest rates, when principal repayments began in 1992, the project would not be able to pay them, raising the spectre of default. Just as important were the structural problems. Although all the cash in the project came from the government, Federated Co-operatives (FCL) was totally in control, as the Gass Commission noted, "because its employees operate and manage the plant ... [Thus] the Province's ability to monitor the performance of this project and to work with its joint-venture partner (CCRL) to reduce its financial exposure is severely restricted under the agreement."[35] No government could be a cash cow for a project run by someone else, who had no obligation to contribute if losses occurred. This project simply had to be changed. The unbelievable challenge was to get our partners, the Canadian government and FCL, to make the necessary changes – changes that would increase their own costs and risks.

Our first call was to FCL. At private meetings in early 1992, FCL took a firm position to which it stuck like glue. NewGrade, it was argued, was a great project, providing jobs and revenue through royalty payments. FCL had from the beginning been clear that it would assume none of the risk and needed the exclusive right to operate the upgrader. In financial terms, the cost of the upgrader would have been doubled if it were not located next to FCL's refinery, so this was its contribution. It was the government that was at fault for financing the project with debt rather than cash. Therefore, the solution was for the government to replace its loan guarantee of more than $300 million with cash, in order to reduce interest payments, and to disband a team put in place to monitor the project because it interfered with FCL's management of the upgrader. The message, in a nutshell, was: A deal is a deal; FCL will not put in more money; FCL will not change the management structure; and FCL will not bear any responsibility for operating losses.

FCL was relying on its political power in communities across the province, which had forced the Devine government to cave in to FCL pressure. In confronting that power, we had some advantages not available to Devine. As the CIC minister from October 1992 to January 1993, I had been president of the Saskatoon Co-op, a large co-op in the FCL system; and many cabinet colleagues, such as Bob Mitchell, had deep roots in the co-op movement. We were familiar with the terrain on which the battle would be waged – in co-op meetings around the province. When we walked into those meetings we would be among fellow co-op members who could not dismiss us as enemies of "the system." Our other advantage was our advisers, some of whom were our own and others who were inherited from Devine's days.

Don Ching and David Dombowsky had extensive experience from the Blakeney era and were invaluable, though I had difficulty with them initially. They had worked closely with Romanow in the 1970s when they were senior executives at the Potash Corporation and he was its minister, and it soon became apparent that the three had key discussions about NewGrade and other projects that did not include me, the minister. I learned from Mr X that the bureaucracy was gossiping about how I was out of the loop, which would undermine my power and respect. In government, if you don't stand your ground, you soon find there is no ground on which to stand. At a cabinet meeting where it was obvious that the premier was making decisions in my portfolio without my involvement, I spoke out – never being one to suffer in silence. I told him that if I was going to be the one who had to face the cameras and defend the decisions, I needed to be included in all the meetings.

Confronting a premier at a cabinet meeting is not a wise strategy, and I have to confess that in the back of my mind I was thinking, "He has just made me CIC minister, so I have a few months before the next cabinet shuffle to redeem myself and dissuade him from his current impulse to send me to the backbenches." But I never again caught the three of them meeting behind my back. Whether it happened or not is another matter. The fundamental issue is that a centralized government structure, in which the premier deals directly with the deputies, sidelines and emasculates ministers.

With that issue resolved, I could benefit from the experience of Ching and Dombowsky, which was reinforced by the people hired by the Devine government to oversee the NewGrade project. These people had become experts on the upgrader; they had been at every meeting and knew the skeletons in all the closets. In the fall of 1992 I had them sequestered in offices, busily compiling all the documents relating to the upgrader.

On 7 November 1992, when Saskatchewan people opened their Saturday newspaper, the front page was plastered with all the details about the New-Grade upgrader. The day before I had called together the media and

presented them with press kits; these contained a short, easy-to-read overview of the project and its costs, followed by all the documents – the contracts, letters, and financial analysis – chronicling how the deal had been negotiated and what the costs were to them, the taxpayers. After months of futile closed-door meetings with FCL and inaccurate press reports, it was time to move the issue to the public arena. My aim was to see what the taxpayers paying the bills thought, and also to release the details to lay the groundwork for an inquiry into the project by Willard Estey, former Saskatchewanian and former justice of the Supreme Court of Canada.

On 18 November when the inquiry was announced, FCL said that it would "be co-operating 100 percent with Mr Estey," though it continued to rally co-op members to pressure the government to back down.[36] By March, as the deadline for the release of Estey's recommendations loomed, FCL changed its tune and made it clear that no matter what Estey recommended, co-op members had told FCL to stick to its guns – a deal is a deal.[37] The Estey Report, released in April, concluded that although the upgrader was a technological success, it was a financial disaster: "The project has, in a financial sense, run aground. Operating at capacity, it cannot sustain its existing debt load." Estey's main recommendation was to replace most of the government loan guarantees with cash, to be invested by all three partners: $55 million from the province, $80 million from FCL, and $150 million from the federal government. As well, future losses were to be shared by the province and FCL.[38]

With the ammunition provided by the Estey Report, the next battle was to pressure FCL and the federal government to do as it recommended. Editorials supported the report and called on all partners to do their part to save the project, but still FCL would not budge. As April drifted into May, with heavy hearts the cabinet came to the conclusion that the last weapon in our arsenal would have to be used: we would have to pass legislation to change the deal.

The ensuing grassroots political battle between FCL and the Romanow government was like a rift within the family. In introducing the legislation to change the contract with FCL, Bob Mitchell, a long time co-op member, said, "FCL has put its private interests ahead of the public good," to which FCL responded that the draconian legislation showed that Saskatchewan had become "an absolute dictatorship."[39] When Premier Romanow said that even expropriation was an option, since the project could not sustain itself and "the fiscal integrity of the province of Saskatchewan [was] threatened," the counterattack came from Vern Leland, president of FCL, who was a longtime Romanow friend and fellow New Democrat. As FCL moved from community to community to meet with local co-ops and warn that their patronage dividends would be threatened if FCL had to invest in NewGrade

and pay its share of losses, following behind were the Romanow cabinet ministers who were co-op members, telling their fellow co-operators that they were also taxpayers and their province's financial future was on the line. It was a pitched battle between two combatants who were experts in grassroots democracy. We were asking co-op members to choose: Was their first loyalty to the co-op movement or to the province of Saskatchewan?

The contest brought out Romanow's superb street-fighting skills. "If FCL feels that the upgrader deal is such a good one, and does not need to be renegotiated," he declared, "then, they can take it right now. There's the offer, for one dollar." FCL declined. And when Conservative leader Rick Swenson was foolhardy enough to ask why the government had to rush to pass legislation, Romanow shot back that it was because the government was losing $63,000 a day on the project, "which to a former Conservative cabinet minister in the Devine administration is peanuts, because he would be used to losing over a million dollars per day."[40]

The fight got very nasty. I was accused of wanting revenge on FCL for dis-agreements with them when I was president of the Saskatoon Co-op. Dale Eisler alleged that the NDP was after FCL for political reasons, mainly because the NDP had lost the 1986 election because of the upgrader deal. And the Conservatives claimed that this was all part of a plot to tarnish the image of the Devine government.[41] Federal Energy Minister Bill McKnight knew a brawl when he saw one and wisely stepped aside, saying only that the province was "well within its jurisdiction" in legislating changes.[42]

By the summer FCL was turning up the heat. At its meetings with dele-gates from around the province it was warning that profits from the refin-ery were being used to pay patronage dividends that kept many rural co-ops alive. Changes to NewGrade would lead to "a shutdown, a demise of many of these retails."[43] Then came the threat to move FCL's head office from Saskatoon to Calgary, where FCL had supposedly been offered free office space by a city that welcomed business. The Canadian Co-operative Association condemned the government for its legislation, as did most newspapers and business columnists; even Dale Eisler called the govern-ment's legislation a "tactical blunder"[44] In August FCL announced it would fight the legislation in court.

At the same time, the pressure on FCL was mounting. While editorialists and columnists criticized the government's legislation, letters to the editor criticized FCL for being unco-operative and worried about the province going bankrupt. Cal Turgeon, for example, manager of Ford Credit Cana-da, said, "I feel comfortable the government has taken the right tack, as a businessman, yes, I think you have to look at all aspects of a deal and even if a contract was written, conditions change and maybe it's time it's looked at again."[45] Advisers to Devine also came out of the woodwork to take on

FCL, and I know that privately even some of Devine's cabinet ministers were cheering for the government. Philip Gordon, a former oil executive who had been an early negotiator under Devine, said, "Throughout the negotiations over the past two and one half years, I have been witness to numerous demands presented by Federated which I believed to be unreasonable and inconsistent with any standard of normal business arrangements and incompatible with sound commercial terms."[46] Ted Hanlon, another oil executive, who had been co-chairman of the NewGrade board under Devine, commented that as much as he had concerns about using legislation to break contracts, "I believe the government has no choice."[47] Finally, in July the results of a public-opinion poll were released: 54 percent supported the government and its legislation, while only 28 percent were opposed.[48]

FCL leaders had always said that they were protecting co-op members, but by the summer there was dissension among the members. The Concerned Co-operators Federation, a group to which I had belonged, began a campaign in Saskatoon to put pressure on FCL. One of their posters said it all:

IT'S TIME TO CO-OPERATE!

The NewGrade Heavy Oil Upgrader has turned out to be a real problem for Saskatchewan taxpayers
Concerned Co-op members feel that the management and leadership of FCL does not represent the wishes of co-op members
Co-op members want the upgrader to become a financial success providing benefits to both taxpayers and the co-op movement
Justice Estey provides a framework for a fair settlement
Co-op members want FCL and the government to negotiate in a co-operative manner – with the philosophy upon which our movement is based.
Dear Co-op Member, If you agree with our concern and are displeased with FCL's position call or write FCL

The last time the Concerned Co-operators turned the heat on FCL, the result had been a public meeting attended by more than a thousand co-op members. Now they were soliciting donations to begin a province-wide campaign against FCL. It was grass roots democracy in action.

On 20 August FCL signed a deal with the government. FCL would invest $75 million in NewGrade and share future operating losses up to a maximum of $40 million. The government would not proclaim its legislation; FCL would drop its lawsuit and its threat to move its head office to Calgary. The agreement would not come into effect until the government and FCL convinced the federal government to invest its $150 million.

Prime Minister Jean Chrétien's newly elected Liberal government obviously had other issues on its mind in the fall of 1993 and did not seem to be listening to our cry that the NewGrade upgrader was veering toward default. The government and FCL had made some headway in the summer of 1993 in discussions with the Mulroney government, which had offered to invest between $50 million and $85 million in the project. After the fall election, however, the dynamics changed. The lever we had had with the Mulroney government – that its ministers had been at the ribbon cutting, singing praises of the project – was lost with the Chrétien government. For it, having a Mulroney-inspired megaproject default was certainly not a political embarrassment. Also, the new government was preoccupied with other issues, and the federal finance department was pushing for a broader restructuring that would involve some of the private-sector investors. Such scenarios had already been analysed to death in Saskatchewan and rejected, but it was taking time for the federal government to reach a similar conclusion, and time was what NewGrade did not have.

Early in 1994 there was another NewGrade crisis as the federal government wavered and once again creditors asked the province to cover operating losses. After all our eforts it seemed in February 1994 that we were back where we started. Without the federal money, the project could not be refinanced, and without refinancing to lower interest costs, the project would continue to lose money. The stark choices were presented to the cabinet in March 1994: either commit to covering operating losses or inform creditors that the province was not prepared to cover the losses, which would lead to default. In government, once a line has been drawn in the sand, compromise is possible, but not total retreat. To begin again to cover operating losses would take all the pressure off the federal government and leave the province facing a future of unending losses. So in March 1994 the government decided it would not cover operating losses. Default loomed.

It was an eerie experience reviewing the finance department's detailed plans for the default of the $600 million project. According to the plan, the project after default would have to be restructured with all the creditors involved – including the federal government; and the communications plan was for FCL and the province to join together and blame the federal government for once again abandoning Saskatchewan. The main lesson I learned from reviewing the scenarios was that default is neither orderly nor predictable. Default of the project might trigger a similar fate for the province. Desperate attempts to avoid default led to discussions involving energy ministers and deputy ministers of finance – Wright from Saskatchewan and David Dodge for Canada – and even Chrétien became involved.

On 16 June 1994 the federal government announced that it was investing $125 million in NewGrade and in return it left the project.[49] The arrange-

ment reflected a pattern that would be followed in other Saskatchewan megaproject restructurings. In the short term, the province took on greater obligations. Its share of the contribution, following the Estey Report, was $75 million, and with the federal government leaving the project, the province was left as the sole guarantor of the remaining $234 million in debt. On the other hand, with the debt cut in half, NewGrade was making money by 1996; $130 million of debt would be paid off by 2000, and the rest would be gone by 2007. The province's biggest single financial liability had been made sustainable, and by 1999 FCL was planning a major $236 million expansion of the refinery. When approached for a contribution, the Romanow government politely declined.

By the time the NewGrade project was completed, the Bi-Provincial Upgrader and Crown Life were in crisis. Crown Life had managed to cut its costs by $25 million a year after the move to Regina, and it was back in the black. But, as we used to joke, it was like a tar baby: just when it seemed strong enough to stand on its own two feet, a calamity would occur, gluing it back onto the government. That's what happened in 1995 with the collapse of Confederation Life, which led to tighter regulations about levels of capitalization for other insurance companies. At the same time there was the problem of vanishing premiums. Crown Life and other insurance companies that had sold policies at record high interest rates, promising buyers that their premiums would vanish in a number of years, were forced to renege on their commitments in the 1990s when interest rates declined. The result was lawsuits against the insurance companies for hundreds of millions of dollars.[50] Either Crown Life was going to be weakened by the tighter financial regulations and lawsuits – making it harder to sell – or the government would have to invest more to strengthen the company so that it could be sold. A major complication was the thousand jobs in Regina, where the NDP held all of the seats. Thus, the government lent Crown Life another $150 million, thereby moving from being a captive passenger in Devine's project to taking over the steering wheel of a project that was now ours.

Record profits and steady growth in 1996 and 1997, along with out of court settlements for the vanishing premiums issue, made Crown Life an attractive acquisition and in May 1998 the bulk of its insurance business was sold to Canada Life.[51] Under the terms of the sale, the government was immediately repaid its 1995 loan of $150 million; Canada Life was to maintain at least 675 jobs in Regina for five years and to continue to work with local suppliers to maximize the economic benefits to the province. But it did not move its head offices to Regina. However, Crown Life has remained to become an investment company, and the Saskatchewan government exited from the project without risking any more tax dollars.

Protecting taxpayers' dollars was also the main concern of Don Ching and his fellow Saskatchewan representatives at a pivotal meeting of the shareholders of the Bi-Provincial Upgrader in Husky's boardroom in Calgary in the summer of 1994. It was just weeks after the NewGrade deal had been signed with the federal government, and the governments of Canada and Alberta were negotiating with Husky the price at which they would abandon their investment in Bi-Provincial. As a minor shareholder not known for its co-operation with the other partners, little attention was being paid to Saskatchewan, although everyone knew that because it had not paid its share of cost overruns in 1992, its share of the proceeds from the sale of Bi-Provincial to Husky would be less. Negotiators for Canada and Alberta knew they were in for some heavy losses in selling their investments, but they were not prepared for the three cents on the dollar that Husky was offering. As the negotiating became heated, the Husky representative noticed that Ching had been totally silent, and thinking that Saskatchewan, as the most financially strapped of the three governments, would probably jump at getting three cents on the dollar for its shares, he asked Ching to comment. "Well, if you're saying that the price is three cents on the dollar," Ching said, "Saskatchewan's position is clear. We're not selling, we're buying, not just Canada's shares and Alberta's shares, but Husky; if you really think this is what Bi-Provincial is worth, we'll take your shares too." Stunned silence followed.

In August 1994 as Canada and Alberta were bailing out of the upgrader, Saskatchewan was being called a "backward hick" by federal negotiators and was being chided at home for investing another $43 million in that "moneypit" at Lloydminster. Premier Ralph Klein declared that Alberta would not "spend another cent [on the project] and would like to get out," and federal Energy Minister Anne McLellan said, "What we had to do was get out of what we thought in the long run was a project that wasn't going to be profitable."[52] Saskatchewan's decision to buy not sell was not made frivolously. With only two upgraders in Canada and both of them in Saskatchewan, the province had acquired over the years extensive expertise in the area. Projections clearly showed that the project was going to become profitable in the next few years. So the approach taken by Saskatchewan was simply to wait and then sell when the price was high.

After buying out Alberta and Canada, Saskatchewan and Husky became 50–50 partners; and after some downsizing and restructuring, as the upgrader began to turn a profit, Saskatchewan sold its shares to Husky in 1998. The difference was the price. In 1994 Canada sold its $558 million shares for $42 million, while Alberta cashed in its $424 million for $32 mil-

lion. The two governments lost $907 million of taxpayers' dollars on the transaction. In 1998 Saskatchewan sold its shares to Husky for $310 million, recovering every dollar invested.[53]

The idea of selling just for the sake of selling was what Devine had done in the 1980s, and it was the tack taken by the opposition and by various business journalists in the 1990s. Within months of our being elected, business columnists had been saying that the government ought to sell its holdings, as if this were some sort of statement of ideology. In one article in October 1993 under the headline "Government Should Sell Holdings," the government was advised to sell its Cameco shares, the argument being that a profit of $80 million could be made.[54] Saskatchewan's Cameco shares were not sold in 1993 when the federal government unloaded five million shares at $14.60 a piece. Instead, they were sold in February 1996, when our financial advisers recommended the sale, at a price of $71.50 per share, making a profit of $681 million for the province.[55]

Rather than making decisions based on ideology, governments should make decisions on the basis of sound financial advice. What taxpayers should expect from governments is a plan outlining what their long-term intentions are regarding specific investments. In other words, a government should inform the public about the investments that it plans to retain in the long term and explain why there is a public interest in keeping those investments. It should also list the investments that it plans to sell at some point in the future. Beyond that, it has to be left to the government to determine the selling date, based on the best possible financial advice.

The difference between the Devine and Romanow governments in their handling of public investments is simply explained. No one who knew Grant Devine ever said that he lacked either brains or good intentions. His problem was that he allowed politics and his own gut reactions to overrule sound well-thought-out advice. Who made the difference in our restructuring of the megaprojects? Our advisers. Civil servants who had advised Blakeney and Devine before us, and outside advisers whom we hired to beef up the government's own expertise, were responsible for the financial projections and long-term game plans that told us as politicians what the choices were. Our job as politicians was to make the final decisions and sell the public on them. Many of the same advisers who were so central to the success of our megaproject strategy had been there to give similar advice to Devine. The difference was that we listened.

In 1998 when Moody's upgraded Saskatchewan's credit rating, it praised CIC for "rationalizing the operations of the commercial Crowns, restructuring its investment portfolio and reducing the province's loan exposure." Of the $106 million surplus for that year's budget, $100 million was

a special CIC dividend that came from the sale of the Bi-Provincial Upgrader.[56]

The megaprojects, however, were only part of the financial problem that plagued Saskatchewan in the 1990s. The other larger and even more difficult task was to cut government spending by more than $1 billion and to make decisions that would cause a lot of pain and anguish for people. The turning point in that process came in 1993.

The 1993 Fiscal Crisis

The year 1993 was pivotal in Canada's fiscal affairs. At the federal level, the Conservatives, preparing to meet their makers at the polls, tabled a budget that had grandiose plans to tackle the deficit based on vague spending cuts in the future and overly optimistic assumptions about the economy. For their part, the federal Liberals, carried away with the latitude available to the opposition at election time, promised to replace the GST, a promise that would squander a lot of their goodwill with the provinces as they scrambled to deliver on it, and in the election they spoke about jobs, not the fiscal nightmare. The Liberals' downplaying of the deficit and debt may have comforted voters but did not reassure the financial analysts, who were wondering whether the result of the 1993 federal election would be "government by the Liberals, the NDP, the PCS or the IMF."[1] All the federal Liberals had to do to see the magnitude of the fiscal problem was to look at what was happening in the provinces in early 1993. As deficits and debts mounted and credit ratings declined, there was public speculation about limits on provincial borrowing, about governments defaulting, and about the need for a federal plan to bail out provinces sinking in a sea of unsustainable debt.

The use of the word "terrifying" to describe Saskatchewan's fiscal situation was especially true in 1993 as three events, unknown to the public, signalled the crisis. It was in early 1993 that the spectre of a fiscal meltdown took concrete form, as Saskatchewan, which was no longer able to borrow money in Canada, even had trouble selling its bonds in New York. At the same time as the pressure was mounting from credit-rating agencies for yet another tough budget, rumblings within the NDP had reached the cabinet table as ministers balked at supporting the difficult choices. Caught between a divided cabinet and intransigent credit-rating agencies, it was in early 1993 that the premier threatened to call an election and I quietly travelled to Ottawa in search of federal help. The crisis of 1993 reduced grown men to

tears, and led to cabinet meetings so contentious that those in the next room were convinced they heard bodies hitting the wall; and it certainly took its toll on our first minister of finance, Ed Tchorzewski. Yet by 18 March when I rose in the legislature to deliver the 1993 budget, I felt confident that our caucus was united and that the remarkable Saskatchewan electorate was prepared for one of the toughest budgets in Canadian history. A budget that we had feared would be our political undoing turned out to be our greatest political success.

The drama that unfolded in Saskatchewan between the swearing in of the Romanow war cabinet on 1 November 1991 and the budget of 18 March 1993 portrays in graphic detail what happens when governments become so beholden to credit-rating agencies that they, rather than voters, dictate the budgets. The events of this period also reveal the struggle within the NDP as deficit reduction and changes associated with the global economy challenged orthodox NDP views. The story about how the deficit monster was wrestled to the ground is also a lesson in politics. Like other governments in Canada, Saskatchewan turned a political problem into a political success by persuading voters that the difficult choices simply had to be made. The way in which the very difficult decisions of the 1990s were sold to the Canadian people is an excellent lesson in political management and a hopeful sign of what can be done to move an electorate by picking the right policies and communicating them effectively.

If only voters enjoying all the government programs and tax cuts in the 1980s had known the real cost that they would end up paying! The long-term costs of the elimination of the gas tax and the programs to subsidize mortgage rates and home improvements were added up by the Department of Finance in 1996. The programs themselves cost $1.32 billion, but because the government deferred paying for them by running deficits for ten years, there was also compound interest to be paid. The interest alone cost $2.7 billion, more than twice the cost of the programs. Consequently, the people of Saskatchewan, in return for not paying the gas tax for eight years and having their mortgages and home improvements subsidized, ultimately paid $4.07 billion of their hard-earned tax dollars, enough money to finance all Saskatchewan government spending for one whole year.[2] In the 1980s, however, it seemed as if the wonderful game could go on forever as governments across Canada spent more than they took in and added the shortfall to the debt.

By the late 1980s the growing mountain of debt worried credit-rating agencies, whose task it is to evaluate the capacity of borrowers to repay their obligations. The credit ratings for Canadian governments began to be downgraded, which in turn meant paying higher interest rates. The higher rates added significantly to the cost of government. Saskatchewan, for example,

in the early 1990s had to borrow more than $1 billion a year on average to refinance old bonds coming due and to cover the current year's deficit.

In the early 1990s the fastest-growing costs for Canadian governments were interest payments, which were spiralling out of control as higher interest costs led to bigger deficits and growing debt, which further pushed up interest costs. As the vicious cycle of deficit/debt and interest worsened, further credit-rating downgrades led some investors to refuse to lend to provinces such as Saskatchewan, so the number of investors willing to buy government bonds shrank. The final threshold was the line between a very low A and a BBB credit rating. As Dennis Mulvill, vice-president of investment banking for RBC Dominion Securities, explained, "As far as BBB bonds go, unless we have extenuating circumstances, we basically stay away from including those grades in the portfolios of our clients."[3] Credit ratings in the BBBs raised the spectre of "hitting the wall" – being unable to borrow the money needed to finance government operations.

In early 1993 Terence Corcoran, a financial analyst for the *Globe and Mail*, portrayed, probably quite accurately, what would happen when Canada hit the wall. The triggering event in his scenario was the inability of Ontario to sell its bonds. (Ontario had joined Saskatchewan in early 1993 in having trouble selling bonds.) This would lead to a dramatic drop in the value of the Canadian dollar and an increase in interest rates that would drive government costs up so dramatically that investors would lose confidence in the governments' ability to repay their obligations. One night, said Corcoran, Canadians would turn on their televisions to find the prime minister of Canada explaining the letter of intent the government had just signed with the International Monetary Fund, which would place "severe restrictions on the ability of the federal and provincial governments to borrow and spend money." In an ominous reference to Saskatchewan and Newfoundland, Canada's most indebted provinces, the prime minister would say, "Tomorrow I will begin emergency consultations with provincial premiers, including the premiers of two provinces where federal officials have essentially taken over control of fiscal planning under IMF instructions."[4] The desperate scramble to avoid such a scenario had begun the day we were sworn in to government.

At our first cabinet meeting all ministers were presented with documents to be signed agreeing to a cut in our pay in the name of fiscal restraint. After that, the bad news just kept rolling in like tidal waves. Just as we had absorbed one dose of woe, another wave would roll in to sweep the feet out from under us again. Three days into our new government, we were told that the deficit for 1991–92 was going to be more than half a billion dollars higher than the very unreliable Conservatives' budget estimate. Also looming on the horizon in a matter of days was the NDP convention, where the

party faithful who had worked so hard to get us elected would be joyously passing resolutions telling us to spend millions of dollars rebuilding the New Jerusalem after Saskatchewan people had endured nine years in Devine's wilderness.

To curb the New Democrats' appetite for new spending, the government made a series of announcements just before the convention in mid-November to impress upon the public the size of the deficit inherited from Devine. The deficit for 1991–92 would be close to $1 billion, the public was told, and immediate cost-saving measures were touted, including the 10 percent cut to cabinet ministers' salaries and the closing of the trade offices opened by the Conservatives in Hong Kong and Minneapolis. The deficit announcement was part of our election commitment to transparent and accountable government and was the opening volley in a campaign to prepare the public for a very tough 1992 budget. The cuts were to convey to both voters and lenders that we planned to act quickly and decisively to deal with the fiscal problem. The government also announced the Saskatchewan Financial Management Review Commission, headed by Don Gass, former president of the Canadian Chartered Accountants' Association, to report to the public by February 1992 on the province's financial situation.

The appointment of an independent body to report on the magnitude of the fiscal crisis so that there would be support for the solution was a model followed by Alberta and other provinces. It reflected the need to establish credibility with a cynical electorate. For the better part of a decade, Canadian governments had been warning of a financial problem, and any number of plans to attack the growing deficits had been publicized, only to be derailed by higher than planned deficits. Voters would be rightly cynical of yet another warning of a fiscal crisis, followed by the latest plan to tackle it. Public cynicism was especially prevalent in Saskatchewan because of such outlandish schemes as Fair Share and the parade of MLAs who were being charged, convicted, and in some cases imprisoned for fraudulent use of government expense accounts. Gass did succeed in convincing voters about the seriousness of the fiscal crisis and in laying the groundwork for the unpopular choices; however, laying the facts and figures on the table also heightened the concern of the credit-rating agencies, as we soon discovered.

As soon as the billion-dollar deficit was made public in mid-November, the credit-rating agencies summoned our minister of finance, Ed Tchorzewski, to meetings in New York and Toronto and minced no words in their message. The province, from their point of view, had an unsustainable deficit, a huge debt, megaprojects that were in financial trouble, a weakening economy, and a federal government that was offloading its own financial problems onto the provinces. Credit raters had to be persuaded quickly that we had a plan to turn the situation around; otherwise, they would downgrade

our credit ratings even further. Professions of good intentions meant nothing to financiers who had heard such promises many times before; they would judge us on the basis of our actions – specifically, our first budget. They were not interested, we were told, in who got the province into this mess; all that they wanted to know was what we planned to do about it. "While a new administration certainly DESERVES the benefit of the doubt and the luxury of time," Tchorzewski warned, "everything I heard in my meetings with the credit rating agencies and investment dealers tells me that both are in critically short supply." On 25 November, less than two weeks after the billion-dollar deficit was announced, one of the two big American credit-rating agencies, Standard and Poor's, downgraded our credit from A2 to A3, the very bottom of the A category.[5]

From that point on, our number one financial priority was to preserve our A category credit-rating and prevent a slide into the BBBs. By 1991 Saskatchewan's credit ratings had slipped from being among the highest in Canada in the early 1980s – with high As across the board – to one of the lowest. While one Canadian company, Canadian Bond Rating Services, had Saskatchewan in the low As, the other Canadian agency, Dominion Bond Rating Service, already had lowered the province to the BBBs. Of much greater significance were the two New York agencies. Although Moody's did not follow Standard and Poor's lead but kept Saskatchewan at A2 – two steps above the BBBs – both had added to their November assessments the ominous warning that the province "was on credit watch," under close scrutiny, "with negative implications."[6]

Shock, disbelief, and despair overwhelmed the cabinet at its planning session at Government House on 23 and 24 January 1992 as the Department of Finance laid out the full dimensions of Saskatchewan's financial situation. The tax cuts, grants, and other government spending in the 1980s had transformed a province with no government debt in 1982 into a jurisdiction with $8.865 billion in government debt as of October 1991, and that was only the beginning.[7] Changes in accounting, which always seemed so boring to taxpayers, added more than $800 million to the debt.[8] The crown agency established in the 1980s to allow cabinet ministers to invest in projects without the scrutiny of the finance department added $3.5 million in bad investments, while GigaText, Deputy Premier Eric Berntson's pet project, contributed $4 million.[9] Devine's decision to ignore the advice of his financial advisers about when to sell the Potash Corporation of Saskatchewan increased the province's debt by $361 million;[10] $875 million of bad loans, made by the Crown Investments Corporation, had to be assumed by taxpayers, and there was as well the $1.6 billion in loan guarantees for some very shaky megaprojects.[11]

With a total debt of $14.8 billion, Saskatchewan led all of Canada in debt

per capita. With interest costs that would rise to more than $800 million a
year, a deficit of $500 million would automatically grow to $750 million in
five years, driven solely by the wonders of compound interest, with no new
spending.[12] Standard and Poor's put Saskatchewan's situation in perspec-
tive when it observed that Saskatchewan's tax-supported debt was 180 per-
cent of its annual revenue, while the next worst Canadian province had a
debt that was 115–120 percent of its revenue.[13] Saskatchewan was truly a
canary in the coal mine.

After taking a day to absorb the shock and debate the alternatives, the war
cabinet emerged from its planning session with a firm resolve to attack the
fiscal crisis, a decision that reflected both the ability of the cabinet members
and the advantages of a decentralized cabinet structure. Never before or
since have I worked with a group of people as able, committed, and strate-
gic as my colleagues in the war cabinet. Moreover, the relationship between
the ministers and the centre of government made the most of their abilities.
The federal government and some provincial regimes, such as Mike Harris's
government in Ontario, have had a very centralized power structure, in
which the first minister and his officials call a lot of the shots.[14] Such a sys-
tem takes power away from the elected people – the ministers – and puts it
into the hands of people appointed by the first minister. It also fails to capi-
talize on the ministers' capacity to make decisions based on advice from
their deputies. In the war cabinet the ministers ran their departments as they
saw fit, without interference from the centre, with the result that when a
decision came to cabinet, you knew that the minister had analysed the
advice and options provided by the bureaucracy and had applied his or her
own judgment to arrive at the result. Although the premier's chief of staff
always had good advice about strategy and communications and although
his deputies knew government, never was there any doubt that it was the
elected people, not the bureaucrats or the political staff, who were in
charge. And although there was a committee structure, it was at cabinet
meetings – often long, contentious cabinet meetings – where the real debate
and decision making occurred. Such a structure empowered the ministers
and took full advantage of their experience and judgment. The ability, team
spirit, and political courage of the small war cabinet was an important bea-
con of strength as the fiscal crisis and the divisions within caucus swirled
around us.

The campaign to tell the public about our fiscal crisis began literally hours
after our cabinet meeting, when the premier made a speech to hundreds of
delegates at the Saskatchewan Urban Municipalities Association. As
Romanow outlined the fiscal challenge and promised a co-operative, com-
passionate approach to cutting that would seek out "new ideas and
approaches, casting nothing aside," the room became silent and sombre. As

his speech built to the key line, "Fiscal integrity must be restored to Saskatchewan,"[15] the savvy municipal politicians began to nod their heads. At that moment, the cabinet ministers present knew that if we crossed the province, meeting in every town hall and church basement with the same message, we could win over the Saskatchewan electorate.

So that's what we did. Louise Simard set aside any fond hopes she might have had of being seen as a compassionate Florence Nightingale type of health minister. She had to reverse course on the promises she had made in opposition – to enhance health-care programs such as the drug plan – and, instead, prepare the public for a budget that chipped away at the principle of health-care universality, with changes to the drug plan that geared benefits to income and need. I had to warn seniors that they would lose their Heritage Grants, which many relied on to help pay for property taxes, and disabuse the hundreds of social groups of their dreams of a major reinvestment in poverty-reduction initiatives. Berny Wiens had to advise cash-strapped farmers that there was little we could do to help them. Carol Carson had to work with municipalities to brace them for cuts of more than 25 percent. And Ed Tchorzewski had to lay the groundwork for increases in the sales tax, gas tax, personal income tax, and corporate taxes, as well as taking the internal slings and arrows from our own members who thought that members of the cabinet had lost whatever little political acumen they once had.

The cabinet was so overwhelmed by the demands of attending public meetings, running the government, and preparing for an incredibly difficult budget that we did not spend enough time with our large caucus, in which there was major trouble brewing by the spring of 1992. For most in caucus, the malaise came from a genuine sense of isolation, as well as uncertainty about our future direction. They had not spent the same hours as the cabinet wrestling with the fiscal situation, and the proposed spending cuts represented a major assault on NDP orthodoxy. There were, however, others who were stirring the pot of discontent. The anger of the "liquor cabinet" at being left out of the original cabinet had not abated, and it increased when in April another person was added to the cabinet and it was not one of them. Ned Shillington, a Regina lawyer and a veteran of Blakeney's cabinet, joined the team and played an invaluable role in stiffening the resolve of exhausted treasury board ministers, but the "liquor cabinet" viewed Shillington as yet another minister who was more concerned with doing the right thing than with considering the politics of a situation.

Some of the caucus discontent dated back to the defeat of the Blakeney government in 1982. According to the late-night grumbling, the Romanow cabinet, like the one in 1982, had been totally captured by the finance bureaucracy. Rather than thinking politically, the cabinet had become just

like the bureaucrats, mesmerized by the goal of cleaning up the financial mess – which would cost all of them their seats in the next election, just as in 1982, and would bring the return of the Tories, who would again spend their way to two terms in government. As well as being politically inept, the cabinet, according to its critics, was naïve enough to believe all of the crap put out by the finance bureaucrats. The Department of Finance, so the story went, always made things sound worse than they were and always had money hidden somewhere. It was especially galling to some that the finance officials were the same ones who had advised Devine. The grumblers said that if they were in cabinet, they would fire Devine's old bureaucrats, find the hidden money, and spend it, just as Bob Rae had done in Ontario, so that Saskatchewan could grow its way out of the fiscal morass. Although the grumblers were a small minority, their mutterings unsettled others in the caucus and raised questions which cabinet ministers were too busy to answer.

Discontent in the caucus led to angry scenes. When the idea of implementing a health-care premium, similar to the one in Alberta, was presented to the caucus, a group charged that we were attacking fundamental NDP principles, and the story was leaked to the press.[16] As the premier travelled the province to lay the groundwork for the 1992 budget, there were further heated exchanges, before and after the public meetings, with local MLAs about health-care premiums. Another sign of the defiant mood was a report written by the caucus health committee condemning cabinet's proposed cuts to health care. When Myron Kowalsky presented the report to Romanow on behalf of the committee, the premier glanced at it, then angrily tore it up, telling Kowalsky to do the same with the rest of the copies and to tell the committee to never again write such a report. Kowalsky also alleges that there was a plot by a group of malcontents – who had worked long and hard to stoke the flames of discontent among many caucus members – to challenge Romanow's leadership at a caucus meeting. Just before the meeting Kowalsky, known as a loyal team player, slipped the premier a note urging him to commit himself to spend more time with his caucus, which he did, and the burning issue that had fuelled the discontent was diffused. Whether or not there was a plan to challenge the premier's leadership will never be known; but there is no doubt that the caucus struggled to reconcile the massive cuts proposed for the 1992 budget with their long-held NDP values, and in early 1992 we in cabinet did not do enough to help them.

The dissent in caucus reflected the difficulty, faced by parties of all political stripes in Canada, of maintaining caucus unity. The Canadian parliamentary system requires unity in government ranks in order to function; yet the system is based on the dominance of the cabinet, which draws a line between those who make the decisions and those who at best advise or at

worst become idle bystanders. Times have changed since the days of Macdonald and Cartier, when party whips could merely call in the members (disparagingly dubbed the sheep, or the *moutons* in French) and instruct them how to vote. Contemporary backbenchers have a greater sense of independence and a desire to achieve some of their own goals during their careers. Controlling caucus is especially difficulty when governments win with a large majority, as we did. In Colin Thatcher's colourful variation of Winston's Churchill's line, he said, "With huge majorities, the opposition is not across the aisle but behind you, and to make matters worse, at least when they're across the aisle you can look them in the eye, but when they're behind you, you have to watch your back."[17] Soon after the excitement of a big election win fades, some MLAs face the disappointment of being overlooked for a cabinet job, while others come to see that their grandiose plans to change the world are being constrained by the limits on their role as backbenchers. Making caucus feel part of the decision making and utilizing the expertise of its members is a major challenge for Canadian governments and one that we faced in early 1992.

In the end, the discontent in the caucus taught members of the war cabinet a valuable lesson. We came to see that caucus members are a government's front-line troops – its eyes, ears, and voices in the community – and they need to be treated with the utmost respect. An initial token of that respect was the setting aside of further discussions about a health-care premium. More generally, from the spring of 1992 on, it was an ironclad rule that all ministers had to meet regularly with caucus committees and vet all major decisions with them. The premier also made it clear that any minister who lost the confidence of caucus would also lose his or her cabinet job. For his part, Romanow became very patient with caucus members, spending hours explaining our problems, seeking their advice, and drawing the malcontents out of the weeds so that he could refute their arguments and isolate the most troublesome. This more open and inclusive approach to caucus paid huge dividends. Every major budget decision was discussed at caucus well before the budget was presented in the legislature, and never again after 1992 was there a leak. In turn, caucus members such as Kowalsky, Walter Jess, and Lorne Scott became invaluable sources of street-smart advice, and Harry Van Mulligen, chair of the caucus fiscal committee, reported that after working with the NDP members in his riding, dramatic action to deal with the fiscal crisis was both necessary and politically possible. By the time our first budget was presented on 7 May 1992, the embers of discontent had been doused and what appeared to be a united team cheered the minister of finance as he rose to deliver the budget.

Tchorzewski's budget was a landmark in Saskatchewan history. The emotion felt by a partisan New Democrat like Tchorzewski showed through in

the budget speech, which began, "Last October, Saskatchewan people turned from secrecy to openness, from conflict to co-operation, from inequity to fairness, from injustice to compassion." He went on to say that "a proud history of operating surpluses," (referring to the CCF-NDP tradition of sound financial management) had become "an unbroken string of deficits, year after year." Spending, which had on average increased by 6 percent over the past ten years ,was now to be cut by 3 percent through such measures as decreasing communications allowances, merging or eliminating departments, reducing grants to schools, universities, hospitals, and municipalities, and ending the Saskatchewan Pension Plan, which had provided government cost-matched funding for pensions for homemakers. Small but strategic improvements in the social safety net and targeted tax cuts for business provided the glimmers of hope in a budget that also increased a bevy of taxes. With the budget commitment to reduce the deficit to $517 million – $300 million less than in the previous year – the Romanow government had established its first target, a standard by which our success could be measured.[18]

Saskatchewan had never seen a budget like this since the Great Depression. "I can tell you this off the record," a senior aide to Premier Romanow said, tongue in cheek, "this is not a pre-election budget"; and one reporter wrote: "Wednesday night [after the budget speech] government caucus members asked legislature staff to get rid of the flowers in the rotunda area [below the gallery] to allow government members to leap to their death after voters see what we're doing to them in the budget."[19] Business groups warned that the tax increases would choke out growth in the already faltering economy; farm groups complained of cuts to agriculture spending and political commentators criticized "the intensely partisan budget speech." But interviews with people on the street showed a mixed reaction, with at least some understanding the need for harsh measures.[20]

It was disappointing to find that some of the harshest words came from people who were supposed to be our allies. Barb Byers, president of the Saskatchewan Federation of Labour, said she felt like a battered woman who had traded in one abusive husband (presumably Devine) for another (presumably Romanow). She added, "We weren't invited to Devine's party, but yet somehow we're being asked to pay the price for it" – an interesting comment in view of the fact that virtually every taxpayer had benefited from Devine's cheap gas (union members weren't all riding bicycles in the 1980s). "What we have is the business agenda run by people in pink suits instead of blue suits," was the comment of one left-wing critic, while another echoed sentiments of other New Democrats when he asked, "What about increasing oil royalties?"[21]

The budget, however, had been written with the credit-rating agencies in

mind and we awaited their reaction. Moody's had already acted in March. As already noted, the Gass Commission report, released in February, had revealed the enormous size of the deficit and debt, and had convinced Moody's that the province's financial situation was deteriorating. On 9 March Moody's had downgraded the province's credit rating from A2 to A3, the last rung in the A category. Canadian Bond Rating Services had also dropped the province to bottom of the As. The budget's main focus had been to prevent a slide into the BBB category, which meant gaining the confidence of Standard and Poor's.

The mood was tense on 25 May 1992 as Tchorzewski and two senior Saskatchewan finance officials reviewed briefing notes on the plane en route to New York City for a highly confidential meeting with Standard and Poor's. The meeting was a secret one, unknown to the public and even to some members of the war cabinet. It had been requested by Saskatchewan when it was informed that Standard and Poor's was considering lowering the province's credit rating to BBB.

The trip was a desperate attempt to persuade the influential credit raters that we had the financial situation under control and a downgrade was not necessary. Tchorzewski's crucial meeting with the bond raters reveals the extent to which the province's autonomy had been eroded by its indebtedness. In the 1980s I had been one of many academics worried about what the Free Trade Agreement would do to our independence and quality of life, oblivious to the equally great threat posed to both by our growing deficits and debt. Tchorzewski's meetings with the credit raters left no doubt about who was in charge as he pleaded Saskatchewan's case. The May budget, he urged, had been the toughest in Canada, being the only one that actually cut grants for health and education. The credit raters should have been satisfied on at least two of their main concerns about heavily indebted jurisdictions; the government had acted quickly and aggressively to cut spending, and it was building a public consensus for even more drastic action. To downgrade the province now would be destabilizing, since it would make borrowing even more difficult and costly than it already was. Logic and reason gave way to pleading. Tchorzewski said he had come to New York "in spite of the political hazard" he was running by being seen to "grovel before New York credit-rating agencies," and he begged the rating agency to give the province more time. He added that he was "prepared to provide whatever assurances are needed."[22]

Two days after Tchorzewski's plea for time, Standard and Poor's downgraded the province of Saskatchewan's credit rating into the BBB category. The downgrade meant that borrowing costs would increase and more short-term money would have to be borrowed (leaving the province more vulnerable to interest rate increases); also, we would have to rely more on

foreign borrowing, worsening our vulnerability to a decline in the value of the dollar, and there would be limits on our borrowings. As the summer progressed, we discovered that the number of institutions willing to lend money to the province had indeed shrunk, from 150 a decade earlier to 25.[23] By the summer of 1992, it seemed that things could not get worse. But they did.

I remember so clearly that August morning when, driving from my cottage to Saskatoon, I was horrified to see that crops that had been golden and upright the previous day were now black and withered from an early frost. Like others in the war cabinet, I knew that our hope for an economic turnaround in 1992 had died that day and that the prospect of meeting the $517 million deficit target was bleak. In the fall of 1992 the future looked grim: we were not going to make our very first budget target; the economy was shrinking; we had to make another round of painful choices, which had to be sold to the public; and to top it all off, some of our allies and party members were not even willing to concede that there was a problem.

Throughout the 1990s left-wing writers across Canada tried to persuade the public, and NDP members particularly, that there was no fiscal crisis and that the financial problems that did exist could be solved without cutting programs that benefited people. The problem, according to the left, was not government spending but interest rate increases and tax loopholes for corporations and the wealthy. The Saskatchewan Government Employees Union, for example, depicted the fiscal crisis as nothing more than a bogeyman that was being used by their employer, the government, to get the employees to accept a wage freeze. Notions like this were fed by widely read books, which argued that the fiscal crisis was a right-wing conspiracy to soften people up for cuts to social programs. Each year the left released an alternative budget, which reiterated the view that had been orthodox NDP thinking until the 1990s – that closing tax loopholes, making the rich pay, raising royalties, or introducing taxes such as a wealth tax would deal with the fiscal situation.[24]

Arguments denying the fiscal crisis and advocating easy solutions that did not involve cuts to popular programs created endless problems for us. Our members read the material, recognized that it was much closer to traditional NDP thinking than what the government was advocating, and at meeting after meeting the war cabinet was challenged for moving to the right and abandoning NDP principles. The vast majority of Saskatchewan New Democrats are very practical, and by the end of a meeting most had usually come to accept the government's position. Nevertheless, dealing with such divisions within our own ranks was draining and discouraging, especially for loyal party stalwarts like Ed Tchorzewski.

By the fall of 1992 Tchorzewski was faltering under the weight of the bur-

den he was carrying, and when I became CIC minister responsible for the megaprojects I was also made associate finance minister, with the task of providing him with some support. Over the next four months, I saw the stress of the job take its toll on a decent hard-working man. He had a profound sense of duty, which gave him the strength to carry on, even though he was suffering inside. He would come to my office overwrought with emotion about the problems with the rating agencies, the divisions in the party and the caucus, the lack of consistent overt support from key players on our team, and I would try to reassure him. Literally minutes later, he might be in a press scrum, where he portrayed the image required of him – the confident, calm, experienced captain of the province's fiscal ship.

Although intellectually he knew what had to be done to cure the province's financial ills, emotionally he struggled with the choices. Saskatchewan is a small province, and it's difficult to make cuts without affecting someone you know. This was especially true of the NDP, since cuts have a much more dramatic effect on low-income people, the backbone of the urban NDP. After his first budget, Tchorzewski was devastated to realize that one of his neighbours, a man with a young family and bad health problems, had been fired because of the budget cuts. When Tchorzewski visited the man, he was very understanding – it was Tchorzewski who wept about what he had done.

There is a very macho side of politics that demands endless hours of work and a stiff upper lip; the thinking is that dedication to your government job means working from dawn to midnight during the week, and devotion to the party requires attending party events on the weekend. Tchorzewski put in punishing hours trying to fulfill both roles. Politics is also supposedly not for the faint of heart. Thus, for a proud man such as Tchorzewski it was difficult to admit, until the very end, the extent to which he was struggling and to demand more help and support from everyone around him.

As the fall progressed, I thought I was giving him the support he needed to carry on. In retrospect, I realize that he was training me to do his job. I would say, "Look, you don't have to go that meeting or to chair treasury board today; I'll do it," and he would agree. I thought that was progress, and so did he, but it was progress toward different goals. I should have realized his intentions in December 1992 as we approached key budget decisions and he and his deputy minister, John Wright, were snowed in at the nation's capital. When he phoned to tell me, I began to discuss ways to rearrange the schedule so that he could chair these all-important meetings. His response was prophetic: "You chair treasury board; you make the decisions. I know you can do it."

On 6 January 1993, when I arrived in my office after the Christmas break and was told that I had to take an event for Tchorzewski, who was on his

way to Saskatoon to see the premier, and that Allan Blakeney was waiting to see me, I knew what was happening. Blakeney's message was that a minister of finance of such a financially troubled province could not quit so close to a budget without sending a dangerous message to the financial community. I agreed that credit-rating agencies might think that the resignation of a finance minister signalled a lack of cabinet support for his proposed course of action and was symptomatic of a split in government ranks. I explained the internal situation to the former premier and told him that I would do what I could, but I pointed out that there were limits to the sacrifices we could expect a man to make. I then phoned the premier and told him what he needed to say to persuade Tchorzewski to stay. To no avail. Tchorzewski's health was suffering – he had shingles, a very painful condition, and he needed time and rest. As I said to my good friend Bob Mitchell, it was as if a man was drowning and none of us could find the buoy to throw out to save him.

There are two moments deeply ingrained in my memory about the transition from Tchorzewski to me as finance minister. In the hallways of the legislature outside the room in which I was to be sworn in, Tchorzewski put his hands on my shoulders, looked me straight in the eye, and said, "Remember you are now the minister of finance. When you speak, you are not just speaking to the Saskatchewan electorate; you are speaking to the financial community in Toronto, New York, and beyond. You have to rise above the partisan fray. " After the swearing in as we sat in his office discussing the transition, he stopped, looked across at me, and said, "I'll always be there for you." And he was.

Watching what happened to Tchorzewski was the most defining experience in my political career. From my perspective, Tchorzewski was left shouldering the massive burden of the fiscal crisis at the same time as he had to manage those in the party who denied the existence of a crisis, those in caucus who sniped at his decisions, and others who did not provide the support he needed. Such people were working through their own problems with accepting the fiscal realities; however, Tchorzewski was bearing the brunt of the lack of unity on the team. I saw what politics could do to a person and I was determined that it would not happen to me. I saw how lonely a minister of finance can become, and I concluded that the whole team needed to be locked into solving the fiscal crisis. And I saw what happened to a finance minister known for his gentleness. It was a job that demanded firmness and determination, as Romanow said when he appointed me finance minister: "Develop that steely Trudeau glare that tells the world that you will brook no opposition."

The day Ed Tchorzewski quit, Combat Barbie was born. Combat Barbie was my nickname in the marble palace, and it bespoke a toughness which I

believe is absolutely essential for success in the rough and tumble world of politics. I was tough about my own personal schedule and my attitude toward the job. The government could have me all week, but weekends were family time, and woe betide anyone who tried to infringe on that sacred territory. My job, I told myself, was like a coat – something that I could take off after work was done – not like my skin, which was an inextricable part of me. The province was not going to be any better off if I drove myself to the grave. I could not allow myself to have one sleepless night over this job – and I never did. I was tough about what I expected from my colleagues. As Don Ching, president of CIC and my bridge partner, used to say, "Drive them crazy before they drive you around the bend."

Shades of Combat Barbie had appeared less than two weeks after my appointment to cabinet (and, as it turned out, the incident proved to be a factor in Romanow's decision to move me to finance two years later). The premier phoned me at a hotel in Toronto, where I was attending a ministers meeting, and his cryptic comment was: "You made the headlines today. Great picture, not so great story." He explained: "The headline is, 'Need For Food Banks Unlikely to Disappear,' and just in case the reader missed the point, the first line in the story is, 'Food banks will likely be part of the Saskatchewan scene for several years to come, says Saskatchewan's new minister of social services.'" "In politics," continued the premier, "you've got to give people hope, especially if you're a minister of social services in an NDP government that has just won an election on a platform of eliminating food banks." I replied that I, too, hoped that food banks could be eliminated, but asked, "What good is false hope?" Social agencies and many New Democrats had very high expectations about what we would do to eliminate poverty, but our lack of money meant that we could not come close to satisfying them. Therefore, as I said in my interview for the newspaper, "We want to be responsible here and not lead people to believe that something is coming that we might not be able to deliver."[25] What I was trying to do was shape people's expectations. Thus, I travelled the province, levelled with people about our financial mess, listened to their ideas about where small amounts of money might do a lot of good, and prepared them for a very difficult budget. The premier's approach reflected the politics of the 1970s, when there had been a lot more money and a lot fewer difficult decisions to make. My message reflected the 1990s, when difficult choices could only be sold by changing people's expectations of what government could and could not do for them.

The stony silence on the other end of the phone told me that the premier did not buy my argument in November 1991, but by May 1992 he was coming around. One of the biggest surprises in the 1992 budget was the reaction from social groups. After ten long years in which the Devine government

had chipped away at the social safety net, social agencies might well expect an NDP government to make a major reinvestment in social programs and to express a sense of anger and betrayal at the modest measures in the budget. Instead, criticism was muted. A critic, who called the small amount of new funding a "gesture," conceded that "the NDP made its gesture in the right direction"; there was praise for funding for child hunger programs and a lot of silent acceptance of the inevitable.[26] To his credit, the premier told the story of my comments about food banks again and again and acknowledged that he had come to see that the way out of the financial mess involved some straight talk – being very honest with people and shaping their expectations. By early 1993 the level of honesty at times became almost brutal. One very zealous cabinet minister managed to get a headline, "Province on the Brink of Bankruptcy," which sent shudders through the Department of Finance, and the premier himself got into the spirit when he warned about "amputations of programs."[27]

The most important reason why people across Canada accepted the difficult decisions of the 1990s was that politicians in all parties and regions levelled with the public and challenged head-on long-established views about what people could legitimately expect from their governments. Whatever the minor differences in tone and message, the theme was the same: Canada was in trouble from coast to coast in the 1990s because Canadians had expected too much from their governments in the 1970s and 1980s. Whatever the problem – rising interest rates for mortgages, escalating prescription drug costs, expensive gasoline, high levels of unemployment – Canadians instinctively looked to their governments for the solution. For their part, politicians just as instinctively responded by scrambling to fulfill public expectations, even when this meant running deficits. In responding to the public's immediate needs, politicians had failed to warn the public about the long-term costs. In the 1990s, when governments were forced to tell people that there were limits to what governments could do for them and that they had to lower their expectations so that the future would not be even worse, the public responded.

While it is often said that voters get the politicians they deserve, it is equally true that there is a relationship between how intelligently politicians present their case and the intelligence level of the voters' response. The case for deficit reduction in Canada in the 1990s worked because it was coherent, consistent, and compelling. The material for public meetings in Saskatchewan was typical. Interest costs, which had taken less than two cents of every tax dollar in 1982, were gobbling up more than fifteen cents a decade later and would continue to grow, crowding out spending for other priority areas. On the other hand, if the budget was balanced and the debt reduced, interest payments would decline, creating more freedom to fund

other initiatives.[28] Families understood the need to live within their means, and they came to see that governments were no different. Saskatchewan's fiscal situation was compared to a house: "The structure of the house – the underlying economy – is strong. The house is very attractive, offering a wonderful lifestyle to the people here. The problem with the house is that it's mortgaged to the hilt."[29] As Romanow said, "We either wrestle to the ground the demon of debt or ... in the next two years we're going to find it difficult to borrow money."[30] As well as being compelling, the arguments had to be repeated at every possible venue and had to reflect a united team. The lone voice of a finance minister crying in the wilderness, as had been the case in the 1980s, had to be replaced by the chorus of all ministers singing from the same songbook. Unity was essential, but it was still elusive in Saskatchewan in early 1993.

The foundations for unity were laid paradoxically by Tchorzewski's resignation and by the consensus-oriented decision making in the Saskatchewan government. "I know what needs to be done and I'm prepared to go down with the ship," I told the premier when he asked me to be finance minister. There is a saying "Finance always gets its minister," and this view was especially prevalent in 1993. While rivals urged me to take the finance position, friends like Bob Mitchell warned, "This is not a hillside that you need to die on." Overlooked was the possibility that making the difficult choices did not necessarily mean political suicide. In my four months as associate finance minister, I had concluded that Saskatchewan had no choice but to act dramatically and quickly. I had talked to many people, including my brother-in-law, David MacKinnon, who had extensive experience in government and finance in Ontario. His message was: "All governments in Canada are in a fiscal mess, and politicians are going to have to lead the way out. Don't assume that finance is a career breaker; in the 1990s, it could be a career maker." Thus, in January 1993, my resolve was as firm as Tchorzewski's; but his departure had strengthened my position. The government simply could not lose another finance minister. Cabinet and caucus could complain and criticize all they wanted, but in the end the politics of the situation dictated that, like it or not, they would have to unite around this finance minister.

Unity and consensus also resulted from a decision-making process in Saskatchewan similar to what Paul Martin later created at the federal level. Program review, according to Martin, was a major factor in the success of his 1995 budget.[31] The federal process involved treasury board and a committee of cabinet ministers, chaired by Marcel Massé, evaluating virtually all government spending according to the following tests: Was the program in the public interest? Did the federal government need to be involved, or could the provinces or the private or voluntary sector do the job better?

How could programs that were retained become more efficient? Was the program affordable?[32] The federal process, created specifically to deal with the deficit decision making, had the advantages of ensuring a thorough review of government finances by elected leaders – the ministers – and of building consensus. The treasury board was a cross-section of cabinet, and thus the views of cabinet would be infused into the decisions. At the same time, there would be broadly based support at the cabinet table for the choices made. The treasury board process that had operated for years in Saskatchewan was exactly the same as Martin's program review and had the same advantage of building consensus.

The first step in unifying the government was to coalesce the five ministers on treasury board into a strong and united team, a task made easier by my own inexperience, which forced me to rely on the experience of my colleagues. Besides Tchorzewski, there was John Penner, the new associate finance minister. A man in his sixties, Penner had the bearing of a wise elder – soft spoken and approachable. The premier used to say that Penner spoke about me as a daughter whom he had to protect, and I know that when caucus members complained to him about my unwillingness to bend, his reply was always the same: "Of course she won't bend. She's the minister of finance, and you should support her." Next to Tchorzewski, Ned Shillington had the most experience in government and was notorious for his toughness. His standard question to departments was: "What catastrophe will befall the world tomorrow if we cancel this program? Or maybe your whole department?" He was especially ruthless with departments that tried to circumvent the process by announcing measures without treasury board's approval. For such deputies his question was: "Did you bring your own chequebook today, because you're going to need it; the government did not approve your spending, so it's you personally who is going to pay." Berny Wiens was a devout Mennonite farmer, who was generous, outgoing, intelligent, and talkative. We could never teach him to do an eight-second sound byte, but we could always rely on his booming voice to take on all critics at cabinet or caucus. Darrel Cunningham, a rather shy man, was a superb street-smart politician, who knew the politics of rural Saskatchewan yet believed that preserving rural Saskatchewan meant changing it. As we spent hours poring over budget documents, the six of us became a strong team.

It is impossible to describe the agony and sheer exhaustion that come from endless hours of going line by line through budgets, looking for cuts that, have to add up to millions and millions of dollars. The six of us would sit there, often from early morning until late at night, combing through the paper, questioning the deputies, and debating the decisions. There was always strength in numbers. Troublesome deputies were given the full treatment: all six ministers would ask blistering questions, making it clear to the

deputy that he was not just dealing with one ornery finance minister but with six ministers, any one of whom could be the deputy's new minister after the next cabinet shuffle. There was also a roller coaster of emotions. Giddiness sometimes took over late at night. At about midnight, after a particularly unco-operative deputy and his department left the treasury boardroom, I spun around in my chair and declared, "Why don't we just blow the whole department away?" But sounder heads prevailed. There were many somber moments, especially when the finance department reviewed the impact of the budget – the number of jobs that would be lost or the hospitals and schools that would be closed. Such realities were devastating. We knew the human impact of the decisions we were making, but we had to steel ourselves and set these thoughts aside; otherwise, we would never be able to make the decisions that we all knew had to be made.

Paul Martin has observed that a problem in Canada is the lack of understanding of public finances, which leads many outside government to underestimate the magnitude of the measures required to cut millions of dollars in government spending. As an example, Martin recalls a long meeting he had with business leaders at which he opened the government's books, presented the range of choices, and then asked them to put together the budget. After hours of grappling with the choices, they threw up their hands and conceded that they could not come up with the decisions that would balance the budget.[33] Unlike the business leaders, as Saskatchewan finance minister I had no choice but to find the money. The credit-rating agencies' message was very clear: Either reduce the deficit to $300 million in the 1993 budget or face further downgrades and the prospect of not being able to borrow the hundreds of millions needed to run the government.

An absolutely fundamental decision in 1993 was that the pattern of deficit reduction followed in Canada since the 1980s had to end. For a decade, the federal government and the provinces had gone down the same road every year: the finance minister would present a difficult budget with the goal of reducing the deficit by a certain amount; then the next year, the same finance minister would report back, usually to explain why the target had not been achieved but occasionally to celebrate the fact that the deficit had actually declined. But what was there for taxpayers to celebrate? There was still a deficit, interest payments and debt were still growing, and everyone knew that there was more bad news to come. Deficit fatigue was a natural result of what seemed to be a never-ending cycle of bad news and a deficit monster that it seemed would never be tamed.

In 1993 Saskatchewan led the way out of the quagmire with the bold stroke of a four-year plan to actually balance the budget, which led the *Globe and Mail* to wonder "whether the other provinces [would] follow suit by laying out a long-term financial plan."[34] Alberta did. Our 1993 budget, as the

Globe explained, "would get all of the bad news out of the way at once" by announcing the tax increases and program cuts that were necessary to achieve a balanced budget. Although some of the program cuts – for instance, the reductions in grants to health, education, and municipal government – would not come into effect until 1994, they would be announced so that everybody would know how things stood and could look to the future with some hope of better things to come. Along with the 1993 budget was our detailed four-year plan, specifying the declining deficit levels: the 1992 deficit of $592 million would decline to $296 million by 1993; by 1994 the deficit would be $190 million; by 1995 it would be $70 million; and by 1996 Saskatchewan would have a balanced budget.[35] With a long-term plan to balance the budget, Saskatchewan would blaze a trail out of the quicksand of eternal deficits and onto the higher ground of growing financial freedom.

Devising this long-term, detailed plan had put me at odds with the Department of Finance, whose deputy minister once said to me, "You drove us crazy, but you brought out the best in us." I was not an easy minister to work for. I was demanding and I had no qualms about giving any of my officials a piece of my mind, without thinking that the power of a minister can be intimidating to civil servants. But finance officials always knew where the government was going and they understood my determination to reach that destination. Although I sometimes fought with them, I also defended them. I withstood terrible criticism in the fall of 1994 for appearing to have said that I refused to cut the sales tax, even though this would leave the province better off, because I did not want to forfeit equalization payments from Ottawa. What I did not mention was that the comment stemmed from a badly worded letter written by a senior finance official. On another occasion, the department drew the wrath of the government for sending out notices – during a hotly contested by-election – informing scores of people that they owed back taxes for goods that had been brought in from the United States months and even years earlier. After defending the department before cabinet, I settled the matter with my deputy minister, John Wright, telling him: "John, there are a lot of people who are angry about getting tax notices for goods brought in from the United States ages ago, and at one o'clock there is going to be an open-line program on the radio in which they will vent their anger. I won't be on the program. John, I'm sending you instead, and if you're lucky, I won't call and scream at you." After that, the issue was over. Though I was at odds with the department over some issues, I always felt uncomfortable ignoring its advice.

Officials in the finance department were rocks of stability in our difficult budget deliberations. They had learned so much, not only about deficit reduction but also about how to deal with the public, as a result of their

experience in working on the Devine Conservatives' restraint budgets in the late 1980s. As professional civil servants, they were extremely valuable sources of advice. Having watched three other finance ministers flounder on the same quest upon which I had embarked – restoring financial integrity to the province – they knew all the pitfalls that awaited me. Late at night, after the other ministers had left, in rooms literally filled with smoke (as the finance officials bolstered the province's tobacco tax revenue), they would impart their wisdom in the hope that I would make it through the field of political obstacles that had tripped up my predecessors. Of all their sound advice about government, two ideas always stayed with me: Chart your direction and stick with it; the voters will reward consistency. And be strategic – pick your fights. I greatly respect the people in the finance department and firmly believe that it is a minister's responsibility to consider carefully the advice of his or her department. But a minister also has to be prepared, when there are good reasons, to override such advice. My long-term financial plan was one such time.

From a financial and technical point of view, I agreed with the civil servants' analysis. Their very valid point was that by putting out three deficit targets, for 1993, 1994, and 1995, the government was leaving itself vulnerable to again missing at least one of the targets, thereby reinforcing the cynicism and deficit fatigue of taxpayers. Their advice was especially telling because by late 1992 it was clear that the one target the Romanow government had publicized – a deficit of $517 million in 1992 – was not going to be met, since the deficit was climbing closer to $600 million.

The more important political objectives, however, were to give hope to Saskatchewan taxpayers and give unity to the government team. Only by showing Saskatchewan people in detail how we planned to balance the budget could we convince them that there was an end to their misery. Just as important, the minute those deficit targets were made public, the caucus and party would be forced to take ownership of the finance agenda and unite around it. As the press rightly concluded when the four-year plan was released, the NDP "was staking its hopes" and "its political future" on meeting those targets.[36] With the balanced budget plan, sticking to the course of fiscal restraint was no longer just the concern of the minister of finance; it was the responsibility of the whole caucus. Every one of them knew that missing the targets, which were at the heart of our agenda, would probably cost them their seats. And nothing focuses the mind of a politician like the prospect of losing one's seat.

Holding in my hand my hot-off-the-press balanced budget plan, with its $600 million in cuts and tax increases, I merrily walked into the two-day cabinet meeting in January 1993 at which the budget had to be finalized. Rather than being confident of success, I should have remembered the

saying "pride comes before a fall." My confidence rested on the unity of the treasury board team and on the force of our argument. Finance officials, armed with all the facts, figures, and graphs, were fully prepared for battle; as true professionals, if anyone in cabinet challenged the plan, they would never utter a word about their reservations but would cite all the arguments in favour of it. As well, the treasury board was prepared to intervene strategically in the debate that would follow my presentation in order to rally support for our joint decisions. And there was Bob Mitchell. Mitchell had such extensive experience in government at the bureaucratic and political levels that he carried extraordinary weight in any cabinet debate. He was my oldest and dearest friend in the cabinet – quite willing when necessary to take me aside and tell me that I was dead wrong. But if I was in a political jam, he was always there for me.

My argument, even as I review my notes today, was compelling. The issue of the 1990s, I began, was debt. Canada had one of the highest levels of debt of the G7 countries, and Saskatchewan held a similar distinction among the provinces. Unfortunately, there was no national strategy to coordinate deficit reduction, so even as we struggled with our crisis, the federal government was offloading more than $500 million a year of costs onto the province. Leftist pamphlets such as "The Deficit Made Me Do It" raised issues like lowering interest rates – which our government strongly supported – which could be initiated at the federal level, but on the provincial scene there were no easy answers. We had to set aside our fears and our traditional ideas about politics, and become leaders. We could be pathfinders, I said. Saskatchewan could make history by leading the way out of the debt trap and doing so with compassion for the less fortunate. In political terms, the balanced budget plan meant getting all the bad news out of the way early in our mandate and going into the next election, balanced budget in hand, saying that we had delivered on our promise. It was time to look beyond the short-term political problems and take the long-term view. The choice was clear. Either adopt the 1993 budget or prepare the province for default.

The argument, unfortunately, was not being presented to the war cabinet but to a much larger cabinet of eighteen, many of whom were members of the class of 1986. When Romanow had enlarged the cabinet in late 1992 and early 1993, he had added members who had spent long years in opposition attacking Devine on the basis of traditional NDP positions. Like the premier himself, they had made brilliant speeches defending fertile NDP territory, such as progressive taxation, universal health care, and enhanced funding for a whole range of worthy causes. The budget of 1993 looked more like the Devine measures they had attacked than the promises they had made. Having never experienced the responsibility that comes with governing, they

were less familiar with leading than criticizing, less accustomed to long-term considerations, and more in tune with the immediate politics of a situation. In early 1993 the divisions that had plagued caucus a year earlier now bedevilled the cabinet.

To my horror, the response to my argument was that there was only one choice that was both politically sensible and would save us from abandoning fundamental NDP principles – default. This rationale centred on the politics of the budget and the extent to which its measures flew in the face of so much that the NDP represented. The cuts and tax increases would be political suicide – no government could survive them, and they would destroy the party. The budget, it was argued, defied every rule about traditional politics in Saskatchewan. It was common knowledge that closing a hospital in Saskatchewan meant losing the riding, yet the budget proposed to close fifty-two hospitals in one fell swoop. Medicare was the bedrock of the Saskatchewan NDP, yet the budget would cancel the Children's Dental Plan, created by Blakeney in the 1970s, and end the universal coverage of the Prescription Drug Plan. In opposition the NDP had railed against Devine for raising taxes for people and cutting taxes for business – exactly what this budget did. The sales tax was to be raised from 8 to 9 percent and the gas tax would go up another two cents, while there were targeted tax reductions for business sectors, such as manufacturing and processing. Farmers angry about the reduction in GRIP's coverage would now be told that in two years the province would abandon the program altogether. And grants for schools, hospitals, universities, and local governments would be cut in 1993 and 1994 by anywhere from 5 percent to 13 percent. The critics were dead right in saying that both traditional NDP ideas and traditional politics were been challenged head-on with the 1993 budget.

As the minister of finance who proposed these drastic measures, I felt heartsick at some of the choices. The Children's Dental Plan was a model of preventative medicine; communities on the west side of the province would struggle for survival with a 9 percent sales tax right next to Alberta, which had no sales tax; and the University of Saskatchewan would suffer a decline in quality that would reduce what had been one of Canada's finest universities to the very bottom of *Maclean's* ratings of Canadian universities. Terrible as the choices were, the alternative was worse. I had read every briefing book, looked at every imaginable scenario, and concluded that waiting or temporizing would be abdicating our duty to lead. We had to act quickly to solve the fiscal crisis ourselves; otherwise, the decisions would be made elsewhere. One area that was never cut was social program spending. Indeed, as the harsh measures were introduced, we strengthened the social safety net to protect the poorest of the poor and the most vulnerable. Did

anyone really think that a hard cold look at the numbers from outsiders would lead to the same choices?

My confidence also came from touring the province for more than a year, beginning as minister of social services, during which time I had come to know and respect the people of Saskatchewan. Like many other Canadians, they were people who had settled in a brutally harsh land, had weathered the Depression (two-thirds of Saskatchewan people had been destitute in 1937), and had volunteered in two world wars to fight in far-off countries. These people understood the fiscal crisis and were well ahead of their politicians in being ready for the solution. The 1993 budget was a difficult but necessary measure. I was not budging. The other five treasury board ministers were not budging either. The finance department had no other alternative to recommend that would prevent default. And the government could not afford to lose another finance minister.

The divided cabinet put Romanow in a difficult spot. At heart, Roy Romanow is a Ukrainian boy from west-side (working-class) Saskatoon. As a first-generation Canadian, he has a deep love for Canada and Saskatchewan, and is a mix of ambition and insecurity. As a person from the working-class part of town, he identifies with the underdog and believes in universal health care and quality education. As someone from a very traditional family, he shares bedrock values such as living up to one's commitments and doing one's duty.

As a leader he was an artful blend of the politician and the statesman, and there was often an internal struggle over which side would dominate. As a superb politician with an uncanny ability to read the Saskatchewan electorate, his instincts would have told him that the critics of the budget were right. The medicine being proposed for the deficit disease was explosive and maybe even deadly. As a leader concerned about his own reputation, he was aware of the many words he had uttered in opposition that he would have to eat if the 1993 budget saw the light of day. And he would know that at least some members of the New Democratic Party would feel betrayed by what would appear to be attacks on core NDP principles.

But his other side would have told him that his first loyalty was not to the party but to the people of Saskatchewan, and that more important than politics in the long run was doing the right thing. He believed firmly, as he used to say, that "nothing beats brains," and his experience in government had taught him the importance of getting the best advice, following due process, and weighing choices carefully. As minister of finance, I followed two principles in dealing with the premier: first, to discover his long-term goals, outside the parameters of an immediate crisis (and at the fall cabinet planning meetings, his commitment to restoring the province's finances had been unequivocal); then to bring forward the steps needed to achieve these goals

and prepare for the fight of my life. As a person who often worked his way to a decision by arguing for the alternatives, he would aggressively attack a plan of action, pointing out the pitfalls and political problems. To win, you needed to have your homework done, your ducks in cabinet lined up, and your case solid, and you had to stick to your guns. "Mr Premier, this is the right thing to do," was the line to which I constantly returned. Mild-mannered cabinet ministers had trouble stomaching the raised voices and the fists pounding the table; observant ones saw that, in the end, politics and the party were usually trumped by the best interests of the people of the province and by "doing the right thing."

Notions of defaulting infuriated the premier. His outburst in cabinet resembled his reaction a few weeks later, when Bob White and other trade union leaders proposed default to the three NDP premiers – Romanow, Rae, and Mike Harcourt of British Columbia. Romanow exploded and told them, "We'll never form a government anywhere ever again with that attitude ... It's my job to get us out of ... this god-forsaken hole ... And if I have to do it without you and the labour movement I will."[37] I would have liked to ask Bob White if his idea of default meant offering up the pensions of his members, since many pension plans had invested in what were considered safe government bonds on which White and the others were now proposing that we default.

During my presentation of the budget to cabinet, there was an attack on the finance department figures; a few ministers suggested that some of the deputies – our appointees, not the holdovers from Devine – were whispering that the finance department was putting an especially negative spin on the numbers. After another explosion from Romanow, deputy ministers were summoned to the cabinet meeting for what was called "a public hanging" and were taught a painful lesson about trying to undermine the finance department. But despite all the controversy, there was no increased support in the cabinet for the budget.

As the group began to descend into laughter, ridiculing the budget, Bob Mitchell intervened. He gave an impassioned speech in support of the budget that silenced the room and took many by surprise, since Mitchell was usually seen as a big spender. As the cabinet began to warm up to the budget, Romanow suggested that we break for a week to rethink our positions. After the meeting, as Mitchell and I walked through the streets of Regina to our cars, I said, "Bob, that was a great speech in support of the budget; but it didn't really sound like you. Did you really believe all of that stuff?" He laughed and said, "Hell no, but I had to support you, kid." If blood sport is the guts of politics, loyalty is its heart.

The break gave me a chance to play one last card – a call to federal Finance Minister Don Mazankowski, whom I had never met but who, I firmly

believed, had to have an interest in the prospect of a province defaulting. I told no one except Mitchell and my deputy minister about my plan, since I did not want to become mired in the wrangling that was typical of federal-provincial relations in Saskatchewan, where running against the federal government was standard practice. Although I understood the politics of the tactic, the end result was often self-defeating, as the events of 1992 and 1993 showed. Into the negative mix of Mulroney and key ministers seeing the Romanow government as the socialists who had defeated Devine, we had added huge public battles over agriculture, especially our attacks on GRIP, and the federal government had responded. It had announced that the Saskatchewan government would have to pay the full costs of welfare for off-reserve Indians, a measure that would cost us at least $30 million more a year. Although other provinces had already accepted such a change, officials in Saskatchewan finance were told by their counterparts in Ottawa that the federal finance bureaucracy had in fact recommended against the decision, on the grounds that Saskatchewan's finances were too fragile; but the decision was a political one. I did not know or care whether this was true; what I did know was that Saskatchewan's relations with the federal government were characterized by suspicion, paranoia, and posturing, all of which would only hamper my quest to get some money to ease the budget through cabinet. So I kept my plan to call Mazankowski a secret.

I flew to Ottawa accompanied by my deputy minister, John Wright, for the meeting with Mazankowski and his deputy minister, David Dodge, at the finance building. I found Mazankowski to be a bright, quiet-spoken person who deserved his reputation as Mulroney's deputy prime minister and fixer. He quickly got down to the business of what could be done to "fix" our problem without appearing to be giving Saskatchewan special treatment – a position that I, as a finance minister, understood. The final decision was that the federal government would make a long-discussed but never implemented change in the equalization formula as it affected the amount clawed back from potash royalties. Some later complained that the amount, $14.9 million, was meagre help for a province on the brink. My own view was that considering what had happened in the past two years in our relationship with the federal government, both Mazankowski and Dodge were being co-operative and helpful; $14.9 million was enough money for me to return to Saskatchewan and make some minor but symbolic budget changes that eased its passage through cabinet. Besides, little did we know that we would again have to turn to Ottawa for help.

After the budget passed cabinet, I spent two whole days sitting at the head of the long caucus table flanked by finance officials, answering caucus members' questions and trying to inspire them with the long-term vision of the current difficult measures. As the hours passed, I could see that they

were moving from resigned acceptance to enthusiasm. Caucus members had spent more time than cabinet ministers talking to constituents, and most believed that the people of the province were ready for difficult choices. They had also watched Eric Malling's popular w5 documentary about what happened when New Zealand almost defaulted, a story which the trade unions quickly tried to discredit by publishing *If Pigs Could Fly: The Hard Truth about the 'Economic Miracle' That Ruined New Zealand.*[38] In the end, caucus caught the vision of a principled government doing the right thing and of being trailblazers for the rest of Canada. I left caucus energized by the spirit of a team uniting grimly but resolutely, like an army going into battle.

There was, however, one last hurdle. As well as setting a target for the 1993 deficit, which our proposed budget met, the rating agencies had set a limit of $600 million for the deficit in the 1992 budget. As the 1992 deficit drifted past our target of $517 and approached $600 million, we were moving again into dangerous territory. In mid-February the finance department had to inform cabinet that the 1992 deficit would come in well above the $600 million limit and further action was necessary.

When this news was presented to an evening cabinet meeting by finance officials, all hell broke loose as some members, this time joined by a senior member of the war cabinet, returned to the idea of default, and a few launched a vicious attack on the competence and loyalty of the finance public servants. The meeting became a melee as voices were raised, fists were pounded, and accusations were hurled back and forth. As those outside the room listened in horror, the cabinet door flew open and the premier stormed across the small reception area to his office, yelling back that he wanted me, Tchorzewski, and the senior minister who had supported default to come to his office immediately and that he would deal with the rest tomorrow. Romanow had used lots of "carrots" – in the form of long hours spent trying to persuade cabinet and caucus to unite around the budget. The cabinet's outburst was veering dangerously close to a challenge to his leadership, so it was time for a stick, and he brought out the biggest stick a first minister has – the power to call an election. After telling the small group assembled in his office that he planned to call an election, we left for the night. I spent the next day working on the budget but heard in graphic detail what happened in cabinet and caucus. The premier did visit the lieutenant governor, Sylvia Fedoruk, and returned to confront his cabinet and caucus, telling them that the government had made a decision to support the 1993 budget and he was not prepared to be captain of a divided ship. So either the team had to unite behind the decision or he was calling an election, so that the province could be run by a group who would actually govern. He then asked each member, one by one, to state his or her choice: either support the 1993 budget or call an election. Not surprisingly, the support for

the budget was unanimous. After that, our team was united. The future of the government was now clearly tied to the fate of the 1993 budget, and each member had an interest in its success. As for the problem with our 1992 deficit, it was solved when the federal government made an unexpected fiscal stabilization payment of $30 million to Saskatchewan to bring the deficit down to $592 million.

The fact that the first minister supported the finance minister in uniting the team behind tough measures occurred in other Canadian governments and was a major factor in the success of deficit reduction in the 1990s. Although we had a lot of battles, I never doubted that if I pushed long enough and hard enough, with a united treasury board and finance department at my side, the premier would support my recommendations as finance minister. The same was true at the federal level. Whatever the rivalries may have been between Chrétien and Martin, the federal finance minister said that the prime minister supported his budget initiatives at every step.[39] Similarly in Alberta, although treasurer Jim Dinning had supported Klein's rival, Nancy Betkowski, in the Conservative leadership race, the two always spoke with one voice on budget matters. This was a complete contrast to the 1980s, when finance ministers took positions similar to their counterparts in the 1990s but always ended up standing alone when the going got tough. Only when the premier and finance minister stood together was the team united and the government's energy focused on defeating the deficit.

By the time I delivered the budget on 18 March 1993, there was a growing consensus across Canada that what had been a fiscal problem had become a fiscal crisis that required strong action. Such headlines as "Provinces in Crisis," and "Ottawa Seeks Way to Bail Out Provinces: Federal Agency Would Take Over" helped, as did the national attention given to Saskatchewan's budget.[40] Days before it was delivered, a *Globe and Mail* story explained that Saskatchewan's goal was to preserve its credit rating, and said of me: "When local critics tell her the province's debt isn't as bad as it looks, she says she tells them their views are simply not as important as those of the rating agencies, 'It's like looking in the mirror and you say, Gee, I'm beautiful. But if the credit rating agencies say, you're ugly, you're ugly.'"[41] Any doubts about our choices vanished in the week before the budget when Saskatchewan bonds issued in New York failed to sell easily and quickly. It was a warning.

Preparing for and delivering a budget is exhilarating and totally engrossing, like preparing to skydive and planning a wedding at the same time. In my case it was probably worse, since I was both a perfectionist and an interventionist. I insisted on writing my own budget speech, which drove the finance officials crazy. Television never lies, and when you deliver your lines

they simply have to be coming from both the head and the heart. Weeks before, hours are spent practicing and re-writing the speech, absorbing all of the details of the budget so that it can be explained clearly to the folks in Rosetown or credit raters in New York. There are always final details to be worked out: ministers who feel they did not get what they were promised, further refinements of the communications strategy, wrangles about when the opposition and press can see the budget, and shopping for new shoes, which always attracted a lot of press attention, and for a whole new outfit, which somehow always went unnoticed. As budget day nears, there is increased security at the finance department since a leak of the sales tax increase, for example, would provide an unfair advantage. Our family was in the process of buying a new car, and I had to ensure that the purchase occurred after the budget to avoid the allegation that I was benefiting from my knowledge of it.

When the Brinks trucks bring the budget over to the legislature, the adrenalin rush begins. Budget day is a whirlwind of activity. Early in the morning the press is briefed for more than an hour by the finance officials, whose role is to "sell" the budget. Waiting anxiously in my office to see if the budget is selling, I'm hooked up to communications officials on the scene, who report on early reactions. Then, after the finance briefing, the officials come to my office, and John Wright, displaying his years of experience at the game, says, "Minister, here's where they're going to come at you ... and here's your comeback." Then at 10 AM it's my turn. The Minister's Press Conference, with all cameras and tape recorders rolling, is a free-wheeling exchange in which the press asks anything and everything – it is a test of the minister's knowledge and conviction. Many of the clips in the evening news will come from this event. Next, it's back to the office, where fellow ministers visit, some bringing flowers and others, best wishes – most acting as if I'm preparing for a funeral more than a wedding. The budget speech itself is a performance to a packed legislature with full media coverage, that you simply have to execute well, since it's when all the work comes together. I especially wanted to do well since my two sons were in that audience. Standing in the legislature, I felt determined and confident, knowing that behind me was a caucus in which the knives had been set aside and a team was united with a common goal. More than anything, as I delivered that speech I was speaking to the people of Saskatchewan, because I had faith in them – in my heart I felt they would understand. As soon as I took my seat, a page handed me a note: "Janice, Beautifully and effectively done. It couldn't have been better delivered. I'm proud of you. Ed. T."

Selling the budget is almost as important as crafting it. After the opposition had had its say, there was a rush to the rotunda for a bevy of interviews with local and national media, which took up most of the afternoon,

followed by a visit to the reception held for the financiers who had flown in from New York and elsewhere, a thank-you speech at the finance party, and back to the office to scan the media reaction and prepare for the next day's question period. Defending the budget in the legislature was actually fun and easy. The Conservatives had created the mess, so they were easy to discredit; and to any other critic of a particular cut or tax increase, the answer was simple: "Okay, if you don't want to do that, what other measures would you take to find the money to balance the budget?" Immediately after question period, the ministers fanned out across the province with prewritten speeches and prearranged press events, while the MLAs, with their budget kits in hand, prepared to return to their constituencies to give speeches and write local newspaper columns. There were ads in the newspapers, fliers with budget details dropped off at people's homes – all organized and planned with one goal in mind: to convince the people of Saskatchewan that we had a plan for a balanced budget that would put today's misery behind them and create a better future for their children. Behind the whole communications exercise was the idea that in the seven to ten days after its delivery, a budget is branded. The public's image of it gels and is fixed; thus, the goal is always to repeat again and again the message that you want forever fixed in voters' minds.

Soon after its delivery, it was clear that Saskatchewan people had bought the budget's message. It is almost always a mistake in politics to confuse interest groups with the general public. Interest groups squawked. Business complained about the tax increases; municipal leaders warned about a tax revolt; the left argued that the government should not be cutting spending but should tax the rich and the corporations, and labour attacked the cuts to government employees and targeted tax reductions for business with the mantra, "It's Grant Devine's method of creating jobs and it didn't work."[42] Typical of the reaction on the street was Evelyn Jay, a retired schoolteacher and volunteer from Regina, who said: "I think we'll just have to live with it. I sort of feel that we've got to do something – we all know it. We're in this problem together and I think we really have to live with it if we're going to try to get rid of the deficit. Everybody has to suffer the consequences."[43] Jay's sentiments were confirmed in a public-opinion poll released in July in which 61 percent of respondents agreed that "the budget took steps that were going to lead the province in the right direction." Throughout our term in government, the highest scores in polls were for financial management.[44]

The press played a vital role in putting the fiscal problem and its solution to the public and in riding the roller coaster of the credit raters' reactions to the budget. Unheard of before 1993 were such features as extensive interviews with financial analysts and bond dealers, explaining in painstaking detail such things as credit ratings and why they mattered.[45] The press also

picked up on the extent to which the budget challenged traditional NDP views; for example, an article by Murray Mandryk under the heading, "Tough Times in Land of Oz," stated: "MacKinnon was brave enough to again wander into the haunted forest where many old friends of the NDP – some from the left-wing of the NDP caucus and some from groups like the Saskatchewan Federation of Labor – lie ready to ambush." Most editorials supported the budget. To cite one example, the local newspaper in Weyburn, a community that lost a major health-care facility because of budget cuts, editorialized: "MacKinnon and her government might be surprised at the extent of support among what may be a majority of citizens for the decision of this and several other provincial governments to say 'enough is enough' to deficit fighting that is pushing us all toward bankruptcy ... The government has probably earned an A for overall effort, as to the details, we all have our own choices and priorities."[46] The press was also very generous in its treatment of me. Mandryk wrote about "a focused minister with a focused message" as follows:

But at least there is a plan on paper ... something to give us some sense that there is a way out of this mess. That feeling of control has dominated this year's budget process ... She has been incredibly focused. As a result, an incredibly focused message has come out. It is a sense of control that we haven't seen in the Saskatchewan government in a long time.[47]

The press also dutifully picked up on the comments of outside financial experts to the effect that Saskatchewan was a trendsetter for other provinces. Coming from a small province that does not wield a lot of power on the national scene, Saskatchewan people beam with pride when outsiders praise their efforts. One external financier commented, "While all Canadian provinces face similar problems of large deficits and debt loads as well as high taxes, Saskatchewan is demonstrating leadership in finding and implementing solutions"; another said, "If every government in the country followed Saskatchewan's lead, Canada would be out of its fiscal difficulties by the middle of the decade."[48]

The judges that mattered most, for better or worse, were the credit-rating agencies, and in late April the premier and I, along with finance officials, flew to New York to continue our selling job. The officials had provided the agencies with all the financial data, but the agencies wanted to see the political leaders so that they could look them straight in the eye and test their mettle to stay the course and carry through on their commitments. As I sat in Moody's boardroom in New York's financial district, these influential credit raters asked the key question: "You have laid out a four-year plan with specific deficit targets, are you totally committed to meeting those

targets?" Summoning all of his determination, Romanow responded force-fully: "We are totally committed to meeting those targets. Look, we're politi-cians and these are public targets. How do you think we'll fare in the next election if we miss them? We are locked into meeting those targets." At that moment I realized that although there would still be some turbulent waters ahead for Saskatchewan, there would no longer be tidal waves that could sweep our feet from under us, because the premier believed what he had just said and so did the credit raters.

The headline "Bond Raters Back Regina" said it all. News that the two major American credit-rating agencies and Canadian Bond Rating Services had confirmed our credit rating was only the beginning of the good news from the financial community. When Salomon Brothers, a New York finan-cial agency, ranked the Canadian provinces according to the outlook for their credit, it put Saskatchewan first, with the comment: "The province most beleaguered by the rating agencies also is the one with the most impressive attempt to attack its fiscal problems."[49] The provincial auditor declared that Saskatchewan "now has the best record on deficit control in the country," while headlines such as "Sask. Gets Good Marks" and "Sask. Debt Plan Lauded" reflected both the positive news from the financial com-munity and the level of interest in the province.[50] In a remarkable exchange, when one Regina reporter argued that the province's fiscal performance was not really as impressive as suggested by the Toronto-based Investment Deal-ers Association of Canada, its vice-president, Ian Russell, wrote a stinging public letter, stating that "Saskatchewan, well before all other Canadian provinces, recognized the need to reduce spending to sustainable levels" and accused the reporter of having "his head firmly stuck in the sand."[51] And in July 1993, Dale Eisler wrote a column headlined "Breathe a Bit Eas-ier, Saskatchewan," in which he reported that when the province went to New York to sell its bonds, the issue sold out in a day. A Wall Street analyst explained: "Investors are responding to the province's fiscal strategy ... Investors ... see it [Saskatchewan] as having addressed its fiscal problems and believe they are getting a slight advantage by buying Saskatchewan bonds." Eisler continued: "The bottom line to all this is that the debt noose around our necks has been loosened. There is reason to believe the fiscal sit-uation is getting better, not worse. At least that's what the people who bought $500 million worth of our bonds this week thought. And they should know. They're the judge and jury."[52] Eisler would have been even more impressed had he known that less than four months earlier Saskatchewan had had great difficulty even selling its bonds. How quickly life changes in finance and in politics!

The 1993 provincial budgets in Saskatchewan and other provinces did not only challenge established financial practices in Canada but also took on

traditional ideas about politics. Long-established beliefs that more was better and that Canadian people lacked the courage and vision to see beyond today's needs were proved wrong. Canadian people showed, as they had in the Second World War, that if they can be convinced that sacrifices today will bring a better tomorrow for them and their children, they will rise to the challenge.

The extent to which traditional ideas about politics turned on a dime in 1993 was revealed in an exchange between me and Garry Aldridge, the premier's chief of staff. A few weeks before the budget, Aldridge had said to me, "Look, the premier is out of all of this stuff about the budget. It's bad news and you know that premiers don't do bad news; ministers do, so from now on the budget is all yours." I said, "Fair enough," and went along my merry way until 29 March, about ten days after the budget, when *Maclean's* carried a feature on provincial budgets with two large colour photos of me. Aldridge asked me, "How come your picture's in *Maclean's*? You know that if there is positive media coverage the premier does it, not the minister." "I know, Garry," I replied, "but remember this budget is bad news."

The year 1993 was a turning point for Saskatchewan and other provinces. It was the year in which difficult decisions were made at the provincial level to reverse the course of growing deficits and debt. The 1993 provincial budgets captured national attention, with a great deal of interest being shown in the different ways in which the various provinces tackled their deficits. A common approach was to compare Saskatchewan and Alberta – two deficit fighters, one right wing, the other left wing – to determine the points of departure between the two and to assess which would provide a better model for the federal government as it began its own trek down the deficit-reduction road.

Differing Provincial Approaches to Deficit Reduction

The images could not have been starker – Alberta flexing its muscles, Saskatchewan sugaring its medicine; Alberta cutting, Saskatchewan taxing; the Alberta Advantage of lower taxes counterpoised with the Alberta Disadvantage of the social "outcasts."[1] In the 1990s, as provinces attacked their deficits and redefined what voters could expect from their governments, Alberta and Saskatchewan, as two of the leaders in deficit reduction, were often contrasted as being polar opposites. What were the differences between the approaches taken by right-wing Alberta and left-wing Saskatchewan? When it came to rewriting political science texts about what government should and should not do, it was apparent that all governments in Canada travelled similar paths. More united them than divided them. But there were major forks in the road, such as differing ideas of what constituted fairness, and there were profoundly different attitudes toward the poor and the social safety net. The Alberta deficit-reduction plan got most of the ink, but was it an approach that could be exported to other governments in Canada?

At federal-provincial finance ministers' meetings, while the rest of us appeared overburdened by our struggles with the deficit, Alberta Treasurer Jim Dinning could be heard enthusiastically preaching the religion of restraint. Coming from the most unabashedly right wing of Canada's provinces, Dinning could speak of downsizing government and cutting spending with a missionary zeal that sounded like a foreign language in most provinces. While Saskatchewan drew on its history of cooperation, community, and compassion as a source of strength in a fiscal struggle that was seen as harsh and unrelenting, Alberta's heritage of individualism and its strong entrepreneurial culture meant that its leaders could feel, in Dinning's words, "a sense of pride and accomplishment" in slashing spending while at the same time preserving Alberta as a low tax haven for entrepreneurs.[2] Alberta's political culture, then, was fertile ground for an aggressive

form of deficit reduction that could not flourish in the more barren soil of other provinces.

A picture in *Maclean's* of Alberta Premier Ralph Klein proudly wielding a huge pair of scissors cemented the popular image of Alberta as the champion in cutting spending. But what about the facts? In the mid-1990s, the extent to which Saskatchewan cut spending was masked by the spiralling growth of interest costs and the offloading of responsibility for off-reserve Indian welfare onto the province, which happened later in Saskatchewan than elsewhere. In 2000, when academics analysed the data, they were surprised to find that in fact spending had been cut most dramatically in Saskatchewan. According to economist Paul Boothe, although Saskatchewan did raise taxes, the revenue increase was minor, at 8 percent over four years, relative to spending cuts of 20 percent, which exceeded those in Alberta.[3] Necessity not ideology dictated Saskatchewan's choice. Cutting had to go deeper in Saskatchewan because its fiscal crisis was worse. Also, the bases from which cutting began were different.

Dinning, though well liked by his fellow finance ministers, tested their patience when he waxed eloquent about the Alberta model, since all knew that there was a world of difference between shedding hundreds of millions from a well-padded Alberta budget and trimming spending in already lean provinces, such as Saskatchewan and Newfoundland. Oil and gas revenues that had climbed to almost $1,000 per capita in the mid-1990s put Alberta in a league of its own. Dating back to the 1950s, Alberta governments had always talked a good line about limiting the size of government, but in fact Alberta led all of Canada in spending per capita. Only Alberta could afford both low taxes and a rich array of health, education, and other programs.[4] Cutting the Alberta civil service in the 1990s has to be seen in the context of its growth from 18,648 in 1971 to 32,729 in 1982 and the fact that in 1991 Alberta had twenty-eight civil servants per thousand people, while the Canadian average was twenty.[5] Because programs were so rich and the civil service so ample, Alberta could make drastic cuts more easily than other provinces. This point was highlighted in 1993, after both Saskatchewan and Alberta brought down their cost-cutting budgets. Per capita spending in Alberta was still $800 higher than in Saskatchewan.[6]

A final way in which Alberta is in no sense a typical Canadian province is in the size of its debt. Although Alberta had a sizable deficit with which to grapple, its debt per capita in 1996 was $4,505 per person, while Saskatchewan's was $13,198 per person.[7] At the same time, Alberta was in the unique position of having the assets of the Alberta Heritage Trust Fund, which had been begun in the 1970s to invest windfall revenues from oil and gas. "At the beginning of the 1990s," according to economist Bradford Reid, "the accumulated stock of outstanding debt was matched by the financial

assets residing within the Alberta Heritage Trust Fund, leaving a net debt of approximately zero."[8]

With its entrepreneurial political culture, its exceptional bounty of oil and gas revenue, its low debt and a high spending base, Alberta was uniquely positioned to come out with all guns blazing in favour of spending cuts rather than tax increases. Other provinces, whether they liked it or not, had to raise taxes as well as cutting spending to balance their books. Even the claim that Alberta did not increase taxes has to be qualified. Various user fees were increased to the tune of $81 million, seniors' tax deductions were reduced, and there was a 20 percent rise in Alberta health-care premiums, which are not tied to use of the health-care system but are, in effect, taxes by another name.[9] Alberta has no sales tax, while Saskatchewan has no health-care premium, and the cost of each to taxpayers is similar. In 1995, when Saskatchewan's sales tax was at 9 percent, a family of four with an income of $50,000 paid $920 in Saskatchewan sales tax, while a similar Alberta family paid $780 for its health-care premium. In 1997, when Saskatchewan's sales tax was lowered to 7 percent, the Saskatchewan family paid $715 in sales tax, while a comparable Alberta family paid $816 for health-care premiums.[10] In fact all provinces, no matter what the rhetoric, used taxes – in the broadest sense of taking more money out of taxpayers' pockets – to balance budgets. The differences were in degree, not in kind.

The use of tax increases in Saskatchewan reflected a fundamentally different definition of fairness from that of its neighbour. Alberta's budgets were seen to be fair when the cuts were spread across the board, with no exceptions. The goal was to attack the sin of overspending, and since all departments of government were guilty of the crime, all had to live with the consequences. For the Alberta Conservatives there was a rectitude to what was being done – government was being shrunk to its right size and being made more accountable, which was a noble undertaking. Fairness within a right-wing framework means treating everyone more or less equally, without taking account of the fact that people are not equal in their circumstances. A 5 percent cut in welfare benefits is going to be a lot more painful than a 5 percent cut in money for economic development.

Spending cuts inevitably hurt the poor more than the rich. A 1994 economic analysis showed that people in the lower half of the income ladder benefit from government spending, while those in the upper half pay more in taxes than they receive in benefits from government programs.[11] By focusing almost exclusively on spending cuts, Alberta was inflicting the burden unequally, with the poor, the vulnerable and the disadvantaged bearing a disproportionate share of the load. Albertans themselves understood this reality, as a 1995 poll showed. When people were asked who benefited from the government's budget-cutting choices, there was only one

group clearly identified as winners: 58.9 percent of Albertans believed that big business won from the choices made. Albertans were equally certain about the losers: 79.7 percent believed that college and university students were losers, 79 percent thought senior citizens lost, and 74 percent thought that the poor lost.[12] The sense that there were obvious winners and losers was reflected in greater internal divisions within the province, which resulted in angry protests over the choices made.

In Saskatchewan, necessity not ideology was driving the choices, and fairness meant that everyone had to share in the sacrifice. There was no joy in the task of redefining the role of government through massive cuts to programs that directly affected people. Budget cutting was seen as a painful exercise, in which fairness meant pulling together and ensuring that every group shared at least some of the load. Increases in the sales tax or the gas tax were driven by necessity: they were simply ways to raise money.

The high-income surtaxes imposed in Saskatchewan's 1992 budget were implemented in the name of fairness. By placing a special tax on those in the upper echelons of the income ladder, we were making a fundamental point that everyone had to share in the pain. The thinking was that we were all in this boat together and were all going to have do our share of heavy rowing to get out of the troubled waters. The NDP government in British Columbia took the notion of fairness a step further when, on top of an income surtax, it added a new tax on luxury cars and expensive homes, with the argument that "those most able to shoulder the heaviest burden" should pay more.[13] Even some members of the business community accepted the idea that fairness involved taxing those who could most afford to pay. In 1993, when Saskatchewan's sales tax was raised from 8 percent to 9 percent, a Regina business leader, Don Black, said, "Frankly, a one percent increase in the sales tax isn't going to hit me as hard as it will hit lower-income earners," and he went on to suggest that another surtax aimed specifically at high-income earners would have been fairer.[14]

Raising surtaxes in the name of fairness was a harder message to communicate than the Alberta approach. Alberta's message was clear and simple: we're cutting spending because we believe in smaller government, and we're not taxing because we're committed to making the province grow through lower tax rates. Our message was more convoluted because we had to balance the ideal of fairness with the reality of the need for competitive tax rates in a global economy. Sharing the pain involved imposing high-income surtaxes until the budget was balanced. In the long run, the global marketplace in which we all operated would necessitate lowering the same taxes so that Saskatchewan could retain and attract the highly educated, skilled people needed for success in the knowledge-based economy. Juggling fairness and competitiveness was not as simple as merely choosing one over the other.

The difference in the Alberta and Saskatchewan deficit-reduction strate-
gies was reflected in the nature of the opposition in the two provinces. In
Alberta, Ontario, and British Columbia (after the election of the Campbell
government), where cost cutting was the focus of deficit reduction, the
anger was visible and pronounced, as public demonstrations and protesters
were featured on the front pages of newspapers and were the lead stories on
the evening news. Although the protests had no effect on the electoral
prospects of the governments involved, it is noteworthy that in both Alber-
ta and Ontario, as soon as the budgets were balanced, there was a major
reinvestment in sensitive areas that had been cut, such as health care.

In Saskatchewan, where the main opposition came from those against tax
hikes, tax revolts were the most serious weapon used to pressure the gov-
ernment. When Saskatchewan's sales tax was raised to 9 percent in the 1993
budget, businesses on the west side of the province complained bitterly,
with some justification, that they could not compete with neighbouring
Alberta communities in which there was no sales tax. A survey of small
businesses in 1995 showed that 58 percent of west-side businesses saw
cross-border shopping as a major problem;[15] a coalition of businesses was
formed to pressure the government, and the small community of St Walburg
went a step further in announcing its intention to stop collecting the sales
tax.

Though the antitax coalitions were more subtle and subdued in their tac-
tics than the angry protesters in Alberta or Ontario, the decision by St Wal-
burg to discontinue its tax collection required firm action. Accordingly, on
the evening of 26 July 1993, I had a closed-door meeting with the main busi-
ness and community leaders of the pretty little town. My focus was on the
tax auditors who would be coming into their community. Failure to collect
taxes was against the law, and as soon as it was established that the law was
being broken, government tax auditors would stream into the community to
scrutinize the books of the various businesses for at least the last ten years.
I added that there might, of course, be prosecutions and fines for back taxes
not properly collected. As the implications of being the focal point of a team
of tax auditors sank in, the business leaders proposed a compromise: they
would continue to collect taxes as long as I promised not to sic the auditors
on their community. Tax protesters like those in St Walburg were in reality
law-abiding citizens, who would concede in private that they understood
the province's fiscal plight. In 1993 they may have lost the battle, but in 1997
they won the war when the government, in a surprise move, dropped the
sales tax from 9 percent to 7 percent. Like Alberta, Saskatchewan moved to
cover its weakest flank as soon as its fortunes improved.

Across Canada opposition parties had a difficult time attacking the cost-
cutting agenda of the various governments. When under attack for cutting

a particular program or raising a specific tax, the standard and very effective response from governments was: "Fine, if you don't like these choices to balance the budget, where exactly would you find the money to eliminate the deficit?" Once the public and the press accepted the idea of a bottom line, a limit to what governments could spend, the nature of opposition changed dramatically.

It is no coincidence that the era of deficit reduction was the time when NDP fortunes declined. In the 1970s, when the NDP could play the role of trailblazer for the Liberals by being advocates for more – more social spending, more health-care benefits, more public ownership – the NDP had prospered. By the 1990s, when voters knew that such a policy was not realistic, NDP rhetoric seemed out of date, its promises rang hollow, and voters began to turn elsewhere for more practical choices.

The problems New Democrats had in persuading social activists and public-sector unions to find innovative ways to tackle the fiscal crisis was illustrated by the failure of Ontario NDP Premier Bob Rae's social contract experiment. In 1993 the Rae government's deficit reduction plan called for a $2 billion cut to the civil service. Achieving the $2 billion reduction through across-the-board cuts would have meant that 40,000 Ontario public servants would lose their jobs, and because of the unions' seniority-based system, the most junior – often the youngest and the part-timers, who were predominantly women – would be the first to go. Instead of the government unilaterally cutting, Rae proposed a social contract, in which the union leadership would be invited to participate in a joint decision-making exercise to cut spending by $2 billion while minimizing job losses for those on the public payroll, and minimizing service cuts to Ontario people. No doubt it was a tricky proposition for the unions, since it struck at the heart of collective bargaining. But it was also an opportunity for the unions to share decision making and seek a solution to the fiscal crisis that would be fairer than major job losses for its most vulnerable members.[16]

Rather than getting co-operation, Rae was subjected to lectures, protests, and screaming matches, which reflected the failings of the Canadian left in dealing with the deficit crisis. The problem was exemplified in labour leader Bob White's tirade delivered to the three NDP premiers – Rae, Harcourt, and Romanow: "Why the hell should working people see all their benefits and everything we've been fighting for all these years go down the drain because you guys have bought into this new-conservative economics. You're elected to fight for our people, not to stick your nose up Mulroney's ass." Labour leaders like White, by denying that there was a fiscal crisis, shirked any responsibility for helping NDP governments cut spending to reduce the deficit. As Rae explained, the standard left-wing response to his warning that his government would hit a fiscal wall if action was not taken

was: "That's not a wall, it's a door, or even a window; don't be such a dupe
to the right, we can always borrow to meet the deficit; the deficit is not a real
problem, it's a manufactured problem that you shouldn't be worrying
about."[17] By perpetuating the notion that the fiscal crisis was a phantom
conjured up by right-wing governments, the left in Canada made a funda-
mental strategic choice. In the 1990s fiscal crisis and the massive restructur-
ing of Canada that ensued, the left had relegated itself to the status of
bystander.

Meanwhile, despite differences over taxes, many common themes
emerged as the provinces redesigned government. The budget-cutting exer-
cise of the 1990s was similar to a household finding itself short of cash. Like
the household, governments were forced to prioritize and work toward a
bottom line. Cabinet ministers had to sit down and ask themselves which
spending was expendable and which was essential to the current health and
long-term well-being of their provinces. Redefining government, refocusing
its role, and rethinking its limits was an exercise that occurred from coast to
coast, and it was the most important beneficial long-term change to come
out of the deficit-fighting era.

When provinces began down the long road of cutting spending, all began
with visible cuts at the top. Cabinet ministers' salaries were cut, communi-
cations budgets were slashed, and the size of cabinets and caucuses was
reduced. Leading by example was an important part of persuading the pub-
lic to accept cuts. Although the dollar savings from such visible cuts at the
top were miniscule, they were important symbolically. The average person
could understand something as straightforward as a pay cut, and if people
were going to suffer they wanted to know that their elected officials were
sharing in the pain.

Streamlining the delivery of services was also a common theme. Gov-
ernment bureaucracies had grown, over the years as new programs had
been added to the existing mix, with no clearly defined sense of cost effec-
tiveness and a bottom line. Administrative costs were often high. And too
often government departments had developed a gatekeeper mentality, see-
ing it as their role to police their client groups and enforce a dizzying array
of regulations. The new focus in the 1990s was to make government more
efficient, service oriented, and accountable. Overlap and duplication were
attacked, administrative costs were reduced, and the ideal was of a public
service working in partnership with client groups in the community to
achieve the desired outcomes. By focusing on the results, some (though not
all) governments became more flexible and imaginative in deciding how to
achieve the desired results. In Alberta, for instance, all government depart-
ments were required to develop three-year business plans, with specific
performance targets that could be measured and for which the depart-

ments could be held accountable.[18] Other governments followed suit in requiring that the public service develop clearly defined and measurable goals and be held accountable.

Across-the-board cuts to the pay and benefits of public servants were also common. Quebec legislated a two-year wage freeze, while Alberta rolled back public-sector wages by 5 percent. Manitoba forced civil servants to accept "Filmon Fridays," fifteen days off per year without pay (so named for premier Gary Filmon). All provinces dramatically reduced the size of their civil service, and most tried to cushion the blow by supplementing dismissals with early retirement schemes.[19] The effect on the civil service was traumatic. In the short term, morale declined. In the long term, the virtual freeze on hiring meant that a whole generation of new thinking will be almost entirely lost, and the declining prestige of the public sector will be a challenge to governments as they seek to replace retiring baby boomers.

Moving beyond promoting efficiency to experimenting with innovative ways of delivering services represented an ideological fork in the road. Alberta privatized services previously run by government, such as liquor stores, while New Brunswick tried private-public partnerships to deliver public services in new ways. NDP governments, with their close ties to public-sector unions, did not venture into such territory. In Saskatchewan, for example, there were no public-sector wage freezes, rollbacks, or unpaid days off; although job losses occurred in the public sector, members of public-sector unions who retained their positions escaped the deep cuts experienced in other areas.

A defining feature of NDP governments was their unquestioning belief that public services had to be delivered by the public sector. Yet the cost of paying for these services increased dramatically in the 1990s in Saskatchewan and British Columbia. Public-sector salary settlements in Saskatchewan during this period usually exceeded inflation; benefits were enhanced, earned days off preserved, and salary settlements were enriched by adding pay equity adjustments into the mix.

The cost of government services was increasing, not because of service enhancements but because of salary settlements. Thus, the Saskatchewan government announced in its 1999 budget that more than 190 million new dollars were being spent in health care; but since almost all the new money was going to public-sector wages in one form or another, the public was left bewildered as to why so much more was being spent with no discernible improvement in the health system.

Because of a similar approach in British Columbia, the scene was set for the cash-strapped new Liberal government of Gordon Campbell, elected in BC in 2001, to save significant dollars by shifting the delivery of services from the public to the private sector. The greater the gap between the salary

levels of public-sector employees and wage rates for equivalent jobs in the private sector, the more likely it is that a right-wing government will see enough financial benefit to take on the fight to move jobs from the public to the private sector.

The whipsawing back and forth from public- to private-sector service delivery under right-wing and left-wing governments does not help voters, who want the best possible services at the most affordable costs. Just as voters should be suspicious of governments committed to the ideology that public-sector service delivery is of itself an unquestionable virtue, they should also be skeptical of the view expressed by Premier Klein that "a large central bureaucracy is an inefficient way of delivering public services" – a remark that reflects an ingrained bias against public-sector service delivery.[20]

The preliminary report of the commission headed by Senator Michael Kirby examining medicare made an important point: rather than squabbling over whether the public or private sector delivers services, the focus should be on the outcome – the quality of the services being delivered, an idea supported by Canadian voters.[21] Taxpayers should demand that governments follow this advice. The role of the government should be to focus on the end result – quality and affordable services. Beyond this, governments should establish the parameters and standards for the services to be delivered, should ensure an open, accountable decision-making process, and then be broad-minded and imaginative in deciding the most appropriate vehicle to use in delivering a specific government service or program.

Despite parting company over service delivery, governments of all stripes passed legislation to try to limit the ability of future governments to rack up huge deficits and debts. It was impossible to be a finance minister in the 1990s and not conclude that being forced to make decisions in a crisis led to terrible mistakes. Too often, especially in Alberta and Ontario, where there is an ideological predisposition to reduce the presence of government, spending was reduced by a set amount without the full implications of such decisions being analysed. Premier Klein admitted that in Alberta dramatic cuts were made to health care without a vision of what the new system would look like.[22] In Ontario, the Walkerton tragedy, where people died from drinking unsafe water, was a terrible example of what can happen when services are cut without fully considering the consequences. A less tragic example was the decision of Glen Clark, as British Columbia's finance minister, to experiment with tax fairness by increasing property taxes for homes valued at more than $500,000, without taking into account the fact that some of the homeowners were seniors of modest means, whose homes had appreciated in value only because of the skyrocketing price of housing in Vancouver.[23] All provinces that trimmed health care budgets would prob-

ably like to revisit their decisions to cut funding for the education and train-
ing of doctors, nurses, and other health care professionals. Current and
future shortages date back to those decisions made in haste under the pres-
sure of runaway deficits and tumbling credit ratings.

Virtue cannot be legislated; nonetheless, governments can use legislation
to warn voters when public finances are moving into troubled waters. This
was the aim of government legislation in the 1990s – to ensure both open-
ness in accounting for public finances and limits on government's freedom
to spend and move around public funds. Accounting may appear boring,
but we ignore it at our peril. In the 1980s part of the reason why public anx-
iety about overspending had not been as acute as it might have been was
that accounting obscured the problem. Crown agencies that spent govern-
ment money did not always report their results to the public. In other cases,
financial reports were delayed for literally years and were therefore out of
date by the time they were released. Accounting changes were used to hide
financial problems, and governments had a lot of freedom to move money
from one fund or agency to another, thereby masking the true dimensions of
cash shortfalls.

In the 1990s accountability for public finances improved dramatically. All
government agencies were required to make regular and timely public
reports; many provinces moved to an accrual accounting system, which
meant that public costs had to be recorded as soon as commitments were
made, rather than allowing such expenses to be moved forward to some
future date; and all provinces moved to "summary financial statements" – a
single financial statement that included the financial results from all gov-
ernment agencies. The latter was extremely important in preventing gov-
ernments from hiding deficits by moving money around among different
government agencies. The importance attached to accounting methods was
reflected in *Red Ink*, published in 1995 by the Canada West Foundation,
which evaluated the accounting methods of the provinces. While Quebec,
British Columbia, Nova Scotia, and Prince Edward Island received failing
grades, Saskatchewan topped the class with 85 percent for financial state-
ments that were "very 'reader-friendly' and clear." At least in future, tax-
payers would be fully aware of their government's fiscal situation.[24]

Several provinces introduced balanced budget legislation as a preventa-
tive measure. The most stringent legislation, which received an A+ from tax-
payers' associations, was Manitoba's; it required that budgets be balanced
every year unless there was either a natural disaster or a decline of more
than 5 percent in revenue, and the penalty for an illegal deficit was a 20 per-
cent pay cut for ministers. At the other end of the spectrum, an F was given
to New Brunswick for legislation that merely stated the objective of balanc-
ing the budget over a four-year time frame. Alberta and Saskatchewan

tailored their legislation to concerns specific to their respective provinces. Alberta outlawed deficits, legislated that all budget surpluses at year-end must automatically be applied to debt reduction, provided that a sales tax could only be introduced after a referendum, and forced governments to use energy estimates based on the average price of energy for the past five years, the goal being to prevent future governments from using optimistic energy price estimates to hide a deficit.[25]

In Saskatchewan, our legislation, which was drawn up over the very logical objections of the finance department that we should not be tying the hands of future governments, required balanced budgets over a four-year cycle, but its most interesting provisions were attempts to close the gate on practices that had led to the fiscal mess. Changes in accounting had led to $800 million in hidden deficits, so the legislation stated that if a government changed its accounting method during a four-year cycle, the calculation of whether or not there was a deficit would be based on the original accounting method. To end the practice of cash-strapped governments selling major assets and then spending the money, the legislation stated that if an asset was sold, the money could not simply be spent but would be applied to debt reduction. Theoretically, these changes, along with the new accounting controls, should mean that future governments will return to deficit financing at their peril. However, it will ultimately depend on the vigilance of the public. If voters return to the time-worn tradition of expecting governments to be all things to all people, then no amount of legislation will prevent a drift back into deficits.

The idea that governments could no longer be all things to all people was the most important long-term change to come out of the 1990s. For too long, particularly in Saskatchewan, with its history of big government, the government had extended its sway without the question being asked: What should government do and what should be left to other agencies or become the responsibility of individuals? In wrestling with this issue, there was ground common to all provinces. In May 1994 Premier Ralph Klein outlined "the five core businesses" on which the Government of Alberta would focus. It is interesting to see in which areas Saskatchewan supported Klein's view of government and where the fault lines emerged.

His first point, that Alberta "will invest in people and ideas," would be supported by all governments, since education is as popular as motherhood, and it is especially important in the current knowledge-based economy. As the number of jobs that depend on muscle and brawn plummet, there is a corresponding growth in opportunities that require well-tutored minds. Of all the jobs that government should do well in the twenty-first century, developing an educated, skilled workforce should top the list, and it should be closely followed by investing in ideas. To succeed in the new economy

will require significant investment in Canadian research so that we can begin to close the productivity gap with other major industrialized nations. In a world in which the best new technology will win the day, investing in research is essential. So where did the dollars in this area go? While Saskatchewan cut education by 19 percent over a four-year period, Alberta made cuts of only 4 percent in this vital area – though the Alberta figure is misleading, since the main tool used to cut spending in social services was to move welfare recipients into training programs and pay them out of the education budget.[26] Nonetheless, there is no evidence that right-wing governments cut education more drastically than their left-wing counterparts. Moreover, Alberta has an enviable record as being a leader in health-care research.

The second role for government, according to Klein, was to "build a strong, sustainable and prosperous province." This umbrella covered two other tasks of government with which all provinces would agree: maintaining law and order, and financing a quality infrastructure that includes highways, telecommunications, and utilities. In explaining how to strengthen the economy, Klein's approach marked a clear departure from the practices – if not the rhetoric – of the 1980s when he said, "Governments do not create jobs – the private sector does ... The role of government is to create the economic climate in which businesses, large and small, can flourish." In financial terms, all governments made their biggest cuts in the areas of economic development.[27] Gone were the days of megaprojects, grants for business start-ups, and direct investments in specific business ventures.

There was, however, a fundamental difference between Alberta and Saskatchewan. Jim Dinning was very clear in his budget speech that the Alberta government was turning its back on the past and would no longer be playing a significant role in economic development. "We have learned our lesson," he said. "Government cannot stimulate the economy with quick fixes ... we are getting out of the business of direct business subsidies."[28] In Saskatchewan, although megaprojects were declared a thing of the past, and the new language of economic development (where government's role was to create the right climate for investment) was used, there was no explicit commitment to take the government out of the role of picking winners and losers. Fiscal restraint meant that there was no money to invest in business ventures in the 1990s, but what would happen when the good times returned? The door was left open for New Democrats, with their history of using government as a major player in the economy, to return to the practice of making direct investments and picking winners and losers.

Health care was another vital area mentioned in Klein's speech, and here the similarities among provinces were more important than the differences. The 1992 report, *A Saskatchewan Vision for Health: A Framework for Change*,

drove health-care reform in Saskatchewan, and it has been considered "instrumental in shaping the health reform initiatives undertaken in both Alberta and B.C."[29] Change was driven by skyrocketing costs in a system that represented the largest single responsibility for every province. The first major change was in governance. In Saskatchewan, four hundred hospital and other boards were consolidated into some thirty regional health districts, with the power to make key operating decisions in their area. Allowing boundaries to be determined at the local level was designed to foster more local participation in the changes; but in the end, Alberta's choice of seventeen health districts and New Brunswick's eight were more realistic than Saskatchewan's thirty.[30] Health districts allowed for more integration and coordination, since all health-care facilities were under one board, which had the power to eliminate duplication and find cost savings through mechanisms such as joint tendering of services. There was also a shift in funding toward a more needs-based approach, in which funding to districts was based on an assessment of the needs of the population in terms of age and other factors. As money was cut from acute care – hospital beds – it was enhanced in home care. Also, health promotion and prevention were major components of the reform. Not only were there major similarities in health-care reform in all provinces, but there were no major differences in the level of cuts between left-wing and right-wing provinces; in fact, if anything, Saskatchewan cut health-care funding more than Alberta.[31]

In the current debate about the future of medicare, there is a tendency to paint a major divide between right and left, as if some governments in Canada support medicare and others seek to undermine it. This is more an exercise of myth making than of fact finding. In fact Ontario, under the Conservative government of Mike Harris, was usually near the top of the list of governments funding health care; and, as just noted, Saskatchewan cut health-care funding more than Alberta.[32] Health care benefits the middle classes and especially seniors. I have been at many a cabinet meeting where ministers shudder at the electoral power of seniors. Seniors are growing in number; they vote; they are vocal, and as Brian Mulroney found out in 1986, they can be more effective than almost any other group in forcing a government to back down. Thus, both right- and left-leaning governments in Canada share the same aim: to provide a quality health system that is accessible to Canadians while still being affordable. The difference is in how they do so.

The most difficult part of health-care reform in the early 1990s was the closure of hospitals, as politicians across Canada faced the consequences of having been involved in all those wonderful ribbon cuttings for new hospitals. The problem was worse in Saskatchewan than elsewhere because politicians of all political stripes had made great hay out of opening hospi-

tals, some in communities where there were almost as many gophers as people. As a result, by 1991 Saskatchewan had more hospital beds per capita than any other province; while the Canadian average was 30.7 hospital beds per thousand, Saskatchewan had 77.9 beds per thousand. Although the many small rural hospitals were rarely used except in emergencies, they provided much-needed employment, as well as a sense of security that help was at hand, and they were important in keeping struggling towns and villages alive. But medical advances meant that procedures that had required weeks in hospital a generation earlier could now be done by day surgery. Also, the cost of the hospital beds was enormous: $1 million could be used to pay for 6 hospital beds, 30 nursing-home clients, or 427 home-care clients.[33]

Even so, the politics of closing hospital beds was devastating. I vividly recall the treasury board meeting, held on the eleventh floor of the finance building, at which the deputy minister of health was told that we had decided to close fifty-two hospitals. As he left, he said "After what you told me today, I might just as well go out the window." Soon afterwards, his minister, Louise Simard, was almost mobbed outside the Legislative Building for what was seen as her decision to close hospitals. After the 1993 budget that closed the fifty-two hospitals, cabinet ministers fanned out across the province to face the people affected by our choices. I remember being sent to Wynyard, a town east of Saskatoon. The crowd was sullen yet was resigned to a difficult but necessary decision. Years later, when I met some community leaders from Wynyard at the airport, they asked when I'd be back for another visit. They did not for one minute like the decision, but they understood.

The association of health reform with hospital closures and the protests that followed meant that as provinces' finances improved, they shied away from making other necessary changes to health care for fear of provoking another angry public reaction. In retrospect, we in Saskatchewan should have followed the minister of health's recommendation to make the cuts and close the hospitals first and then proceed with health-care reform. As Louise Simard said, health-care reform was forever tainted by its association with the closure of the hospitals. As a result, after Simard left cabinet in 1994, health-care reform stalled. Even though budget consultations in 1996 showed that there was public support for a movement toward primary health-care reform, we avoided going down that road because it would have meant tampering with the fee-for-service system by which Saskatchewan doctors were paid.

The biggest mistake of my political career was agreeing to put $40 million extra into health care in the fall of 1996. The press release left little doubt that the funding was designed to allow health boards "more flexibility to

manage the pace of health renewal."[34] But the subtext was that the government was so unnerved by the mounting protests over the bed and facility closures made at the local level by health boards that it had simply caved in and thrown money at the system. Worse, fear of dramatic changes such as more bed closures led the government to shift its message and actually discourage locally elected boards from making major changes. The combination of actively stalling reform, giving health-care workers increasingly generous salary settlements, and throwing money at the system was lethal. The system's voracious appetite for cash was whetted. Only more and more money would keep all quiet on the health-care front. By losing our courage to continue down the road to reforming health care, we were making the same mistake that Colin Thatcher lamented in his reflections on Devine's handling of agriculture. What we cherished most, we tried to preserve rather than change, and in doing so we jeopardized its future.

If health was not an ideological divide between right and left, social policy certainly was. "Compassion: The Defining Feature" was one of the major subheadings in my 1993 budget, in which I said: "This Budget requires sacrifice. But there are some in our midst who cannot be asked to sacrifice more; they have nothing left to give. Our strength as a society is reflected in our willingness to protect our weakest members."[35] The budget announced increased spending to address poverty, including increases in welfare rates. It was a fundamental belief of our government that cuts, no matter how well targeted and balanced by high-income surtaxes, hit the weakest and most vulnerable members of society the hardest; therefore the social safety net had to be strengthened. Contrast this view with cuts to social programs and welfare benefits in Alberta in the name of welfare reform; or the fact that the Klein government issued welfare recipients with bus passes to get them out of the province; or Premier Klein's comment that "people should take responsibility for themselves and their families."[36] Also, contrast the Saskatchewan approach with Ontario, where in the mid-1990s one of the first actions of Mike Harris's newly elected Conservative government was a 21 percent cut in welfare benefits, which saw 600,000 of Ontario's poorest citizens lose one-fifth of their income. Meanwhile, Harris's minister of social services advised the poor that they could economize by buying dented cans of tuna for sixty-nine cents.[37] Or contrast it with British Columbia, where Gordon Campbell's Liberal government in 2002 cut its spending on welfare by one-third, took single mothers with children over three off the welfare rolls, and ended bus passes for low-income seniors and the disabled.[38] Both the Ontario and British Columbia governments had preceded these announcements with major tax cuts for those well enough off to pay income tax. Attitudes toward poverty were what divided right and left, and the difference was as stark as night and day.

The right-wing view was reflected in Klein's speech about governments' core businesses, in which there was no mention of the need for governments to address inequalities, redistribute income, or promote equality of opportunity. This view represented a break with long-established Conservative policy. Traditional Conservatives saw society as an organic whole, composed of different classes and groups, where leaders had a duty to protect society's weakest members.[39] The new right of Margaret Thatcher and Ronald Reagan saw no such paternalistic role for the state. Their focus was on minimizing the state's role in order to protect individual freedom. The assumption was that all individuals were equally free, with no consideration being given to the differences in their circumstances and their capacity to exercise such freedom. In this view, welfare reform meant removing an intrusive state from the lives of welfare recipients and forcing them to take responsibility for their own lives. This approach assumed that people were on welfare because of some personal choice or because they were failures; that only harsh measures would move them off the dole; and that such treatment was just and right since they were not pulling their share of the load. As one writer put it, "The poor must pull themselves up by their bootstraps, change their ways, and get a job."[40]

Saskatchewan is an excellent example of the chasm between right and left over social policy, since it was a hotbed of right-wing welfare reform in the 1980s, while in the 1990s left-wing policies were implemented. Saskatchewan's social experiment was especially dramatic because of Grant Schmidt, who had been social services minister from 1986 to 1989 and was very outspoken. For example, he began his speech to the National Council of Women as follows: "I'm about to give a braless speech ... It has a point here, a point there and is shaky in the middle."[41] Known for telling welfare recipients that his wife could feed their family "on what I pay on welfare" and advising the poor to grow gardens, Schmidt continued to deny that poverty was a problem in Saskatchewan even as food banks flourished and children went to school hungry.[42]

At the heart of Schmidt's welfare reform was the assumption that the only way to get welfare recipients to work is to force them. The various work-for-welfare programs were mandatory – welfare recipients had to participate or lose their benefits. But when I was minister of social services, I found that work programs were always oversubscribed; the task was to find the right criteria to choose among the eager participants. The idea that people were being forced to work reflected a punitive approach, with politicians being tough on "lazy welfare bums." Although the work programs sometimes contained some worthwhile training, including literacy and resumé writing, they did not prepare people for long-term employment. They operated more as revolving doors. For example, many workfare programs subsidized

employers to hire welfare recipients for a mere twenty weeks, just long enough for the worker to qualify for unemployment insurance, which was paid by the federal government. Such programs were more about providing cheap labour to employers and shifting costs to the federal government rather than helping the unemployed. Also, there was often little relationship between the programs created and the profiles of the clients. The most effective and expensive Saskatchewan program was New Careers, a construction company that taught welfare recipients construction skills by building tourist and recreational facilities. But although this very costly program was worthwhile, it did nothing for the vast majority of people on welfare – single-parent women.

If governments really wanted welfare recipients to enter the workforce, then their actions were often counterproductive. Moving from welfare to work could be costly for people because wages were often not much higher than welfare benefits; and children, whose drug, eyeglasses, and dental costs were covered under welfare, lost these benefits when their parents entered the workforce. Also, there was no incentive to work part-time since whatever money was made from working was reduced from one's welfare benefits. In addition, the government actually made it more difficult for people on welfare to work by ending the free bus passes that had previously been available to welfare recipients and seniors. Schmidt's response to the question of how people on welfare were supposed to attend job interviews without bus passes was: "If one of my relatives had a job interview in Saskatoon and was on welfare, I would make sure that that relative got there, and I wouldn't ask the government for any money"[43] This said more about the mindset of Grant Schmidt than about the reality of life on welfare. And the right-wing version of family values, which presumed that the ideal woman was at home being a wife and mother, meant that the government refused to promote and finance more daycare, an approach that was at odds with its goal of getting single parents to move from welfare to work.

The other dimension of forcing people on welfare to work was cutting their benefits. As in other provinces, a distinction had been made in Saskatchewan between the deserving poor – the elderly or infirm, who it was assumed were not responsible for their woes – and the undeserving poor – able-bodied single people. When the Devine government cut the benefits for the latter group by 50 percent, a single male welfare recipient, Murray Chambers, took the government to court on the grounds that he was being discriminated against just because he was not married. When Chambers won his case, Schmidt commented, "I would think he would be better off using his energy looking for employment than looking for more government money," and he then proceeded to equalize the benefits between married and single people by cutting the benefits of married

childless couples so that they could join Chambers in his scramble to survive.[44]

The other main focus of right-wing welfare reform was weeding out fraud, a move that stigmatized and humiliated people. Since the Devine government apparently assumed that most people connived to defraud the system, it forced recipients to pick up their cheques rather than having them mailed – this, after their bus passes had been revoked. Unmarried women were especially badly treated. The goal was to identify a male head of the household who would be responsible for the cost of keeping the woman so that the government could be relieved of paying her welfare cheques. By the time I became minister, the system was almost obsessive in its search for "the man in the house." The departmental manual stood on its head the fundamental presumption that one is innocent until proven guilty when it advised case workers as follows: "In situations where a couple appears to be living common law, it is the client's responsibility to clearly establish otherwise."[45] To help find the man in the house and other kinds of fraud, the Special Investigations Branch, manned by former RCMP officers, was created. According to Harvey Stalwick, former director of the school of social work at the University of Regina, individuals suspected of fraud were not the only ones investigated. Those who spoke out against government policy were also "targeted for surveillance."[46] When I became minister and found the surveillance cameras and other equipment in the specially fitted-out vans that were used to spy on people, I wondered how such activities could be possible in a free and democratic society.

By the early 1990s the results of almost a decade of welfare reform in Saskatchewan were clear as studies of the effects of right-wing policies were documented. As early as 1984 the trend line had been established: while welfare rates had been a mere 10 percent below the poverty line in 1978, by 1984 they were 50 percent below the line for singles and 30 percent below for families. By 1988 the National Council on Welfare reported that 19.8 percent of the people of Saskatchewan were living below the poverty line, with only Newfoundland having a worse record. By 1992 Saskatchewan had gone from having one of the lowest child poverty rates in Canada in 1982 to having one of the highest, with one in five of the province's children growing up in poverty. The press, overwhelmed by the heart-rending experience of visiting burgeoning food banks and volunteer programs to feed hungry children, was calling for action in articles with such headlines as "Child Poverty in Saskatchewan Scandalously High." Clearly, welfare reform had failed totally in its goal to break the cycle of poverty.[47]

"If you give up on breaking the cycle of poverty," I said in early 1992 when outlining our very different social policy, "you're giving up on the future of Saskatchewan. It's a tough job, but we are committed to breaking

the cycle of poverty." I went on to explain that the provincial government could not do the job alone but had to work in partnership with other governments, non-governmental organizations (NGOs), and other groups in the community. Our focal point was clear: "We simply can't allow one child in five to grow up poor." As well as the cost "in terms of human potential," there was "the cost to the taxpayer," I explained: "Poor children have many more health-care problems than others. They have more problems in school, they are more likely to become young offenders, and the list goes on. Dealing with the poverty situation today will actually save us money tomorrow."[48] Immediate action included cost-shared funding for programs to feed hungry children, with local community groups providing their share through volunteerism.

Within months of our election, the main pillars of welfare reform were swept aside. The Fraud Squad (the name for the Special Investigations Branch) was disbanded, mandatory cheque pick-up was ended, the burden of proof in allegations was placed on the department not the client, welfare rates were raised, and work-for-welfare programs were changed. As the document outlining these changes said, "People who are forced to rely upon assistance would be treated fairly and with respect."[49] The differences in approach were highlighted in the handling of work programs. When I announced in December 1991 that Saskatchewan Works, the Conservatives' work-for-welfare scheme, was under review (to which the Saskatoon *Star Phoenix* editorial declared, "Good riddance to forced labor"), I outlined my objections to the program: "I don't see a lot of counseling. There's not an educational component. Often the training part is hard to find."[50] Its replacement, the Community Assistance Program, under which the government paid NGOs such as daycares and other non-profit community groups to hire welfare recipients focused on two goals. First and foremost, what benefits did the client get from the job? For instance, was there a training and counselling component? And were there prospects for a full-time job? Secondly, what benefits did the community get from the project? The differences were fundamental. While the Conservatives' programs had a punitive tone, since their goal was to force presumably reluctant welfare recipients into the workforce, our approach was to use the work programs as a vehicle to give people the tools they needed to do what the vast majority wanted – get a full-time job. Our target was modest: if 10 percent of those who participated succeeded in getting long-term jobs, we'd call the program a success. And the cost was high: $10 million. But as I said then and as I believe today, "In a province that has the sort of social problems we have right now, it's something that we can't afford not to do."[51]

Ironically, left and right agreed on the long-term social policy goal that we wanted to achieve; the parting of ways was over the route to get there and

over basic assumptions about why people were poor. Both right and left agreed that the welfare system too often trapped people in a cycle of dependency; thus, we all wanted to get people off welfare, and where humanly possible, into the workforce. We also agreed that we wanted people to take more responsibility for their fate and become more self-sufficient; for example, my 1996 budget speech said, "Our social safety net must also be there to protect people but it should never become a trap. Real pride and hope come with self-respect and self-sufficiency." Where we parted company was in our assumptions. While the right assumed that individuals were usually responsible for their own misfortunes, people like me believed that in the vast majority of cases there is a sad story that explains why people are poor. Similarly, while the right believes that people have to be kicked out of the welfare trap, I believe that most people on welfare would love to have a job if only they could get some help in making their way to that goal. Thus, the right used sticks while the left used carrots. And while the right was miserly with its cash, the left was more generous.

The difference was vividly revealed in the long-term programs that we initiated in Saskatchewan to deal with poverty, especially poverty among children. Many of the measures were preventative. In Alberta the Klein government cancelled funding for kindergarten, though the negative public reaction led to a partial reinstatement. In Saskatchewan we did the exact opposite. Children who were identified as being at risk of not doing well in school because of their family circumstances were enrolled in government-funded preschools. The idea was to identify problems early and treat them quickly and effectively, so that by the time children from a troubled situation reached kindergarten, they would be equal participants with the rest of the class. We expanded the community schools program, whereby schools in low-income neighbourhoods receive extra funding and additional resources to deal with the many social problems that prevent poor children from doing well. And we established the Children's Action Plan, a cross-departmental initiative that funded community programs that complemented our government projects aimed at reducing poverty.

While the right wing used the stick of cutting welfare benefits to get people to work, we used the carrot of removing the disincentives to work. We immediately began to allow people on welfare to get part-time jobs without having all the money clawed back through cuts in welfare benefits. We funded the Family Income Plan, which topped up the money that families earned from low-paying jobs so that they could afford to get off welfare. Our major achievement was the 1993 Child Benefit. As mentioned above, one of the main disincentives to leaving welfare was that children lost so many benefits: free prescription drugs, eyeglasses, dental care, and other important supports. The Child Benefit provided these benefits to low-income

children whether their parents were on welfare or not. The positive effects were twofold: parents could get jobs without losing welfare benefits, and all low-income children received better care.

The programs were supplemented by specific action to deal with the high poverty levels among aboriginal people, who comprise 13 percent of the province's population. Treaty land entitlements were settled with the effect that more than $400 million dollars was transferred from the federal and provincial governments to First Nations people to compensate them for land they had been promised but had not received when the treaties were signed in the nineteenth century. There were also concerted efforts to create economic development opportunities for aboriginal people. Casinos were developed in partnership with First Nations to provide more than a thousand jobs for their people and new sources of revenue for needy reserves. And a massive expansion of forestry in the 1990s was based on the principle that to gain access to forests for cutting, companies were required to have aboriginal business partners. As a result, the American forestry giant Weyerhaeuser signed its first ever partnership with three Saskatchewan First Nations bands. These and other initiatives designed to tackle the unacceptably high poverty rates among aboriginal people are further examples of using carrots rather than sticks to break the poverty cycle.

Looking back from the vantage point of 2002, the key question is, What worked best, the stick or the carrot? The answer is unequivocal. In 2001 the Canadian Council on Social Development compared the success rates of Saskatchewan, Alberta, and Ontario in reducing poverty. It found that in Saskatchewan in 1993, 50.9 percent of single-parent families lived below the low-income cutoff definition of poverty; by 1998 that number had been reduced to 19.9 percent. In Ontario the number of single-parent families living in what was defined as poverty had actually increased, going from 35.7 percent in 1993 to 36.2 percent in 1998, even though Ontario experienced strong economic growth during that period. In Alberta, despite the booming economy, the same poverty index had moved down only slightly from 43.9 to 35.8 percent. The other measure of poverty was the extent to which the income of poor families was below what was required to escape from poverty. In Alberta in 1993 the after-tax income of single-parent families was $5,430 less than the low-income cutoffs; by 1998 it had risen to $8,147. Similarly, in Ontario the gap had risen from $5,852 to $6,192. Only in Saskatchewan did the gap decline, from $5,976 to $4,124. The progress that Saskatchewan made in reducing poverty was related to the various programs to improve the lives of children, specifically the Child Benefit. As the economist for the Canadian Council on Social Development said, "The key Saskatchewan programs include a provincial income supplement and health benefits for low income working families ... They've really put quite

a lot of money into income supplements for families leaving welfare for work." It's amazing what constitutes "a lot of money": Saskatchewan had spent $37 million to top up federal programs, while Ontario (which is ten times larger) spent $106 million, and Alberta contributed a meagre $6 million.[52] Now that it's clear that carrots work, maybe governments can begin laying down their sticks.

The urgency of addressing poverty needs to temper ideas about restricting government's role to make it more strategic. The marketplace will always distribute its benefits unevenly; it is the task of government to lessen the inequities, since a growing gap between rich and poor harms us all in the end. The notion that "the poor will always be with us" may have made some hard-headed and hard-hearted sense in the early part of the century, when there were lots of menial jobs to be performed. But in a knowledge-based economy, where more and more jobs depend on tutored minds rather than strong backs, poverty is costly. One of the main indicators of both good health and education is family income. Thus, poverty means higher health-care costs, more money for welfare, jails, prisons, and other institutions, more violence, and more crime. How much wiser and more humane it is to invest the money upfront to tackle poverty, especially since we know we're going to pay anyway.

The streamlining and refocusing of government that occurred in the 1990s has to be balanced with government's role to ease the transitions in the rapidly changing global economy and protect and empower those who have trouble keeping up in the competitive world of the twenty-first century. The victory of the free market economy over a planned socialist state has been complete in an economic sense. Hence, governments of all political stripes recognize that they cannot protect their voters from global changes and they have to accept the realities of an open economy, such as the need to have competitive tax rates. However, the market economy cannot be allowed to determine the distribution of income. In such a rapidly changing world, government has to manage change and help people adapt. The knowledge-based economy, which rewards the best and brightest, leaves behind far too many who cannot for a variety of reasons share in the benefits of economic growth. A major role for government is to identify why some are falling behind and help give them the tools they need to make their contribution to society. Governments are always eager to create the conditions for prosperity, but they have to be equally concerned that all people have a chance to develop their talents to the full and enjoy their share of the benefits of prosperity.

When it comes to defining the role of government, surely after all the pain inflicted in the name of deficit reduction in the 1990s, politicians have to get it right this time. Canadians have a history of looking to governments to

solve their problems. Yet when called upon to make the sacrifices necessary to restructure government programs and redefine governments' role, they responded with understanding and quiet support. Governments, like other organizations, need to be strategic; they need to define their key tasks and do them well, because their actions are so important to our future well-being. The essential role of governments, beyond maintaining peace and order, should be as follows: investing in education and research to equip people to do well in the information economy and to ensure our future economic growth; creating the right conditions for strengthening the economy in an environmentally sustainable way; providing the basic infrastructure and services essential to our economic and social well-being; maintaining a quality but affordable health-care system; and continuing to address the inequities created by the marketplace.

Although they reached their goals in different ways, Saskatchewan and Alberta shared the sense of joy and relief in 1995 as they led the way out of the deficit quagmire and announced their first balanced budgets in more than a decade. As one Saskatchewan political columnist put it, "This is nothing less than a major turning point in the province's history ... In some respects it could be as pivotal to the psychology of the province as when Saskatchewan finally emerged from the social and economic calamity of the dirty thirties."[53] Along with balanced budgets came improved credit ratings as Saskatchewan climbed steadily up the ladder back into the solid A category. The result was also declining debt; within three years Saskatchewan's debt to GDP ratio was reduced from its high of 70 percent to less than 40 percent.

However, 1995 was also the year of the landmark federal budget. In making his choices, Paul Martin had plenty of models on both right and left from which to choose. The choices he made not only redefined the role of government generally; they reshaped the face of Canada and the nature of the federation in ways that dramatically affected the lives of ordinary Canadians. For in selling the public on the merits of budget cutting, the provinces had unwittingly laid the groundwork for the federal government, which now turned its attention to the task of cutting the budgets of the budget cutters.

PART THREE

The National and Federal-Provincial Scene

As I stood at an ironing board pressing my outfit for the upcoming federal-provincial finance ministers' meeting at the Lord Beaverbrook hotel in Frederiction, New Brunswick, in June 1996, my fourteen-year-old son William responded to a knock on the door by opening it to an exuberant, grinning man who burst into the room, jumped up and down with his arms raised into a V for victory, and then collapsed on the bed laughing. After talking with me for a few minutes about strategy for the next day's meeting, he danced his way out of the room. A wide-eyed William asked, "Who was that?" My matter-of-fact-response – Jim Dinning – elicited the obvious observation that Dinning was a Conservative and the Alberta treasurer, who was depicted by the press as my right-wing rival in the deficit wars. Without even thinking, I said, "Jim Dinning is a fellow finance minister, and he's a friend of Saskatchewan. Because of him, Saskatchewan has $30 million more than it would have had otherwise, and for a province in our financial straits, that's friendship."

Paul Martin and
the Finance Ministers' Club

It's hard not to like Paul Martin, even when he is cutting your transfer payments. Besides his obvious charm, he always made provincial finance ministers feel as if they were important players in federal decision making. In retrospect, it is easy to see that soon after being appointed federal finance minister, he knew where he was heading on key issues and began subtly but relentlessly to steer us in his direction. Nonetheless, all of the major federal decisions between 1993 and 1996 were vetted in some fashion by the provincial finance ministers. Marcel Massé, the minister who spearheaded the federal budget exercise called program review, described his mission and invited us to join his efforts to reduce overlap and duplication in federal-provincial programs. Lloyd Axworthy, minister of human resources, gave us a presentation of his proposed redesign of Canada's social programs and asked for our co-operation. The governor of the Bank of Canada discussed interest rates and other aspects of Canadian monetary policy at a meeting of finance ministers and sought our input. At a time when first ministers' meetings were few and far between, finance ministers met regularly and had passionate debates about the future direction of Canada. In the end, the fiscal choices of the 1990s did more to reshape Canada than any other set of decisions since the Second World War. The redesign may not have been to our liking, but at least we had our say in charting Canada's course.

In one fell swoop, the 1995 budget redefined the role of the federal government in Canada. It removed the federal government as the major player in health care, leaving the provinces as the main drivers of one of Canada's most cherished programs. Operating funding for postsecondary education, considered since the 1950s an area where a national presence was essential, was in effect left up to the provinces. The welfare state, created in the two decades after the Second World War, was completely reworked as the ideal of security from cradle to grave was replaced by the goal of ending the cycle

of welfare dependency and empowering people to make their own way in the world.

The decentralization of power from the federal to provincial governments was certainly at the heart of the changes, yet the result was more complex. While the federal government exited from some areas, it entered new ones. The first new social program in thirty years, the National Child Benefit, designed to alleviate child poverty, was created in the midst of all the cutbacks and downsizing of the 1990s; and the Innovation Strategy, to build Canada's research capacity, was launched at the same time. Rather than merely retreating, the federal government was repositioning itself for a new role in the twenty-first century.

Years of haggling at constitutional discussions had failed to achieve the sweeping changes in federal-provincial fiscal relations that the minister of finance made with a few lines in his 1995 budget speech. What is remarkable is that these massive changes were made unilaterally with little public debate, all in the name of deficit reduction. And the changes had the support of the Canadian electorate. How did such a remarkable turn of events come about in Canada? Was it necessary for the federal government to act unilaterally to refashion Canada?

Right after the 1993 federal election in which Jean Chrétien and the Liberals ousted the Conservatives, finance ministers of all political stripes exuded enthusiasm for working co-operatively to redesign Canada. It was not obvious then that unilateral action would be the chosen route out of Canada's fiscal morass. There were bold attempts to rise above merely cutting spending and withdrawing from responsibilities. Lloyd Axworthy led a well-intentioned effort to work with the provinces and other groups to rebuild Canada's social safety net, an exercise similar to Bob Rae's innovative plan to fashion a social contract with labour when he was premier of Ontario in the early 1990s. By 1996, however, the goodwill and noble dreams of those seeking co-operative solutions had evaporated, and plans to restructure rather than merely cut had fallen by the wayside. Were such efforts doomed from the beginning? Why was the co-operative spirit of 1993 replaced by mutual suspicion and distrust by 1996?

Politics, regionalism, and policy all help explain what happened in the 1990s, but so do personalities. The choices made in that period reflected the people in charge not only at the federal level but also in the provinces. The change in the tone and approach that had occurred by 1996 was in part related to the fact that the faces around the finance ministers' table were very different those that had been there three years earlier. Who the finance ministers were, what they believed, and how they interacted with one another influenced the course of events.

Despite the increasing controversies after 1993, there was a certain civility and common understanding. Whatever our many differences, we shared a common bond as embattled finance ministers struggling to steer our course through totally uncharted waters. And we knew that this was a critical juncture in Canadian history in which there was not much margin for veering off course. By including us in his dialogue about the future of Canada, Paul Martin had melded the varied characters around the table into the finance ministers' club.

Within hours of his appointment, Martin signalled his respect for his fellow finance ministers by calling them from the Hôtel-Dieu hospital in Windsor, where he was at the bedside of his dying mother. In his conversations with his provincial counterparts, he acknowledged his status as a newcomer who did not have their experience in finance. For instance, although the Atlantic provinces were generally not big players, because of their size and heavy dependence on the federal government, the experience of a seasoned veteran such as Alan Maher of New Brunswick was respected. And we in Saskatchewan had already delivered two tough budgets and laid out plans to balance the books. In our chat, Martin observed that Saskatchewan's moderate NDP government provided a good model for the federal Liberals and then asked for advice. I told him that he would never regret accepting the finance portfolio (which I had heard he had taken with great reluctance). Debt was the issue of the 1990s, and finance was the commanding heights of government, where the decisions that shaped the future were made. I added that finance ministers could never be loved but they could be respected. This was especially true of Liberal and NDP finance ministers, whose parties were not really committed to deficit reduction. To be truly valued as finance ministers we should return as Conservatives in our next lives. Asking for advice was Martin's trademark. Our words of wisdom probably did not fundamentally alter his course – they merely refined his thinking – but the gesture of seeking input reflected an openness and a collegiality that were at the heart of the Martin decision-making process.

Beginning with the first meeting in Halifax in December 1993, Martin and his provincial counterparts rode a roller coaster of issues over the next three years. The federal decision in 1994 to cut tobacco taxes and constant wrangling over the GST from 1994 to 1996 led to heated exchanges and regional divisions. Martin's first budget in 1994 evoked a collective sigh of relief from provinces who did not get a cut in their transfer payments – money paid by the federal government for medicare and other programs. But the budget was greeted with a chorus of criticism from the business community, journalists, and others, who argued that the fiscal problem was not really being tackled. Such critics were silenced by Martin's 1995 budget, which made

record-breaking cuts in spending. The aftermath of the 1995 choices coincided with the period of most intense wrangling over the GST, producing a very tense atmosphere at the 1996 finance ministers' meetings. When I left finance in July 1997, I was the last of the original finance ministers who had welcomed Martin in the fall of 1993. In less than four years, all my original provincial colleagues had left, for a variety of reasons.

The old adage that finance was a career ender in politics did not apply in the 1990s; three of the ministers around the table were destined for the premier's chair, and just as many became runners-up in the contest for the top job. The profile given to finance ministers in the 1990s was unprecedented. They were often on the front pages of newspapers, rather than their premiers, some of whom were not pleased that their finance ministers were getting more ink than themselves. To be solid, reliable and respected by the business community are the ideal attributes of any finance minister, but in the 1990s they also needed a certain toughness, the ability to make difficult choices and drive them through sometimes reluctant cabinets and caucuses, and also the ability to sell the choices to the public. Most of the 1993 finance ministers were effective communicators and strong personalities, and this, combined with the controversial subject matter, produced spirited and heated exchanges.

The battle lines in these exchanges shifted, but the most lasting alliances were regional. Our regional allies were our neighbours, fellow westerners who had the same basic view of the world. Just as stricter rules for unemployment insurance and cuts to the military solidified the bonds among the Atlantic provinces, any federal policies that seemed to discriminate against western Canada drew our region together. Our closest ally was Manitoba. We shared the same demographics, with aboriginal people comprising more than 10 percent of our population, and we commiserated with each other as the federal government offloaded as many of its aboriginal commitments as possible onto our doorsteps. We both had struggling farmers, whom the federal government virtually cut loose in its race to lead the international pack in ending subsidies to farmers. Both Saskatchewan and Manitoba were middle-ranking provinces, with sounder economies and lower unemployment rates than Atlantic Canada but without the rich oil reserves of an Alberta or the size of an Ontario. Although one was NDP and the other Conservative, both governments were moderate, with leaders committed to a strong united Canada. Manitoba's premier, Gary Filmon, and his wife Janice were well known and liked by our cabinet; and Eric Stefanson, the Gimli accountant who was Manitoba's finance minister, was a strong voice at the finance ministers' table in condemning federal cuts to transfer payments and in seeking co-operative solutions to problems.

The bonds among the four western provinces and the two northern territories were strengthened at the annual western premiers' conference, whose communiqués provide a glimpse into the unique regional mindset. "Western governments," in the words of the 1996 communiqué, "led the way in finding innovative ways to live within their means."[1] In 1992 the western provinces had a combined deficit of $6.3 billion; by 1996 this had been turned into a $422 million surplus. As well as being in the forefront of deficit reduction, western Canada had the lowest unemployment rates of any region and the fastest-growing economies. Western finance ministers feared that because of the fiscal and economic strength of the region, it would be targeted by the federal government for especially difficult cuts, without consideration being given to the volatility of our resource-based economies, which could veer dramatically downward with a drop in oil, gas, or agricultural prices.

Another major concern of the region was the growing imbalance between provincial responsibilities and the tax resources available to finance these commitments. As the 1994 communiqué explained, in the 1960s and 1970s the federal and provincial governments had "combined to establish our jointly-funded and comprehensive system of transfer payments" for health, postsecondary education, and social programs.[2] In the 1970s the federal government had paid about 50 percent of the costs of such programs. However, in the 1980s and 1990s, as the federal government offloaded more than $4 billion of these costs onto the western provinces, its share of funding had dropped to 32 percent.[3] The solution was for the federal government either to fully fund its share of the programs or to transfer to the provinces tax points to restore the balance between program costs and tax revenues.

Most striking about the positions taken by the western premiers and the northern leaders in the early 1990s was their national focus and the emphasis on co-operation and working together. "Western Premiers Call for National Partnership for Fiscal Renewal" was the headline of the communiqué from the meeting in November 1993 in Canmore, Alberta. Growing deficits and debt, the report stated, were "not just a federal problem and not just a provincial or territorial problem. It is a national problem. All governments must work together in partnership to resolve it." The proposed program, "New Partnerships for Fiscal Renewal," involved a step-by-step process, beginning with a first ministers' priority-setting meeting, which would be followed by a federal-provincial finance ministers' meeting to discuss affordability. The goals were to work in partnership to redesign social programs to make them more efficient and effective; to reduce overlap and duplication; and to coordinate and co-operate in a national action plan for deficit reduction and economic growth.[4]

Having the leaders and ministers from the northern governments at the table of western leaders added a broader and more inclusive dimension to the call for national solutions to problems. Although the personalities often changed and although distance meant that their attendance was more problematic than for the rest of us, northerners were deeply committed to Canada and brought an acute sense of social problems to the table. They softened our agenda and made us very conscious of the fact that whatever our provincial problems were, they were minor relative to the struggles of northern Canadians. The inclusion of the northerners also gave the western contingent significant power at the finance table. If all the northern and western governments were of the same view on an issue, they actually constituted a majority of the provinces outside Quebec at national meetings.

The goal of our 1993 meeting to find national solutions to our problems was shared by our Alberta hosts, though it was tempered by our deeply rooted suspicion of the federal government. The electoral strength of central Canada fed westerners' fears that their region's interests always took a back seat. Such fears seemed to be confirmed in the 1970s by the National Energy Policy, which interfered with the almost sacred provincial control over natural resources, and by Prime Minister Trudeau's glib comment, "Why should I sell your wheat!" Leery of the centralizing tendencies of the Liberals, and aware of how well the grassroots Reform Party had done in western Canada in the 1993 federal election, Alberta Premier Ralph Klein and Treasurer Dinning were skeptical. The Chrétien government might be talking a different line from Trudeau, but its power base also was in eastern and central Canada. Co-operation was fine, but there remained a lingering distrust of the federal Liberal government, an unease that subsequent events did little to dissipate.

I always suspected that Ralph Klein was a closet liberal. Hedged in by the Reform Party federally and a very right-wing rural Conservative caucus provincially, he had to sound tough on issues such as welfare reform or protecting provincial jurisdiction. Yet he was as committed as any Canadian to a major federal role in health, postsecondary education, and social programs His main point was very valid: if the federal government wanted to set the standards for programs such as health care, it had to pay its share of the costs. Behind closed doors, Klein was a reasonable and unassuming guy. At the 1995 western premiers' meeting in Yorkton, when I finished giving the finance minister's report, Klein said, "That's a good report and I agree with it – at least I think I do, if I understand it properly." In a political world of huge egos and lots of machismo, his ability to admit his limitations openly made Klein an attractive personality.

Jim Dinning was a powerful force at finance ministers' meetings and one of Martin's strongest allies in stormy seas. A former civil servant, Dinning was very policy oriented and almost fearless in his willingness to take on a challenge. Maybe this came from his personal circumstances. Elizabeth Cull, British Columbia's finance minister, Eric Stefanson and I marvelled at his dual role as both a provincial treasurer and a single parent raising four fairly young children. Dinning split off from the rest of the finance ministers in his support for Martin's need to cut transfer payments to the provinces. As a province with deep enough pockets to withstand more federal cuts, Alberta's position irked many of us.

Throughout 1994 a pattern was set. Martin would warn the provincial ministers, "I'm going to have to cut you," which would provoke a collective howl from nine of the ten provinces to the effect that we could not take any more punishment. We were already cut to the bone; there was no fat left. At this point, Dinning would invariably intervene to tell us to stop whining and remember that there could be "no sacred cows"; that the federal finance minister had to be given a free hand to cut us as well as everything else. Although I was one of the most vocal opponents of Martin's cuts to transfer payments, I could see Dinning's point, much as I disliked his message.

Despite Dinning's support of Martin's deep cuts, we were driven closer together as our hopes for a national strategy to deal with Canada's fiscal problems faded, and by 1994 we had formed our own unofficial western finance ministers' club. As well as meeting annually, we met before every national meeting to coordinate strategy, and we talked regularly on the phone.

It is ironic that while the press depicted the rivalry and ideological divisions between Alberta and Saskatchewan, Dinning and I developed a good working relationship, which explains his rather unusual entry into my hotel room in Fredericton in 1996 and my explanation to my son that Dinning was a friend of Saskatchewan. I was alluding to a favour I had asked of Dinning at a private meeting following a western finance ministers' gathering. It concerned equalization payments – the money paid by the federal government to poorer provinces to ensure that all provincial governments can afford to provide a basic level of social programming. A major part of Saskatchewan's equalization payment from the federal government involved comparing our oil revenue with Alberta's; however, since Alberta did not receive equalization, it did not bother to file detailed oil data, and this was costing Saskatchewan an estimated $30 million a year in lost equalization money. My request to Dinning was that Alberta file its data, and I offered to pay the costs involved in compiling the information. His response was unequivocal: "No problem. We'll do it for you and we'll

absorb the cost." Some two years later, when Dinning left provincial poli-
tics, I hosted a dinner in his honour at the Château Laurier in Ottawa – I felt
that Saskatchewan taxpayers owed him a big thank-you. And during the
1999 Saskatchewan election, as Dinning travelled through Saskatoon and
saw my lawn signs, he called and with his usual wry sense of humour said,
"You're the only New Democrat that I would actually knock on doors for."
Having an Alberta Conservative door knocking in a staunchly NDP work-
ing-class riding would confirm all of the left-wing fears about my real
agenda in politics!

Although regional ties were the dominant consideration in forging
alliances, political affiliation also mattered, and this led to close ties and a
bird's-eye view into the two very different NDP regimes: Bob Rae's in
Ontario and Mike Harcourt's in British Columbia. Before attending my first
finance ministers' meeting – the one chaired by Don Mazankowski in 1993
– I called Ontario's finance minister, Floyd Laughren, to seek advice from
my NDP colleague. Similarly, a few months later Elizabeth Cull (who
replaced Glen Clark as finance minister in the Harcourt government in
British Columbia) called to chat before attending her first meeting.
Although Ontario and British Columbia, as larger and more affluent
provinces, had different interests from Saskatchewan, we were all New
Democrats facing the same problems within our party: aggressive and
uncompromising public-sector unions and militant leftists who delighted in
preaching the doctrine that the deficit was an illusion conjured up by Bay
Street bankers.

In British Columbia the contrast between Harcourt's two finance min-
isters, Glen Clark and Elizabeth Cull, was reflected in a story involving
the two. It will be recalled that Clark had incited a storm of protest with
his decision in the 1993 budget to take an extra tax bite from owners of
properties valued at more than $500,000, a measure that inadvertently
caught many elderly Vancouverites of modest means. During the legis-
lative session, when Clark and Cull were chatting in the members'
lounge, Clark was informed that more than 750 irate property owners had
staged a protest. "There would have been twice as many had the orga-
nizers provided valet parking," quipped Clark. Cull chuckled at the allu-
sion to the supposedly upper-income status of the protesters, but warned
Clark not to use the line in the upcoming question period. Nevertheless,
when questioned in the legislature, Clark bristled with excitement as he
built up to his finely honed line, while a horrified Cull kicked at his shins,
trying to urge moderation. While Clark loved the cut and thrust of poli-
tics, Cull was committed to the more staid and serious business of
governing well.

Elizabeth Cull and Mike Harcourt made an able and extremely likable team in British Columbia. As a former mayor of Vancouver, Harcourt had the experience and breadth of vision, while Cull, a community planner elected in a very difficult Victoria seat, worked prodigiously hard and had excellent judgment. At finance ministers' meetings, as other provinces touted the deep spending cuts they had made to curtail their ballooning deficits, Cull seemed out of step as she explained that British Columbia's spending was still growing. With a relatively small debt, British Columbia's New Democrats could not join their Saskatchewan counterparts in arguing the urgency of dramatic spending cuts; more to the point, migrants from other parts of Canada were still flooding into Lotus Land as the economy boomed and as the demand for education and health care grew by leaps and bounds. As Harcourt used to say in response to calls for cuts to spending, "We have the equivalent of Newfoundland coming to British Columbia every five years."[5] Dramatic downsizing in British Columbia would have to await the election of the Campbell government in 2001, when budget cuts coincided with a downturn in the economy.

Decency can be the undoing of political leaders, as the case of Mike Harcourt shows. Generous to the core, he lacked the ruthless streak that is sometimes needed for survival in the dog-eat-dog world of politics. I will always remember the advice Roy Romanow privately gave him at a western Canadian premiers' meeting in Yorkton, Saskatchewan, in 1995 as the controversy dubbed "bingogate" swirled around the BC premier. "Mike," Romanow said, "somebody's got to carry the can for this supposed scandal. The public will want you to identify the culprits and make them face the consequences, otherwise this issue will drag you down with it." Within months, Harcourt was gone.

The resignation of Harcourt and the defeat of Cull in the 1996 election dramatically changed the dynamic of the finance ministers' club. Cull's replacement, a law professor, Andrew Petter, was bright and moderate, but as he readily conceded he was not calling the shots. While Harcourt had run a decentralized ship in which able ministers such as Cull could chart a course and get the backing of both premier and cabinet, the new premier, Glen Clark, ran a much more centralized operation. A demoralized Petter regularly bemoaned his new premier's practice of calling finance officials to his office to vet their recommendations before treasury board meetings, without the courtesy of even informing the finance minister. A finance minister who is not calling the financial shots and does not have the backing of the premier is like a rudderless ship being tossed to and fro by each passing wave. The advent of Clark also marked a change

in British Columbia's approach to the rest of Canada. While Cull and Harcourt could be tough with Ottawa and demand a fair shake for their province, they both believed in a strong federal government that was committed to providing quality health, education, and social programs, and they could always be relied on to seek common ground with other provinces and with the federal government. Sadly, the same could not be said of the Clark regime. With politics rather than policy driving the agenda, Clark took a much more hard-line approach to Ottawa, a tack that was more in tune with British Columbians' distrust of the east but made reaching compromises difficult, if not impossible, and put one of Canada's larger provinces in the volatile category.

Misfortune also befell the NDP government in Ontario, which never really had a chance. As an Ontario public servant put it, the NDP victory in the 1990 election had been like a dog chasing a car and then catching it. The unexpected victory meant that Rae never had the luxury afforded to Romanow, who was widely favoured to win the 1991 election and become premier, and who could therefore use the carrot of cabinet posts to lure experienced, quality candidates. Without a handful of first-class ministers, any government will flounder. Also, Rae's timing could not have been worse. With Ontario deeply mired in recession as well as debt, Rae had to fight on both the jobs front and the deficit front at the same time – an impossible task. And neither the right nor the left gave him any quarter; business crucified him for doing too little to reduce the deficit, and the unions brought him down for doing too much. Mistakes were made, as Rae himself says – "Too soon old, too late smart" – but in politics nothing beats luck.

Floyd Laughren, who had the unwavering support of Rae, was an important stabilizer at the finance table. A quiet-spoken, thoughtful representative of northern Ontario, he had a good strategic sense and was always careful about how Ontario wielded its enormous power at the finance meetings. His advice during our first conversation in May 1993 was excellent. In our meeting with Mazankowski, we two NDP provinces should focus on the high interest rate policies of the Bank of Canada, which had worsened both the recession and the deficit/debt crisis. Before the meeting, John Crow, the strong-minded governor of the Bank of Canada, had said that he was prepared to listen to the advice of the provinces. But it was clear after the meeting that he was not prepared to listen to advice that contradicted his unswerving commitment to fighting inflation through high interest rates. Laughren rightly remarked that it was going to take more than a handful of angry provincial finance ministers to move Crow off his high interest rate mark.[6] In attacking policy issues such as high interest rates or federal cuts to provincial transfer payments, Laughren was always very firm. Where he

was cautious was in appearing to undermine in any way Ontario's support for a strong federal government that promoted equality of opportunity for Canadians from all backgrounds and regions.

Ontario had good reason to feel aggrieved in the early 1990s. At the same time as it was suffering through a major recession with record levels of unemployment, the federal government in 1990 unilaterally "capped" (limited) its financing for welfare payments for the three provinces that did not receive equalization: Ontario, British Columbia, and Alberta. Under the Canada Assistance Plan, established in the 1960s, the federal government was obliged to fund 50 percent of provincial welfare costs. But in the late 1980s Ontario, under its Liberal premier, David Peterson, had hiked welfare rates by more than 10 percent, knowing full well that half of the tab would be paid by Ottawa. Fiscal prudence meant limiting the federal treasury's exposure to unpredictable increases in welfare rates in provinces that were rich enough to take care of their own poor. But Canada's most affluent provinces already contributed billions to the equalization program that provided money to the poorer provinces based on their need. The cap on CAP, as it was nicknamed, angered all three affected provinces. But with the most troubled economy, Ontario was hit hardest; in 1992 alone, for instance, Ontario lost 167,000 jobs. At the meetings, Laughren was unrelenting in his attack on the cap on CAP, which he dubbed "backdoor equalization." Ontario, he emphasized again and again, supported equalization but could not afford to support "backdoor equalization" as well. In public, however, he chose his words carefully, a fact that reflected his and Rae's view of Canada.

Rae and Laughren, despite their grave concerns about the fiscal unfairness in Ontario's treatment, still had an attachment to the traditional view of the role of Ontario in Canada, a view that I grew up with in my early years in Ontario. "Give me a place to stand and a place to grow and call this land On-ta-ri-o," – the catchy Ontario theme song at Expo '67 – reflected a strong pride in the province, but there was never any doubt that Ontario and Canada were one and the same. Ontario was the bedrock, the centre, the largest province, which benefited most from Confederation and could be relied upon to seek some middle ground, find a common solution to any divisive Canadian problem. John Robarts, Conservative premier of Ontario in the 1960s, bragged to his hometown audience at the University of Western Ontario, where I was a student, that if there were problems with Quebec, he merely picked up the phone and talked to Daniel Johnson, the Union Nationale premier of the province next door. Similarly, Bill Davis, Conservative premier in the 1970s, prided himself on the co-operative relationship he had with the Liberal federal government of Prime Minister Trudeau. In the same tradition, Laughren at the finance table and Rae at first ministers'

meetings could be counted on to be conciliators, constructive players inter-
ested in seeking the middle ground. Whether it was a replacement for the
GST or the thorny issue of transfer payments, Laughren, despite his anger at
some of the federal positions, was a voice of moderation, often seeking what
turned out to be elusive compromises. It was a noble vision of Ontario's
place in Canada – one, unfortunately, that time and events had made anti-
quated. This became apparent after the 1995 election of the Harris Conserv-
atives.

One of the two most important changes at the finance ministers' club
between 1993 and 1996 was the rift between the Harris Conservatives and
the Chrétien Liberals, a parting of the ways that was reflected in a palpa-
ble tension between Martin and the Conservative finance minister, Ernie
Eves. The roots of the problem were many. At a finance ministers' meeting,
Eves told me a story that was repeated almost verbatim by Mike Harris at
the 1998 premiers' conference in Saskatoon. At its lowest ebb, when the
Ontario Conservatives were making their deepest and most painful cuts,
Prime Minister Chrétien made a speech in Ontario, albeit to a partisan Lib-
eral audience, condemning the hard-hearted and heavy-handed approach
of the right-wing Tories. From the Liberal perspective, Ontario was a bat-
tleground that had yielded a rich harvest of federal Liberal seats in the
1993 election, and partisan politics is partisan politics. For the Conserva-
tives, however, there is an unwritten rule that politicians, especially prime
ministers, don't venture into the domain of their rivals and attack their
positions, especially when the government is in an unusually vulnerable
position.

Beyond this incident, there were other reasons for the new divide in
Canadian politics. Ideology divided Canada's most right-wing government
from the federal Liberals, who fancied themselves as champions of com-
passion, fairness, and tolerance. Timing also played a part, with Eves land-
ing on the scene at the most intense and rancorous period of federal cuts to
provincial grants and at the bitterest part of the GST controversy. More fun-
damentally, Eves's positions reflected the new realities of Ontario's view of
the world. Ontario the conciliator was based on an east-west economic axis,
in which Ontario was the main beneficiary of Confederation and therefore
stood to lose most in any rupture of the union. Years of integration into a
north-south continental economy – accelerated by the 1965 Auto Pact,
which essentially created a North American auto industry, and capped by
the Free Trade Agreement of the late 1980s – had changed Ontario's orien-
tation from east-west to north-south. The standards by which Ontarians
judged themselves were less and less Montreal or Vancouver and more and
more New York or Michigan. Also, the Harris government, committed to
protecting the pocketbooks of middle-class Ontario taxpayers, reflected

their growing reluctance to pay the shots for equality of opportunity in other parts of Canada when they themselves were struggling to make ends meet.

For a whole variety of reasons, Ontario could no longer be relied on to play the part of conciliator. Ironically, Eves's positions were not dramatically different from Laughren's. The change was in approach. Gone were the restraint, the spirit of co-operation, and the sense of noblesse oblige to lead. Instead, Ernie was like all the rest of us – free to air his beefs and quite content to be at odds with big brother in Ottawa. Instead of co-operation between Canada's largest province and the federal government, Ontario became a battleground, where the federal Liberals and provincial Conservatives waged public relations wars to blame each other for an overburdened health-care system and other woes. If the game was partisan politics, then every party, it seemed, could play, especially with so many Ontario seats at stake. It was a bold new world of federal-provincial relations and one for which there were no established rules or precedents. For the Canadian ship of state, the shift in Ontario's position was like losing a part of the country's rudder.

Even more dramatic than the change in Ontario's role in confederation was the other monumental change – the election of a separatist government in Quebec in September 1994. Prior to this, finance ministers, like other Canadians, had been lulled into a false sense of complacency about the nature of Confederation. At my first finance meeting, in May 1993, Gérard D. Lévesque, Quebec's finance veteran, had urged the federal and provincial governments to work together to end overlap and duplication.[7] Later, he approached me about working together to fulfill Mazankowski's commitment to improve the equalization formula as it affected potash revenues, a change that would also have implications for Quebec. When Lévesque passed away, he was replaced by André Bourbeau, a charming man, who also was congenial and co-operative. He too stressed the need to streamline the bureaucracy, and he chided the federal government for not following Quebec's example of a 20 percent reduction in the civil service, accompanied by early retirements and relocations to the private sector. At his last meeting Bourbeau made an appeal, which in retrospect we should have taken a lot more seriously, for a speedy transfer of manpower and training to the provinces to help the Liberals in the upcoming provincial election. It was ironic that the Quebec ministers took such a hard line on the size of the civil service when their officials were among the best in Canada. The tradition of the best and brightest entering the professions or public service was reflected in the likes of Quebec's deputy minister of finance, Alain Rheaume, whose ministers always had well-argued and eloquent opening statements.

When Rheaume wrote to his fellow deputies on 27 September 1994 to introduce his new minister, the letter was in French only – a sign of what was to come. The first Parti Québécois finance minister, Jean Campeau, who had a distinguished background in business, government, and academe, was quickly followed by the quiet and aloof Pauline Marois, who would later fail in her leadership bid against her successor in the finance portfolio, Bernard Landry. As a New Democrat, I found the Parti Québécois ministers frustrating. They were sophisticated, well informed, and very progressive on social and educational issues, so they should have been natural soulmates of the NDP. In fact, at one of the meetings I had a delightful time chatting over lunch with Bernard Landry; we both had academic backgrounds and found plenty of common ground when talking about general issues of public policy. But developing good working relationships with ministers of any party meant following the unwritten rule. Don't raise the issues that you know will naturally divide you from the minister to whom you are speaking. Thus, Landry and I never talked about the c word – Canada.

Having the separatists at the finance table was like hitting a brick wall. Disagreements are one thing – they can be discussed – but closed minds are another. There is no point in talking. No matter who the minister was or what the issue, the Quebec approach was the same: to react with great suspicion, even paranoia, to every federal proposal; to assume that the federal government was conspiring to invade provincial jurisdiction; to protect and advance provincial rights at every turn; and to derail any proposals for national initiatives or new policy thrusts. Undoubtedly, the main reason why the spirit of co-operation that existed in 1993 had evaporated three years later was the change in Quebec's position. Knowing and representing Quebec as he did, Paul Martin understood this. But the rest of us had to confront the separatist reality in the flesh to see the major obstacle that Quebec presented to many of our dreams about the future direction of Canada. As much as I was committed to a strong central government imposing national standards, left unanswered was the question, How could such a vision of Canada be sold in Quebec?

Martin handled the separatists with grace and humour. Although he understood and respected Quebec, he was not from the province, and this made a world of difference in his handling of the issue. I came to understand this difference during a phone conversation with him the night before Quebec's referendum vote in 1995, when he alerted all finance ministers to be on standby in case the "yes" forces won. Coming from Ontario, I was very attached to the idea of a Canada which included Quebec – a position not shared by all western ministers – and I told him so. He responded warmly and explained that the native Quebecers in the cabinet were emo-

tionally devastated by the prospect of a "yes" vote, while he, as a person born in Ontario, was more dispassionate. In a nutshell, this explained the difference between Trudeau's and Chrétien's view of Quebec and Martin's. As native Quebecers who were also federalists, Trudeau and Chrétien talked about what was best for Quebec or what Quebec should be like; it should support bilingualism and biculturalism, and share their vision of a Canada in which French and English were treated equally from sea to sea. They had deep emotional attachments to the province and like a parent tutoring a greatly loved child, they wanted it to grow up in the best way possible.

Because Martin was more emotionally detached, he was more realistic. The only government in which French Canadians were a majority was in Quebec, so Quebec governments of all political stripes favoured the decentralization of powers to the provinces. Hence, Martin endorsed the Meech Lake Accord, which involved more decentralization and was widely supported in Quebec. Chrétien and Trudeau were on the other side of the fence. As Martin crafted the 1995 budget and its redistribution of power within Canada, there is no doubt in my mind that he, along with like-minded Quebecers such as Marcel Massé, were trying to accommodate the reality rather than the ideal of Quebec.

Of all the personalities around the finance table, clearly Martin mattered the most. Although his style was understated and his humour often self-deprecating, his presence dominated the meetings. After the formal meetings attended by ministers, deputies, and other political staff, at which the ministers made their points based on notes prepared by their departments, there was usually a lunch attended by ministers only, when more frank discussion occurred (although Martin was never shy about letting loose with a room full of officials). Martin was spirited, determined, and impatient to move forward, but his defining feature was his ability to see the big picture. He clearly was not in politics merely to manage the day-to-day affairs of government. Initially, he struggled to see how he could be creative as the finance minister of a nearly bankrupt country. I have no doubt that the 1995 budget was his doing and that the major changes in Canada that it precipitated were of his making. He was the architect who gave great thought to the wholesale redesign of Canada for the twenty-first century, based on a combination of what he thought was realistic and what he hoped was possible.

Martin's relationship with his first deputy minister, David Dodge, shaped his approach to the provinces. It was rumoured that Martin could be merciless in the demands he made of public servants, and his explosive temper was legendary. There was initially visible tension between the two, perhaps because Dodge, although a career civil servant, had served as Mazankowski's

deputy. Over time, however, the relationship became one of mutual respect, and Dodge clearly felt comfortable taking on his minister. He was valuable to Martin not only because of his experience but because of the respect that he had from the provincial deputy ministers. It was not uncommon for Dodge to call the provincial deputies after a contentious federal-provincial meeting and try to smooth over differences or pave the way for consensus or compromise.

A similar role was played by Martin's chief of staff, Terrie O'Leary. Martin's confidence in her was well known, and it allowed her to act as a bridge between him and the provincial ministers, especially the women like Cull and me. O'Leary was always very approachable and eager to minimize tensions. After an especially heated meeting about the GST, I called her to suggest that she remind her boss that although I may have said harsh things at the meeting, I had left by the back door and had not repeated my comments to the press. Key working relationships are often repaired through such informal chats with trusted aides.

Martin's relationship with Chrétien was also central to the unfolding of events. There is a natural tension between a finance minister – whose task in the 1990s was to chart a fiscal course and be the cop at the cabinet table, exercising the discipline to keep the government on track – and a first minister, who has to worry about other fundamental concerns, such as the unity of the cabinet and caucus. These tensions could have been exacerbated by the history of the Chrétien-Martin relationship after a rather bitter leadership fight, but they were not. Whatever the two men thought of each other personally, Martin clearly had the complete backing of his prime minister. Any thoughts that a provincial finance minister might do an end run around Martin by having her or his premier call the prime minister about an issue were quickly dispelled. In dealing with the outside world, the two stood as one, and on finance issues it was Martin who did the talking. But although Martin was discreet about his relationship with the prime minister, he clearly disagreed with Chrétien on some issues. The fact that the professional relationship between two supposed rivals worked so well was a credit to both and was one of the major reasons for the success of the Liberals after 1993. It was only when the deficit wars were behind them that the differences between Martin and Chrétien became irreconcilable.

What Martin brought to the Liberals, along with his credibility and big-picture thinking, was his scrappiness and tenacity, two essential ingredients in political success. A fight with him was a no-holds-barred affair. I had my own tussles with him behind closed doors, but in 1996 our disputes spilled over into the public arena. In one case, I had been hammering for months at the federal government for its cuts to provincial funding

for health, education, and social programs, and Martin came to Saskatchewan to defend his choices and dispute my numbers. The Saskatchewan public got a glimpse of his hard-hitting private style when he said that although I was a nice person, I really did not understand the numbers and was engaging in "an accounting flim flam" that he would have "thought a grade six student wouldn't try"; he added that with $1 billion in Cameco shares, the province should stop blaming Ottawa for underfunding social programs. Responding in kind, I accused him of "fiddling with numbers to mislead the public" and added, "If people believe Martin's numbers they probably believe he'll get rid of the GST in the next federal budget." I took some modest satisfaction from an editorial in the Regina *Leader Post* suggesting that since Saskatchewan had a better fiscal record than the federal government, "rather than dispensing advice, he might ask for some."[8] I nearly always knew where Martin was coming from and why he was making the choices he did. But this understanding never stopped me from disagreeing with him, often passionately and if necessary publicly.

Although I always liked and respected Martin, our relationship had a testy dimension that prompted an insightful article by Saskatchewan political columnist Mark Wyatt. Written just after the successful cloning of a British sheep named Dolly, the article speculated that there was actually a human precedent for the cloning. In the 1930s and 1940s, Martin (born in Windsor) and I (born a few hundred kilometres away in Kitchener) had been cloned, suggested Wyatt. Evidence of the cloning became public only after we both became finance ministers in the 1990s. Both of us inherited a fiscal mess from a Conservative government and began a war on the deficit. Both of us offloaded a fair share of the fiscal problem onto third parties – in Martin's case, the provinces; in my case, municipalities, universities, and health and school boards. Both of us cut health and education but cried foul when anyone criticized us for it. And both of us harboured the design to lead our party. "Despite their many similarities," Wyatt concluded, "MacKinnon and Martin are constantly sniping at one another – almost like brother and sister."[9]

As well as being scrappy, Martin was a political strategist. In making his choices, he was acutely conscious of the political implications. Areas in which the federal government provided funding but had no control over program design or received no political credit were candidates for offloading. Similarly, new areas that promised both policy and political advantages were embraced, for instance, reducing child poverty. Thus, as the federal government set out on the trail blazed by the provinces to get its fiscal house in order, provincial finance ministers knew what Canadians only suspected – that there was a strategic mastermind at the helm who could bring a lot of

heartache and grief to the provinces. Martin, we knew, had the power to change the future of Canada, and many of us sensed that he would be fearless in using that power.

Even before the 1995 budget, however, there were other issues that aroused the ire of the provinces, especially those in western Canada, and dampened the optimism and goodwill that was so apparent in 1993. Before considering Martin's budget choices and their implications, it is necessary to understand how these other issues played into the unfolding federal-provincial drama at the finance ministers' club.

CHAPTER EIGHT

Regional Divisions: A Tempest in a Teapot and the Mad Hatter's Tea Party

As federal Finance Minister Paul Martin emerged all smiles from his first federal-provincial meeting in Halifax in December 1993, he said with satisfaction, "I think we had a very, very good start ... People weren't just speaking for the cameras, they were genuinely saying, Look, we've all got the same problem and we're only going to come out of it if we work together." His conclusion – "there was a genuine desire to achieve a solution, so I feel very, very good" – was endorsed by several of his provincial counterparts. Floyd Laughren talked optimistically about his hopes that the provinces and federal government would co-operate in redesigning health and welfare programs, while Allan Maher, the veteran from New Brunswick, hailed the new "spirit of co-operation" at the finance ministers' table as "a breath of fresh air." The host minister, Bernie Boudreau, was pleased that "there seemed to be a commitment by everyone to engage in a new process of co-operative problem solving," and he observed, "The strongest feeling I took from the meeting was that there's now a recognition that we share the debt problem as a family in this country."[1]

The enthusiasm outside the meeting reflected the tone at the meeting itself, where the room had been full of the expectations that accompany a new government. The contrast with the last meetings, chaired by Mazankowski, was striking. The format and much of the material was the same – not surprisingly, since it was prepared by the same officials – but the tone of the Mazankowski meetings had been much more subdued. A government at the end of its mandate preparing to meet its makers at the polls is not in a strong position to tackle major challenges like deficit reduction. A sense of the declining power of the Conservatives had been reflected in the unwillingness of provincial finance ministers even to meet with Kim Campbell, the frontrunner in the Conservative leadership race, before there was a federal election.[2] Now, with Martin in the chair representing the new Liberal government, ministers were brimming with ideas and enthusiasm. And

Martin was the bearer of glad tidings: the provinces would be given plenty of warning before any major reductions in transfer payments were made, which meant that there would be no significant cuts to provincial funding in the upcoming 1994 federal budget.

The next meeting, held in Montreal in January, was just as upbeat. The major announcement was that the federal government was renewing its funding for equalization for the next five years. Improvements in the funding formula meant more money for some provinces, Saskatchewan being the biggest winner, receiving $60 million more per year. There were proposals for a national highways program, an idea endorsed the same year by the western premiers, and support for a national review of the tax regime. Hopes of federal-provincial co-operation and of national solutions to Canadian problems were still riding high in early 1994.

Less than two years later, the mood had soured. The enthusiasm for federal-provincial partnerships, so apparent in the 1993 *Western Finance Ministers' Report*, had cooled by the time of the 1995 report, which contained the chilling warning: "The federal and provincial/territorial governments are mature and experienced and need to treat each other as equals. There should be no junior partners." The 1996 report was even blunter. It objected to federal policies that discriminated "against one or more provinces/territories and thereby treat individuals differently on the basis of their province/territory of residence." At another point it stated, "We object to the use of tax dollars in an inequitable manner." With respect to an independent agency to collect federal and provincial taxes, an idea long supported by western ministers, by 1996 the same ministers were suspicious that the "Commission will be controlled by the federal government and will not represent a true federal-provincial/territorial partnership."

Western ministers were models of diplomacy compared with the public brawl that had erupted in Ontario by this time. Finance Minister Ernie Eves put the federal government on notice that it "should not pursue a divide and conquer strategy in trying to hammer out accords with the provinces." Premier Mike Harris was even stronger: "Hell will freeze over before Ontario blends the GST and the provincial sales tax."[3] Thus, in three short years, optimism and goodwill were replaced with distrust and anger.

For western finance ministers, signs of trouble began early with what should have been good news for provincial governments – the infrastructure program. Announced with great fanfare during the 1993 election as a $6 billion program that was the centrepiece of the Liberal agenda to create jobs and get the economy moving, the expensive program in fact depended on contributions of $2 billion each from provincial and municipal governments. Broke provincial governments were relieved to be told through their officials that the federal government would be flexible over the issue of

whether the provincial monies had to be "new" or could merely be "repackaged." Certainly, we in Saskatchewan simply reprofiled capital projects that were already planned and applied for federal cost sharing – it was all that we could afford.

What took all the western governments totally by surprise was the criterion used by the federal government to allocate the funds. Unemployment levels were the main benchmark, meaning the higher a province's official unemployment rate, the more funds it would receive. From the point of view of the federal government, if the goal of the infrastructure program was to create jobs, it was only fair that the regions suffering most from unemployment would get the most help. The counter argument was that the equalization program and the unemployment insurance system already helped level the field among the provinces, and this was yet another example of "backdoor equalization." How many times did the stronger provinces have to contribute to helping the weaker? In Saskatchewan's case, its record low unemployment levels meant that it would receive $18 million less than if the money were distributed on a per capita basis. Within weeks of being elected, the federal Liberals were unwittingly driving the western provinces together.

As the region with the lowest unemployment levels in Canada, western governments quickly formed a common front. We all agreed that we had to stand up to the federal government and challenge a program that was seen as being fundamentally unfair to our region.[4] The western provinces, especially Manitoba and Saskatchewan, had more aboriginal people than other parts of Canada, and although their unemployment levels were outrageously high, most did not pay unemployment insurance and would not be included in the federal counting. Farmers also did not pay unemployment insurance, even though they were struggling to make ends meet, and they too were located in western Canada in significant numbers. Moreover, with a strong work ethic rooted in the family farm, westerners had an almost moral aversion to going on unemployment insurance; rather than staying home and collecting unemployment insurance, hundreds if not thousands of people from the prairies reluctantly left home when times got tough to find jobs in other provinces. The program touched a nerve of resentment that westerners were being punished for doing well and believing in working hard.

The use of unemployment levels for infrastructure made us leery of the Liberals' agenda and appeared to confirm our worst fears that because western Canada was seen to be strong fiscally and economically, it was being targeted for tougher treatment. Such a notion was especially galling because when tough times hit us, in the form of low oil prices or major agricultural problems, there were few federal programs to bail us out; we were on our

own. It was the kind of issue that fuelled the flames of western alienation and explained why a protest movement such as the Reform Party caught on like a prairie fire.

Equally suspicious was the fact that the main beneficiaries were the provinces with the highest unemployment levels – the four Atlantic provinces – all of which just happened to have Liberal governments. Our suspicions of a Liberal political agenda deepened over time as the Atlantic provinces increasingly took positions at the finance table supporting the federal government, which in turn introduced new programs favouring the Atlantic provinces.

Within three months another issue deepened the wedge between the federal government and western Canada and brought the first substantive victory for the new western Canadian finance ministers' club. The issue, surprisingly enough, was tobacco taxes. By the early 1990s smuggling, cross-border shopping, and the underground economy were serious problems, especially in Ontario and Quebec. The GST had spawned an underground economy, with many people avoiding paying the required taxes. The relatively high Canadian dollar and lower American taxes and prices had fed cross-border shopping, and First Nations reserves in Quebec that spanned the Canadian-American border had become havens for smuggling, especially of much cheaper American cigarettes. Cash-strapped governments were missing the lost tax dollars. But beyond the financial issue, there was a legitimate concern about people's growing acceptance of ignoring tax laws. With some of the more militant Quebec reserves involved, smuggling was also feeding into the self-government argument that First Nations could move goods across the border without paying taxes, and was raising the spectre of two tax regimes – one for First Nations and one for the rest of us.

At our finance ministers' meeting in Montreal in January 1994 the Quebec minister described the problem in graphic detail, pointing out that there was even a moral aspect to the issue, in that police had virtually given up any hope of enforcing tax laws on reserves. The stakes in Quebec were especially high since Liberal Premier Robert Bourassa had just been replaced by the very pro-federalist Liberal, Daniel Johnson, who would have to call an election in the near future – a nerve-racking prospect in view of the fact that the Parti Québécois was leading in public-opinion polls. Didn't we all want to do what we could to prevent a separatist victory in Quebec? We did. There was no doubt in Montreal that all provinces sympathized with the Quebec Liberals' problem and were anxious to help. What we were totally unprepared for was the way in which the federal and Quebec governments planned to tackle smuggling.

Shock and disbelief greeted the federal five-point antismuggling plan, the centrepiece of which was a dramatic cut in tobacco taxes. As well as step-

ping up tax enforcement and policing, the federal government would immediately lower its cigarette taxes by $5 a carton and then cost-match provincial tax cuts of more than $5 up to a limit of $10. Overnight the cost of cigarettes would plummet. Quebec immediately accepted the federal offer and dropped its cigarette taxes by $11 a carton, which triggered a $10 cut in federal taxes. Once the federal/provincial sales tax cuts were factored in, the cost of a carton of cigarettes in Quebec would drop from $47.00 to $22.73. It might have been a great way to put smugglers out of business, but it was an awful way to run a country.

The federal proposal was criticized on several counts. With smoking being the number-one preventable killer in Canada, governments had raised cigarette taxes to discourage smoking, especially among young people, and statistics showed that the strategy was working: as cigarettes became more costly, smoking declined. Certainly, it seemed the reverse would also be true: cheaper cigarettes would mean more smoking, especially among young people. How could this be progress? There was also a financial issue. Saskatchewan and many other provinces did not have a smuggling problem, yet we stood to lose a big chunk of the more than $100 million that we collected in cigarette taxes. As well, there was a national issue. The federal proposal meant that there would be different federal taxes in different regions of Canada. For instance, federal taxes on a carton of cigarettes in provinces that did not accept Ottawa's offer would be $5.36, while federal taxes on the same carton of cigarettes in Quebec would be a mere 96 cents. The plan to defeat the divisive demon of separatism was creating other divisions of its own.

Western finance ministers had good reason to be especially upset by the proposal. Saskatchewan's case was typical. We estimated that at the very most we lost 15 percent of our revenue through smuggling and tax evasion of all kinds, and the statistic was stable, not growing. In part, this was because we lacked the seamless, heavily populated border with the United States that existed in Ontario and Quebec. Also, smuggling was not socially acceptable: in western Canada there was a much stronger belief that one obeyed the law and paid one's fair share of taxes. But even though we did not have the disease, we were going to get the cure. We faced either cutting a tax that we did not want to cut, thereby losing millions of dollars that we could not afford to lose, or watching cheaper cigarettes flood in from other parts of Canada. So we came out fighting. Premier Klein kept it simple: "We don't have the smuggling problem that exists in Quebec and to some extent in Ontario and other provinces, so we won't be lowering our taxes." Stefanson from Manitoba speculated that his government might respond to the federal $5 cut in tobacco taxes by raising provincial taxes on cigarettes by an equivalent amount. And I said, "What bothers me is that people in

Saskatchewan, because of the Liberal government, may be enticed to become smugglers," bringing in cheap cigarettes from other parts of Canada.[5]

Behind our public arguments was a very important point of principle – the western governments' serious concern about creating different federal tax regimes in different regions. The whole thrust of our 1993 *Western Finance Ministers' Report* had been about finding national solutions to Canadian problems, about having one policy for all of Canada. The tobacco tax proposal was taking us in the opposite direction. In the words of our 1994 report, "The Western provinces feel strongly that it is inappropriate for the federal government to levy different rates for any tax based solely on the province of residence of the taxpayer."[6] But the western finance ministers' strong views on a patchwork quilt of federal taxes went unheeded. It was, unfortunately, a practice to which the federal government would return.

As we plotted strategy in our western ministers' club, we came to see a way out of our dilemma. The main issue in deciding whether or not to cave in and reduce tobacco taxes was the domino effect: What would your neighbour do? The key province for western Canada was Ontario, so if Ontario could resist cutting its taxes, maybe the western provinces could do the same. Floyd Laughren was absolutely firm in his opposition to cutting tobacco taxes, for all the same reasons as the western ministers, but the issue for him was not desire, it was geography. Would Ontario be able to resist the pressure of cheap cigarettes coming in from Quebec? Nova Scotia, New Brunswick, and Prince Edward Island had already signalled their intention to reduce their taxes. For the rest of us it became like a game of chicken. We contacted one another regularly, seeking updates on our positions. We came to trust the fact that none of the finance ministers would change their minds. But we were all members of different governments. What if one of the governments, for some reason, changed its position? At first it seemed that the plan might work because Ontario was so determined to resist, but it was only delaying the inevitable. I remember how disappointed Laughren was when he brought the news that Ontario had no choice. Its huge open border with Quebec meant that Ontario had to follow suit and reduce its tobacco taxes.

Geography may have been the Achilles heel of Ontario, but it was the saving grace of western Canada. From years of teaching Canadian history, I remembered reading about the Red River Resistance in what is now Manitoba, when the federal government was helpless to quell the rebels because it was so difficult to move troops from central Canada through the rock and muskeg of northern Ontario. Transportation had improved since then, but there was still only one lonely road linking east to west. The heart of the strategy was to give financial support to Manitoba so that it could beef up

its antismuggling efforts along that long, lonely road. The strategy was aptly described in the *Star Phoenix* headline: "West to Fortify Borders against Smuggling." Our contribution to Manitoba's enforcement efforts was a manageable $240,000, a pittance relative to what we would have lost either by lowering our tax rates or simply reacting to the east-west cigarette traffic that would have probably occurred. Saskatchewan people were very supportive. As mail order companies tried to contact them from other parts of Canada offering cheap cigarettes, public-spirited citizens, including some notorious smokers, passed the information on to our government (some adding the admonition to go after the tax evaders). Symbolically, our seven-point plan on the tobacco tax issue, which included public education on paying tobacco taxes, ended by "demanding a single, countrywide excise rate."[7]

The western finance ministers' decision to go our own way on the tobacco tax issue was important in forging stronger bonds among us. When we informed the other finance ministers of our decision, there was no animosity, only quiet chuckling. And I remember Paul Martin giving us a genuine but highly skeptical "Good luck." The rewarding thing about our decision was that we were taking our fate into our own hands. Rather than doing what western governments had done for too much of their history – protesting, complaining, and voting against something – we were acting. We pulled together to ensure that Manitoba was properly financed to do its job at the border, and we did our job in increasing tax enforcement. We proved the naysayers wrong by keeping our tobacco taxes high while keeping the smugglers out, and we western ministers were stronger and more united because of our victory.

Within a year, the Quebec Liberals had been replaced by the Parti Québécois; by then smuggling had subsided, and the federal and provincial governments began to ease their tobacco taxes back up. The issue had been more like a tempest in a teapot than a crisis, but it had made us wary and was good training for the next skirmish. In handling the GST issue, the federal government, according to authors Greenspon and Wilson-Smith, tried to pressure the provinces to harmonize their sales taxes with the GST, "but as much as Martin tried, he could not persuade the provinces, particularly the western ones, to come on side."[8] In saying this, the authors did not realize that by the time the GST was on the front burner of the finance ministers' club, the western provinces were old pros at resisting federal pressure.

If the tobacco tax was a tempest in a teapot, the GST fiasco was the Mad Hatter's tea party. Only a politician could appreciate the machinations surrounding this contentious issue. The average clear-thinking voter, as the polls showed, had wisely dismissed the GST as a top-of-the-mind issue by 1995 and had moved on to other practical matters, such as whether or not

the country would drift into bankruptcy or be fragmented by a separatist victory in the Quebec referendum.[9] But in marble palaces across this land, politicians tortured themselves for much of 1995 and 1996 over the fate of the much-hated goods and services tax. If political scientists ever want a case study of politics run amok, they should study the handling of the GST. For all their political savvy, the Liberals, as the *Globe and Mail* pointed out in the summer of 1995, had "done the impossible. The GST used to be a Conservative problem, now it's theirs."[10] As subsequent events would show, desperate Liberals connived to pass the political hot potato on to the provinces by making the GST their problem.

For the federal Liberals, the GST involved two of the most difficult issues for politicians: integrity and internal unity. The aim of the Red Book – a policy statement produced by the Liberals during the 1993 election – was to reassure cynical voters who were convinced that all politicians, once they were elected, either ignored or actually contradicted the promises they had made during the campaign. The Red Book made specific promises, with costs attached to them, and made it clear that the commitments were like a contract between the party and the voters, who would get what they had voted for.[11] Unfortunately for the Liberals, one of the most high-profile commitments in the Red Book was to replace the GST. The text had some weasel words in it, notably that the finance committee of the House of Commons would be given one year "to report on all options for alternatives to the current GST. A Liberal government will replace the GST with a system that generates equivalent revenues, is fairer to consumers and to small business, minimizes disruption to small business, and promotes federal-provincial fiscal co-operation and harmonization."[12] A fundamental disconnect between the federal Liberals and the provinces – and indeed most Canadians – centred around this wording. From the provinces' perspective, the average voter heard "replace the GST," and if the Liberals could not deliver on that, then any other exercise was just political chicanery. Key Liberals, however, seemed to think that all voters were lawyers who would carefully scrutinize the words in the Red Book and cut them some slack about what constituted delivering on their promise. If these Liberals were right, then their goal to harmonize the GST with provincial sales taxes would be seen as fulfilling their commitments and preserving their integrity.

The other obvious problem was with caucus. Chrétien, it seems, was an experienced enough politician to be leery of making such an expensive promise.[13] However, as the polls tightened before the 1993 election and there was pressure because of the NDP commitment to scrap the GST, a nervous caucus nudged him into making the extravagant promise that turned out to be political dynamite. Caucus members wanted the promise because it would sell like hot cakes on doorsteps. (I know this from my personal

experience in the 1991 election, in which the Saskatchewan New Democrats promised to undo the provincial harmonization of the GST implemented by the Devine Conservatives. Although I was personally uncomfortable with the position, I witnessed its huge electoral appeal.) The popularity of the Liberals' GST promise meant that by the end of the 1993 campaign caucus members had visited thousands of people in their ridings and given them their personal commitment that after the next election the GST would be gone. For a prime minister and finance minister, it would be daunting to have at their backs so many caucus members with their integrity and political future on the line.

To understand the bizarre unfolding of the GST drama, it is necessary to appreciate the pressure that was coming from the federal Liberal caucus. In August 1995, Toronto area MP Carolyn Parrish said, "I think the GST is going to become a hot point – if we don't do something about it our credibility is lost." Soon afterwards, another Liberal MP, Daniel McTeague, said that he and other caucus members might not run in the next election if the GST was not replaced by a harmonized federal-provincial sales tax. In February 1996, yet another Liberal MP, Dennis Mills, warned the government that it had to find some way to replace the GST; by May of the same year Mills had been become so disillusioned by the lack of progress on the GST that he left the Liberal benches to sit as an independent. The killer blow was delivered by Toronto MP John Nunziata, who voted against Martin's 1996 budget on the devastating grounds that "this budget represents the final retreat from our election promise to scrap the GST ... Scrapping and harmonizing are not synonymous ... it is a red herring this harmonization." The cruel double whammy that Nunziata delivered was, first, to lay the hard facts on the line – the promise had been to replace the GST, not to fiddle around with it – and then to force the party to turf him out for voting against the budget. Such public expressions of dissent were only the tip of the iceberg. If that many MPs were willing to jeopardize their political future by publicly criticizing their own party, imagine how many others kept their anger over the GST quiet. There obviously were huge problems within the Liberal caucus.[14]

Never mind the caucus, the Liberal front bench was way out on a limb on the GST. Martin may well have had second thoughts on the issue by 1993; but he had co-authored the Red Book. The deputy prime minister, Sheila Copps, had publicly promised to resign if the Liberals did not replace the GST. And Prime Minister Chrétien had his own track record to defend. For instance, in Saskatoon in September 1993 he had laid out a pretty clear game plan. "I say to you provinces," he declared, "we have to have harmonization." Small business, he explained, faced a mess: "Some items have no tax at all, some have only provincial tax, some have only federal tax and most have both taxes." The biggest mistake the Tories had made,

Chrétien ventured, was to avoid harmonizing the GST with the provincial sales tax.[15]

How a prime minister was going to force reluctant provinces to participate in his harmonization venture and share ownership of the most politically unpopular tax in Canadian history was a mystery that was not uppermost in Liberal minds while they were on the hustings. The crucial point is that by the time the 1993 election was over, the elected members of the Liberal Party, from top to bottom, were thoroughly committed to a major election promise that was virtually impossible to deliver. Only such a background can explain their bizarre handling of the GST issue after they became the government.

Martin was dogged, and rather sly, in his determination to get the provinces into the mindset of helping the Liberals solve their GST problem. The same was true of Chrétien. As Premier Harris said publicly in March 1996, "The prime minister in every discussion we have ever had by phone, at a sporting event, somehow or other mentions the GST."[16] When Martin raised the issue of harmonization at my first private meeting with him, my response was that I was personally open to considering any alternatives but he had to keep in mind that the Saskatchewan NDP had its own credibility to consider. After delivering on its 1991 election promise to undo Devine's harmonization of the provincial sales tax with the GST – at a cost of more than $70 million – there would have to be some compelling benefits to Saskatchewan taxpayers for me to successfully persuade my caucus to reverse course and reestablish the harmonization that we had just undone. Martin expressed confidence that the tricky political minefield could be traversed. My approach was similar to most other finance ministers: we were open to looking at options but skeptical that a mutually beneficial result could be achieved.

Martin continued to press the GST agenda in late 1993 and 1994. He was subtle. In his first letter to provincial finance ministers in November 1993 he was low key: "Perhaps we could start by discussing the possible benefits of tax coordination." In his next missive a month later he was more direct: "We should also continue our discussion on tax coordination issues in general, as well as on the GST review and tax on income."[17] At the same time the parliamentary committee that had been promised during the election was travelling Canada trying to drum up support for changes to the GST, with harmonization emerging as the favored option.

By early 1994 some battle lines were being drawn behind closed doors. Martin and the federal Liberals were focusing almost exclusively on the GST and wanted to move quickly. The agenda outlined at the December 1993 finance meeting had called for federal legislation reforming the GST to be introduced in the fall of 1995, with the changes to come into effect in early

1996. On the other hand, most provinces were equally firm in the view that any changes to the GST could only come as part of a broader tax package. NDP governments were especially committed to the need to improve tax fairness, while western governments pushed for more provincial flexibility to design our income tax systems and consistently supported the idea of a national tax collection agency to reduce administrative duplication by collecting both federal and provincial taxes. Whatever the differences in emphasis, most provinces wanted to move more slowly, with a more comprehensive package of tax changes that would visibly benefit the average taxpayer, while the Liberals, because of their internal problems, pushed for a quick fix of the GST.

At the same time as provinces were quietly being pressed behind the scenes to help fix the GST problem, the federal government was drumming up public and business support for harmonization as another way to pressure the provinces. The federal argument had a lot of appeal to some segments of the business community. A harmonized tax would be simpler: rather than two expensive and cumbersome tax regimes, there would be one sales tax base and administration. Equally attractive were the business input tax credits: with the GST, businesses had their sales taxes reimbursed through these tax credits, which in effect meant that they did not pay sales taxes.

The federal efforts led to pressure on the provinces from business groups to support federal harmonization proposals. However, for every business letter that I received urging harmonization, there was another from some segment of the business community warning of its dangers. Businesses that were already paying the provincial sales tax obviously stood to benefit, since they would have their taxes rebated. The catch was that in Saskatchewan, with its very narrow tax base, no businesses in the huge service sector paid the provincial sales tax. Thus, they saw no benefit to themselves and feared a huge loss of business because their customers would now have to pay sales taxes on services. Restaurant owners said that when the GST had been introduced, business had plummeted; harmonization, by doubling the taxes on restaurant meals, would have the same disastrous effect. The Canadian Association of Maid Services had its own horror stories about what had happened to its business when Quebec expanded its tax base to cover services. Similarly, the Alliance of Canadian Travel Associations had dire predictions about what taxing travel services would do to tourism. And the list went on: repairs, real estate fees, hairdressing, dry cleaning were all services where customers would see taxes double overnight in Saskatchewan.

The battleground with the average voter was a tougher one for the federal government. Martin used to argue that there was only one taxpayer, by

which he meant that if businesses got a tax break with harmonization, then they would pass the benefit on to consumers in lower prices for the goods or services they sold. Such trust in the business community was not common among my constituents, who were just as likely to believe that a tax cut for business would lead to larger business profits. The biggest stumbling block of harmonization, from the provinces' point of view, was that it represented a tax shift from business to consumers. While businesses would pay less, consumers would pay more, and they would do so in a very visible way by paying more for all the services they use every day. For Elizabeth Cull, Eric Stefanson, Floyd Laughren, and me, this was an absolutely compelling argument against harmonization and one that we returned to again and again.

It was against this backdrop that the federal government made its proposal to a finance ministers' meeting on 28 June 1995 and leaned heavily on the provinces to support its plan. The package included a 12 percent national sales tax on all items covered by the GST, with input tax credits for business, and with one common tax collector. This was the part of the package that the federal government emphasized in its press releases, but it was the rest of the package that was of the greatest concern to the provinces: there would be a new flat tax on income, and the federal government would give the provinces more latitude to raise payroll and capital taxes to make up for the revenue they would lose by harmonizing. Martin made it clear that he intended to move on the sales tax that year and he expected provincial cooperation. At a later date, he said, we could talk about reform of other parts of the tax system, but we had to begin with small chunks, with some initial successes; this was to be our first tax reform success and the federal government was pressuring all provinces to pledge their support.

For hours the debate among the provinces raged. Newfoundland quickly jumped on board, arguing that in the interests of national unity we had to move quickly to fix the GST problem. Similarly, Prince Edward Island stressed the importance of simplifying the tax system and recommended that the proposal move forward. Nova Scotia was so enthusiastic that it was prepared to move forward even if it meant less revenue for the province. New Brunswick, facing an election in the near future, was more concerned about losing some $300 million in revenue but concluded that, for the sake of the country, officials needed to work over the summer to refine the proposal. The Liberal provinces had clearly lined up behind the federal government in its quest to fix the GST problem.

Ontario and the western provinces were just as clearly lined up on the other side. The most vocal was Cull from British Columbia, who presented a detailed analysis of what the proposal meant to the average taxpayer. To Martin she said, "This is not the success that we want to start with." In

British Columbia, she pointed out, business would be relieved of $1 billion in taxes, while consumers would see their taxes go up. The average family, Cull calculated, would pay $400 more a year in taxes. British Columbia had made a commitment to its voters that there would be no tax increases, and this proposal was contrary to that promise. Manitoba and Saskatchewan also emphasized the new tax burden on middle-class families that would result from taxing services and introducing a flat tax on income, and neither liked the prospect of having to increase capital and payroll taxes for business to make up for the lost revenue. The Yukon shared these concerns and added that the new national sales tax would be very detrimental to the vitally important tourism industry.

An unamused Martin then weighed into the debate, angry that we had all identified problems but had few solutions. He was prepared to spend the summer working on refinements to the proposal, but it was crystal clear that the pressure on the provinces to come on board would be strong. After Martin left the meeting, some of us commented that we were trying to be helpful but had not created the GST problem, so why were we being blamed for not having a solution?

Over the next several months, various provinces proposed compromise alternatives, starting with Ontario. Like the western ministers, Laughren was convinced that the federal proposal represented a shift in taxes from business to consumers, but he wanted to try to find some middle ground. In September, Ontario proposed to trade its provincial sales tax to the federal government in exchange for personal income tax points. By stepping forward in this way, Ontario cleared the path for other provinces to submit options. Manitoba had a plan that would see the federal government collecting all the sales taxes while the provinces took a larger role in income taxes. Alberta even got into the act. Although it had no sales tax, Alberta could see an advantage in the federal government assuming all sales tax revenues and then compensating all provinces, including Alberta. My own department, astutely observing that the GST was a "federal problem" that required a "federal solution," offered advice on how the federal government could get rid of the GST by raising a raft of federal taxes.

Confusion became chaos after the Quebec election, when the separatists entered the fray. Ever ready to strip the federal government of power and aggrandize the powers of Quebec, it proposed that the federal government abandon the sales tax field and turn it over to the provinces in exchange for handing the provinces more responsibilities. Following this path, Quebec could have achieved at the finance ministers' table what it would seek in a referendum. None of the proposals resonated with federal officials, who, after all, had designed the GST and saw harmonization as the logical next step in its evolution.

Martin continued to pressure the provinces to sign on to some variation of his plan, knowing full well that, as with the tobacco tax, there would be a domino effect. If a large province such as Ontario harmonized and introduced input tax credits, the competitive pressure on the rest of us to fall into line would be enormous. As a result, it became once again a game of chicken, with provinces checking regularly with their neighbours to see if they were caving in to federal pressure.

Once again Ontario was the key. None of us in the West liked the federal proposal and we knew that standing together enhanced our strength, but if Ontario buckled, all bets were off. Laughren, we knew, shared our concerns. Like us, he repeated the mantra that Martin's proposal meant a shift in taxes from business to consumers. But time was not on Laughren's side. As 1994 slipped into 1995, we all knew that there had to be an Ontario election, and no one could be optimistic that Laughren would be back. The alternative in Ontario was another Liberal government, and judging from the position of the four at the table, that scenario did not look good. Then there was the third-place Mike Harris, who was a real problem because he had actually committed to harmonize Ontario's sales tax with the GST, or so the ministers believed. The year 1995 was going to be a tense one on the GST front.

When Harris's Conservative government was elected in early June, the western ministers were nervous but not ready to surrender, and Martin kept up the pressure. In late June, he met with the western finance ministers and told us that the new Ontario government planned to harmonize, with the clear implication that we should get on side. Harris's comments during the election had certainly led the federal government to believe that he had made a commitment to harmonize, so if it could just work out the deal with Ontario, then the recalcitrant western provinces would almost certainly have to follow.

There was suspense at the finance ministers' table later that year when we reassembled and Ontario's new finance minister, Ernie Eves, prepared to speak. Eves was a man of few words who was difficult to read at the best of times. On this issue he had kept his cards very close to his chest, and although there had been rumours, none of us knew for certain what he planned to say. Ontario, he announced, had looked long and hard at the federal proposal for a national sales tax, but it represented a shift in taxes from business to consumers; thus, Ontario would not harmonize. Elizabeth Cull, who was sitting next to me, leaned over and whispered, "Janice, he's using Floyd Laughren's briefing notes!" Like the western provinces, the Ontario Conservatives' initial attraction to the idea of harmonization had faded as more analysis was done on its implications. The Harris Conservatives had just won a stunning upset victory in the Ontario election on a platform of tax cuts for middle-income families. What harmonization meant to them

was a tax increase for those same middle-income families. As Eves told the press in response to a question about harmonization, "We're into lowering taxes not raising them."[18]

Still Martin refused to relent. With Ontario joining the recalcitrant western provinces, Martin turned his attention to Atlantic Canada. As the story spread that Martin was going to do a special deal with the Atlantics, the sniping started. I observed that "in English Canada all you really have, it looks like, are Liberal provinces interested in a Liberal proposal." When Martin countered that the same offer was being made to the western provinces, Eves shot back, "No one in western Canada knows about the federal deal. Either they are making it up in their sleep, or they are talking to somebody who is not listening."[19] Throughout the GST battle, the Quebec separatist ministers intervened whenever they could to stir the pot, and congratulated themselves on their decision to move as far away as possible from this Mad Hatter's tea party. Unmoved by the criticism, Martin continued his discussions.

The fight was getting nasty, and by early 1996 there were signs of pandemonium in federal Liberal ranks. In February Sheila Copps, the deputy prime minister, waded into the fray by saying that Martin would be announcing a replacement for the GST in the next budget. Chrétien, when asked, backed away from Copps's position, promising only that the GST would be gone before the next election, while Martin confused the issue further by talking about harmonization. Premier Romanow commented, "It's confused thinking by the federal government, because it's going to be gone, the GST, and then it's not going to be gone." Dale Botting of the Canadian Federation of Independent Business also admitted to being "perplexed" and moved back from his support of harmonization by pointing out that it required "co-operation" by the provinces and left them short of revenue. My contribution was to suggest that "before Ottawa comes up with any tax proposals for the provinces, it better get its own house in order."[20] Contributing further to the sense of bedlam were comments from business groups, previously supporters of harmonization, who now thought that the cure looked worse than the disease. "Don't Fix the GST, Businesses Plead – Small Business Will Be Worse Off" was one headline. To top it all off, a public-opinion poll showed that Canadians hated income taxes more than the GST, so the government would be better off just keeping the GST.[21] Still Martin persisted.

Sniping turned to anger when the terms of the deal between the federal government and the Atlantic provinces were made public in April 1996. There would be a 15 percent national sales tax in Atlantic Canada, and to compensate the four provinces for lost revenue, the federal government would give them a total of $ l billion in transitional funding over four years.

As well, the Atlantic provinces would be allowed to deduct capital and pay-roll taxes from federal corporate taxes payable, a tax advantage not available to the other provinces, so once again there were differential tax rates for different parts of Canada. In announcing the deal, Martin cited the Red Book promise and argued that the first step in living up to that commitment had been taken. He justified giving $1 billion to the Atlantic provinces as follows: "Canada is built on the recognition that the regions of the country must help each other when they are going through a period of profound structural change."[22] Quebec quickly stepped up to the plate and asked for $1.9 billion for having harmonized its tax regime years earlier. To add to the confusion, Martin, having just argued that the federal Liberals were living up to their commitments, proceeded to apologize for his "mistake" in thinking the GST could be replaced.[23] Martin's apology, in turn, put pressure on Sheila Copps to live up to her pledge to quit if the GST was not replaced; so Copps quit her seat – but then ran in a by-election and was re-elected. As pandemonium prevailed in Ottawa, wily Canadian voters remained convinced that nothing had been done to replace the GST.

Any hopes Martin might have had that Ontario and the western provinces would be lured to buy into the Atlantic deal were quickly dashed as the controversy descended into mutual recriminations. The silly season of the spin doctors began in early 1996 when federal Liberals tried to blame the provinces for their failure to change the GST. A Saskatchewan Liberal MP, Gordon Kirkby, managed to get the headline "Kirkby Blames NDP for GST." A few days later, Prince Edward Island's newspaper, the *Guardian*, carried the story "Lack of GST Progress Blamed on Provinces." Three days later, Martin was on Saskatchewan radio saying that it was the provinces that were standing in the way of dealing with the GST. To which I responded, "The federal government's commitment to replace the GST is not being obstructed by the provinces, it is being obstructed by their [the federal government's] lack of desire to really replace the GST." For good measure, I added, "You can take the GST, you can dress it up, you can do whatever you want to its hair. But really it's the same old GST and the federal government is doing what the Tories always wanted to do – spread it further into provincial jurisdiction."[24]

The resolve of Saskatchewan and other western provinces was strengthened by growing evidence from Atlantic Canada about the cost to taxpayers of their new tax regime. We were also heartened by the support of our own voters, as reflected in one of the many letters I received:

Although I may not always agree with the policies of the NDP, I wish to affirm you, however, in your stand of not cowering to Mr. Paul Martin's insistent demands for the Provinces to harmonize their Sales Taxes with the hated GST. Why should our tax

monies help to promote the Liberal promise of removing the GST. It is my conviction that if the Liberals have cooked their own stew, they may as well stew in their own brew.[25]

In May, a study done for the Nova Scotia government contradicted earlier assertions that consumers would benefit from harmonization and revealed that the average family would in fact pay $335 more a year in taxes.[26] To prepare for question period, I requested clippings of headlines from Atlantic Canada about the blended sales tax (BST): "Mixed Tax Rate to Hike Costs," "BST Adds to Power Bill Woes," "Blended Sales Tax Equals Tax Hike," "Harmonized Tax Would Hurt Catalogue Shopping," and "Blended Sales Tax Could Drive Battered Construction Industry to Ground."[27] But the Saskatchewan opposition never did ask a question about harmonization; and within three years three of the four Atlantic Liberal governments had been defeated.

The GST fiasco brought federal-provincial relations to an all-time low, culminating in an extremely bitter exchange at the finance ministers' meeting in New Brunswick in June. In Ontario, Premier Harris attacked the federal government for "bribing the Atlantic provinces, with taxpayers' dollars to try to cut a deal."[28] In Alberta, Premier Klein rejected Martin's argument that it was fair to compensate Atlantic Canada because it was going through restructuring. That's what equalization was about, he retorted.[29] Even journalists argued that the timing could not have been worse: months after the federal government had announced that billions would be cut from provincial transfers, they managed to find $1 billion to facilitate a tax change in one region.[30] The strong criticism of preferential tax provisions for certain regions in the *Western Finance Ministers' Report* in early June 1996 foreshadowed the heated arguments that followed a few weeks later in Fredericton. In a section entitled, "Regional Biases Caused by Federal Tax Policy," the report stated: "Western Finance Ministers believe that federal taxes should be consistent across all provinces and territories. Without such consistency, regional biases are introduced which raise questions about the fairness of the tax system. Continuing differential federal tobacco tax rates is one example of this unfairness." The report continued by criticizing the federal government for perpetuating the problem through the special tax advantages given to Atlantic Canada.

The Saskatchewan position on the eve of the ministers' conference in Fredericton reflected the views of other western provinces: "The Atlantic province's decision to harmonize the Goods and Services Tax, as well as the federal government's approach to changing tobacco taxes, show the divisive nature of regionally-driven tax policies that do not address needs from a national perspective"[31] Behind closed doors in Fredericton, the same

arguments were made, but with a lot more anger. With Ontario and Alberta leading the charge and Quebec relishing the fray, the message was direct and hard hitting: How could we have national unity when the federal government persisted in creating different tax policies in different regions to suit its own political agenda? In response, Martin explained the benefits of harmonization and the nature of the problem faced by the federal government, and asserted the right of the federal government to design tax policies as it saw fit. He genuinely seemed to wonder why Eves and the western ministers were being so crabby. As I listened to the impassioned exchange, I wrote a note to my deputy minister: "The government of Canada is a unifying force; it can act unilaterally, in one fell swoop, to drive six deeply divided provinces together – the imperial federal government." It was one of the angriest and most divisive meetings that I have attended. We had all come such a long way from the meeting in Halifax in 1993. In such a short time we had lost that refreshing, energizing spirit of co-operation, of working together and finding national solutions to national problems.

The tobacco tax and the GST affair, although not major issues in themselves, were important in setting the tone for the bigger debate on the fiscal crisis. They were also a major distraction from the main event. So much energy and goodwill were dissipated in the pursuit of an elusive solution to the GST. Not only did these issues distract us from what should have been our main focus, but they made it more difficult to find a co-operative approach to dealing with the looming fiscal crisis. They, along with changes in the faces and attitudes of those around the finance table, help explain why co-operation on federal-provincial issues was so difficult.

At the same time as the GST controversy was unfolding, the federal government was working away at its strategy to deal with its massive deficit. Reflecting the goodwill around the finance ministers' table in 1993 and 1994, there were genuine federal attempts to find co-operative, inclusive solutions to the fiscal problems. It is important to understand what happened to these decision-making initiatives. Their fate reflects a lot about the nature of Canadian federalism and lays the groundwork for understanding Martin's pivotal 1995 budget.

Working Together?
Redesign or Offloading?

When federal Human Resources Minister Lloyd Axworthy announced on 31 January 1994 his plan to redesign Canada's social programs, he acknowledged that his goal was "ambitious" and his task "complex." Axworthy's lofty ambition to "help shape a new vision of social security for the twenty-first century" was matched by Paul Martin's equally ambitious target to dramatically reduce the nearly $40 billion per year spent on the basket of programs that Axworthy was reviewing. But in early 1994 it was Axworthy's agenda that dominated. So he declared with great enthusiasm that government's role was to "give leadership, to mobilize energy, to foster a common will to improve our common lot." As he explained, a task force of experts would help him develop options, while the House of Commons Standing Committee on Human Resources Development would hold public hearings, and full co-operation with the provinces would be sought.[1] If there was ever fertile ground for such an initiative to take root and blossom, it was in 1994 when there was still a lot of goodwill between the provinces and the federal government and a common view that Canada's social programs needed revamping. Rather than merely cutting the social envelope, the grand vision was to redesign Canada's social safety net to make it both affordable and more relevant to the needs of people in the twenty-first century.

Axworthy's endeavour was more high profile than the other restructuring exercise undertaken by the federal government in 1994 – the quest to reduce federal-provincial overlap. Spearheaded by Marcel Massé, a career civil servant turned politician, the latter initiative involved a joint effort by the two levels of government to find administrative savings by eliminating duplication in the design and delivery of Canadian programs. There was a teeter-totter relationship between Martin's need to wield the axe with massive cuts and Massé's work to use the scalpel of eliminating federal-provincial duplication. The more savings that Massé could find using the refined

method of restructuring, the fewer across-the-board cuts Martin would have to make. Martin was cheering for Massé but planning for the tough medicine.

As both Massé and Axworthy explained their tasks to the provincial finance ministers in 1994 and sought their co-operation, the choices were stark. Reducing the ballooning federal deficit, which had climbed to well over $40 billion, meant massive cuts in federal spending. One way to save money was by restructuring programs. Lurking in the background was the alternative – program review. While Axworthy's mission was to focus on the values that underpinned Canadian social programs and to find cost reductions within that context, program review was a much more fundamental exercise, involving cost/benefit analysis: What were the costs to the federal government of a particular initiative and how did these costs stack up against the benefits? Also, while redesigning social programs was a public operation, program review occurred behind closed doors and allowed the federal government to act unilaterally. Axworthy may have believed that because of his initiative, the social envelope would be exempt from program review; the finance ministers understood otherwise. In 1994, when the Axworthy review was announced, Martin told the finance ministers that money would be removed from the social envelope by 1996. The only issue was how. Either Axworthy, in conjunction with the provinces, would find ways to save billions by redesigning the programs or the money would simply be cut. From day one, the rules of engagement were clear.

The spectre haunting provincial finance ministers was that the federal government would simply continue the pattern of offloading its responsibilities onto the provinces. All finance ministers, except perhaps Alberta, appealed to the federal government to avoid this unco-operative way of cutting federal spending. The offloading of responsibilities was exemplified in the Mulroney government's handling of welfare payments for off-reserve status Indians. When informed that the federal government intended to stop paying these bills, Saskatchewan and other provinces protested and threatened, but in the end had paid. In constitutional terms, the provinces had no choice. Welfare, health, and education were all provincial responsibilities, so if the federal government decided to back out of payments that it had made in the past, then the provinces, unable either to renege on their constitutional responsibilities or to let people starve, had to pick up the tab. Saskatchewan, it is estimated, absorbed about $500 million in federal offloading prior to 1995 as the federal government arbitrarily withdrew its funding from a whole variety of programs and initiatives. I had protested: "It's like a family; when you have a problem and you hand your problem on to your sister, the family still has a problem."[2] But we all knew that the federal government had to find its money one way or another, and if it could

not do so by redesigning or restructuring, it might again do so by offloading. So all finance ministers had a lot on the line in the Massé and Axworthy missions.

As well as answering the question of whether or not the federal government would act unilaterally in its budget cutting, the Massé and Axworthy efforts help explain Martin's view of social programs. Martin's 1995 budget was built on a structure grounded in his view of Quebec, his commitment to the Innovation Strategy, and his idea of the federal role in social programs. Martin's father, Paul Martin senior, had played a major role in creating Canada's social safety net in the 1960s, and Martin junior was too committed to his heritage to abandon his father's legacy. This I discovered from personal experience when I provoked the wrath of Martin by hinting that he was turning his back on his father's achievements. The issue, then, was not *if* the federal government would play a role in the future of Canada's social programs but *how*.

Thus, both the Axworthy and Massé initiatives would answer key questions about the 1995 budget. Could the federal government capitalize on the enthusiastic provincial support in 1993 for co-operative decision making and avoid unilateral offloading? Was there a better way than unilateral federal action?

As Marcel Massé sat at the head of the table in Montreal in January 1994 and gazed around at the faces of the finance ministers, he had every reason to believe he was in friendly company. Several of the ministers had for months stressed the need for the provincial and federal governments to work together to reduce overlap and duplication – what Massé was before us to sell. Quebec Liberal ministers had repeatedly spoken of the need to streamline the administration and programming of the two governments. Alberta was a real hawk on the issue. At the 1992 western Canadian finance ministers' meeting it had tabled a paper entitled "Improving Efficiency and Accountability: Re-balancing Federal-Provincial Spending Responsibility," and in 1993 it had signed an agreement with the Mulroney government to work together on eliminating duplication in five areas – energy, agriculture, environment, economic development, and labour market development – an exercise that resulted in $15 million in immediate savings. The western finance ministers had supported the Alberta approach in their 1993 report, where one of the "recommendations for action" was to "identify and eliminate wasteful overlap and duplication." The Atlantic provinces showed less enthusiasm. With government activity representing such a significant part of their economies, it was understandable that they might see federal-provincial streamlining as a threat to jobs, something difficult to welcome enthusiastically in a region already besieged by unemployment. However, they did not object to the exercise, and on the assumption that silence implies consent, the rest of us proceeded to engage Massé and his mission.

Massé was impressive. His resumé reflected accomplishment: he was highly educated, with many impressive credentials, including a Rhodes Scholarship, and had spent his career at the highest levels of government in Canada and at the International Monetary Fund. His manner and style marked him as a senior civil servant. A man in his fifties, he conveyed competence, discretion, and a deep and intricate knowledge of government. Here was clearly an expert at working files through the massive and complex entrenched federal bureaucracy. His thinking was "big picture"; he described how the deficit/debt crisis was crippling governments and how the global economy was forcing us to reassess the role that governments should play. And his message was reassuring: all provinces would be treated equally. Any offer made to one province on how to reduce duplication in federal-provincial programming or administration would be available to every other province. Clearly, the exercise would be fair, open, and transparent, organized with the oversight of a first-class civil servant – a man with the knowledge and experience in government to put flesh on the raw numbers of billions in the cuts that Martin needed to reduce the deficit. The only question was, Would Massé's expertise be exercised in his capacity as tsar of overlap and duplication or in his role as the chair of program review? Would it be restructuring or offloading?

Martin and Massé were like two peas in a pod when it came to redefining government and redistributing power between the federal and provincial governments. Although one of them came at the issues from the business community and the other from the bureaucracy, they landed in the same place. Their message was that government had to be more strategic. Its ministers had to define the essential tasks that it could perform well and then focus on those areas while withdrawing from less important functions that could be left to others. Just as important, they shared the same view of Quebec: to accommodate Quebec within Canada required a more decentralized federation.[3] It would be simplistic to see this view as nothing more than the federal government endlessly giving away its power to the provinces. It was more sophisticated than that. It involved defining the priority areas in which the federal government had to play a major role in the twenty-first century and then figuring out how to ensure a strong federal presence in those areas in all parts of Canada, including Quebec.

Massé's idea of reducing federal-provincial overlap and duplication did not produce the results needed to blunt the effects of his other exercise, program review. An entrenched federal bureaucracy that is accustomed to calling the shots and is exceptionally adept at resisting attempts to trim its sails foiled the early attempts by the western provinces to establish a federal-provincial tax collection agency that was a true federal-provincial partnership. Also, the exercise was voluntary and not essential to the

federal deficit-reduction strategy, since the federal government could just as easily make unilateral cuts to provincial transfers. But, most important-ly, even a highly successful federal-provincial strategy to eliminate dupli-cation would have found a few million more in savings but not the billions required by the cash-strapped federal government.

Right-wing parties, convinced that government bureaucracy is massive, have habitually overestimated what can be saved by streamlining exercises of one kind or another. But closer scrutiny would have shown them that the basic issue was not the level of government delivering programs; it was the fact that Canada had far more programs than it could afford, irrespective of who was delivering them. Thus, if billions were going to be found by restructuring, it was more likely to come from the expansive and costly net-work of social programs that had been created in response to the Great Depression of the 1930s.

Men rode the rails during the Depression because relief – the only form of assistance at the time – was left to municipalities, which could not afford the burgeoning cost of providing for the unemployed. In the much more pros-perous years following the Second World War, the federal government wove together a social safety net – consisting mainly of welfare and unemploy-ment insurance – to catch the less fortunate. Meanwhile, other programs, such as the family allowance, Canada Pension Plan, Old Age Security, and income supplements for seniors, provided universal social security for the middle classes. As well, after the Massey Commission report in the 1950s had stressed that all provinces (even those whose graduates left in great numbers to work and pay taxes in other parts of Canada) should provide publicly funded advanced education, the federal government began fund-ing postsecondary education. And in the 1960s medicare was created as a national program jointly funded with the provinces. Unfortunately, by the 1990s, this impressive array of programs was suffering from three very dra-matic problems.

First, the programs were no longer affordable. This fact had been masked in the 1970s as the Trudeau government borrowed literally billions of dol-lars, ran up massive deficits, and piled up even larger debts to keep Cana-dians in the style to which they had become accustomed. When the Mul-roney government tampered with some of the programs in the 1980s – notably, the universal family allowance payments and Old Age Security – Canadians protested and stopped the government in its tracks. By the 1990s, there was no dodging the bullet. No finance minister who walked on earth would be able to balance the federal budget without cutting the huge social envelope, including the transfer payments to the provinces for health, wel-fare, and postsecondary education.

The second problem, which became apparent during Axworthy's review,

was that most of the programs were in provincial jurisdiction; during the period of postwar prosperity, the federal government had used its spending power to create programs in education, health, welfare and other areas that were provincial responsibilities, a fact increasingly harped on by Quebec governments after the 1960s. As nationalist and separatist sentiments in Quebec grew, so did the clamour for Ottawa to withdraw its tentacles from provincial programming and give more power to the provinces. Thus, even the staunchly federalist Trudeau government agreed in the 1970s to be less stringent in the conditions placed on its transfer payments to the provinces and to transfer some of the funds in tax points, over which the federal government had absolutely no control. However, Quebec continued to chip away at federal social programming in what was clearly provincial jurisdiction; witness the urgency the Liberal government of Daniel Johnson placed on transferring training to the provinces in 1994. And with the separatists sitting at the table after the 1994 provincial election, there was no support for enhancing in any way the federal role in provincial jurisdiction.

The third main problem with Canada's social programs was that they were outdated. The western finance ministers had stated in 1993 that the two orders of government needed to "review income security programs to effect greater co-ordination between orders of government and between income security programs and the tax system."[4] This referred to the fact that needy people were falling through the cracks between the welfare and unemployment insurance systems. While the federal government cut unemployment insurance, dumping people onto provincial welfare rolls, the provinces designed work-for-welfare schemes to move people onto federal unemployment insurance. Long-term unemployment had tripled between 1976 and 1994; 40 percent of unemployment insurance recipients could be categorized as repeat users, and only 10 percent ever received any job counselling.[5] Similarly, there were twice as many people on welfare in the 1990s as there had been in the 1980s; there was a growing number of poor children and a social safety net whose costs were rising dramatically but whose effectiveness were declining.[6] By the 1990s the social safety net had become a trap from which too many people could not escape. Helping people move from welfare to work was a goal everyone shared. The mood was right for change.

Axworthy's timely and all-important review was breathtaking in its scope, and some of the ideas in his discussion paper "Improving Social Security in Canada," released 5 October 1994, became the building blocks for the National Child Benefit. The welfare system, unemployment insurance, training, and funding for postsecondary education were included in the review, which also tackled such major issues as the alarming growth in child poverty. The exclusion of health care and seniors' benefits would

become salient points for future controversy. The theme of the reform initiative was to improve opportunity and access to jobs, the focus being on working, learning, and security. Under "working," Axworthy proposed to create an employment insurance system out of the existing unemployment scheme, but with more emphasis on training and various options to deal with overuse of the system. The "learning" section detailed his highly controversial plan to change the way postsecondary education was financed. And "security," defined as removing disincentives to work and reducing child poverty, included a proposed block fund to transfer funds to the provinces for welfare, with some basic parameters for standards. Most innovative were the ideas about ways to redirect funding to priority areas. Here the future National Child Benefit was foreshadowed in the suggestions for greater income support for low-income families with children, and an income supplement for working-poor families. Financially, the paper reflected the 1994 budget, which had cut $2.5 billion from the unemployment insurance program and cut transfers to the provinces for health, education, and postsecondary education by $1.5 billion. The discussion paper also made an oblique but ominous reference to the possibility of additional cuts in the 1995–96 budget to meet federal fiscal targets.

As Lloyd Axworthy sat at the head of the finance ministers' table in June 1994 to provide a general preview of his discussion paper, the atmosphere was more tense than when Massé had met the same ministers in January. For Axworthy, the minister responsible for the biggest spending in government, to be surrounded by finance ministers would have been like having an intimate moment with a group of vampires. The tension was heightened by the fact that the meeting followed a heated exchange on the GST. None of the finance ministers, to my knowledge, had any concerns about Axworthy himself, who came across as an intelligent, thoughtful man; but most were leery about his agenda. He began by reassuring the provincial ministers that he wanted a dialogue and said that he was committed to redesigning the social safety net, not simply cutting it by reducing transfers. But some of his other points were ominous. He observed that in the social security system, too much public money went into welfare and not enough into such services as support for low-income families or measures to alleviate child poverty. If money was moved from welfare into these all-important preventative programs, he asked, who, then , would pay for welfare? A collective chill went down the spines of several finance ministers who feared they knew the answer to that question. Curious to some of us was his observation that learning was a national concern. We wondered how this could be when education was clearly a provincial responsibility? The question was answered, to our dismay, a few months later when the specific details of Axworthy's plan to revamp postsecondary education became public.

Other concerns raised by the finance ministers in their meeting with Axworthy also foreshadowed what was to come. My concerns, contained in my speaking notes, were typical: "I strongly urge the federal government to recognize that it should not solve its deficit problems by simply shifting responsibilities and costs onto the provinces." This was a view shared by all of my colleagues; even Dinning argued that the responsibilities given to levels of government had to be commensurate with their capacity to raise revenue. My other main point was also a common concern: "This exercise must be a joint exercise where we agree on the objectives and work closely together in examining the options and act together in implementing reforms." Cull of British Columbia also made a telling point that would be echoed by her colleague in social services, Joy MacPhail. Such an important exercise required national leadership, beginning with a national priority-setting exercise. Our concerns reflected the reality that Axworthy did not have the right people at the table with him; despite the fact that so many of the programs being reviewed were in their bailiwick, the provinces were neither co-managers nor co-chairs of the exercise. Martin, though clearly willing to see if the review would produce the necessary savings, was not participating in Axworthy's show. Finance can be invaluable in a government exercise in fleshing out the possible options and ensuring their affordability. Moreover, it is always involved at the end, with incisive analyses of the workability and affordability of proposals – often not a pretty picture.

The structural weaknesses in the Axworthy exercise can be seen by comparing it with the successful initiative to overhaul one part of Canada's universal social program package, the Canada Pension Plan. Launched in 1966 as a "pay-as-you-go" system of funding retirement benefits, the program was in financial trouble by the 1990s because of the growing number of seniors, the imminent retirement of baby boomers, enhancements to the benefit package, and the slowing of the economy since the 1960s. Without changes, the program was unsustainable. Legislation dictated that at least seven of the ten finance ministers representing 50 percent of the Canadian population had to agree to the required changes by the end of a set review period on 1 January 1997. In less than two years, Martin spearheaded a review, in conjunction with the provinces, which included public hearings and managed to arrive at a package to change the program within the specified time. Although Saskatchewan and British Columbia did not support the final package, since we disagreed with the level of cuts to benefits, the review was a success in the sense that changes in investment policies were made, benefits were reduced, and contribution rates were increased to ensure the long-term viability of a key component of the Canadian social security system.

The overhaul of the Canada Pension Plan contrasted sharply with the

Axworthy review. The former was specific and targeted while the latter was wide-ranging and open ended. While finance stayed aloof from the social program review and was therefore in a position to observe the result with skepticism, finance directed the Canada Pension Plan review. And while there were lots of noble words about provincial co-operation and partnership, the social program review was clearly a federal initiative, while revamping the Canada Pension Plan involved the constant participation of the provinces. The difference between the two processes helps to explain the problems experienced by the social program review. But there were other reasons why Axworthy's efforts ran into trouble.

Axworthy's hope of working in partnership with the provinces, together with social groups, unions, and other interested parties, suffered a severe setback a few days after his initial announcement of the review when the 1994 federal budget cut $2.5 billion from unemployment insurance. To cash-strapped provinces, this meant the removal of people from the unemployment rolls (the responsibility of the federal government) and shifting many of them onto welfare, a tab for which the provinces paid as much as half of the costs.[7] It was offloading and unilateral decision making at their finest. The move soured relations with other supposed partners because it appeared to them that even before the review had begun, the federal government had acted without consulting them.

Cutting unemployment insurance benefits at the same time as social programs are being reviewed is obviously bad timing. However, the more fundamental question is, Did the federal government have a choice? Answering this question requires an understanding of the Canadian fiscal situation in early 1994. A country with more than $500 billion in debt and a deficit of more than $40 billion had just elected a new government. The international financial community knew that the Liberals' last major stint in government – under Trudeau – had led to massive deficits. Worse, in opposition the Liberals had been vehement opponents of the Free Trade Agreement. Credit raters and others had good reason to wonder about the new government's attitude to Canada's fiscal mess. Financiers would ask only one question: Was their money secure in such a heavily leveraged country that had a new government with that kind of track record? Whatever the Liberals' public rhetoric about jobs being the main issue in early 1994, the reality at the Department of Finance was that the government's first budget had to show some serious commitment to dealing with the financial situation. Thus, spending cuts had to be found. But where would a government that had been in office only a matter of months find major spending cuts? As Martin explained, only in defence and human resources were there veteran ministers who could deliver quickly on sizable cuts in spending.[8] Although the last thing that Axworthy needed to launch his review of social programs

was a major cut in unemployment insurance, it was one of the few things that a financially strapped government could offer up as a token of its commitment to deal with the financial mess that was not of its making.

Once a country's fate depends so heavily on the assessments of external financiers, governments lose some of their freedom to choose. Paul Martin had no choice but to make significant spending cuts in his 1994 budget. Every finance minister in the country told him so in no uncertain terms, as did a host of advisers, business people, economists, and others familiar with international finance. The alternative would have been worse. Any hint that investors were losing confidence in Canada and were beginning to withdraw their investments would have prompted a drop in the Canadian dollar and an increase in interest rates; higher interest rates would worsen the deficit/debt crisis and slow the economy, bringing the attendant evils of high unemployment and higher unemployment insurance costs. Failing to act would have risked allowing Canada to fall into a downward cycle that could snowball into a major fiscal crisis.

The fiscal crisis and the pincers that it places on governments help to explain the downfall of Axworthy's noble plan. Axworthy was right in his view that the whole social envelope needed to be revisited. It was all part of a piece. The various programs fed into one another. But an overhaul of that magnitude requires time, and one thing that a fiscal crisis does not grant to governments is time. Not only do bankers want new governments to act quickly to signal their intentions, but political parties have to act quickly if they want to be re-elected. Canadian voters have shown a willingness to re-elect governments that have made tough fiscal choices, but only after the worst is behind them. Governments have a four-year electoral window, which closes quickly. Difficult choices have to be made within the first two years so that the third year is a period of stability and by the fourth year there are visible signs of improvement – some tangible rewards to voters for the pain that they have endured. If the redesign of social programs had been only about modernizing not cutting them, the debate could have occurred over four years, with the redesigned programs being the centrepiece of a government's re-election platform. But cuts had to be made quickly to appease the financiers and to get the bad news out of the way well before an election. Thus the fiscal imperatives virtually doomed Axworthy's bold plan. Prime Minister Kim Campbell had said during the 1993 election campaign that an election was not the time to have a serious discussion about major issues like social policy. The same could be said about a fiscal crisis.

But there were other problems with Axworthy's ideas. The most unpopular of his proposals – his plan for postsecondary education – is a case in point. Axworthy's stunning proposal was to replace federal grants to

provinces for postsecondary education with loans to students, whose repay-
ment schedules would be based on their income levels. The bottom line was
that all of the 1994 budget's $1.5 billion in savings from the social envelope
was to come from postsecondary education. Students and their parents
were furious. Without federal funding, universities, technical schools, and
community colleges would have to raise tuition fees dramatically, and stu-
dent debt levels, which were already high, would worsen. Voters sided with
the students and their parents, and so did provincial governments. Within
hours of hearing the details of the plan, our government representatives
were attending hastily arranged meetings with student representatives to
form a common front in opposition to this part of Axworthy's plan.

What prompted Lloyd Axworthy, an academic himself, to stumble into
such a politically inept proposal? At the finance ministers' meeting in June,
we had been surprised when Axworthy said that learning was a national
concern; in constitutional terms, education was clearly a provincial respon-
sibility. It was especially near and dear to the hearts of Quebecers because of
its intricate relationship with culture and values, and it was jealously guard-
ed by Quebec governments. Consequently, there was no scope for Axwor-
thy to find some innovative way to fund educational institutions, since this
would be a clear intrusion into provincial jurisdiction. Even if Saskat-
chewan, for instance, had offered to allow such a federal intrusion and
accepted the funding for some new national program – as I am sure we
would have done in the cash-strapped 1990s – the gesture would have been
meaningless with the Quebec separatists sitting at the same table. Thus, the
only avenue open to Axworthy in reshaping postsecondary education was
to find an innovative way to fund the individual student. In his scheme of
income-contingent student loans, he thought he had the answer.

When public opinion polls clearly told him that he was mistaken, what
were the alternatives? If funding individual students was not politically sal-
able, Axworthy had no other options to redesign postsecondary education.
According to the parameters established by Martin, if the social programs
restructuring could not reduce costs, then the alternative was analysis by
either Massé's program review or the finance department. In either case, the
result would be to apply a cost-benefit analysis to the established practice of
transferring federal dollars to the provinces to fund postsecondary educa-
tion. The costs to the federal government were substantial, though not as
great as the costs of welfare and health, and the benefits were hard to find.
The provinces had the power to design the programs, and allocate the fund-
ing, and were eager to claim the political credit. They and others who vehe-
mently opposed the income-contingent student loan proposal easily won
their battle. The initiative was buried, never again to see the light of day.
What was not apparent until the 1995 budget was that in terms of overall

funding for postsecondary education, they had lost the war. Only with the Innovation Strategy, which opened the door to federal funding of the individual researcher, did the federal government reappear to play a direct role in funding postsecondary education.

A final explanation for the failure of Axworthy's review was that neither the broad network of groups involved in social policy nor the unions accepted his offer to work together to restructure the social safety net. Their reluctance can partly be explained by their suspicion that the exercise was really about saving money, fears that seemed to be substantiated with the cuts to unemployment insurance in the 1994 budget. However, while the provinces might have good reason to wonder about Axworthy – who was known as a centralist with no record of commitment to partnership with the provinces – social groups should have felt reassured by his proven track record as a social reformer. When listening to him, one had no doubt that his compassion was genuine, as was his openness to real change. But instead of co-operation, Axworthy got criticism, lectures, and protests. As Allan Moscovitch, a professor in the School of Social Work at Carleton University said, "He expected some sympathy, on the basis that mild reforms by a left-leaning Liberal were better than being cleaned out by Martin, but he just didn't get it ... At one high-profile public forum in Toronto in early 1994, he was attacked throughout the whole meeting. There was just no real communication."[9]

There is not one simple reason why Axworthy's review of social programs failed. He made major mistakes, notably not co-chairing the exercise with the provinces and also by trying to save all of the $1.5 billion by his ill-conceived student loans program. As a centralist suspicious of provincial powers, he may even have been the wrong choice for the job. Still, it is difficult to see how the review could have overcome either the unwillingness of the left-wing unions and social groups to come to the table or the constraints placed on governments in the midst of a fiscal crisis. Time, measured decision making, and due process are all casualties when a country's fiscal situation deteriorates to the point that action has to be fast and dramatic. Unilateral action was not necessarily the first choice of governments in the 1990s. It was often the only choice left.

With the fizzling of the Axworthy review, the process for cutting costs in the social envelope shifted from the public experiment with joint decision making to behind-the-scenes unilateral choices made by program review and the Department of Finance. Neither Martin nor Massé could address the fact that social programs needed restructuring, but they could tackle the other two problems of the social envelope: the programs' affordability, and the fact that health, welfare, and postsecondary education were provincial responsibilities. Affordability obviously drove the decision making, but so

did the need to redefine the federal government's future role. A fundamental choice to be made was which areas the federal government should remain in as a major player and which ones it should offload or leave to the provinces. Equally important was how the federal government could remain in areas vital to the future of Canada but still deliver programs that did not conflict with provincial responsibilities – and which would therefore be welcomed in all parts of Canada, including Quebec.

Affordability and provincial control were major problems in both health and welfare. The costs of both were increasing dramatically, and because both were in provincial jurisdiction, with the provinces designing and delivering the programs, the federal government had no capacity to control costs, though it had to pay a good percentage of the bills. The problem was especially acute with welfare. By the terms of the Canada Assistance Plan, the federal government cost-matched funding for welfare. Thus, when the Peterson government in the late 1980s decided on double-digit increases to welfare payments in Ontario, the federal paymaster had no choice but to pay its share. The combination of increasing costs and complete provincial control over the decisions driving these costs would not stand up to the incisive analysis of either program review or finance officials.

The same was true to a lesser extent in health. Although not committed to cost-matching dollars, the federal government was paymaster for a system for which it lacked the capacity to design programs or impose efficient administration. The management and delivery of health care were clearly constitutional responsibilities of the provinces. The Canada Health Act, which specified the main principles of medicare, gave the federal government policing powers – it could act as a gatekeeper, cutting federal funding for provinces that violated the main principles of medicare. But although this gave the federal government more control over health than welfare, the remedy of reducing federal funding was a pretty draconian way for the federal government to participate in health care. And it gave the federal government no leverage to control costs or actively design programs. As in welfare, the federal government was paying billions for a system that was run by the provinces.

The issue of provincial jurisdiction took on new urgency with the election in September 1994 of the Parti Québécois and the prospect of a Quebec referendum on the future of Quebec's place in Canada in the fall of 1995. As Quebec ministers, acutely conscious of the decentralizing imperatives in Quebec politics, both Martin and Massé would have seen the possibility of turning a lose-lose scenario into at least a partial win. Continuing to pour endless dollars into health and welfare programs run by the provinces was a lose-lose. Dramatically reducing federal funding for the social envelope, in exchange for recognizing provincial jurisdiction in these areas and giving

the provinces more flexibility in designing health and social programs, at least had the potential to be a partial win. It would allow federal politicians to tell Quebecers, who were universally concerned about the sanctity of provincial power, that they were gaining more control over their own social agenda. Therefore the bad news of cutting the amount of money available would be offset in Quebec by the good news that there would be more flexibility and freedom for the province to chart its own course.

The federal choices made with respect to health, welfare, and postsecondary education have to be seen in the context of priority setting and strategic government. In late 1994 there is no doubt that finding the savings needed to feed the deficit monster was the main focus of Martin and Massé. But government is also about trade-offs. On the one hand, the federal government could spend billions financing expensive welfare and health systems which the provinces clearly had the power to run. On the other hand, it could withdraw from cost-sharing welfare, temper its commitments to postsecondary education and health, and gain some fiscal room to move into new areas that would ensure Canada's success in the twenty-first century. But in 1995 it was not the creating but the cutting that was the main concern. There was a saying in the 1990s in Saskatchewan finance, "Go big or go home." Its message was: If you are going to take flak for making cuts in a specific area, then at least make it worthwhile by making the cuts as big as possible. Cutting transfers to provinces for health, welfare, and postsecondary education was going to incur the wrath of many Canadians, no matter what the amount was. With $17 billion at stake, if the federal government was going to take the heat, then it might just as well grab as much cash as it could to make the effort worthwhile. It was this kind of thinking that paved the way for the 1995 landmark budget.

Martin's Landmark 1995 Budget

On 27 February 1995 Finance Minister Paul Martin had good reason to feel a sense of accomplishment as he wrapped up a day of selling his budget. "Government must not live in the past," he said in his budget speech, quoting his father, "the government must begin to plan ahead – not timidly, not tentatively – but boldly, imaginatively and courageously."[1] Bold was certainly an apt description of the 1995 budget. With spending cuts in excess of $25 billion, the budget lived up to Martin's billing as "by far the largest set of actions in any Canadian budget since demobilization after the Second World War."[2] Reducing Canadian government spending relative to the size of the economy to its lowest level since 1951 was no mean feat. Equally bold was its redesign of government. Taking a leaf out of the budgets of Saskatchewan and Alberta, Martin winnowed down government to make it more strategic and to reposition it for the twenty-first century. In the long term, the most dramatic changes were those that redefined the relationship between the provinces and the federal government and affected the programs nearest and dearest to the hearts of Canadians – health, education, and social programs. It was here that Martin turned his back on years of Liberal tradition and charted a new course for Canada. And it was here that the greatest controversy would erupt. At the end of budget day, however, Martin could bask in the glow of a job well done. He had made his choices and, just as important, he had sold them. Early responses showed clearly that his budget had passed muster with the two audiences that mattered most: the financial community and Canadian voters.

Martin's budget was a unifying force among provincial finance ministers. Gone were the regional divisions so prominent in debates about the tobacco tax and the GST. Finance ministers from all regions and all political parties united in their anger at the budget's unfairness. We had all expected cuts to provincial transfers, but we were horrified at their size – at the new levels to which Martin had taken the historic problem of offloading federal

responsibilities onto the provinces. Even Alberta was concerned that the imbalance between provincial responsibilities and provincial revenues to finance those tasks had been greatly worsened by Martin's choices. Canadians in both the western and the Atlantic provinces were convinced that their region was being made to bear an unfair share of the burden of deficit reduction. Divisions between right and left were blurred as provincial politicians joined forces with educators, health-care workers, social activists, and other concerned Canadians to decry the massive change in direction which the budget signalled. Premier Roy Romanow called the changes in the budget "un-Canadian," and another staunch Canadian nationalist, Ontario Premier Bob Rae, lamented," It marks the end of Canada as we know it."[3]

The 1995 budget put to rest the whispering among members of the financial community and even some finance ministers that Martin was too nice a guy for his tough job. Mistaking style for substance and caution for indecision, many of us had thought in 1994 that Martin would opt for minimal action on the deficit; and some of us had regarded his collegiality with his provincial counterparts as a substantive commitment to avoid hitting the provinces hard in his cutting exercise. But it was now clear that Martin's limited cuts in the 1994 budget had in fact simply reflected a desire to have a well-thought-out and effectively communicated game plan in place before he proceeded further. Martin had many reasons to move slowly toward his destination.

In terms of his mindset, Martin did not come to the finance minister's portfolio as a deficit hawk. He had co-authored the Red Book, which set a deficit target of 3 percent of GDP, but it took some time and lots of persuasion before he accepted the need for more drastic action. Like most Liberals, he took no joy in cutting government for the sake of cutting. The logic of compound interest drove him, like the rest of us, to accept the reality that if the deficit was not conquered, there would be no hope of the federal government opening new fronts to tackle child poverty or to promote innovation in the economy. Worse, if the fiscal situation deteriorated into a full-blown fiscal crisis, Canada's autonomy to make its own decisions would be compromised. Thus Martin was transformed from being a cautious skeptic to becoming a believer by inescapable facts and logic. As he said in his 1995 budget speech, "The debt and deficit are not inventions of ideology. They are facts of arithmetic. The quicksand of compound interest is real."[4]

As well as developing his own convictions about the deficit, Martin had to navigate his way through two other thorny issues. One was whether to reappoint the governor of the Bank of Canada, John Crow. Appointed governor in 1987 after spending twelve years at the International Monetary Fund, where he had witnessed the damage done to developing countries by runaway inflation, Crow was convinced that inflation had to be eliminated

to protect the value of the Canadian dollar. His firm stand on the subject was strongly supported by the national and international business community. But the flip side for the average homeowner, farmer, or small business person was that interest rates and unemployment levels had reached double digits by 1990. The biggest problem that Mazankowski had faced in taming the deficit had been the skyrocketing interest rates that resulted from Crow's tight monetary policies. The strong-minded Crow was up for reappointment in 1994, and Martin had to make a difficult decision.

In opposition, the Liberals had been very critical of Crow's tight monetary policies.[5] High interest rates, they knew, would wreak havoc with their election commitment to create jobs and reduce the deficit. In addition, many of the provinces were adamant that a change in the direction of monetary policy was required. On the other hand, Crow had the stature in the business community and international financial circles that the Liberals lacked. If Crow was not reappointed, he would be the first governor of the Bank of Canada subjected to such a snub, which would damage the already fragile reputation of the Liberals in key business circles.

Martin handled the issue well and secured a major plank in his plan to tackle the deficit. Crow, after several long and contentious meetings with Martin, decided to withdraw his candidacy for reappointment, paving the way for the appointment of the deputy governor, Gordon Thiessen, who shared Crow's reputation as an advocate of tight money but was more flexible. As one columnist said at the time, "It's a very elegant compromise ... The Liberals get rid of Crow, but they keep his monetary policy."[6] The compromise was a major victory for Martin. Moreover in 2000, when David Dodge, formerly deputy minister of finance, replaced Thiessen, the governor's chair was held by someone who understood what high interest rates meant to a deficit-fighting cash-strapped government committed to building the economy. Thus, the economic slowdown following 11 September 2001 was attacked primarily by the governor of the Bank of Canada's action of lowering interest rates and letting the dollar fall, rather than by the government succumbing to calls for either tax cuts or spending to stimulate the economy.

The major victory that Martin achieved was the establishment of a close working relationship with Thiessen and Dodge, which meant that monetary and fiscal policy worked in tandem, not at cross purposes. Low interest rates and a low dollar were major prongs in Martin's strategy to tame the deficit and stimulate the economy by enhancing the competitiveness of Canadian exports. His deficit numbers would have looked far worse if they had been subjected to Crow's very tight monetary policy and high interest rates.

The other pesky problem for Martin was the Liberals' election commitments. The different positions taken on transfer payments to the provinces

by the four main parties in English-speaking Canada reflected a great deal about their respective approaches to deficit reduction. "We're not planning to cut the transfer payments," Chrétien promised in Saskatchewan in September 1993. To drive home his point, he added, "There's nothing calling for a reduction of the level of the transfer payments."[7] Like the Liberals, the Conservatives straddled the political middle by saying that they too would not cut transfer payments. On the right, the Reform Party's position mirrored the deficit-cutting approaches of the right-wing provinces: health and education transfers would not be touched (a reflection of the fact that health and education spending are not right-left issues in Canada), but the party would cut $1.5 billion from transfers for welfare and equalization.[8] This exemplified the right-wing view that government had no role in redistributing wealth among classes or regions. On the left wing, the NDP promised to increase spending on transfers – thereby trying to sidestep fiscal realities and cling to a past of more and more spending, even as that past was disappearing before our eyes.

As well as needing to slide away from Chrétien's words about the sanctity of transfer payments, Martin had to manoeuvre around the main theme of the Liberal platform: jobs, jobs, jobs. Always concerned about their credibility, and thus their need to appear to be delivering on their promises, the Liberals had made jobs the main theme of the 1994 budget, the centrepiece being the $6 billion infrastructure fund. Jobs and deficit reduction were in fact linked. High deficit and debt levels dampened economic growth and job creation. But this was a fact more accepted by bankers than by voters. By late 1994 the Liberals were the beneficiaries of what matters most in politics – luck. The economy had turned around, allowing Martin to boast that 433,000 jobs had been created in 1994, knocking two points off the unemployment rate. With low inflation, rapidly improving productivity, and record exports, Martin declared: "These statistics tell a story of an economy in bloom, an economy of growth and new jobs."[9] Against such a background, he could shift gears from jobs to deficit and argue that a period of strong economic growth was an ideal time to cut spending.

The other winds that blew Martin toward his 1995 budget were pressure from the business community, the media, and even Canadian voters. Martin benefited enormously, as he concedes, from the groundwork laid by the provinces. While provincial ministers had to build public support for deficit reduction, Martin was pushed by public opinion and by events to take a more aggressive approach. By the summer of 1994, members of the business community and some of the media were talking openly about the inadequacies of his 1994 budget, saying that it was far too timid in its attack on the deficit.[10] Meanwhile, provincial cost cutting had led to a shift in traditional Canadian attitudes toward government. A 1994 poll showed that

"people's expectations of government are diminishing." It continued: "This decline is produced by growing recognition of a deficit crisis, disillusionment with the efficacy of government, and a consensus that citizens cannot rely solely on government to solve the range of problems that government was expected to solve in the past."[11] Canadians' concern about the deficit and their growing support for dramatic action were reflected in comments made by members of the public to the House of Commons finance committee, which held cross-Canada hearings in late 1994 and early 1995. As momentum built for an all-out assault on the deficit, other items fell off the Liberal's agenda.

The Liberals had not come to power in 1993 to defeat the deficit. They knew they had to reduce it, but their agenda had included other goals. In the fall of 1994, the government released some discussion papers that revealed three themes to which the Liberals would return throughout the 1990s and into the new century. Two of the papers dealt with the economy and the fiscal situation. Another was Axworthy's review of social programs. Although the Axworthy initiative was scuttled, his discussion papers contained important new ideas to deal with social problems such as poverty. The fourth paper, released by John Manley, was "Building a More Innovative Economy." As pressure to focus on the deficit increased, the other two issues – tackling child poverty and promoting innovation – took a back seat (although in fact both were delayed rather than derailed).

The head of steam behind aggressive action on the deficit was reinforced by the events of late 1994 and early 1995, which heightened public awareness of the emerging crisis and increased support for tough measures. Luck had again played into Martin's hand. In December 1994 the Mexican peso crisis spooked Canadians about what could happen when a fiscal crisis spins out of control. Their fears were heightened by a *Wall Street Journal* article suggesting that Canada might be just a frozen banana republic. By January, as nervous investors moved some of their money out of Canada, the dollar fell and the governor of the Bank of Canada had to raise interest rates. Then, in February 1995, Moody's, the world-renowned New York credit-rating agency, served notice that it was reviewing Canada's debt, signalling the possibility of a downgrade in Canada's A credit rating. When the news broke, the dollar fell again and interest rates were increased. Financial analysts were blunt about what Moody's shot across the bow meant. One said, "If the budget doesn't meet the markets' expectations, then Moody's is going to pull the trigger."[12] The fall in the dollar and the increase in interest rates affected the pocketbook of ordinary Canadians and brought home to them the urgency of dealing with the country's finances before Canada drifted down the road to a fiscal crisis.

By the time Martin rose in the House of Commons to deliver the 1995

budget, there was a groundswell of public support for drastic action. As there was now such broadly based consensus that tough medicine, no matter how unpalatable, was necessary, the position of the provinces became almost impossible. In other circumstances, if provincial ministers had criticized the massive cuts to health, education, and social programs, their appeals would have resonated with voters. But in the crisis atmosphere of 1995, although Canadians listened to the provinces' case and even agreed, this in no way changed their commitment to follow Martin's lead and rid Canada once and for all of its deficit woes. Ironically, the provinces had unleashed a wave of public support for budget cutting that was now boomeranging back on themselves.

Popular support for the toughest budget in Canadian history can also be explained by its skilful crafting and the way it was introduced. That extra year of planning, laying out the strategy and working on a communications plan, had paid off. Much as I hated it, I had to admit that the 1995 budget was a masterpiece. It borrowed selectively from the budgets of Saskatchewan and Alberta. It reflected the skill of a seasoned bureaucrat, Massé, and the planning and political input from program review. And it showed what can be achieved in politics when there is a consistent message packaged effectively and delivered from coast to coast by a messenger with credibility and commitment. Once the budget hit the floor of the House of Commons on 27 February, it rolled across Canada like a tidal wave. There was no stopping it.

One of its greatest appeals to the public was its position on taxes. Canadians were "taxed to the max" by 1995; tax fatigue was so pervasive that even NDP governments that had used tax increases in their own budgets advised Martin against major tax hikes. Following the Alberta budget's lead, Martin proudly declared that there would be no increases in personal taxes, and he repeated again and again that for every new dollar raised in revenue, more than seven dollars were cut from spending. Thus, like Alberta, one of the trademarks of Martin's budget was that it cut spending and did not raise taxes. Nonetheless, as in Alberta, people would pay more: gas taxes were increased, and there was a whole bevy of fee increases, including a very controversial $975 fee to be paid by all adults who wanted to immigrate to Canada.

Taking a page out of the Saskatchewan approach to taxes, Martin made symbolic gestures in the direction of fairness. He responded to the views of caucus members such as Jim Peterson, chair of the Commons finance committee, who said, "Were we not to have tax measures in here, there might be many Canadians, particularly the wealthy and affluent, who would be escaping the responsibility to contribute their fair share."[13] Thus, things that were considered tax loopholes for the rich – family trusts, for example –

were tightened up or eliminated in the name of equity, with the symbolic goal of ensuring that every group paid some price and bore a share of the sacrifice.

Like the provincial ministers, Martin had to establish credibility. The history of federal and provincial budgets, with their grandiose plans to fix the finances, had turned credit raters into skeptics. They wanted to be shown clearly how the fiscal mess was going to be solved. Many federal and provincial budgets had gone astray because they were based on rosy economic forecasts; assuming high prices for basic commodities allowed governments at budget time to show progress on deficit reduction. But by 1995 credit raters were familiar with the pattern of governments missing their targets because of those same economic assumptions. Thus, like his provincial counterparts, Martin touted the fact that his economic assumptions were cautious. Most important, after the budget was subjected to the scrutinizing eyes of its analysts, the credit raters agreed.

While Alberta and Saskatchewan had established credibility in 1993 by publishing four-year plans to balance their budgets, Martin's strategy was to set low targets and then exceed them. Next to the size of the spending cuts, a track record of delivering on deficit targets is crucial in the financial community's assessment of budgets. Thus, the timidity of Martin's 1994 budget paid off in 1995, when he could declare that he had not only met but had exceeded his deficit-reduction target for 1994. Martin set targets for no more than two years ahead because he believed that he could only predict with accuracy that far into the future. His speech hinted at a balanced budget; for instance, he said, "We have always said that our 3-per-cent interim target was a station on the way, not our ultimate destination."[14] There was, however, no plan to reach that destination. The track record established by Saskatchewan and Alberta in balancing their budgets meant that those who followed – Martin in Canada or Eves in Ontario – did not have to persuade voters that balancing budgets was possible. Canadians knew, from watching the provincial scene, what the end game was and that it was achievable. An additional safeguard was the establishment of a contingency fund that could be used if, for some reason, the budget did veer off course. Although most Canadians were oblivious to the various ways in which Martin established the credibility of his budget, they did watch the evening news or read the daily newspaper, where financial analysts and others with credibility gave the budget a pass mark. Like a snowball rolling downhill, these assessments by the experts added momentum to the already significant public support for the budget.

At the core of the budget was the federal version of redefining government. As Martin put it, "It is this reform in the structure of government spending – in the very redefinition of government itself – that is the main

achievement of this budget."[15] As well as considering how government operated, the budget asked what government should do. Achieving smaller and "smarter" government meant dramatic reductions in all departments, except Indian and Northern Affairs. Department spending was cut by 19 percent and 45,000 civil service positions were to be eliminated.

Like provincial governments, the federal government redefined its role in the economy. Rather than creating jobs directly, government's task was "to provide a framework for the private sector to create jobs – through responsible policies on inflation, on taxation, regulation, trade and the labour market."[16] In specific terms, this meant declaring an official end to megaprojects and cutting business subsidies by 60 percent. The significant point here is that the federal government did not go as far as Alberta and eliminate business subsidies altogether. As in Saskatchewan, the door was left open for the government to continue to invest directly in specific projects. Changes such as these signified the shift to the market-based economy, where government played a less prominent role – a change reflected in more dramatic terms in some of the other budget announcements.

Historic symbols of Canadian nationalism created by previous Liberal governments were swept aside in 1995. Railways – the iron roads whose construction was mythologized by singers and writers alike – had been built by governments determined to carve a distinct Canadian nation out of the northern half of the continent. Canadian National Railways, a key part of the quest to build an east-west Canadian economy, was to be privatized. History had simply passed it by. Free trade with the United States meant that Ontario, for instance, now traded three times as much with the United States as with other parts of Canada, and the triumph of the market economy spelled the end of subsidized freight rates. A similar fate was meted out to Petro-Canada, the federal crown corporation established in the 1970s by the Trudeau government as a beacon of Canadian economic nationalism and federal power. With global corporations operating in an economy that spanned the world, there was no longer a role for government to create bastions of sovereignty and barriers to continentalism. Although Canadians were still deeply attached to the ideal of an independent Canada, the rationale for using crown corporations as vehicles to build a separate and sovereign Canadian economy was gone. In announcing the privatization of these corporations, Martin was not killing them; he was merely officially pronouncing their death. The silence that greeted his decisions showed that Canadians were resigned to the fact that part of their past was fading into the history books, though some of us could be forgiven for feeling sorrow at their passing.

Any notions that ending the era of government-engineered economic development was but a passing fancy were dashed by Martin's commitment

to an ongoing process of "privatizing and commercializing government operations wherever that is feasible and appropriate." In contrast to NDP governments, which were unable to move beyond the principle that public services have to be delivered by the public sector, Martin declared: "Our view is straightforward. If government doesn't need to run something, it shouldn't. And in the future, it won't."[17] A bold new world of strategic government was unfolding.

Strategic government also meant consigning to the history books Trudeau's mission to lessen economic inequalities among regions in Canada. Trudeau's vision of equality encompassed a strategy to alter historically underdeveloped regions such as Atlantic Canada through direct government intervention – a policy that was institutionalized in 1969 when the Department of Regional and Economic Expansion was created, with a mandate to use government incentives to attract business to less developed parts of Canada. Mulroney had tinkered with Trudeau's policies on regional economic development, but the task of dismantling them was left to Martin.

The various federal regional development agencies gobbled up billions of taxpayers' dollars, and although they were near and dear to the hearts of enterprising cabinet ministers, the direct investments never achieved their goal of mitigating economic disparities among regions. I caught a glimpse of the appeal of such programs to cabinet ministers when I was minister of economic development in the late 1990s. By then, the programs were a very pale shadow of what they had been – with minimal dollars involved – but the way in which the funds were spent remained the same. Lump sums were allocated to regional development, but the selection of projects was left to the discretion of federal and provincial ministers, meaning that the projects were not subjected to treasury board scrutiny and did not have to compete with other projects for funding, as did line department spending proposals. There is little more attractive to energetic cabinet ministers than having money to fund their pet projects. I myself focused on funding research projects that were part of Saskatchewan's version of the Innovation Strategy. But the door was certainly open for ministers' pet projects to turn into boondoggles. When Martin was drawing up the 1995 budget, politics dictated that at least a token amount of money should be left in regional development budgets to allow ministers to be creative. But direct government subsidies to entice business to specific regions ended, and the funding for regional development was cut by $550 million.

However, Martin did not leave poorer provinces totally to the whims of the marketplace. In redefining the federal government's role in mitigating regional inequalities, he positioned the Liberals in the middle of the Canadian political spectrum. With the small sums involved and the more restrictive rules for their use, the regional economic development programs that

survived did give regional ministers some scope to do their politics, but gone was the notion that such initiatives would attack the underdevelopment of Atlantic Canada, for example. Thus, Martin and the Reform Party were essentially on the same page when it came to ending the federal government's role in economic engineering. Where the two parted company was over equalization. While Reform was committed to cutting equalization, Martin stressed that one of the first acts of the new Liberal government has been to renew the equalization program for five years, and he sang the praises of the program: "Equalization is a central pillar of Canadian federalism. It ensures that Canadians in our less well-off provinces receive public services comparable to those available elsewhere."[18] In essence, while the federal Liberals did not see a major role for government in the economy, they retained their traditional commitment to ensuring some measure of parity in the quality and accessibility of vital public services such as health and education.

In ending the government's role as a major player in regional economic development and in privatizing crown corporations, Martin was confirming the fact that in the new global economy such vestiges of Canada's past had no place in its future. Where he broke new ground and made controversial choices was in his massive restructuring of transfer payments to the provinces for health, postsecondary education, and welfare. Funding for all three areas was combined into one block transfer, the Canadian Health and Social Transfer (CHST), and the cash that went to the provinces under the new transfer was cut by $7 billion. The approach was the same as Saskatchewan's in that while all the cuts were announced in 1995, they were phased in over a three-year period. Especially clever was the timing of the cuts. The Quebec referendum was due to be held in the fall of 1995, and the federal cuts would not hit until 1996.

The CHST represented a sweeping change in Canadian federalism. When successive Liberal governments introduced these programs in the 1940s, 1950s, and 1960s, they used the federal governments' spending power to create national programs in which Ottawa set the standards. In the 1980s and early 1990s, as the heavily indebted federal government systematically reduced its financial commitments to the social envelope, Alberta and other provinces criticized the contradiction between the federal government setting the standards and the provinces delivering the programs and paying more and more of the bills. Such carping reinforced Quebec's position that health, education, and welfare were provincial responsibilities. There was, then, a teeter-totter at work: either the federal government could put in more money and have a greater say, or it could reduce both its funding and its capacity to set national standards.

Martin's support for the Meech Lake Accord and its goal to decentralize

Canada was reflected in his commitment in the budget speech that "the restrictions attached by the federal government to transfer payments in areas of clear provincial responsibility should be minimized ... They limit the flexibility of the provinces to innovate." In exchange for less money, provinces would get more autonomy. The only vestige of the traditional federal role that remained was the commitment to maintain the five principles of health-care – universality, comprehensiveness, accessibility, portability, and public administration – and the requirement that all provinces provide welfare to applicants without minimum residency requirements. Beyond this, provinces were free to use the federal dollars from the CHST to design programs as they saw fit. Also, as Martin looked to the future, he spoke not of "standards" but of less restrictive "national goals and principles." Equally important, the "principles and objectives" would not be set by the federal government. Instead, federal and provincial ministers would "work together on developing, through mutual consent, a set of shared principles and objectives that could underlie the new Canada Social Transfer."[19] Martin was turning his back on the traditional Liberal approach of a strong central government committed to providing, throughout the country, social programs, that conformed to national standards. He was charting a new course toward a more decentralized federation, in which powerful provinces made the major decisions about programs that Canadians saw as being essential to their national identity.

Another lesson of the 1995 budget was that Trudeau's noble vision of a bilingual, bicultural Canada as the solution to "the Quebec problem" was being relegated to the history books. Canadians would continue to pay lip service to its goals of creating a country where French and English Canadians could feel at home from coast to coast. However, on the eve of a crucial referendum in Quebec on its future relationship with Canada, the federal government did not turn to bilingualism and biculturalism as a solution. Instead, the carrot that was waved to Quebec was more power for the provincial government. This decision reflected the undeniable reality that French Canadians did not look primarily to the federal government, controlled by an English-speaking majority, for their protection; they looked to their provincial government – the only one controlled by French-speaking Canadians – to protect their language and culture. The price for keeping Quebec in Confederation was thus a more decentralized federation. And that's what the 1995 budget delivered.

The budget may have given Martin and the federal Liberals some ammunition for fighting a Quebec referendum, but it offered precious little to placate angry provincial finance ministers. If there was one word to describe the reaction to the 1995 budget in Saskatchewan and many other provinces, it was the Regina newspaper headline, "DEVASTATED."[20] From the provincial

viewpoint, the federal government was solving its financial problems by offloading the majority of them onto the provinces. The dramatic cuts in transfer payments for health, welfare, and postsecondary education were merely the tip of the iceberg. As other federal programs were cut or eliminated, the provinces were left to pick up the pieces. As unemployment insurance rates were cut, the provinces had to pick up the costs of more people on the welfare rolls; and as the federal government moved to define very narrowly its obligations to First Nations people, Saskatchewan and Manitoba (where aboriginal people comprised more than 10 percent of the population) were handed huge bills for services to aboriginals. In addition, federal withdrawal from training programs, done at the urging of Quebec, cost Saskatchewan more than $30 million in new funds to replace existing federal dollars. All provinces made it clear that they could not automatically backfill federal cuts. At the same time, all provinces had no choice but to backfill when it came to welfare, training, or other basic services.

As the finance ministers gathered to lick their wounds after the 1995 budget, the word most frequently heard was "unfair." Provinces in Atlantic Canada and the prairies felt especially aggrieved. Massive cuts in unemployment insurance left the Atlantic region reeling. Then there was the closure and downsizing of military bases in the area and, even worse, the withdrawal of the federal government from regional economic development, which was a huge blow to a region that depended so heavily on government for its growth and prosperity. The Atlantic ministers set aside any sense of common political affiliation with their Liberal cousins in Ottawa and expressed the frustrations of a struggling region that had been hit so hard. Some two years later, federal Liberals expressed shock at their loss of significant seats in Atlantic Canada in the 1997 federal election, but anyone who had been at the finance ministers' meetings following the 1995 budget would not have been surprised.

On the prairies, Saskatchewan was devastated by the elimination of the Crow benefit that had subsidized rail transportation for prairie grain, and by the cuts to agriculture. The idea that agriculture and food production were key national priorities was replaced with the view that agriculture was a business. Symbolically, the massive changes to agriculture in the budget speech came under the heading "Business Subsidies and Support." A huge $2.6 billion annually was to come out of subsidies for the transportation of prairie grain at the same time as federal support for agricultural safety-net programs was reduced by 30 percent. The double whammy dealt a body blow to Saskatchewan farmers, who lost more than $300 million a year on the cancellation of the freight-rate subsidies alone. In exchange, the federal government offered a one-time compensation package, worth $1.6 billion (for a benefit estimated to be worth $7 billion), and a $300 million payment

to be shared by all prairie provinces to help cover the massive costs that would come as the abandonment of branch lines led to a dramatic increase in the trucking of grain, which would inflict major punishment on provincial roads.

Federal politicians such as Gordon Kirkby of Prince Albert defended the decision to abandon the Crow. It was a subsidy, he argued, and contrary to the trade principles of the General Agreement on Tariffs and Trade (GATT). By subsidizing grain but not processed products, it retarded the development of food processing on the prairies; besides, ending subsidization would make the railways more efficient.[21] In its handling of the Crow's elimination, the federal government used a clever ploy, which was also part of its strategy in cutting provincial transfer payments. The elimination of the Crow, it made clear, was nonnegotiable. What was open for negotiation was the formula that would be used to distribute the $1.6 billion compensation package. Forthwith, the legendary divisions among farmers emerged, and they began squabbling over whether the payout should go to landowners or renters.

For a province of one million people to lose more than $300 million a year in support for transportation at the same time as there was a 30 percent cut in funding for agricultural programs was, I firmly believe, an unfair blow. What it meant to the average grain farmer can only be understood by considering specific examples. Bill Cooper, who farmed 3,500 acres in the Foam Lake area, declared, "We got screwed but good, I'll tell you that," and went on to explain that he would get a lump sum payout of $70,000 to compensate for the loss of the Crow benefit, but his freight rates would double and end up costing him $45,000 a year. The bottom line was that his compensation money would be gone in two years, and he could not afford to pay the higher freight rates and keep his farm. By 2001, after the full phase-in of market-driven freight rates, farmers would be paying $1 a bushel to get their grain to port, when the crop would bring in only $1.85 a bushel. The economics for all but the largest farm operations were impossible. For far too many Saskatchewan farmers, the 1995 budget made making ends meet an impossible task.

Divisions among the farmers themselves, and the lack a of united front by prairie politicians, helps explain why the federal government got away with such a major blow to prairie agriculture. For all of our ability to form a common front on other issues, the western finance ministers never really had a common position on agriculture. Saskatchewan New Democrats were hidebound in their commitment to a Crow benefit paid to railways; Alberta Conservatives were ideologically committed to ending the Canadian Wheat Board. And while Saskatchewan grain farmers were wedded to the Crow, the province's livestock producers opposed it because it artificially inflated

feed prices. So rather than uniting around a common position that the federal government should continue to play a major role in providing an effective and affordable national transportation system and should ease the transitions in agriculture, we divided amongst ourselves, leaving the door open for Ottawa to do as it pleased.

A significant turning point on the Crow benefit, from my point of view, was my meeting with Paul Martin at Queensbury Downs in Regina, in March 1995, as he travelled across Canada to sell his budget. At a closed-door meeting before his speaking event, I laid out all the arguments why the simultaneous elimination of the Crow benefit and the cuts to agriculture were unfair. As our minister of agriculture, Darrel Cunningham had said, "We're probably the only country that's ahead of its GATT commitments."[22] While Canada was playing Boy Scout by cutting its subsidies, as directed by GATT, the American and European governments were continuing to subsidize their farmers heavily, leaving Canadian farmers to compete on a totally uneven playing field. There was also regional unfairness. While prairie subsidies were being cut 100 percent, subsidies to the Quebec dairy industry were being cut by a paltry 30 percent. To add insult to injury, the separatist government in Quebec had the gall to seek compensation for its minor loss in federal support. Agriculture was a major sector of the Canadian economy that needed support during a gut-wrenching transition – as had been provided in other sectors, such as the fisheries. It could not simply be bounced on its head. This was the kind of unfairness that fed western alienation, and I warned Martin that he would reap a prairie fire of protest when he came face to face with Saskatchewan farmers.

As I watched Martin leave our scrum and head into the main auditorium, I realized that there were no prairie farmers protesting – only hundreds and hundreds of supporters, applauding his budget – and I knew it was all over. Many farmers, enjoying record high prices and anticipating the one-time payout, did not fully realize the implications of the 1995 decision. Four years later, as the full impact of the Crow changes were felt and grain prices tumbled, there would be protests, rallies, and sit-ins at the legislature, but by then it was too late. Another factor in 1995 was that budget cutting in Saskatchewan had boomeranged against provincial politicians. Our budget cuts had taught Saskatchewan people that the deficit had to be defeated and everyone had to pay their fair share. So what was the point of protesting? It had never worked when people had protested against our government. The week after my meeting with Martin, a local poll showed that nine out of ten people believed that the budget had treated Saskatchewan more harshly than other regions, with 92 percent of farmers sharing this sentiment.[23] But the events at Queensbury Downs had shown that the federal government could make devastating cuts to Saskatchewan agriculture and still have

hundreds of cheering supporters greet its finance minister. Prairie farmers, plagued by shrinking numbers and internal divisions, no longer had the political clout of their counterparts in Europe and the United States. However, as in Atlantic Canada, their sentiments were reflected in the next federal election. In the tradition of prairie protest, they defeated the Liberal MPs who had defended the government's actions and replaced them with Reformers.

Another unfairness of the 1995 budget was that the cuts to the provinces were deeper than those in the federal government's "own backyard." Jim Dinning from Alberta, which had cut public-sector wages by 5 percent, chided the federal minister for merely freezing federal salaries. Atlantic ministers chimed in to point out that federal salaries were much higher than the salary scales for provincial public servants. Especially outrageous to many was the fact that seniors' benefits were untouched. At $20 billion, the Old Age Security (Canada's seniors' pension) and the Guaranteed Income Supplement (a pension supplement for lower-income Canadians) cost the federal government more than the $17 billion in cash that was transferred to the provinces for health, postsecondary education, and welfare. Yet while $7 billion was going to be clawed out of the transfers to the provinces, the seniors' package, except for a few minor changes, survived intact.

Provincial ministers suspected cynical politics at work. Cuts to health, education, and welfare were to be phased in over three years and, most importantly, would be administered by the provinces – which meant that after all of the hoopla of the 1995 budget was a mere memory, Canadians would be turning angrily on their provincial governments, complaining about the inadequacy of funding for these fundamentally important programs. On the other hand, seniors' benefits come from the federal government, so if they had been cut the federal government would have got the blame. Although several ministers argued this case strongly, there was an underlying suspicion that it was Chrétien, not Martin, who refused to touch seniors' benefits. The failure to take on seniors' benefits greatly troubled me.

The issue reflected a generational unfairness in the budget cuts of the 1990s. From my experience as the minister responsible for seniors, I knew that some elderly seniors, especially women, struggle to make ends meet, but seniors in general are the only group in Canada whose benefits provide them with a guaranteed annual income. Seniors deserve to be well protected, but the cost of their universal benefits has to be seen in the context of what is happening to young people in Canada. In 1991, when I became minister of social services, I was shocked to discover that Saskatchewan had the most prosperous seniors and the poorest children. Although $20 billion was being spent protecting seniors from poverty, the most vulnerable in our society – our children – had precious few protections.

The other group unfairly treated were students. Seniors, especially the younger ones, had been major beneficiaries of all the expensive universal programs introduced after the Second World War; they had at least seen some of the rewards that came from the massive deficits and debts racked up to finance these programs. But students in the 1990s saw only bills, which they pay again and again in the form of interest on the massive debt. At the same time as seniors' benefits were being protected, there were major cuts in the funding of postsecondary education – and this at a time when it was universally accepted that to do well young people needed advanced education or training. So students would have to pay more. A lot more. Especially troubling was the fact that these students were Generation X – young people born when the dominance of the baby boomers in the workplace severely restricted their job prospects. I bear no malice toward seniors; I am much closer in age to being a senior than a student. But of all of the things that bothered me about the 1995 budget, the intergenerational unfairness hit me hardest. Just as seniors deserve to live their retirement years in dignity, so do young people deserve to have the opportunity to contribute and make the most of their talents.

The offloading, the ending of regional subsidies such as the Crow, and the $7 billion cut over three years to transfers for health, education, and welfare overwhelmed most provinces. For Saskatchewan, Alberta, Manitoba, and New Brunswick, which had just fought their way out of a massive deficit to declare balanced budgets, the torrent of cuts flooding in from Ottawa drove them right back into that same deficit hole. True, as provinces with balanced budgets that were getting rave reviews from financial agencies, along with credit-rating upgrades, it was not a return to the nerve-racking days of living on the edge of bankruptcy. Having been down this road before, we had lots of experience in cutting, and we in Saskatchewan knew the routine: Go to the public and be sure they know whom to blame for their woes; consult about solutions and make strategic choices. The public co-operated. The press applauded our strategic choice to make cuts to government, laying off another six hundred public servants in order to backfill all the federal cuts to health, education, and welfare. The credit raters again recognized our sound financial management.

But by 1996, when the federal cuts had to be implemented, everyone's patience had worn thin. At one of my first consultation meetings in Regina, a union member expressed a sentiment that I heard all too often at subsequent events: "You're asking us to tighten our belts over and over and over again. I'm here to tell you the middle class and the poor are fed up. And you'd better be looking to getting the money from somewhere else to pay for programs. We're not paying any more."[24] Frustration and anger were merely symptoms. The disease was deficit fatigue. The public was tired of

facing yet another round of cuts. Political leaders were exhausted from once again looking for fat in a government already skeletonlike in its leanness. And the civil service was demoralized. In Saskatchewan, when the Romanow government failed to win a solid majority in the 1999 election, commentators reflecting on its second term (1995–99) wondered why a government that had been so focused and energized in its first term had seemed to drift and lack fight in its second stint. One reason was that following our big majority win in 1995, we could not spend the crucial first year planning and implementing the first phase of a new provincial agenda; instead, we had to expend all our energies and use all our fiscal room to administer the federal cuts. In addition, the federal cuts had sapped our energy and our resolve to fight new fights.

The lack of patience being felt by provincial governments, burdened with administering the federal cuts, burst into nasty federal-provincial skirmishes as Martin and other Liberals tried to minimize the size of the cuts to the social envelope. Yet the $7 billion being cut from the $17 billion for health, education, and welfare over a three-year period was a 40 percent cut. In 1996, the first year of the cuts, 25 percent was being cut from provincial transfers for health, education, and welfare, while other federal spending was going down by only 9 percent. As Saskatchewan politicans trotted out these numbers to health-care groups, universities, and other third parties, their leaders penned angry letters to the federal finance minister.

As health boards complained and the press reported on the disproportionate cuts to Canadians' most cherished programs, the federal government fought back. In August 1995 David Walker, Martin's parliamentary secretary, condemned my talk of a 25 percent cut as "alarmist" and added, "This bogus figure of 25% does a great disservice to the debate."[25] By adding the money paid for equalization and calculating the value of tax points transferred to the provinces in 1977, the federal government argued that the size of its cuts was only 4 percent in 1996. Martin himself weighed into the debate, scolding the provinces for making federal cuts sound worse than they were. To provinces beleaguered by federal offloading, the federal attempts to minimize their burden only fanned the flames of discontent. Thus, in their 1995 report, the western and northern finance ministers said: "The federal government is making misleading statements about the magnitude of the social program transfer cuts ... the federal government only 'muddies the water' by claiming that the cut to transfers is less than the cuts to its own program spending."[26] Petty as the debate may seem, at stake was the vital political point – which level of government would bear the blame for cutting programs that Canadians held dear.

The immediate cuts were only the tip of the iceberg. The bigger issue was what the 1995 budget meant to the future of Canada – the subject of a speech

I gave in August 1995. Health and education, I acknowledged, were provincial responsibilities. "However, for well over fifty years we have recognized that as Canadians living in different regions of a vast land, there is a fundamentally important role for the federal government to provide national financial support for basic services to Canadians, as well as a role in helping to maintain appropriate national standards." Although maintaining its role in equalization, the federal government had been withdrawing for more than a decade from its role in health, education, and other areas, leaving the provinces with new responsibilities and costs but with no new fiscal capacity. With the 1995 budget, "concern has become a crisis," I said. The size of the cuts – "the single largest reductions to the financing of Canada's health, education, and social programs since the Second Word War" – were staggering, especially in light of the growing demand for all these services. The cuts would lead to a crisis in service, I predicted. The second part of the crisis was the lack of "national vision of what the basic standards and principles of our national programs should be." Health, education, and social programs, I argued, "are central to our ability to do well and live well in the 1990s and they are closely tied up with our attachment to Canada and our sense of distinctive Canadian identity." The 1995 budget, then, raised questions about the future face of Canada:

When the federal government is so drastically cutting its funding for health care, does it lose its moral authority to impose national standards on the provinces? With respect to social programs, is Ottawa forcing us back to the patchwork quilt parochialism of Canada during the Depression? Then, hungry men rode empty boxcars being forced from one community to the next in search of basic assistance. Tomorrow, will we find that a provincial government is responding to similar needs for assistance by simply buying people a bus ticket and sending them along to the next province? ... We all want – I am sure – to get our fiscal house in order. But we also want to ensure that when this is achieved, we still have a Canada that we want to call home.[27]

The really striking thing about the fundamental changes of 1995 was that they occurred with so little debate. Attempts to change Canada via the constitutional route have involved protracted federal-provincial meetings, debates in provincial legislatures, and, in the case of the Charlottetown Accord, a national referendum. None of this happened with the 1995 budget. Any ministerial debates that occurred were at the finance ministers' table, and these discussions were behind closed doors. Even finance ministers were not informed until early 1995 of the direction being taken by the federal government. Provincial governments, Parliament, and the public had all been left out in the cold when the abbreviated and heated discus-

sions about Canada's future took place in the corridors of power in Ottawa. As I said in March 1995, "I just sort of wonder what Canada is going to look like ten years from now, when you look at health care and social programs. My concern is that we've fundamentally changed Canada here and we've done it with one budget and we've done it without proper debate."[28] The change was being driven by Martin, by Quebec, and by the new faces in Ontario.

Ernie Eves experienced a baptism by fire when he became Ontario's new finance minister in June 1995. At his back was a province whose economy was shrinking and whose deficit was ballooning to more than $11 billion a year. With an election platform to cut taxes and protect the badly ravaged pocketbooks of middle-class Ontarians, Eves was in a tight box.[29] Unknown to other finance ministers was how he would respond to the billions of dollars in cuts that Ottawa was making to his already meagre plate. His quiet unemotional manner left other finance ministers wondering, as he attended his first federal-provincial meeting. I remember, before the meeting, waiting to be scrummed by the press. As I was rehearsing the tirade that I would deliver about the massive and unmanageable federal cuts to health, education, and welfare, Eves stepped in front of me to the microphone. As I listened, I was taken aback to hear him give my speech. Just another embattled finance minister, who did not even have the luxury of having already achieved a balanced budget, Eves was drowning in a sea of red ink like the rest of us.

Along with protests about transfer cuts came a new Ontario-Ottawa battleground: the growing surplus in the Employment Insurance fund. The position Ontario took on this issue was really an extension of what Eves's predecessor Floyd Laughren used to call "back-door equalization." While Eves, like Laughren, supported equalization as the chosen vehicle for transferring funds from wealthier to poorer provinces, he objected to other programs whose intent was to funnel even more dollars from richer to poorer provinces. Ontario taxpayers could no longer be asked to foot such bills. As noted earlier, Laughren's target had been the cap on CAP, the 1990 federal decision to place a cap on the amount of money transferred to Canada's three richest provinces for welfare. The 1995 budget ended the cap on CAP controversy by ending cost-sharing for welfare. By this time, however, the surplus in the Employment Insurance fund was growing – it would reach $12 billion by 1997 – and Ontario was crying foul, arguing that it was largely Ontario businesses that were paying into the fund, while the beneficiaries were regions with high unemployment, mainly Atlantic Canada. The massive surplus meant that Ontario businesses were being overcharged – another instance of "backdoor equalization." The western provinces sided with Ontario. They too had low unemployment rates and had memories of the

battle over the infrastructure program, in which unemployment levels had been a key criterion for funding from the program.

Although Eves's position was merely an extension of his predecessor's, the Ontario of Ernie Eves and Mike Harris was not the Ontario of Floyd Laughren and Bob Rae. Behind closed doors, Laughren had aggressively pressed his case that Ontario's role was changing and that its taxpayers could not be expected to carry such a heavy load. In public, Rae had appealed for a fair share for Ontario. But of course both were New Democrats wedded, as I was, to a view of Canada that involved a strong central government, financing social programs and setting national standards. In its last year in office, the Rae government had publicly acknowledged the unfairness of Ontario's relationship with the rest of Canada. Statistics compiled by commissions established by the Rae government painted a bleak picture: 5.5 percent of Ontario's GDP, or $1,506 for every Ontarian, was transferred out of the province to some other region at the same time as the federal government, since the 1970s, had offloaded more than $10 billion onto Ontario taxpayers; Ontario paid 43 percent of federal taxes but received only 28 percent of its subsidies. Certainly, in its dying days the Rae government railed against the injustice of what these statistics showed. But its solution was "Fair Share Federalism," a fairer deal for Ontario. And behind the scene, Laughren, to the very end, sought middle ground on issues and reflected a lingering attachment to the vision of a united Canada with a central government strong enough to ensure quality health, education, and social programs from coast to coast.

Such nostalgia for old Ontario was missing in the Ontario of Harris and Eves, who used the 1995 budget to drum up support for their very different vision of Canada and of Ontario's role in Confederation. Underpinning this vision was the stark reality of other statistics; while federal transfers had amounted to 17 percent of Ontario's revenues in 1985, they accounted for a paltry 8 percent in 1998. To put this in perspective, federal transfers accounted for about 40 percent of the revenue of the Atlantic provinces in the 1990s. Equally revealing is the fact that while the federal government originally paid 50 percent of the costs of Ontario's health care, by 1998 it paid only 11 percent.[30] Any relationship between calling the tune and paying the piper meant that, from Ontario's point of view, the federal government had abandoned its authority to set national standards. In a complete about-face, the Ontario Conservatives turned their back on the traditions of Bill Davis and became aggressive advocates for a decentralized Canada. If the provinces were going to pay for key national programs such as health care, then the provinces, not the federal government, should have the authority to set the standards.

Ontario's clarion call for more provincial control over all aspects of social

programming, including setting standards, resonated with Alberta and left Saskatchewan in a difficult position. Alberta, like Ontario, relied less and less on federal money to finance its health care and other social programs and depended more and more on its own resources. How, then, could the federal government continue to unilaterally set national standards when it was not responsible for paying a significant fraction of the costs? Saskatchewan and Manitoba still relied heavily on federal transfers for their budgets. But although we in Saskatchewan were still committed to the ideal of a strong central government, there was no reality underpinning our ideal. Events, economics, and personalities had passed that cherished vision of Canada by.

In August 1996 in Jasper, Alberta, at what has been described as "the most important premiers' conference in the country's history," Ontario and Alberta presented a discussion paper they had jointly commissioned called "ACCESS: A Convention on the Canadian Economic and Social Systems."[31] Authored by Queen's University economist Thomas Courchene, it advocated a restructuring of the Confederation power-sharing arrangements and presented two options. The first would have the federal government surrender its power to set national standards, assigning this to a joint federal-provincial council. The second, more drastic, choice had the federal government entirely abandoning its power to set national standards in favour of allowing the provinces to set national standards by mutual consent. Although it was only a discussion paper in the summer of 1996, it was a portent of where the chain of events set in motion in 1995 would lead.

The 1995 budget dramatically changed the face of Canada because it coalesced with a unique set of circumstances and political players. The changes in the faces at the finance ministers' table reflected the role that personalities played. Had the Liberal government of Daniel Johnson still been in power in Quebec in 1995, the federal case that more provincial autonomy could be exchanged for massive cuts to transfers would have lost its resonance. Whether Ottawa would have found cuts elsewhere, such as in seniors' programming, remains an open question. Similarly, had the NDP government of Bob Rae still been in power in Ontario, Laughren would have made the same arguments as Eves, but he would have done so more within the context of the old Ontario view that as Canada's bedrock, it had an obligation to seek common ground. In British Columbia, if Premier Harcourt had not been replaced by Glen Clark, Elizabeth Cull would have rallied to the appeal that the traditional vision of Canada could not be so easily set aside. As I looked around the finance ministers' table in 1996, it dawned on me that as I fought with Martin to protect the Canada to which I was so attached, I had no powerful allies.

Popular perception was that two right-wing premiers – Klein and Harris

– would use the weakness of the federal government after it nearly lost the 1995 Quebec referendum to drive a stronger Confederation deal for the provinces. Although I can see the logic of this case, as someone who was there at the time I don't read history that way. In 1993, Alberta's newly elected Klein government and its treasurer Jim Dinning were desperately anxious, above all else, about the fiscal state of Alberta and Canada. And although they were skeptical of the federal government, they were committed to seeking national solutions to the problems. It was only when such national solutions faded, and dramatic cuts to transfer payments were made, that Alberta embraced wholeheartedly a position whose logic had always been inescapable: if the provinces are going to pay the bills, then the provinces will have to call the shots. Similarly, it was economics not ideology that drove the Ontario position. Hard-pressed Ontario taxpayers could no longer foot the same bills. Laughren had said it and had appealed for change. Eves said it and acted.

The real culprit in 1995 was the fiscal crisis. Whether or not a national solution to the problem could have been achieved through a joint federal-provincial redesign of social programs will never be known. What we do know is that such a major undertaking would have required time, something not available during a fiscal crisis. If Canadians had debated from coast to coast the choices involved in the 1995 budget, the results might have been different; but when interest payments are increasing by more than $100 million a day and credit raters are warning of downgrades, action is what is required, not debate. Countries such as Argentina have been visibly torn apart by a fiscal crisis, as citizens rioted in the streets. In Canada there were no riots – only resignation and resolve – but the choices that were made did test the resilience of Canadians. The decisions of 1995 were made in the atmosphere of a fiscal crisis in which swift action, of necessity, superseded sound, measured, consultative decision making. If there is a lesson to be learned, it is to tackle problems before they become crises.

In 1995 the most visible aspect of Martin's landmark budget was its cuts to vital social programs and the impetus it gave to a more decentralized federation. These changes, along with its unfairness to both young people and prairie farmers, concerned me a great deal at the time and framed my negative reaction to Martin's choices. Time, it is said, heals all wounds and, it might be added, provides perspective. Martin always said that his goal in attacking the fiscal crisis was to give the federal government breathing room to launch new initiatives. Assessing his choices of 1995, then, has to be done from the vantage point of the present, when Martin's new choices can be evaluated. If being the main financier of Canada's costly social programs is what Martin left behind, in what new direction did he take Canada after 1995? In the end, were his choices the right ones for the future?

The 1995 budget dumped a lot of the federal problems onto the provinces, especially health care. Retreating from responsibility for the escalating costs of health care may have been a wise strategic choice for Martin, but it put the onus on the provinces to make their own difficult decisions. The provinces, however, did not take up the challenge of making fundamental decisions about what health care should look like in the future. From today's vantage point, health care is similar to the deficit in the late 1980s. It threatens to propel Canada into another crisis. Like the deficit in the 1980s, the costs of health care are taking on a life of their own and spiralling beyond the fiscal capacity of provinces. At the same time, Canadians' preoccupation with health care, and the services it provides for people today, is diverting attention and resources from other challenges that need to be addressed to prevent crises tomorrow. The purpose of the next chapter is to analyse the changes at the federal level and then focus on the trade-offs between health and other choices on the provincial scene. As a veteran of the debt crisis of the 1990s, I hope that with a spirited public debate, choices can be made today that will avoid subjecting Canadians to another round of crisis decision making tomorrow.

Health Care, Health Care, and Only Health Care?

While I, like many others, saw the 1995 budget as the end of Canada as we knew it, Paul Martin saw it as the beginning of a new era in which the federal presence in the lives of Canadians would be different but not diminished. In a July 1996 editorial, the *Globe and Mail* described the Canada that was being left behind: "For well over 50 years we have recognized that as Canadians living in different regions of a vast land, there is a fundamentally important role for the federal government to provide national financial support for basic services to Canadians, as well as a role in helping to maintain appropriate national standards."[1] If this was the Canada of the past, the country of the future to which Martin alluded was but a blurry image on the horizon in 1996. What was clear was that the federal government had taken a step back from funding major social programs such as health care and in so doing had limited its authority to set national standards. Still unclear was the new role it would assume. Over the next six years the murky picture in the distance would become more focused.

What became apparent by the early years of the twenty-first century was that the federal government had not merely retreated but had redefined its role for the new century. Any assessment of the 1995 budget has to be done in the context of the trade-offs. By retreating from being the major financier for health care, the federal government gained more fiscal room to move into new areas. By 2002 the federal and provincial governments had co-operated to create the National Child Benefit, Canada's first new social program in thirty years, and the flesh of funding and programming had been put on the bones of the Innovation Strategy. Are these new initiatives critical enough to Canada's future to justify the federal government reducing its role in financing health care? And what are we to make of renewed calls for the federal government to again take up the mantle of being the major financier for the Canadian health care system? If returning to its past role in health care means threatening its new strategic direction in fields such as

innovation and the National Child Benefit, is the trade-off the right one for Canada's future?

Calls for more federal funding for health care have come loudly and clearly from the provinces, which were left with the main responsibility for health, welfare, and postsecondary education funding in the 1995 federal budget. The burden associated with assuming responsibility for welfare was mitigated by the 1996 federal decision to fund the National Child Benefit. Similarly, the Innovation Strategy, introduced in 1997, relieved, to a degree, the pressure on the research side of funding for postsecondary education. And enhancements in funding for the Canadian Health and Social Transfer (CHST), which began in 1997, were designed to help provinces deal with the escalating costs in health care. Despite these actions, there was still an imbalance between the revenue available to provinces and the responsibilities they were trying to fund. While the federal government had repositioned itself for the demands of the new century, the same adjustment had not occurred at the provincial level.

Instead, in the late 1990s, the spiralling costs of health care sapped provinces of their capacity to innovate or to fund adequately other key responsibilities, such as postsecondary education and infrastructure. New revenues that came with better economic times and surplus budgets were quickly gobbled up by the rising costs of health care. By 2002, as the economy faltered, with health-care costs rising faster than provincial revenues, some provinces again faced the dreary choice of either raising taxes or running deficits. Just as the deficit in the 1980s had taken on a life of its own, thrusting Canada ever closer to a precipice, the rapidly escalating costs of health care are threatening both our fiscal achievements and our capacity to deal with other challenges that will be critical to Canada's future.

The fiscal nightmare of the early 1990s overshadowed other problems, such as lagging productivity, growing poverty, and future labour shortages, all of which simply had to be addressed when the deficit crisis began to recede after 1995. Productivity is not an easy concept to understand, but it is at the heart of the economic and social challenges that confronted Canada in the 1990s. *Canada at the Crossroads*, a report by economist Michael Porter, which was co-sponsored by the federal government in 1991, concluded that "the standard of living of a nation depends on the productivity with which it uses its human, capital and natural resources."[2] In simple terms, productivity measures what can be produced by one worker using the equipment or resources available at a particular time. Thus, it depends on both the skill of the worker and the quality of the machinery or process. If a highly skilled worker is using the latest technology to produce the most innovative and competitive products, productivity levels will be high. On the other hand, if the skills of the workforce

have been allowed to deteriorate and the investment in research and development has lagged so that outdated methods and equipment are being used, productivity will suffer. Canadian productivity began to fall relative to the United States in 1974, and by 2000 Canadian productivity trailed American by 19 percent.[3] Thus, the skills of Canadian workers were declining relative to those of their American counterparts, and Canadian companies were not doing enough research to produce the most up-to-date and innovative equipment and technologies.

Productivity is more than just a term; it affects people and the quality of their lives. Declining productivity meant from the mid-1970s, Canadian real incomes declined relative to American incomes. A recent Conference Board of Canada forecast predicts that by 2010 the income gap between Canadians and Americans will be double what it is today.[4] An income gap of this kind will obviously be a factor in enticing some of Canada's best and brightest south of the border. Lower relative Canadian incomes also translate into a decline in the standard of living and quality of life for Canadians and less capacity to fund health, education, and other social programs. Higher productivity, on the other hand, means more high-end jobs, higher income levels, and a greater capacity to fund social programs.[5]

Another symptom of the deeply rooted economic problems of the 1970s and 1980s was the growth in unemployment, welfare, and poverty. Unemployment, which seldom reached 5 percent in the 1950s, was often over 10 percent in the 1980s and early 1990s. At the same time as unemployment was increasing, the federal government was cutting its financial commitment to unemployment insurance, so that by 1995 only one-third of Canada's unemployed were covered by unemployment insurance. The result was that more people fell through the cracks to welfare. Welfare dependency rates, which had been a mere 3 percent in the 1960s, grew to 12 percent during the recession of the early 1990s.[6] Increases in unemployment and welfare led to a growing gap between rich and poor and an increase in poverty. In 1993, when the Liberals became the government, 17.4 percent of Canada's population was poor, with 20.8 percent of its children growing up in poverty.[7]

By the early 1990s, Canada was clearly at a crossroads. The decline in Canadian productivity relative to the United States was merely a symptom of the fact that Canada invested far less than most other developed countries in research and development (R&D) and in upgrading the skills of its people. Canadian companies do less research than their American counterparts because small and medium-sized businesses dominate the Canadian economy and it is more difficult for enterprises of this size to support research. Also, the high level of integration between the Canadian and American economies means that less research is done by trans-national companies on

the Canadian side of the border. Major American-based corporations with branch plants in Canada usually do their R&D at their head offices south of the border.

As well as the fact that the private sector in Canada is not making the major investments in R&D that are needed to keep Canada on the leading edge of technological change, government investment is not keeping pace either. Even in 2000, after a 20 percent increase in funding for R&D, Canada ranked fourteenth in the developed countries in its spending on R&D. Even in the United States, the developed country most committed to enhancing the role of the private sector in all aspects of economic activity, governments are the main financiers of research infrastructure. Just as railways, canals, and roads provided the main arteries for economic development in the nine-teenth and twentieth centuries, laboratories, synchrotrons, and other research infrastructure are the foundation for economic development in the twenty-first century. And just as governments played a major role in fund-ing the infrastructure of the traditional economy, they have become major investors in the research infrastructure of the new economy – except that Canadian governments have lagged behind other developed nations in assuming their responsibility to fund the infrastructure of the future.

The choices for Canada by the early 1990s were stark. One path was for Canada to continue allowing its investment in R&D to slip relative to its competitors, leaving Canadians facing a bleak future of more low-end, low-skilled jobs, vulnerable to the ups and downs of economic cycles. The other route was for governments to catch up to the competition and make the necessary investments. In this scenario, there would be more long-term, quality, high-end jobs and improvements in the standard of living and quality of life that accompany such opportunities. The latter choice was clearly preferable, but it was costly.

Addressing the productivity challenge also meant making better use of people. Growing unemployment and welfare rates in the 1980s reflected the fact that while the economy was undergoing massive changes, governments were not doing enough to retrain workers and upgrade their skills. As com-panies downsized and restructured, employees were spewed out to fend for themselves in a harsh new world of international competition that few understood. Relative to the rest of the industrialized world, Canada, accord-ing to a 1995 government report, did not compare well in "upgrading the skills of the current workforce through employee training."

Canada was also lagging behind in educating and training young people for the jobs of the future. What kinds of skills would be required in the future was no mystery by the early 1990s. While the decade prior to 1994 had seen a net loss of almost 1.4 million jobs for Canadians with high school training or less, there was, in the same period, a net increase of more than

800,000 new jobs in Canada for those with advanced, postsecondary educa-
tion.[8] More highly educated, skilled people were needed for the new econ-
omy. But Canada was not keeping pace with the growing demand for such
people. Relative to other countries, Canada in the early 1990s was experi-
encing "sluggish growth in higher education participation rates," which, if
uncorrected, would lead to " persistent shortages of the skills required for
success in the knowledge-based economy."[9]

The federal government began to address the need for more investments
in R&D and in upgrading the skills and capabilities of Canadians in its 1994
blueprint for the future, "Agenda: Jobs and Growth." Although it was the
fiscal section that took centre stage in 1994, there were two other themes in
the document that intimated where the federal government would move
after the worst of the fiscal crisis was behind it. The report spoke about "get-
ting government right and providing leadership for an innovative econo-
my." It also emphasized the need to address the growing problem of pover-
ty, especially among children, and the need "to renew social programs to
remove the disincentives to work for a better trained, better educated work-
force." The seeds of the Innovation Strategy and the National Child Benefit
were planted in this 1994 document. Equally important, the 1994 paper
launched a series of critical studies of Canada's prospects, which increas-
ingly looked beyond the productivity-related challenges of the 1990s to a
potentially explosive problem looming on the horizon.

Report after report warned that by the end of the first decade of the new
century, Canada would be facing a shortage of skilled, educated people, a
problem that could reach crisis proportions if action was not taken quickly.
The cause was rooted in a combination of the growing need for such people
and the prospective retirement of the baby boomers. Beginning in 2008, as
baby boomers began to retire, Saskatchewan, which had Canada's oldest
workforce, would have an acute shortage of skilled, highly educated people,
and this would compromise our capacity to do well economically and pro-
vide the high level of services to which Canadians have become accus-
tomed. This could undermine both our standard of living and our quality of
life.

The "people" challenge facing Canada in the first decade of the new cen-
tury and beyond is enormous. As Martin put it in his 1997 budget, "Let us
recognize that Canada's greatest natural resources do not lie buried deep in
the ground, but in the skills and the talents of those who walk upon it."[10] In
the early part of the twentieth century, Canada touted its rich heritage of
natural resources as its bounty from heaven. By the end of the same centu-
ry, Canadians could look back on their country's success since the Second
World War and list as their main asset a skilled, educated workforce. Cana-
da's supply of highly qualified people during these years sustained

economic growth and helped attract foreign investment. The main ingredient for success in this new century also will be people. "To succeed in the global, knowledge-based economy, where highly skilled people are more mobile than ever before," a Canadian government study asserted, "a country must produce, attract and retain a critical mass of well-educated and well trained people."[11]

Meeting the people challenge will be a massive undertaking. By 2004 over 70 percent of all new jobs will require advanced education. But more than half of the people in the workforce who will be available from within Canada by 2015 were already in the workplace by 2001. By 2011, the number of people entering the workforce will be virtually equal to the number of baby boomers retiring, meaning that Canada will only be able to expand its labour force through immigration. However, just as we are scrambling to create and retain the skilled workforce that we need to succeed in the future, every other economically advanced country in the world will be experiencing a similar situation. Thus, at the same time as we are turning our eyes to immigration to help alleviate our problems, other countries will be intensifying *their* efforts to lure our best and brightest to opportunities elsewhere. If this is not a looming crisis, I challenge someone to find a more ominous cloud over Canada's future prospects.

Warning signs of the crisis on the horizon are already visible. Medical procedures are already being postponed because of shortages of qualified personnel, whether they are surgeons, technicians, or nurses. Companies complain of being unable to expand because of a shortage of skilled workers. "Universities, colleges and government laboratories have already begun launching a hiring drive to replace the large number of professors, teachers, researchers and administrators reaching retirement age." Firms are already beginning the difficult process of seeking out research personnel – technicians, specialists, managers "to strengthen their innovation capacity and maintain their competitive advantage."[12] Governments give double-digit salary increases to nurses and other groups to stave off a mass exodus of crucial people whose skills are in short supply.[13] If examples like these are already with us in 2002, imagine what the future holds less than a decade from now, when the retirement of the baby boomers will be in full swing!

Shortages are predicted across the board. In the construction industry, for instance, the average age of journeymen is almost fifty, and there is already a shortage of carpenters, electricians, and instrument mechanics. In 2000 the federal government announced that it would have to recruit more than 12,000 people *a year* to replace retiring baby boomers. While the next twelve years will see university enrolment increase by more than 20 percent, two-thirds of the current faculty will retire, leaving Canadians to compete with other advanced nations as we seek to hire 30,000 new faculty. Of our current

students, one in eight doctoral graduates leaves Canada for the United States. Canadians should take the warnings of the report on innovation to heart; its prognosis for the future is withering: "Canada will have great difficulty becoming more competitive without a greater number of highly qualified people to drive the innovation process and apply innovations, including new technologies."[14]

To address the looming shortage of highly skilled people and to enhance Canadian productivity, the federal government adopted the Innovation Strategy.[15] Innovation was defined in the most recent version of the strategy as follows: "It means coming up with new ideas about how to do things better or faster. It is about making a product or offering a service that no one had thought of before. It is about putting new ideas to work in our businesses and industries and having a skilled work force that can use those new ideas. And it is about aggressively pursuing new markets for Canada's products and services."[16] In his 2000 budget speech, Martin waxed poetic about how critical investment in research is to the future of Canada:

The basic question we have to answer is: What are the choices we must make today that in 5, 10 and 20 years' time will be seen as having made a critical difference in making Canada the land of opportunity? ... Today, the strength of a nation is measured not by the weapons it wields, but by the patents it produces; not by the territory it controls, but by the ideas it advances; not only by the wealth of its resources, but by the resourcefulness of its people. In such a world, successful nations will only be those that foster a culture of innovation. They will be those that create new knowledge and bring the products of that knowledge quickly to market.[17]

Research, when combined with a highly educated workforce, will create the new products and technologies that Canada needs in order to prosper in the new century. Cures for diseases will be discovered through research. Feeding a hungry world, without swamping the same world in pesticides and fertilizers, can be achieved by using biotechnology. Finding new and better ways to collect, store, and use information will put countries on the leading edge of technology. The link between research and skills development was made by Martin in his 1997 budget speech, when he said: "It is only if there is an opportunity to develop these products and these services in Canada, not abroad, that our best and our brightest will be able to contribute to the prosperity of their own country."[18] The key to higher productivity, higher wages, and a better quality of life was more investment in research.

Beginning with its 1997 budget, the federal government began to put meat on the skeleton of its Innovation Strategy by making a major investment in research. One of the problems in strengthening Canada's research was the weakness of its infrastructure. Research facilities in universities,

hospitals, and colleges were called the "linchpin" of Canada's research agenda, but in 1997 they were woefully inadequate. Consequently, the Canada Foundation for Innovation (CFI) was established, as an arm's-length agency, to work in partnership with the public and private sectors to finance the upgrading of Canada's research infrastructure. The largest project funded by the CFI was the Canadian Light Source Synchrotron at the University of Saskatchewan, which, at $173 million, was one of the biggest scientific investments in Canadian history. Through projects like this, the CFI, whose funding had reached $1.9 billion by 2001, began the long and costly process of transforming Canada's research capacity.

Subsequent budgets built on the research foundation laid by the creation of the CFI. In 1998 the federal government began what was to become a steady increase in funding for the research councils – the Social Sciences and Humanities Research Council (SSHRC), the Natural Sciences and Engineering Research Council (NSERC), and the National Research Council (NRC) – so that they could in turn provide more money to researchers. In 1999 the Canadian Institutes of Health Research (CIHR), dedicated to promoting medical and health research, was founded, and by 2001 it had received more than $500 million in support. Technology Partnerships was created to bring together government and industry in a joint effort to commercialize more research. And new venture capital funding was made available to encourage small and medium-sized businesses to use research to upgrade the quality of their products and technologies. By 2001 the federal government was spending more than $7 billion a year on its Innovation Strategy, and this was only the beginning.

Lofty targets made public in 2002 reflected the extent of the federal commitment to research. By 2010, in less than a decade, the goal is for Canada to rank among the top five countries in the world in terms of its R&D performance. Within the same time frame, Canada is supposed to rank among world leaders in its share of private-sector sales from new innovations. To facilitate this goal, venture capital investment in Canada is projected to reach the per capita levels prevailing in the United States. By 2010 the Government of Canada will double its current investments in R&D.[19] Achieving milestones like these will only be possible through an ongoing major commitment of federal funding.

The other dimension of the Innovation Strategy was the upgrading of Canadians' skills and education. To address the impending shortage of skilled people and to equip Canadians to do well in the new economy, the federal government has pursued a multifaceted approach. To encourage more people to attend postsecondary education institutions, a variety of tools have been used, including enhanced student loans and registered savings plans that provide tax deductions for parents saving for their children's

education. To achieve the goal of making all young people computer literate, an aggressive program was introduced to hook up schools and other public institutions to the Internet. New initiatives were undertaken to attract skilled immigrants and to do a better job of integrating them into Canadian society. And the Chairs Program, announced in the 2000 budget, represented a major effort to retain Canada's best academics. Over five years, $900 million has been committed to create two thousand new research chairs at Canadian universities. As Martin explained, the new research positions are "designed to attract the best researchers from around the world and to retain the best from across Canada."[20]

Initiatives like these were only the beginning of the drive to enhance Canada's productivity by upgrading the skills of its people and to prepare for a future where the demand for such people will exceed the supply. In 2002 the federal government announced some ambitious targets. One was an increase of 5 percent per year until 2010 of people entering master's and doctoral programs, the aim being to counteract the anticipated shortage of university faculty and researchers. Underpinning this target was the commitment to double graduate fellowships and scholarships, create the Canadian equivalent of the Rhodes Scholarship, and increase the availability of co-operative programs that allow graduate students to mix their studies with practical research in the workplace. The plan also called for a doubling of the number of apprentices in the next decade, for the training of one million more Canadian adults, and for a one-third increase in business investment in training. Making young Canadians more computer literate and upgrading their skills in math, science, and reading were also priorities. And the overarching goal to "brand Canada as a destination of choice for skilled workers" was beefed up by strategies to increase the number of highly skilled immigrants.[21]

While the Innovation Strategy tackled the problem of inadequate investment in R&D and in education and skills upgrading, the Canadian government also had to confront the implications of the increasing levels of poverty. The most ominous sign for the future of human skills development was the alarming growth in child poverty and the number of children on welfare. This was Canada's future workforce, and it was falling through the holes in the social safety net at an alarming rate. As well as the fact that in Canada one child in five was poor, by the 1990s more than one-third of Canada's poor children lived in single-parent families, mostly headed by women. More likely than men to be part-time or casual workers, women were very vulnerable to losing their jobs as layoffs and unemployment increased from the 1970s to the 1990s. Also, the number of economically vulnerable single-parent families increased as divorce became easier and family patterns changed. In Saskatchewan and Manitoba, where aboriginal peo-

ple comprised a full 13 percent of the population, the combination of high birth rates and alarming levels of unemployment and welfare produced child poverty levels that made even the most complacent people concerned about the future.

From so many perspectives, child poverty was a major social problem that simply had to be addressed. As well as the human cost, there was the cost to taxpayers. Poor children were more likely to have health problems, to falter in the educational system or to become involved in crime. Spending money to prevent poverty could actually save expenses for the health, education, and justice systems. Equally troubling was the loss of human potential that came with poverty. Poor children never really had the opportunity to make the most of their abilities; therefore, the talents and creativity of almost one child in five were potentially being lost. With the prospect of looming labour shortages, it was all the more troubling to be losing the potential of so many children, whose future was curtailed by the poverty of their parents. Compassionate reasons for tackling poverty were supplemented by the hard-headed reality that Canada could no longer afford to waste the potential of so many of its young people.

Saskatchewan was at the leading edge of the demographic crisis of the twenty-first century because as well as having Canada's oldest workforce, its non-aboriginal population growth was not sufficient to fill the gap as its baby boomers retired. The greatest population growth was in the aboriginal community, were 60 percent of aboriginal people were under the age of twenty-five. These children were the core of the province's future workforce, and many of them were growing up in poverty. In Saskatoon, with a population of just over 200,000, an estimated 1,000 children a year, many of them aboriginal, are not even participating in the school system. Helping the less fortunate took on a whole new meaning in Saskatchewan as it became apparent in the 1990s that tackling child poverty was the only way to provide the skilled, educated workforce that we were all being told was essential for success in the knowledge-based economy of the future.

The forerunner of the National Child Benefit was created in Saskatchewan in 1993 and like the national version it was designed to overcome some of the long-standing problems with the welfare system. Originally intended to be a program of last resort, welfare had grown by the 1990s to become a major part of Canada's social safety net. The growth in welfare reflected the failure of other systems (the unemployment system, training and retraining programs) to help people adjust to the economic dislocation of the 1980s and 1990s. Unable to cope with the dramatic changes of this period, far too many people had descended into the welfare trap. Rather than being a solution, welfare merely perpetuated the problem. As a bureaucratic system that rested on the premise that, to qualify, people had to show not their competence

but their incompetence, welfare fostered dependence and robbed its recipients of pride and self-respect. Welfare case workers and clients were tangled in a web of rules and regulations which both sides tried to manipulate to their advantage – case workers to save money for cash-strapped governments, and clients to find enough cash to care for their families. Tackling poverty meant ending the cycle of welfare dependency.[22]

The welfare trap was especially constricting for the largest group on welfare – single-parent women. Their welfare cheques barely covered the most basic necessities of life, which meant that they spent most of their time and energy in a scramble for survival. The goal of the vast majority was to get off welfare, but for most there was no way out. Getting a job required education and skills, but the reason many were on welfare was precisely because they lacked just those skills. Then again, working meant finding childcare for their children, but childcare was expensive and the only jobs many could qualify for were low paying. Worst of all, most simply could not afford to take a job even if offered one. What a person could earn in an entry-level minimum-wage job was often less than what was given to a family on welfare; in addition, once a family left welfare the children lost all the drug, eye, and dental benefits which the state had to provide for them when they were public charges. The Child Benefit was designed to end the cycle of welfare dependency and allow single parents to enter the workforce without having to sacrifice the benefits available to their children.[23]

Saskatchewan's success with its provincial Child Benefit, along with the ideas in the various federal studies into Canada's social programs, coalesced to pressure all Canadian governments to create the first new social program in Canada in thirty years. Saskatchewan Premier Roy Romanow was, I know, very proud of his role in pushing the issue of child poverty onto the national agenda in the 1990s. Lloyd Axworthy also deserves some credit for advancing the idea. His ill-fated review of social programs in 1994 contained the seeds of what became the National Child Benefit. Thus, the premiers and the prime minister agreed in 1996 that in two years the National Child Benefit would be introduced to combat child poverty.

The National Child Benefit was a model of federal-provincial co-operation and a critical new strategic direction for the federal government. The program provided for an income-tested benefit that would be paid to all low-income families, whether the head of the family was working or not. As well, the program covered the basic eye, dental, and drug needs of low-income children. Not only would all children have their basic needs covered, but their parents could enter the workforce without being penalized. All costs of the National Child Benefit would be paid for by the federal government, which would not be invading provincial jurisdiction, since the federal monies were paid directly to individual Canadians. In exchange,

provinces agreed to funnel monies previously used to finance welfare for families into other programs designed to alleviate or prevent child poverty. It was an example of federal-provincial co-ordination in the interests of achieving a common national objective – to address the debilitating problem of child poverty.

At the same time as the National Child Benefit was being negotiated, the two levels of government were sorting out their differences in the area of social policy, a process that reached a milestone in 1999 with the signing of the Social Union Framework Agreement. The 1995 budget put the federal government firmly on the path of reducing its commitment to health, post-secondary education, and welfare in exchange for a greater recognition of the provinces' right to design programs in these areas to suit local needs. Not all federal Liberals were happy with the abandonment of the federal role. Consequently, in 1998 the federal government announced the Millennium Scholarship program, which provided federal assistance to cash-strapped but able postsecondary students. Immediately, Quebec jumped on the program, asserting that it was an unwarranted intrusion into the field of education, which was clearly a provincial matter and one that was vital to Quebec culture. The Millennium Scholarship stayed, but by the next year it was obvious that Quebec, backed by Ontario and Alberta, had won its point. The terms of the 1999 Social Union, agreed to by the prime minister and all the premiers outside Quebec, prevented such incursions into provincial jurisdiction in future. The agreement, after committing to work together and coordinate efforts to provide quality social programs for all Canadians, stated that any new federal intrusion into provincial jurisdiction could occur only if it had the support of the majority of the provinces. Also, there was provision for a dispute-resolution mechanism to arbitrate future disputes between the two levels of government. Thus, the decentralization of the Canadian federation, which had been advanced by the 1995 budget, was cemented with the 1999 Social Union agreement.

The Social Union and the National Child Benefit changed but did not neuter the federal government's role in social policy. The latter showed that the federal government was still committed to playing a role in lessening inequalities in Canada. Its role, however, would be strategic and would be consistent with the limitations on its constitutional powers. Rather than spreading its resources thinly across a variety of areas, such as health, post-secondary education, and welfare in which it had no constitutional power to design or deliver programs, it would champion a discrete program, fully within its jurisdiction, that tackled a specific social problem. With one initiative, the federal presence was reasserted in the social policy sphere, but was achieved in such a way that its efforts were applauded rather than being attacked.

The federal government had changed its role in social programs from that of gatekeeper to one of partnership. In the traditional postwar world of Canadian social programs, a strong federal government had funded social programs and policed provinces to abide by national standards in designing and delivering them. Familiar as this pattern was, by the 1990s it was no longer consistent with reality. The federal government lacked the resources to pay the piper that was a necessary part of calling the tune. More to the point, a more nationalistic Quebec would no longer tolerate federal incursions into provincial jurisdiction. For me, a strong central government enforcing national standards was a wonderful ideal, but how did it mesh with the reality that I confronted head-on with the separatists at the finance ministers' table? No Quebec government in the 1990s would accept a powerful federal government acting as gatekeeper by imposing standards on provinces in areas that were clearly within the provincial bailiwick. Lacking both the resources and the jurisdiction to support the older vision of Canada, the federal government had to carve out a new role for itself in social programs.

Reluctant as I am to let go of the older vision of Canada, I can see that the idea of the federal government working in partnership with the provinces is more in tune with Canadian attitudes in the twenty-first century. The older vision of Canada presumed a hierarchy in power, with the federal government as the superior agency setting the rules for the subordinate provinces. Command and control structures were more in tune with the attitudes and lifestyles of Canadians in the decades after the Second World War. Most Canadians still worked in a hierarchical setting with a clearly delineated chain of command. Attitudes toward institutions were still deferential, and Canadians expected their leaders to be a cut above the average voter. By the end of the century, however, hierarchies in the workplace had been flattened. Canadians regarded government and other institutions with more skepticism, and voters expected to be able to identify with their leaders. Within this context, there was a lot of resonance in the ideal of two levels of government working co-operatively, each in its own niche, to achieve a common goal. As Paul Martin said in his 1997 budget speech, meeting the "challenge" of child poverty "requires a national effort, a co-operative strategy." The provinces, he explained, "are best equipped to deliver the services and support families' needs," while the federal government, "through the provision of an equal level of support for all low-income families," could provide "a platform on which the provinces can build."[24] It was a new world in federal-provincial relations. And while it was not one that people like me, wedded to an older version of the Canadian dream, welcomed easily, it was a realistic and workable solution to federal-provincial relations.

In assuming a major role in combatting child poverty, the federal govern-

ment was also reflecting some of the fundamental values that distinguished Canadians from Americans. As Canadians cast about to define what makes them different from Americans, the extent to which they value quality of life and social programs are two distinguishing features. While the American dream is based on the notion of individualism and self-reliance, Canadians balance their commitment to self-reliance with a greater concern for the well-being of society as a whole. Poverty in American eyes is a symptom of failure. If people are poor, they have in some way failed to take advantage of the enormous opportunities available to them as part of the American dream. Canadians are more compassionate in their judgments. A recent poll, for instance, found that few Canadians blamed the poor for their plight, and a full 82 percent agreed with the statement that poverty is caused because "people have not had the opportunity to improve themselves through things like education and training."[25] Canadians are more likely to assess their quality of life by taking into account the condition of society's less fortunate members. A healthy society means that all children, no matter what their background, need to have the opportunity to make the most of their talents. Addressing child poverty, then, was a goal widely supported by Canadians and one that could become a key part of a new definition of what constituted the Canadian dream.

In taking up the mantle to fight child poverty, the federal government was dealing with a major social problem at the same time as it was addressing Canada's critical economic challenge of developing an educated, skilled workforce to replace retiring baby boomers. Also, child poverty is merely the tip of the iceberg. Homelessness, for instance, is a growing social problem and a symptom of the despair and helplessness of far too many Canadians. Addressing the root causes of poverty is essential but also expensive. In 1997, $6 billion was committed to supplementing the incomes of families who were earning $26,000 or less. In two years, more than $ 1 billion had been added to the program. A year later, the prime minister announced that, in conjunction with the provinces, the federal government was investing more money into the area of early childhood intervention – programs to deal with the problems of at-risk children at a very early age – and the next year more resources went to deal with the long-standing and exceptionally high poverty among aboriginal children.

The need to invest in initiatives like these to tackle Canada's most debilitating social problems has to be kept in mind when there is a call for more and more dollars for health. One of the best ways to promote long-term health is to eradicate poverty. And the definition of Canada's distinctiveness does not rest solely on one program – medicare – but is rooted more deeply in the concept that all Canadians, whether rich or poor, deserve an equal chance to make the most of their God-given talents and abilities.

From the vantage point of 2002, the new Canada that Martin alluded to in the 1995 budget is clearly in focus. Martin has succeeded in balancing the necessity of allocating resources to meet the current needs of Canadians today with the equally demanding task of investing in areas that will prepare for the challenges of tomorrow. The federal government is still a major contributor to current social programs. Seniors' benefits, for which the federal government is almost solely responsible, cost more than $20 billion a year; and in 2001, $29 billion in cash transfers went to the provinces for health, postsecondary education, and welfare, while another $10 billion was invested in the National Child Benefit and other federal social programs. At the same time, by limiting its commitments in these areas, the federal government has embraced the challenge to invest in innovation and the upgrading of Canadian skills to prepare Canada for the challenges of the future.

Whether Canada prospers and reaches the lofty heights to which it might aspire will depend greatly on our success with these two initiatives. Whether we have narrowed the gap between rich and poor and are reaping the rewards of the heretofore untapped talent of all Canadians will be vital in determining our future. Whether we innovate and expand the bounds of knowledge and creativity will also be critical in influencing what lies ahead. Upgrading the skills of workers and investing in technology have already begun to slow the declining levels of Canadian productivity. As Canadian productivity increases, wages will follow suit and Canada will be poised to provide the opportunities required to retain the next generation of innovative and enterprising Canadians.

The importance of the Innovation Strategy and National Child Benefit to Canada's future has to be communicated strongly to those demanding a massive infusion of funds to support the current health care system. Such a drain of funds would jeopardize the long-term prospects of Canadians. The future will require even more investment in innovation and poverty reduction to forestall a future clouded by shortages of skilled, educated people, shortages that could blunt our prospects and retard Canada's ability to reach its potential.

Although it may have been difficult to see in 1995, it was time for the federal government to steer the Canadian ship of state in a new direction. In 1995 what was most obvious was the dislocation and hardship that resulted from Martin's choices. Seven years later, with the new initiatives clearly in view, I have to concede that Martin chose well. Much as it is important to cling to traditions of the past, it is important to pave the way to the future. For those of us who still have nostalgic feelings about the Canada left behind in 1995, I recall my observation in my last budget speech: "While we have to remember the lessons of the past, we cannot return to it."[26]

One of the reasons why the federal government could open new fronts in

the areas of child poverty and innovation is that its most thorny problems had been handed over to the provinces. But as well as being responsible for health care, postsecondary education, and welfare, the provinces are also the primary financiers for infrastructure, such as roads, highways, and water and sewer systems. Having more freedom to design programs to suit local needs was cold comfort to provinces whose politicians faced a bleak future of having major responsibilities without the tax base to fund them. While the federal government had made the strategic decision to reduce its commitments in some spheres so that it could move into new areas that would be vital to Canada's future, the provinces, in the late 1990s and early 2000s, were mired in a desperate scramble to meet the insatiable demands of a health-care system whose costs, like the deficit in the late 1980s, were spiralling out of control.

As minister of finance from 1993 to 1997, I watched the costs of the current health-care system increase dramatically, and in 1997 when Premier Romanow asked me to be Saskatchewan's minister of health, I told him that only sweeping changes to the system could save it. Battle weary from my stint in finance by 1997, I was seeking a new challenge (though my first preference was to spearhead the provincial version of the Innovation Strategy), and by the late 1990s health care was a challenge in every province, as angry taxpayers saw waiting lists increase and emergency rooms become more congested. To me these were merely symptoms of the bigger problem; like governments, the health-care system was trying to do too much with too little, and it was showing the strain. The system needed both structural changes and billions of new dollars, much more than could be provided by either level of government without huge sacrifices in other areas. As a staunch defender of the principles of medicare, I argued in favour of performing the radical surgery needed for its survival. This talk, however, represented a special kind of heresy in Saskatchewan, the birthplace of medicare, where New Democrats in particular cling tenaciously to the system as structured. Thus, Romanow listened carefully, mused about the politics of such radical changes, and then made me minister of economic development – my first choice from the beginning.

The problem with health-care costs worsened after 1997, driven by the development of new drugs, procedures, and equipment, higher and higher salaries for increasingly scarce health-care professionals, and an aging population. Roy Romanow, head of the Commission on the Future of Health Care in Canada, suggests that the current health-care system is affordable because per capita spending on health care and its share of the GDP are the same in 2002 as a decade ago; he also observes that what matters is the total cost of the service, not what portion is paid for by taxpayers.[27] One problem with this measure of affordability is that it does not take account of the

deficits accumulated by hospitals and health boards and the hidden costs of outdated medical equipment that has deteriorated in the last decade as cash-strapped governments scrambled to fund an overstretched system. These costs are estimated be in the hundreds of billions, and recently the Ontario Hospitals Association declared that many of its hospitals were facing insolvency.[28] To evaluate the costs of the health system without considering these costs is like making a financial assessment of an organization that does not take account of its debt or the depreciation of its assets. Also, a recent Conference Board of Canada report concluded that costs relative to GDP are not a reliable measure of affordability, since government revenue does not necessarily increase with GDP growth. Indeed, in the next twenty years "the overall share of government revenues relative to GDP is expected to decline"; at the same time, future health-care spending will increase faster than the growth in GDP.[29]

The reports on health care by Senator Michael Kirby (*The Health of Canadians: The Federal Role*) and Don Mazankowski (*A Framework for Reform: Report of the Premier's Advisory Council on Health*) use a much better measure of affordability when they relate the cost of health care to spending on other priority areas. According to the Conference Board of Canada, spending on education and health were about equal in 1997, but by 2001 education funding had fallen behind by $8 billion and the gap continues to widen.[30] Students paying higher tuition fees as a result of this shift would disagree with Romanow's view that it does not matter how much of the cost of a public service is borne by the individual and what share is paid by government. At the heart of public policy debate is the allocation of scarce government resources among competing spending priorities.

The root of the fiscal problem in health care is that its costs are increasing at a much faster rate than government revenue. Between 1998 and 2000 Canadian health-care costs rose by almost 28 percent while federal government revenue went up by less than 12 percent.[31] The Saskatchewan health-care commission headed by Kenneth J. Fyke, concluded in 2001 that simply maintaining the current Saskatchewan system, with no new programs, services, or personnel, would mean increasing the health budget by 6.5 percent a year while government revenues would increase at most by 3 percent, which meant that "the province is locked into spending almost all of its forecast increase in revenues on health." In Alberta health-care costs have been increasing by an average of 10 percent a year since 1996, outpacing government revenue growth.[32] Just as compound interest caught up with deficit spending by the late 1980s, the huge and growing costs of the current health-care system have been catching up with the fiscal capacity of Canadian governments since the late 1990s.

The public's reaction to the emerging crisis in health care is similar to its

response to the deficit in the 1980s. Since its inception in the 1960s, medicare has grown to become considered a public good – a set of services so highly prized because of their value to society as a whole that they should be almost exclusively publicly financed. It is this idea that underpins the ideal of health care as an entitlement, as something individuals have a right to. Polls reveal that the threat to this entitlement posed by health care's escalating costs has not yet registered with the public. As in the 1980s, polls show that there is an acceptance of the fact that there is a problem and also a widely shared hope that the solution will be found somewhere else. Just as Canadians wanted the deficit tamed by cutting the civil service or reducing government waste, they now hope that the health-care system can be salvaged by changing its structure, ending inefficiencies, or just by finding more money. As in the late 1980s, nervous politicians dance around the issue, knowing the implications of the escalating costs but fearing the wrath of voters who do not want to see their benefits cut and the contributions from their pocketbooks increased.

From my experience, provincial governments have been spending massive amounts of money on health care not on the basis of sound policy analysis but in response to pressure from polls about public opinion. Budget cycles in Saskatchewan followed a familiar pattern for many of the ten years that I was in cabinet. At the beginning of the cycle, there was a great resolve to limit spending on health care so that other priority areas – which were acknowledged to be critical to the long-term development of the province – would not get short shrift. The health department would then proceed to outline in detail the hospitals that would have to be closed, the services cut, and the fees increased. I always found it ironic that while the health department could describe graphically what not giving the system enough money would do, it could never guarantee what would be achieved by the money put into the system. As the politicians listened, envisioning thousands of irate voters, the majority would wave the white flag on the understanding that the current year was only a "transition," which meant that health had to be given the lion's share of new money to fund the transition. The next year we all vowed that the health-care system would be dramatically restructured so that it would become affordable. After ten years in politics and ten "transitions" to a restructured health-care system, I lost faith and patience.

What has been the result of spending all this money on health care? Despite the massive infusion of funds, the health-care system is still not thriving but just getting by on a subsistence diet. From the point of view of the patient, there are long waiting lists and the development of a two-tier system. With most Canadians living in close proximity to the American border, wealthy patients can jump the queue for waiting lists in Canada by

merely crossing the border and paying for immediate treatment. Despite the billions spent on health care, Canadians lack the confidence that the system will be there for them when they need it. As for health-care professionals, the stresses and strains are taking their toll; low morale and frustration at working conditions are common, a situation that is made more acute by the serious shortages of nurses, doctors, and technicians and the aging of equipment. How can Canada expect to compete with other countries that are trying to lure away scarce health-care professionals when the workplace is besieged by the stresses of underfunding?

The billions put into health care by provincial governments have come at the expense of other priority areas. Alberta's case is typical. In 1990–91 Alberta dedicated 24 percent of its budget to health care; by 2000–1 about 33 percent went to health care; and it is estimated that 50 percent of the budget will be going to health by 2008 and its share of the spending pie will continue to grow. The Conference Board of Canada predicts that in the next twenty years public spending per capita will increase by 58 percent in health and only 17 percent for all other government services.[33]

Health care is engaged in a David and Goliath battle for scarce provincial resources. The Goliath is a public so committed to medicare that it evokes terror in its politicians, who would rather face angry students over high tuition fees or disgruntled mayors complaining about crumbling infrastructure than confront irate seniors or baby boomers concerned about health care. Hence, they scramble desperately to find money for health care in the vain hope of shortening a waiting list or two. The Davids are the other funding priorities – education, training, research and development, poverty reduction, environment, and infrastructure – which always play second fiddle or poor cousin to the mighty Goliath of health care. Thus, in Saskatchewan in the 1999 budget, research and development got a $10 million fund merely to cost-match federal funds for CFI projects; the badly damaged highway system received $5 million more; there was an increase of about $8 million for operating costs for all of the province's postsecondary institutions and no new initiatives on the environment, while a whopping $195 million new dollars were spent on sustaining the existing health system. Eighty-five cents of every new dollar collected in 1999 went to health care. The imbalance between spending on the current health system and investing in areas that will prepare us to face the challenges of the future is striking.

Linking the Goliath of health-care spending and the David of everything else is a public unaccustomed to making trade-offs. Poll after poll shows Canadians' deep attachment to medicare. But such polls omit one of the major realities of public policy decision making – the need for trade-offs. When Canadians are asked what they would like to see in the health-care

system, the trade-offs are not apparent. It's like asking people what kind of car they want to drive without considering what sort of house would be affordable on the money left over from their salary. Do Canadians enjoy driving on bumpy, pot-holed highways, some of which are even dangerous, and do they realize the economic development implications of having a highway system whose quality is so markedly inferior to the interstate system in the United States? What about the environment? Walkerton was a tragic example of problems with the safety of public drinking water, but there are many more Walkertons waiting to happen in provinces across Canada, and water quality is just one of the pressing environmental issues that we will confront. What about poverty, which still haunts us? What about the provinces' role in the Innovation Strategy? And what about the recent announcement by the dean of law at the University of Toronto that tuition fees for students would rise to over $20,000? Only when the debate about health care is posed in the context of trade-offs like these will we come to grips with the real choices.

The tuition decision reflects the fact that as provincial governments scramble to find cash for the troubled health-care system, one of the casualties is an inadequately funded education system. Twenty years ago Canadian governments invested $11,000 for every student; by 1999 this amount in constant dollars had dropped to $7,000. The relative decline in Canadian funding for education has occurred at the same as Americans governments have been significantly increasing their funding for public postsecondary education, a comparison that is critical since competition for students spans the Canadian-American border. Between 1995 and 2000, American governments increased per student funding for postsecondary education by 20 percent, while Canadian governments reduced theirs by 20 percent. The trigger for the University of Toronto law school decision on tuition was the fact that Michigan universities – which compete for Ontario students – receive three times as much per student from their state government as Ontario universities get from the province.[34]

The University of Toronto tuition decision should be a wake-up call, since it signals that while Canadians have been preoccupied with keeping the front door closed on American-style two-tier health care, American-style two-tier education has been creeping in the back door. With more and more students willing to look beyond their borders for education, Canadian colleges and universities are caught between the proverbial rock and hard place. On the one hand, they can work hard to keep tuition affordable while watching their ablest professors being lured south of the border, which means that they are sacrificing quality in the interests of accessibility. The message to our young people is then that Canada is about mediocrity; if you want excellence go elsewhere. The other choice is to emphasize quality,

seeking out the very best faculty. But this means paying first-class salaries like those in the United States, which in turn will mean raising tuition fees, thereby jeopardizing access. Sure, all universities with high tuition have bursaries and other programs for gifted people who lack significant financial resources, but we're kidding ourselves if we don't think that double-digit tuition discourages many able students from pursuing higher education. Money will matter more, and the poor kid from the wrong side of the tracks will bear the brunt of this.

The University of Toronto decision also opens the door to another dimension of the American two-tier system. Historically, the Canadian system has not been characterized by the dramatic gap that exists in the American system between universities at the top, such as the Ivy League group, and those at the other end of the spectrum. If, however, universities such as Toronto use higher salaries to attract the best faculty, what happens to the rest? Without similar increases, the gap between those at the top of the academic ladder and the rest will widen until we too move to an American-style system, where the elite – those with either the highest marks or the most money – go to a top rung of institutions. As the recruiters for the largest law firms or the best high-tech companies seek out talent, they will naturally gravitate to the first tier of institutions. For Canadians who do not embrace the elitist dimension of the American dream, such inequality in education and opportunity could be a bitter pill to swallow.

The relative decline in funding for education also makes it more difficult for Canada to meet the challenge of providing the skilled, educated workforce that will be needed to address lagging productivity and looming labour shortages. In 2002 the Conference Board of Canada found that while only 6 percent of jobs will be open to those who are not high school graduates, 18 percent of Canada's youth will drop out of high school. The high school drop-out rate for aboriginal people is still about 70 percent. And 40 percent of adults lack the literacy skills needed for success in the knowledge-based economy.[35]

Shortages of highly trained people are also the product of enrolment caps on key programs. Consider two examples. Mind-boggling is the only word to describe the recent scenario in Alberta, where the report of the Premier's Advisory Council on Health was released in December 2001, documenting the fact that a serious shortage of health-care professionals was one of the key factors driving up health-care costs. The report warned that by 2004–5 the province would need 1,329 more physicians and 6,000 new nurses. Less than four months later, it was reported that the University of Alberta was still struggling to find the funding to open up more places for doctors and nurses.[36]

Another example involves the Saskatchewan decision, it its 2000 budget,

to provide another $2 million to the provinces' universities and technical institutes to raise the very restrictive limits on entry to computer science programs. I pushed for this investment after meeting with the owner of a Saskatoon-based computer programming firm who had just won a major international award for excellence. The entrepreneur explained that the main advantage of locating in Saskatoon was the quality of the computer science graduates, though he quickly added that they were getting harder and harder to find because of very restrictive caps on enrolment. In a classic understatement, he observed that this was puzzling, since it was common knowledge that computer science graduates were essential to success in the information age and shortages were already apparent. "Why," he asked, "in such a critical area as computer science are there such restrictive limits on enrolment, which means that each and every year eager students with good marks are rejected? I don't get it." My reply was, "Neither do I."

Rather than burdening students with restrictive caps on essential programs and ever-higher tuition fees, advanced education should join health care and become accepted as a public good that is based on mutual responsibility and co-payment. Canadians are still in the mindset of the 1980s in which education was seen as a private good – something that benefits mainly the individual.[37] While there is obviously some truth to this view, it is equally true that at a time when society is in such desperate need of more highly educated and skilled people, advanced education is by definition a public good. Every time a student fails to complete grade 12 or a high school graduate, discouraged by the cost of tuition or the enrolment limits on programs, decides not to continue with his or her education, we all lose, just as we all lose every time a worker is discouraged by the same considerations from upgrading his or her skills. Canadian nurses have recommended that governments address shortages in their profession by giving nurses free tuition and assistance with high student-loan debt loads, and the Canadian Medical Association has urged governments to enhance funding to universities to raise caps on medical programs and to ease tuition and other financial burdens for students.[38] Such reports point the way to the future. With current or looming shortages of educated, skilled people in many sectors, policies like these should be expanded beyond health care. Rather than putting obstacles in the way of prospective students, governments should be paving the road for people to continue their education.

As the problems in education show, the sustainability of the health-care system needs to be addressed to avoid a dual crisis. Without dramatic change and significantly more funding, the health-care system will continue to hobble along on a subsistence diet rather than providing timely quality care. Also, unless the rapidly increasing costs of the system are addressed, health care will continue to expand its share of the government

revenue pie at the expense of other priorities. As a result, current shortages of skilled, educated people will worsen to the point of crisis, and lagging productivity will mean a relative decline in Canadian incomes and fewer resources to fund health care and other priorities.

Provincial governments and others see more federal funding for health care as a major part of the solution to the system's funding woes. Although the federal government has indicated that it will put more money into health care, the question is, How much? In terms of health-care needs, funding the current system and all the new procedures and treatments that will become available in the future, as well as replacing the rapidly aging equipment and infrastructure, would mean allocating all of the future federal surpluses to health care, and it is arguable that the system still would not be "fixed." For example, within months of the federal government committing more than $20 billion to health, the province's message was that a lot more money was required. However, the federal government can only allocate the lion's share of its future surpluses to health care by going down the road travelled by the provinces and jeopardizing other priority areas. The Innovation Strategy and the Child Benefit are critical to Canada's future and will require billions in new investment. Other poverty issues, such as homelessness, cannot be ignored. Canada will have to invest more in environmental initiatives to reduce greenhouse gas emissions. September 11 showed the woeful inadequacies of Canada's military. And municipal governments are making a powerful case about what inadequate support for cities means to the lives of the majority of Canadians who inhabit them. While the provinces argue (as I did when I was a provincial minister) that they need a bigger share of federal revenue because there is an imbalance between their responsibilities and revenue, independent analysis might well show that it is local governments – who have to rely on regressive property taxes – that are being asked to do too much with too little. Deciding how much of the future federal surpluses should be invested in health care has to be debated in the context of these trade-offs.

Recent reports on health care by Romanow, Kirby, and Mazankowski recommend ways to improve the current system, and they share important common ground. All agree on the following changes: more prevention and promotion of healthy lifestyles; moving to a primary health-care model, which means that patients with minor health problems would be seen by a nurse or another health-care professional rather than a doctor; changing the fee-for-service payment system (which acts as an incentive to use the system); and introducing more accountability so that it will be possible to measure not just the money going into health care but the outcomes or the results. This is progress.

There is some important common ground among the various govern-

ments on fundamental issues. The goal of the medicare system – to ensure that all Canadians, whether rich or poor, can access the system when they need it – is endorsed by all provinces. More progress.

The two national reports by Kirby and Romanow also agree on the need for governments to pay home care and drug costs for a period of time after patients are released from hospital in order to ensure that there is no financial incentive to prolong a patient's stay in an expensive hospital facility. The same logic leads Kirby to propose funding to allow palliative-care patients to be cared for at home. The escalating costs of drugs and their central role in treating patients is the basis for Kirby's proposal for a limited national drug plan. His plan would have the federal government cover catastrophic drug costs – defined as annual drug costs in excess of $5,000 or drug costs that exceed 3 percent of family income – and would include a national drug formulary to regulate the drugs to be covered. Romanow advocates more funding for catastrophic drug costs, for upgrading diagnostic equipment, and for improving rural and aboriginal health-care delivery.

Kirby, on the other hand, calls for more federal funding to upgrade health care infrastructure, promote research, and alleviate shortages of medical professionals. He also recommends more funding to universities to open up more spaces for doctors, nurses and other medical personnel, and more investment in research and in information technology. He stresses the challenge associated with retaining researchers and recommends devoting one percent of total health-care spending to research. And he emphasizes the need to invest $4 billion in academic health sciences centres, since they are major centres for medical research, the education and training of health-care professionals, and tertiary care.

Both also recommend mechanisms to monitor health-care spending and outcomes and ways to restore Canadians' confidence that the system can provide timely care. Kirby favours a health-care commissioner and council and a health-care guarantee, which would provide that either patients were treated in a timely manner or governments would have to fund alternative treatment in another jurisdiction. Kirby also adds a chilling warning to the effect that if governments cannot ensure timely access to health care, then a challenge under the Charter of Rights and Freedoms would allow patients to buy private insurance – a course that would open the door to a parallel health-care system. Romanow's answer is a similar institutional change – a health-care council – as well as a health-care covenant outlining patients' rights and responsibilities.

A point of departure between Romanow, on one side, and Kirby and Mazankowski , on the other, is over the desirability of allowing more competition and a larger role for the private sector in health care. Romanow's argument is that when health-care costs relative to GDP are considered, the

publicly funded Canadian system is more efficient than the American private-sector-dominated system; therefore Canadians should expand the scope of the publicly funded system. This argument is open to debate on several grounds, including the previously mentioned point that costs relative to GDP do not take account of the backlog of outdated equipment and health-care facilities or the accumulated debt of hospitals. Also, as Romanow points out, the cost-effectiveness of the Canadian system is rooted in the fact "that single-payer insurance systems have lower administrative costs" than the American private system, with its maze of bureaucracies.[39] Neither Kirby nor Mazankowski are recommending ending the single-payer payment system; they are arguing for more competition and openness to private-sector involvement in the delivery of services within the framework of this system.

Terms such as "competition" and "a greater role for the private sector" conjure up in the public mind visions of the American system, with its well-documented inequities, inefficiencies, and high costs. Special-interest groups fan public anxieties by pouncing on any changes to the current system, seeing them as the thin edge of the wedge opening the way for American-style health care. In fact, no one writing reports for governments in Canada today is advocating an American-style health regime. Also overlooked in the debate is the fact that Western European countries, many with better records than ours in social policy, have moved to various models that blend public and private funding. Finally, the Canada Health Act provides that services covered by medicare have to be publicly funded and administered, but there is no stipulation that such services have to be publicly delivered.

Kirby recommends that rather than funding hospitals using global budgets, funding should be linked directly to the specific services provided. In practice, this would mean that if a particular procedure within the hospital system was not delivered as effectively as it might be, then doctors and other health-care professionals would have an incentive to open a private clinic specializing in this particular service and to seek government funding. Mazankowski proposes that health districts have the freedom to choose how health services are delivered. That is, the criteria for health districts should be quality and cost-effective services; whether these services are delivered by the public, private, or co-operative sector should not be the basis of decision making. The concept of introducing competition and choice, which exist in virtually every other sphere of activity, has the potential to increase the effectiveness and affordability of health-care services.

Public sector unions protest vehemently against delivering health services through the private sector (understandably so, since their jobs are on the

line). Yet these same public-sector unions are using their monopoly on the right to deliver services in an exclusively public system to demand double-digit wage increases. Higher and higher wage settlements – some resulting from a shortage of professionals such as nurses but others based on union bargaining power – are a major factor in the increasing cost of health care. It is understandable that governments facing such a scenario would want more choices available to them in the delivery of health services. Polls, according to Bricker and Greenspon, show the parameters within which Canadians are open to more competition and a larger role for the private sector in health care. They describe Canadian attitudes as follows: "I don't care if my food [in a health-care facility] is prepared by a public-sector employee or a private-sector employee. And I support the efforts of any government to eliminate waste by resorting to private-sector disciplines or even private-sector operators. But I need to have faith that the system is a public system – financed publicly for the public good and therefore wholly accountable to me as a citizen"[40] More competition and an emphasis on quality, performance, and costs – rather than on whether the service provider is public or private – is the wave of the future in delivering health-care services.

It is also impossible to see how government funding alone will be able to pay for the billions and billions of new dollars required to update badly deteriorated medical equipment and facilities. Governments simply will not be able to afford to do the necessary upgrading in a timely way. Hence, the choice will be to face the health-care consequences of getting by with less than state-of-the-art facilities and equipment or being open to imaginative private-public partnerships to finance the projects.

Although changes such as these will enhance the affordability of health care, they will not by themselves be enough to close the wide gap between the rising costs of the system and the increases in government revenue. Although it can be argued that cost savings will result from some of the proposed changes, at the same time these will likely be more than offset by the costliness of new drugs, procedures, treatments and equipment, the aging of the population, and growing public expectations. Kirby and Mazankowski curb public expectations by confronting the affordability issue and recommending difficult but necessary measures to make health care sustainable.

One way to contain costs is to restrict what is covered by medicare. The Mazankowski report asks a critical question about what the Canada Health Act means when it guarantees comprehensiveness: "It's time to think carefully about what can and should be covered by Medicare. The system was never designed to cover all aspects of health services but people have come to expect that it will – and at no cost to individuals."[41] To deal with one of

the main cost driver of the system – the plethora of new procedures, treatments, drugs, and therapies – the report recommends that a panel of experts determine what services should be covered within the framework of a set budget, with the clear understanding that if a new service is to be funded, some other less-effective service should be dropped. Canadians would have to take personal responsibility for services not covered; but the gain would be that the essential services covered would be of the highest quality and there would be guarantees of speedy access to them. What the report is saying is that the health-care system, like other services in the twenty-first century, has to be strategic – it needs to focus on what is most essential, and it needs to do these jobs exceptionally well.

Kirby and Mazankowski also propose new ways to get more money into health care. Kirby's Senate committee "categorically rejects the position that the problems of Canada's health care system can be solved in a way that is cost-free to individual Canadians," while the Mazankowski report states, "If we depend only on provincial and federal general revenues to support health care," the future is one of "rationing" of health services; opening up other sources of revenue – a euphemism for making people pay more – will make it possible to "improve access, expand health care services, and realize the potential of new techniques and treatments."[42] More rationing or more money from people's pocketbooks is the choice. Both Kirby and Mazankowski recommend finding new money through a health-care premium. When a tax-averse province such as Alberta advocates a new revenue measure to support a social program, it merits consideration!

Although Canadians obviously prefer Romanow's message that they do not have to pay more for their health care, they should ask themselves a basic question: Do they really believe that by relying solely on the current tax system, the health-care system can afford to cover all the new procedures, treatments, and cures that will inevitably come onto the market in the future? The Mazankowski commission found that people are prepared to pay more if governments can guarantee better services. But rather than simply increasing taxes, governments need to show people that there is a direct link between their dollars and improved health care.[43]

A health-care premium, according to Kirby and Mazankowski, would not only help finance health care but would also prevent health from taking the lion's share of revenues from other priority areas. One hopes that the federal government does not travel the provincial road of allocating more and more dollars to health care at the expense of other vital priorities. Instead, as Kirby says, we now have to turn to the "most difficult health care issue" – how to pay for health care without jeopardizing funding for other vital areas.[44]

While Kirby and Mazankowski try to contain public expectations and

confront difficult but necessary choices in health care, Romanow rejects any radical restructuring in favour of an expanded and more centralized system. Although it's hard to argue with the need for more information, account-ability, and measurement of outcomes, provinces have grounds for objecting to a central agency monitoring their health-care performance and to be con-cerned about expanding a system that they are already struggling to fund. It's like recommending that the solution to fixing a house with a leaky roof and outdated wiring is to invest in an addition. The ideal of a national sys-tem in which services and standards are centrally determined is at odds with the reality that it is the provinces that deliver and fund the majority of services. Also, the unanimous resolution of Quebec's National Assembly in opposing the centralizing thrust of the Romanow report is a reminder that Quebec is but one province committed to a decentralized federation. Cana-dians from all backgrounds will remain committed to a health-care system that ensures that all citizens, whether rich or poor, can access health care, not because of standards imposed centrally but because Canadians from coast to coast share the same ideal.

As well as rejecting a bold restructuring of health care to make it more affordable, the Romanow report rejects innovative ways of finding new money to pay for the system. The report is right in saying that income taxes are the fairest way to pay for services such as health care. However, income taxes cannot be raised without jeopardizing our ability to attract the highly skilled and educated people who will increasingly be in short supply. Infor-mation technology has opened the door to other innovative ways to finance health care, from co-payments to health-care premiums, which can be geared to income and health status. These payments could be assessed annually rather than at the time when care is needed – as is the case with user fees. One by one, these ideas were rejected by the Romnaow report on the grounds that they would shift health-care costs from the government to individuals, which would not be equitable. The debate needs to be broad-ened to consider the relative equity of shifting more and more of the costs of education onto students in the form of tuition and student debt load. With-out new sources of revenue, beyond what can be raised by taxes, health care will continue to be plagued by the most visible symbol of rationing – long waiting lists.

With no prescription for radical restructuring or new revenue sources, the Romanow report's answer is to invest $6.5 billion into health care in the short term and to increase health-care spending to reflect the growth in health-care costs. Since these costs are growing faster than the economy – Romanow estimates a multiplier of 1.25 – the crowding out of other priori-ties that occurred at the provincial level would be transferred to the federal scene in the medium term. In the long term, health-care costs, like the deficit

in the 1990s, will grow beyond the capacity of any government to fund them.

Those who call for the federal government to return to its past role in funding close to 50 percent of the cost of health care have to consider the new responsibilities undertaken by the federal government since 1995, all of which have a valid claim to future federal surpluses. The Innovation Strategy, which funds the labs and other research facilities that are the twenty-first century version of the past's railway and canal infrastructure, will be critical to enhancing Canada's lagging productivity and ensuring that Canadians have the income levels to fund health and other social programs. The Child Benefit and other programs to address poverty will be vital in allowing children from all backgrounds to develop their talents to the fullest and become part of the educated, skilled workforce that is essential to Canada's success in the knowledge-based economy. The demands of the environment will require a level of federal investment in this sector that was not present in the past. Cities will in all likelihood make an effective case that of the three levels of government, they need access to another source of revenue than the regressive property tax. And a compelling argument can be made that Canada's military has deteriorated to the point that new federal funding in this area is required.

Medicare, it is true, is important to our sense of what it means to be Canadian. But the Canadian dream encompasses more than this. As I said in my last budget speech, "We must work continually to ensure that every person, whether rich or poor, has access to health care, every child, whether rich or poor, can get a quality education; and a social safety net is in place to catch those who have fallen on hard times and need help getting back on their feet."[45]

Going Backward or Forward?
Post-Deficit Drift and Exiting Politics

Paul Martin's departure from cabinet in June 2002 rekindled memories of my exit from the political stage and my constant admonition to my sons that politics is neither fair nor rational. That Canada's most powerful and successful cabinet minister could be summarily dismissed shocked and angered many Canadians. The Martin-Chrétien episode gave the public a rare glimpse into the infighting that sadly is often part and parcel of political life. It also reflected what happens in governments when a major battle, like the fight against the deficit, is over and the divisions and rivalries that have been submerged during the common fight surface to sap more and more of the time and energy of those around the cabinet table. Also, the incident reflected the extent to which politics is one of the last bastions of hierarchy, an arena where the power of the first minister is so pervasive that it can be his or her undoing.

Although it would be presumptuous to suggest that there is a parallel between the political exit of Canada's most accomplished finance minister and my own choice to leave politics, the common thread in the two events is what happened to governments after the deficit monster was slain. There were a lot of similarities between the Romanow and Chrétien governments. Both won decisive victories against discredited Conservative governments only to face a looming fiscal crisis. Both made dramatic cuts in spending, which garnered the support of the business community and approval of the electorate but which left elements within both the Liberal Party and NDP believing that deficit reduction was a right-wing agenda. And both presented a united front during the deficit fight and then, after the goal of balancing budgets was achieved, both were perceived to be adrift with no all-encompassing new policy direction to steer the ship of state. Spending patterns and policy choices began to drift away from the 1990s mold and return to habits supposedly forsaken during the deficit wars. In both cases squabbling, bickering, and rivalries came to the fore again, though those in

Ottawa, especially between Chrétien and Martin, were more widely report-ed than those in Regina, which did not pit the finance minister against the first minister. What, then, was the glue that cemented the team and focused the agenda during the deficit battles? What happened after the budgets were balanced? What is the dividing line between government at the top of its game and government merely managing the daily affairs of state?

My experience in politics spanned both ends of the spectrum. Cast in the public mind as a key architect of deficit cutting and strategic government of the 1990s, I was touted as a potential successor to Romanow; but when the job became vacant in the fall of 2000, I quickly declined to run. I was the only member of the original war cabinet to join the new government of Premier Lorne Calvert in early 2001, but after serving for only three weeks I resigned from the cabinet, and within months vacated my seat. When I departed I spoke about wanting to write about my experiences, about wanting to give the new premier more scope to rejuvenate the team, and wanting to open up a Saskatoon cabinet seat to help solve an internally divisive contest between two very good MLAs for the speaker's chair. All true, but not the whole story. Constrained by a desire to avoid a public slugfest with my former col-leagues, and by cabinet confidentiality – one reason for my departure was the 2001 budget that had not even been tabled in the legislature – I promised that in my book I would answer the personal questions that I dodged at the time of my departure. Why did I decline to run for the NDP leadership? Why did I make such a hasty and seemingly unplanned exit from the political stage? And why was it I – the one who had barely made it into the original cabinet – who remained longer than the other ten, including Romanow himself?

Answering these questions involves explaining how I got into politics in the first place and some of the formative experiences in my political career. Like many women, I never considered politics as a career, even though my extended family was interested in public affairs. My grandmother, a CCFer who believed ardently in the social gospel (and had a wonderful saying, "If you help a lame dog over a style, you'll be all the better for it"), instilled in me a social conscience – no one in Canada, I firmly believe, should grow up poor. From my dad, a very thoughtful businessman and an Ontario Conser-vative voter, I learned a passionate Canadian nationalism, which led to my conviction that a strong central government should use its power to erect barriers (such as crown corporations) to promote Canadian sovereignty. These political beliefs, along with my admiration for the NDP's opposition to the War Measures Act in 1970, led me into the NDP fold. But although I was intellectually attached to the NDP, I never accepted the black and white view of the world that comes with partisan politics. I was unmoved by appeals to blind partisanship, so common with governments on their last legs – the

argument that bad as we are, we have to stay in power to keep the heathen hordes in the opposition from storming the barricades.

Education was the key that opened the door to opportunities in my life. In my extended family, I was the first member and the only one of fifteen cousins to attend university, thanks to the quality education system in Etobicoke, Ontario, and the strong encouragement of my teachers. Because of these factors, I had excellent marks and had all my education paid for by scholarships. If I had had to scramble to find the money for tuition and living expenses, as so many students do today, I wonder how different my future would have been. Access to quality education is the hallmark of a society committed to equality of opportunity.

My drift into active politics began after 1975 when my husband Peter – a Maritimer by birth – and I moved to Saskatoon to join the faculty at the University of Saskatchewan. In 1983 there was a bitter strike at the Saskatoon Co-op, which ran grocery stores, gas stations, and home centres in the city. A group of co-op members asked the board of directors to hold a public meeting to discuss the strike, and when the request was denied, the only way to force an official public meeting was to petition the Department of Co-operatives to impeach the board of directors. At the widely publicized and emotionally charged meeting, which was attended by more than a thousand, I moved the motion and made a speech arguing that any elected board of directors that refused to meet with its members should be impeached. The motion was soundly defeated. The next day, I received a call from Roy Romanow, who was at the university after his defeat in the 1982 election. He had advised me against presenting the petition on the grounds that I would be branded "a flaming radical," so I was surprised when he said, "Congratulations. You won. One-third of that audience supported your motion to impeach well-known and respected Saskatoon citizens and replace them with a bunch of total unknowns. You've got a future in politics."

The next year, I was elected to the Saskatoon Co-op's board, and I became president in 1986, just as the co-op was careening toward bankruptcy. A bold plan to restructure the organization by eliminating some units and downsizing others was drawn up by a team that included past allies (such as the United Food and Commercial Workers Union) and former foes (such as the wholesaler Federated Co-op, which had been on the other side at the 1983 meeting). As president, I was front and centre in selling the tough medicine to the co-op's 32,000 members. In so doing, I discovered the genius of Saskatchewan politics. Saskatchewan voters possess a rare combination of political savvy, hard-headed practicality, and an openness to innovation and experimentation, that simply did not exist in more traditional provinces, such as my native Ontario. No wonder Saskatchewan people had been trailblazers in medicare! They are open-minded enough to embrace dramatic

change, but hard-headed enough to be sure that it will work. From my co-op experience I concluded that this was a province that could travel into new territory, and these were voters who could be persuaded to change.

The appeal of politics stemmed from my respect and affection for the Saskatchewan electorate. However, I soon experienced the ugly side of partisan politics. After the co-op public meeting I was persuaded to run on the official slate for vice-president of the Saskatchewan NDP at its convention in the fall of 1983, at which the party was bitterly divided into right- and left-wing factions over the future of uranium mining in the province. Having been branded a radical for wanting to impeach distinguished Saskatoon citizens on the co-op board, I was now castigated as an establishment person because my name was on the official party slate. Caught in the crossfire of party infighting, I was called a cow, among other names, and was booed and defeated by the assembled New Democrats. Devastated and in tears, I informed Romanow, who had encouraged me to run, that never ever again would I have anything to do with partisan politics. Hence, when NDP leader Allan Blakeney approached me to run before the 1986 election, he had barely finished his pitch when I politely declined. Friendly lunches, pep talks, and enthusiastic encouragement from other New Democrats did nothing to lessen my resolve to steer clear of elected office – until there was an offer that I could not refuse without wondering forever whether I had turned my back on the opportunity of a lifetime. I ended up running in one of the safest NDP seats in the province, in an uncontested nomination (where the sitting MLA had resigned), and went straight into cabinet, where I stayed for ten years until I announced my political exit. As I said to one of my deputy ministers, "I've never fought for a nomination, I've never run in a seat that was not easily winnable, and I've never been a backbencher." His fitting response was, "Minister, this is probably for the best because I don't think that you would have been particularly good at doing any of those things."

Ironically, while gender was the reason that I was recruited on such attractive terms, I was able to go into politics because I did not have to face many of the barriers that keep women out. Women often find it difficult to raise money for nominations, and they shy away from the prospect of a nomination fight that brings out the nasty, personal, and petty side of the game. These aspects of seeking a nomination would have deterred me had it not been for the fact that by the late 1980s all political parties knew that women voters no longer followed the lead of the men in their lives, and a key to getting the women's votes was to have women candidates. Thus, the Saskatchewan New Democratic Party Women (SNDW), under the enthusiastic leadership of its president, Marg Morrissette, began actively recruiting women to run in the 1991 election and even had a fund to help defray the cost of women's nomination contests. Romanow used his extensive persua-

sive powers on prospective candidates and was always a strong booster of women politicians. On many occasions in the 1990s he beamed with pride as he reminded audiences that he had appointed Canada's first female finance minister, that he had put women in the most senior and difficult portfolios in government – finance, health, economic development, government house leader – and, he joked, that the best men in his cabinet were the women. Never before or since was there the same determination to bring women into the political fold as in the 1991 election, and I was fortunate enough to be at the right place at the right time.

But getting one's foot in the door is only the beginning, and during my political career I was all too often horrified by the treatment meted out to women in the rough and tumble world of politics. Lynda Haverstock, a fellow academic who led the Saskatchewan Liberal Party from oblivion to official opposition status in 1995, was soon unceremoniously dumped from the leadership in a nasty public exchange with her members. The Calvert administration, whose transition team was all male, dropped four women in its first eighteen months in office, moving Saskatchewan from a high in 1991 when 40 percent of the cabinet were female, down to a situation in June 2002 where less than 15 percent were women, with none in senior portfolios. Especially troubling was the case of Judy Junor, president of the Saskatchewan Union of Nurses, who was wooed in 1998 to quit her job and run in a Saskatoon by-election, which she won handily. Soon after, she was appointed associate minister of health and endured the wrath of her former colleagues when she supported back-to-work legislation to end a nurses' strike. After Romanow's departure, the new premier, concerned with complaints from Regina that Saskatoon had too many ministers, asked Junor to step aside from cabinet but promised her the speaker's chair. When it became apparent that the premier could not deliver on his promise, since the speaker's position was elected and a more experienced, male MLA was seeking the job, Junor again stepped aside. A few months later, when I left the legislature in June 2001, I impressed upon the premier that as I was vacating a Saskatoon seat, I expected him to do the right thing and reappoint Junor to cabinet. Which he did. Until the fall, when another problem – this time a government downsizing exercise – saw Junor again dumped from cabinet. Disillusioned and feeling humiliated, Junor reflected on her experience with the wistful comment that she had tried to be a co-operative team player.

Examples like these reinforced my conviction that success in politics requires a certain toughness. The sad reality is that being known as a team player can easily translate into accepting demotions or some other hit for the sake of the team, something that I was never prepared to do. I came from a generation of women – the early postwar baby boomers – who were on the

frontiers of change. While breaking through glass ceilings to move into new territory, the women of my generation still worked in circumstances in which women were an insignificant minority in a male-dominated world. At university, my friends and I still believed that we were there looking for husbands and only stumbled into careers. We endured the humiliation of politely rebuffing sexual advances by male professors, of being told that business and law were for men not for us, and of finding out, as I did as a master's student, that I had to get a higher mark than my fellow male students to be accepted into the PH D program. With such experiences behind me, I did not enter politics under any illusions that the world was either rational or fair, or that there would be any reward for taking a hit for the team. By 1991, after spending twenty years in academia, as a graduate student and professor, I had also learned how to survive in a male-dominated world – how to hide vulnerabilities, seek out allies, and if necessary be as tough as nails. Yet the notion of storming the barricades to force change was hardly an option for my generation of women, when there were only one or maybe two of us around the decision-making table. Instead, change had to be pushed gradually; and doing well in a world still run by men meant working with them, not against them. The male world is not monolithic, and throughout my career men have been invaluable mentors, allies, colleagues, and friends.

Two other advantages I had were the support and wise counsel of a woman politician with five years more experience than I, and the strong backing of my husband and two sons. Louise Simard, who was elected in 1986, was the same age as me, and we both had a professional background and young children. We supported and comforted each other through tough political fights, in battling for more balance between government work and family time, and we developed a friendship that withstood the test of being in rival political positions. As finance minister in 1993, I had to make dramatic cuts in the health budget, including closing fifty-two rural hospitals – painful decisions that Simard, as minister of health, had to implement and defend.

Politics takes a toll on families, but spouses and children can be a politician's refuge from the hurly-burly of public life. As a cabinet minister in 1991 I had to live part time in Regina and leave my husband and two sons, aged nine and twelve, in Saskatoon. Besides missing far too many soccer games, plays, and other special events, I had to turn control of what had been my own household over to them and hold my tongue when I was home on the weekends. The Saskatchewan press was very good about not considering the private lives of my children to be newsworthy, but I knew that my sons sometimes struggled with having their mother constantly in the public eye. When one son began high school, he gently requested that I

not attend events at his new school but let dad do that job – until a few weeks later, when he said, "My new friends know who you are and they like your hair, so it's okay to come to my school." And when my husband became president of the University of Saskatchewan, the board of governors conceded publicly that it had wrestled with the issue of whether there was a conflict between his position and mine.

Despite these challenges, my family was my sanctuary. Although they attended the budget speech and a few special occasions, they rarely came to either government or party events. They were not part of the political fray, and we all liked it that way. To make up for my absence, I insisted on spending almost every weekend at home or at the cottage with them. We talked a lot about politics and my job, and they provided excellent advice over the years. They were always in my corner with my best interests at heart, and just as I had their blessing when I entered politics, it was one of my sons who triggered my exit.

Family backing, the support of mentors, colleagues, and friends, and experiences in the school of hard knocks was the baggage I brought with me to Regina in November 1991 to embark on the exhilarating journey of being part of a new government at an important crossroads in the province's history. Many involved in the Romanow government between its election in 1991 and the time the budget was balanced in 1995 remember that period as the highlight of their public careers. One such person was Ed Tchorzewski, who had paid a heavy price for his role in deficit reduction, having had to resign as finance minister in 1993 because of health problems related to stress. Although he was a political veteran who had served in many portfolios in the Blakeney government (considered to be one of Canada's best governments in the 1970s), in Tchorzewski's mind, the early 1990s was "our greatest moment," a "time when government was at its best." As he explained it, the deficit-cutting period was a time when government "really had to grapple with the issues that mattered for the future," and "everything was strategic and we became masters at implementation out of necessity." Suzanne Murray, who felt "fortunate" to be part of the caucus in the 1990s, said, "We had a job to do, a huge job, and were so focused, so determined in our direction. There was a camaraderie the like of which I have never known; it was truly wonderful. I will feel part of the 1991–1995 caucus forever."

The unity, focus, and team spirit of that period can partly be explained by the fact that like the Chrétien government in 1993–97, we were a new government, moving from the opposition benches to the driver's seat at a time of major crisis. Recruiting candidates to run against the tired and scandal-ridden Mulroney government in Ottawa was probably as easy as it was to recruit highly qualified Saskatchewan people to take on the Devine regime.

People were key to the success of our first government. The original war cabinet included veterans who had years of political experience and new-comers who had behind them successful careers in business, local government, and education. These were people with proven track records, lieutenants upon whom a first minister could rely for advice and direction. In the early days of a new government, the elected members flex their muscles by asserting their control over the agenda. The civil servants advise on policy, while political staff advise on politics and on the spin to put on decisions, but neither group is entrenched. Years on the opposition benches and months on the campaign trail have tightened the bonds among the elected members, who certainly are of the view that they did not go to all the trouble of winning an election just to turn decision making over to civil servants or staffers. A process in which decision making rests with elected people takes full advantage of the varied skills and political instincts of the diverse group that comprises a caucus. The cabinet and caucus are the ones elected by the public to represent its interests, and it is they who should make the final decisions and be held accountable to voters.

Governing during a crisis also explains the unity and commitment of the first Romanow administration. Ironically, while crisis decision making is flawed because the need to act quickly limits choices as well as opportunities for public debate, it often takes a crisis for politicians to confront stark choices and unite behind a cause. The deficit crisis, in Martin's words, was like fighting a war. In wartime, governments have to be focused and absolutely single-minded in their direction. So like any army going into the fray, the cabinet and caucus had to set aside policy differences and political rivalries and support and defend each other. Certainly, there were major divisions in our government and minor skirmishes at the federal level as the cabinet and caucus wrestled with the decision to tackle the deficit. But once the choice was made, there was no turning back. The Saskatchewan government, like its counterparts elsewhere in Canada, so unequivocally tied its political fortunes to balancing the budget that failure on the issue would have jeopardized even the safest seat in the province. Premier, cabinet, and caucus were all in the same boat, and we all had to do our part to keep the ship afloat and get it to its destination.

The fiscal crisis also forced the newly elected governments in Regina and Ottawa to stay connected with their constituents. Galvanizing the public behind difficult and often painful choices meant reaching out to voters through every possible avenue and becoming experts at communication. By 1995 taxi drivers, for instance, could speak knowledgeably about deficits, debt, and credit ratings because caucus members were less likely to be pining about being overlooked for cabinet and more inclined to be beavering away in their ridings, holding meetings or taping interviews explaining the

difficult budget choices in the hope of holding onto their seats. No speaking engagement was too small, no part of the province too remote, no group too hostile. Every opportunity to sell our message was embraced, because the linchpin in the deficit fight was an electorate that bought into the problem and was therefore prepared to live with the solution.

The deficit crisis also created a façade of unity by papering over potential policy divisions, since there was no choice but to limit the role of government and make it more strategic. The main achievement of the deficit reduction era was to redefine the role that government should play at the dawn of the new century, a task that was actually made much easier by the shortage of cash. By the 1990s the open borders that came with the global economy meant that crown corporations could no longer be used to assert Canadian or provincial control over the economy, and the lessons of the 1980s had shown the folly of believing that problems like unemployment could be solved by direct government investments in businesses or by job-creation grants to individuals. Embracing the view that government's role should be limited to creating the conditions for sustainable development, with the private sector being the main job creator, was straightforward because there simply wasn't the money to create new crown corporations, invest in businesses, or provide job-creation grants. Similarly, governments in the 1990s had to act strategically, focusing scarce finances on areas that were deemed to be essential. Whether strategic government was the right choice for the future was not open to debate in the 1990s; it was the only option left. Also, the shortage of cash eased the transition to seeing social programs less as entitlements and more as vehicles to help people move from the welfare trap or the unemployment ghetto to the workplace. Unity in the name of deficit reduction cobbled over the fact that some cabinet ministers in both Regina and Ottawa wholeheartedly embraced the more strategic role for government while others merely accepted the need to limit government's role temporarily because of the fiscal crisis.

Once the deficit monster was slain, cracks within the government team could no longer be papered over and the ingredients for success in the 1991–95 period began to slip away – beginning the very night of the Romanow government's re-election. Smiling for the cameras was hard on election night when it became apparent that two rural members of the war cabinet were going down to defeat. Especially troubling to me was the loss of Darrel Cunningham, a staunch ally and friend, and a critically important treasury board minister. The loss of Cunningham brought back memories of the sadness a few months earlier when we lost Louise Simard, the only Saskatchewan health minister in the 1990s who had believed that preserving medicare meant boldly redesigning the system. The backbone of the original treasury board was also weakened when John Penner, the vice-

chair, had to leave politics in 1994 because of ill health and when Ed Tchorzewski left cabinet shortly after the 1995 election. Of the original team of five ministers who had been my allies in spearheading the difficult 1993 budget through cabinet and caucus, three were gone by the end of 1995. As well as losing politicians, the long-time deputy minister of finance, John Wright, became president of a crown corporation in 1995, and the government's chief political strategist, Garry Aldridge, left for the private sector the next year.

The spate of departures reflected exhaustion. In Saskatchewan the deficit crisis had been much worse than at the federal level, especially since we also had to break new ground in educating the public about the fiscal problem. Also, at the provincial level it is harder to keep very able people when issues of national or international significance are not on the radar scene. Also, many people elected in 1991 came to politics to be agents of change, and as the prospect of bold change dimmed after 1995, so did their interest in cabinet jobs, especially when there were fewer debates about overall direction and more time spent on the less noble side of politics.

Without the all-encompassing sense of direction and purpose of the deficit-reduction period, the scramble for power and place became more pronounced after 1995. Politics is at once the highest calling and the nastiest game. The power to change the course of history makes politics unbelievably challenging, at times all-consuming, even addictive, and its obsessive allure has ruined many a politician's personal life. At the same time, politics is a contest for power and prominence that thrives on partisanship and sometimes suffers from vicious infighting. The recipe for infighting begins with a large dose of ego – the very act of running for a nomination or seat involves being convinced that you are better for the job than anyone else. Add to the mix agendas – almost every politician runs for office to achieve some goal. The mix of ego and agenda produces the witch's brew of the political scramble that is played out in the public eye and behind closed doors. Not all political agendas can be accommodated; therefore, the success of one political agenda has to come at the expense of another. Politics is a pecking order, and one's standing in the competition is publicly noted, with all the implications for ego inflation or deflation. Some are in cabinet; others are not. Some cabinet posts are senior; others are junior. Cabinet members are sworn in and sit around the table in order of precedence – a combination of seniority and current stature – so where one sits suggests one's political clout. Ego, pride, and ambition make politicians acutely conscious of their rank in the pecking order and whether they are perceived to be a rising star

ay's hero.

Ottawa and Regina, the press fuelled this side of politics. Balanc-
ıdget and winning re-election seemed like closing a chapter of

political history, and soon after these milestones were reached the press began to speculate about whether the respective first ministers would resign and who was angling to replace them. The issue never reached the intensity in Regina that it did in Ottawa, where there was constant speculation about Chrétien's future plans, about the line-up of potential replacements, and the rivalry between Chrétien and Martin. However, my limited experience with a much more muted version of the scenario showed me how detrimental to team spirit such speculation can be.

No sooner had the ink dried on the stories of our 1995 election victory than the press began to speculate about whether this was Romanow's last election. It asserted that Dwain Lingenfelter and I were vying to succeed him, and it declared the leadership race on, even though there was scant evidence to back up such a claim. Worse, reporters kept score on which of the two of us was ahead in the phantom leadership race, based on dubious assessments of our political wins and losses. Although we all tried to laugh it off, the reports about the contest added a whole new dimension to our team spirit. Speculation about whether one's political days are numbered irritates a leader and makes him at least a little leery of those who supposedly are after his job. Lingenfelter and I, acutely conscious of doing our jobs under a microscope, could not escape from the new competitive spirit, and we increasingly glanced sideways to see what the other was doing. And although I was convinced that Romanow was not quitting, my supporters in the party regularly urged me to build a network for the anticipated leadership race; this produced episodic, half-hearted attempts on my part to organize political support – one of those jobs for which I had neither skill nor liking. Whether Lingenfelter and I were in a leadership contest or not, the press had declared one, and some caucus and party members began to pick sides.

Declaring victory on the deficit also opened the door to debates about the future, which revealed cracks in the team. In Saskatchewan, the 1995 election highlighted the growing concern about the troubled state of the New Democratic Party. The sizable election victory was achieved because many swing voters went to the polls to endorse the government, while many long-time NDP voters stayed home, just as they had done in two by-elections that we lost before 1995. Declining party membership and less enthusiasm for conventions were other signs of trouble in the party. After 1995, Romanow and others increasingly talked about the dangers of losing the party.

The 1990s was a tough decade for the NDP. Federally, after winning an all-time high number of seats in 1988, the party was reduced to a historic low in 1993. Even core supporters like trade unionists and self-identified left-wingers no longer supported the NDP; and devastating for future prospects was its declining support among young people.[1] Electoral defeats inevitably

led to a clarion call by some that the party had lost because it had abandoned its ideological roots, and therefore the solution was to move it further left. This in turn only magnified divisions within the party, leaving federal NDP leader Alexa McDonough with the thankless task of straddling a party torn between those who wanted it to be a protest movement and those committed to providing voters with a realistic left-wing alternative. Unsure of which identity it wanted to embrace, the NDP lost on both counts: mainstream voters abandoned it, and protest voters in western Canada moved from the NDP to the Reform Party. The nub of the problem was that the NDP had not come to grips with the new world of the 1990s and had parted company with voters, who accepted inescapable realities such as the global economy.[2]

While the federal NDP stuck to traditional positions and lost the electorate, the Romanow government in the 1990s tried to modernize the NDP and was in danger of losing the party. In a conscious effort to move the Saskatchewan NDP along the path of British Labour Prime Minister Tony Blair, the Romanow government nudged it toward a modern version of social democracy. The Manitoba government of Gary Doer is another excellent example of a moderate NDP government. Doer accepts the need for balanced budgets, preaches the need to reform health care, and cites education as his highest priority.[3]

Central to the new left-wing thinking was strategic government. Common to both right and left in the 1990s was the growing understanding that governments could no longer be all things to all people. For the right, the solution was limited government – restricting government to its most basic tasks to give more scope to the private sector. Strategic government did not mean merely diminishing the role of government; as we have seen, it involved focusing its efforts and resources on areas most critical to the future and doing those jobs exceedingly well. The visible manifestation of strategic government is strategic spending, where dollars are allocated to the highest priority areas, rather than being spent to placate interest groups or to smooth over political problems, as so often happens in politics. A second principle involved accepting the market economy, which meant providing incentives to people or organizations – for example, using tax cuts to promote investment in research and development – and using disincentives, such as fees, to control the cost of programs or to discourage overuse of a service. The market economy had become a reality that was not going away, and the private sector had changed from being more than just the big bad multinationals of the 1970s; many small businesses now were headed by women, aboriginals, and young people. A final concept was the idea of mutual responsibility. As Simard, the author of our short-lived experiment with health-care reform, used to say, people could not look only to govern-

ment to take care of them but must accept more responsibility for their own health and well-being.

What became apparent after 1995 was that while Saskatchewan voters were willing to embrace the main tenets of a modernized NDP, some New Democrats were not. Grassroots New Democrats, like the ones who worked long and hard as volunteers in my riding, are some of the most generous, caring people I know. But coming to grips with fiscal restraint and the implications of the global economy did not come easily to such people. New Democrats instinctively want to help people by creating new programs to improve their lives and by using government to solve people's problems. The attachment of some New Democrats to the ideas of the 1970s – what the war cabinet used to call "the good old-time religion" – was shown at party meetings, when Romanow would give a rousing speech about the modernized version of social democracy, after which he would receive a standing ovation, but then there would be a question-and-answer session in which the same old issues were raised: If there was a problem in the economy, why couldn't we just create another crown corporation to fix it? Wasn't it about time to reintroduce the 1970s children's dental plan? Surely there was some new agricultural program that we could devise to save the family farm. And why couldn't corporations pay higher royalties so that we could fund social programs? The gap between the electorate and the party made it difficult for the government to establish a postdeficit reduction agenda.

In 1997 I moved from finance to economic development to help pursue such an agenda. Supporters who were urging me to run for the leadership thought I needed to broaden my image beyond that of a bean counter. By 1997 most of my allies in the battle for strategic spending were either gone, or on their way out, and the stress of finance was beginning to take its toll, as my deputy minister Bill Jones understood. One day as we were chatting he said, "Boss you've taken a lot of flak in this job, you don't need to take any more; you've done your time." Romanow understood, although when we were discussing the details he wondered aloud, "It's been Lancaster [Saskatchewan Rough Rider quarterback Ron Lancaster] to Reed [George Reed, Lancaster's star receiver] for so long and it's worked so well, why change a good thing?" The plan was that I would go to economic development and give the same priority to expanding the economy as I had to deficit reduction. What I discovered was that the hardest job in a Saskatchewan NDP government is not that of the finance minister – there is a strong tradition of sound management and fiscal integrity in the CCF-NDP – it is being minister of economic development, as I was from 1997 to 2001.

New Democrats are experts at redistributing wealth but not so good at

creating the wealth to be reallocated. The blueprint for economic development in the eyes of many New Democrats was the Blakeney strategy of the 1970s, which relied on crown corporations, primarily in the resource sector, to produce wealth, which was captured by government through high royalties in order to fund social programs. But government ownership was hardly the answer to economic development in the 1990s, especially at a time when an emerging demographic crisis in the province made building the economy imperative. With a static population of just over one million, which included more seniors and aboriginal children per capita than elsewhere in Canada, the province desperately needed more taxpayers to pay for its services and sustain its quality of life.

My dilemma was finding sectors of the economy which the government could promote without running headlong into one of the interest groups associated with the NDP or one of the party's many cherished causes. Call centres employed lots of people and were easy to attract, except that the Saskatchewan Federation of Labor let me know in no uncertain terms that these were low-end, non-union jobs which an NDP government should not be pursuing. Half of the province was forested, but forestry had never been promoted as in other provinces. With some of the few virgin forests left on the continent, there were spectacular opportunities to attract companies to Saskatchewan not only to harvest the raw timber but also to process the product in the province. Ardent environmentalists in our midst, however, objected to cutting down more trees because of the impact on the global ecology.

Similar obstacles greeted attempts to rejuvenate rural communities and stop the out-migration of rural people to the cities. Diversifying agriculture involved moving into intensive livestock operations, such as hog barns, which raised hackles because they were corporate entities, not family farms, and because of their impact on the environment. Lifting the restrictions on the amount of farmland that could be owned by people outside the province would help attract new farmers, a major issue since the average age of a farmer was well over fifty, except that preventing "outsiders," even other Canadians, from owning large tracts of land was seen as one of the sacred bastions of the family farm. Saskatoon already had a worldwide reputation as a leader in biotechnology – being home to the federal labs at the Plant Biotechnology Institute, the college of agriculture at the University of Saskatchewan, and corporations from around the world doing research at Innovation Place. Promoting biotechnology, however, meant being associated with genetically modified food, which some of our members vociferously opposed.

The inability to find common ground on economic development illustrates some of the main problems of the post-deficit period. Building the

economy, though a major long-term problem for Saskatchewan, was not a crisis with the same immediate dire consequences of the fiscal crisis. Consequently, there was no urgency to set aside differences and rally around the cause. The same was true of health care. In 1997, when I was willing to become health minister, the rapidly escalating costs of health care foreshadowed an emerging crisis. It was my assessment that Saskatchewan voters could be persuaded that the system needed to be revamped; but Romanow did not embrace my offer, because he judged that the party would not countenance dramatic changes to its most cherished program, especially on the heels of the painful cuts that came with deficit reduction. We were probably both right. But if neither of the two major issues of the late 1990s could become the focus of the new government, what did this mean for the direction of the government?

There was no overriding vision or common purpose to unite the team, paper over differences, and drive the agenda as there had been during the fiscal crisis. This is not to diminish what was achieved both federally and provincially in the post-deficit period. The Child Benefit was a major breakthrough in dealing with child poverty. Nationally, the Innovation Strategy, with its investments in research and training, was clearly forward looking, and there were modest but strategic provincial investments in research and development. In Saskatchewan, new agreements with aboriginal people gave them more control over social programs and enhanced their role in the economy. And at the university level, a new protocol limited the power of the government to use appointments to the board of governors as patronage, and a new funding formula readjusted the balance between the province's two universities. These were all worthwhile initiatives. The problem was that there was no overarching agenda to tie together the various initiatives and to act as a filter through which choices could be screened.

The result was more divisiveness, a drift back to some of the pre-1990s practices that had supposedly been disavowed during deficit reduction, and governments responding to the acute day-to-day crises more than to chronic long-term crises. When Paul Martin stated on his departure from cabinet in June 2002 that there were policy differences between himself and the prime minister, he was merely confirming what was already common knowledge. On the issue of Quebec and its role in Confederation, for instance, Martin was much more decentralist than Chrétien, as was shown in their difference of opinion over the Meech Lake Accord at the time of the Liberal leadership convention. During the deficit crisis their differences were muted, with Chrétien actively supporting Martin's 1995 decentralizing budget. Yet within months of balancing the budget and being re-elected, Chrétien announced – over the objections of his finance minister –the Millennium Scholarship Program, which caused a furor in Quebec because of

its alleged intrusion into provincial jurisdiction.[4] The differences over Quebec persisted, with Martin quietly opposing Chrétien's Clarity Bill, which specified conditions for a future referendum – an eventuality that Martin believed would never come to pass if the Quebec file was handled properly.

As well as more pronounced policy differences in the post-deficit era, there was a backtracking on some of the fundamental principles of the 1990s. Two examples at the federal level are especially revealing. In late 2000 and early 2001 there was a protracted controversy about government contracts awarded to companies and individuals in order to create jobs. While the public debate raged around the role of patronage in the decisions of Human Resources and Development Canada, almost ignored was the key question: Why was the government once again in the business of using direct grants to businesses or individuals as a vehicle to create jobs? Wasn't that what this same government, a few years earlier, had said did not work, when it was fighting the deficit and cutting costs? Chrétien defended the grants in traditional pre-1990s fashion by proudly citing the thousands of jobs supposedly created by them. Martin's silence spoke volumes. After all, he was on record as believing that job creation was to be driven mainly by the private sector while the government's job was to create the conditions for growth.

The second example concerns the retreat from the changes made to unemployment insurance during the period of deficit reduction. In 1994 and 1995, at the height of deficit reduction, the unemployment insurance system was revamped to encourage more training and preparation for the workplace and to discourage seasonal workers from relying on the program as a permanent subsidy for their lifestyle. Although the changes were strictly in accord with the notion of strategic government, they were cited by Liberals as one of the main reasons why the party lost so many seats in Atlantic Canada in the 1997 election. As a result, just before the 2000 election, Chrétien moved to reverse some of the changes in unemployment insurance made in Martin's 1994 and 1995 budgets.

During the unofficial leadership campaign in the summer of 2002, the differences between Chrétien and Martin emerged again in their plans to reinvest in upgrading crumbling municipal infrastructure. Both agreed that the federal government needed to play a role in funding water, sewers, roads, and other essential parts of municipal infrastructure. Chrétien proposed that the federal government fund such initiatives directly (reflecting his roots in the Trudeau era, when Ottawa flexed its muscles by asserting its power in areas, such as urban affairs, which were under provincial jurisdiction). Martin, on the other hand, supported a more decentralized approach, which recognized provincial jurisdiction over municipalities and called for

co-operation among all three levels of government; also, instead of reverting to the traditional centralist model of having the federal government fund municipal initiatives, he proposed to provide local governments with more tax revenue so that they could make their own choices.[5]

The differences between the two men, which had been buried during the deficit-fighting days, were fundamental. The divide was between a prime minister who was still in many ways a product of the 1970s and a finance minister who was the main architect of the policy thrust of the 1990s. And while Chrétien was a consummate politician, content with managing the daily affairs of government, Martin was more policy oriented and was committed to making strategic choices to prepare Canada for the challenges of the future.

What these examples reflect is that while all Liberals were in the same political tent in the 1990s in such matters as cutting job-creation grants or revamping unemployment insurance, the unity was superficial and was triggered only by the deficit crisis. All could agree that choices like cutting job-creation grants or changing unemployment insurance to balance the budget were better than other alternatives – such as depriving seniors of their pensions. Once the crisis was over the divisions emerged. Some, like Martin, actually embraced the changes as good policy choices for the future, while others, like Chrétien, were quick to return to the more familiar, traditional territory once the country's finances had improved.

Similar divisions emerged in Saskatchewan, where the flashpoints were the government's role in the economy and the emergence of spending patterns driven more by crisis management than by an overall sense of strategic direction. Within months of balancing the budget and being re-elected, the Romanow government was divided over what to do with the more than $600 million in "profits" from the sale of its Cameco shares. One group in cabinet favoured using the money to reduce the debt of the Crown Investments Corporation (CIC), since it was the holding company for all of the government's commercial investments. My argument, as finance minister, was that the proceeds should be used to reduce government debt, thereby cutting interest costs and freeing up more money for priority areas like health, education, and tax reduction. After weeks of intense and often angry debate and enough reports to make the trees tremble at the paper consumed, the profits were split evenly. As a politician, I understood the art of compromise, but I was not comfortable with the choice made. For me, this was the first step away from strategic spending and the beginning of a new expansion of the crown sector.

The unity that had prevailed in the early 1990s about the role of the government in the economy and the crown sector had not been deeply rooted. In the early 1990s, a cash-starved government simply lacked the resources

to invest in the economy or create new crown corporations. But after the crisis was over, the government returned to the 1970s practice of using crown corporations and direct government investment to try to engineer economic growth. Creating new crown corporations, however, often restricted the growth of the private sector and smothered opportunities for community economic development. For example, a new crown corporation, Information Services Corporation, was created to automate the government's land titles system; but it soon produced a vague business plan to move into other information technology areas, in direct competition with many small and struggling private companies. To make matters worse, there were cost overruns and the need for injections of more government cash into a project that I had always considered ill conceived. Another example was the government's decision to promote the ethanol industry, a good strategic move. However, before communities even had a chance to arrange partnerships to develop the industry at the local level, CIC negotiated with a large American company to build the new ethanol plants, with a hefty investment from the government. As the government began again to invest directly in individual businesses – picking winners and losers – it came up with some losers, as its predecessors had done. A plan to grow the potato industry by using irrigated land in the Lake Diefenbaker area (coincidentally in a riding held only narrowly by the government) led to the creation of Spudco, a crown corporation that went belly up, taking taxpayers' dollars with it.

Increasingly, I had questions that were difficult to answer. Why were we investing time, energy, and taxpayers' dollars returning to the 1970s view that governments can use economic engineering to kick-start the economy? Why were we not focusing our efforts and dollars on the critical jobs that the government needed to do effectively to create a better future for Saskatchewan people – developing and funding a quality education system, redesigning health care for the future, building a first-class infrastructure of roads, sewer, water, and also research, and addressing poverty? The government seemed to be reverting to patterns of the past more than addressing the challenges of the future.

The drift away from strategic spending was partly the result of a shift to crisis management. Governments spring to action in response to a crisis, whether the crisis is a chronic long-term one like the deficit or a more immediate short-term problem. Governments that lack an overarching long-term agenda are more vulnerable to being swept along by the crisis of the day, so that instead of driving the agenda, they are being driven to act by interest groups or by immediate events. And the easiest way for governments to act to solve a short-term problem is to spend money.

The drift in Saskatchewan toward crisis management and away from strategic spending was illustrated by the handling of labour relations.

Strikes are always troublesome to NDP governments because of their close ties to labour and their distaste for passing back-to-work legislation. As unions became more aggressive in their demands after 1995, the crisis management of strikes and potential strikes became a major consumer of government time, energy, and money. Settling or avoiding strikes resulted in wage settlements well above the norm elsewhere, which were topped up by extra money to smooth inequities among unions and to implement pay equity. A report done by the finance department in 1999 tallied up the cost of this example of crisis management: public-sector salaries were the only area in which the government had more than backfilled the cuts of the early 1990s. Did this mean that public-sector salaries were the government's highest priority? No. It showed that crisis management rather than a long-term game plan was driving the agenda, and the result was a disconnect between the government's stated priorities (health, education, poverty reduction, and infrastructure) and where the government was actually spending its money. The use of money to diffuse an immediate crisis was justified by its proponents as just being part of politics, and there is some truth in this view. By the late 1990s, with the deficit conquered, the government had returned to "business as usual."

Crisis management and advancing age also lead governments to spend more time in the capital and less time connecting with voters. In the early 1990s there had been no choice but to be on the hustings selling the government's message. By the late 1990s, the government's message was less clear and not as urgent. Also, dealing with immediate crises and resolving internal divisions over such issues as government investment sap a government's time, and energy, and trap it in the capital, the place where governments are often defeated.

Other changes of the late 1990s also took their toll and led to a more centralized approach to governing. As the task of governing becomes more mundane and the divisions within the ranks more chronic, it is difficult to keep and attract very able people. Unspeakable sadness overwhelmed me every time one of the members of the original war cabinet drifted away. And drift away they did. Of the original eleven ministers, only three lost elections; the rest simply moved on. There is no one reason why Bob Mitchell decided in 1998 to announce his departure, but I remember the cabinet meeting at which we bowed to public pressure and reversed a contentious health-care decision. He leaned over to me and whispered, "Today is the day that we stopped governing." Fast on the heels of Mitchell's departure was the exit of the rock-solid Ned Shillington and the announcement that Suzanne Murray, the most upbeat, spirited member of the caucus, also was departing.

Departures can be rejuvenating if capable new candidates are recruited to

replace them. But they weren't. The problem in recruiting able people with proven track records in other walks of life was exemplified by the fate that befell star candidates in the run-up to the 1999 election. One of our star candidates, Chris Axworthy, a former federal member of parliament, was elected. However, three stellar recruits for the election – a mayor, a Saskatoon city councillor who topped the polls, and a former police chief – were all defeated, – not by the voters but at nomination meetings, where New Democrats opted instead for long-standing party members committed to traditional NDP policies. So as cabinets got bigger, they were filled with decent, well-meaning people, but not the all-star cast of the original group, and while the latter had been able lieutenants to whom a premier could delegate a lot of power, the newcomers were ministers who required more central direction and control.

This, along with other factors, explains the tendency for governments to become more centralized over time, a phenomenon described very well by political scientist Donald Savoie.[6] The management of short-term crises requires constant intervention by the centre – the premier's office – to steer the ship of state through turbulent waters. Also, as governments age, some elements of the bureaucracy become more entrenched. In the early years of our government, deputies worked with their ministers in developing policies that were then forwarded to cabinet for debate and decision. By the end of our government, this decentralized approach had been replaced by the more centralized view that deputies work for the premier. Considering how busy the premier is, this really means that deputies work for the deputy to the premier, an unelected civil servant. Such an approach has the advantage of circumscribing the power of weak ministers, but it stymies strong ministers and undermines their accountability to voters. One example of the problem was the 2002 federal agriculture package, designed to assist farmers devastated by a combination of drought and the United States' subsidies to its own farmers. What infuriated Canadian farmers and prairie governments was that the package allegedly came from the federal government's deputy minister of agriculture and the civil service, not the minister. How can voters hold the deputy minister accountable for the decision? He is not elected, his fate does not rest on his ability to persuade voters of the merits of his policies, and he cannot be taken to task by voters for his choices.

Over time, power is also centralized in the hands of the staff surrounding the first minister, which distances him from his key lieutenants in cabinet and his foot soldiers in caucus. Staff live with ministers at their worst, when they are tired, short tempered, and frustrated, and they put in long hard hours doing a lot of the dirty work for their bosses. The flip side is that they have tremendous power. They see the first minister more often than his ministers – for daily briefings on media reports on the latest crises, or on

upcoming meetings. They spend hours travelling with him. They are also gatekeepers, who advise the first minister about which events he should attend and whom he should meet. As the premier's schedule becomes more filled with national events or meetings with high-powered executives, more and more of the trouble shooting within government falls to the premier's staff.

In turn, staff see their task as protecting their boss at all costs, and increasingly speaking with authority on his behalf– a situation fraught with danger, as was shown in June 2002 when the staunchly Liberal Asper family, who owned the CanWest Global chain of newspapers, allegedly fired some of its journalists for criticizing the prime minister. When the fired journalists alleged that Chrétien's staff regularly called the Aspers to complain about their newspapers' coverage of him, the prime minister denied that he had ever intervened. Both the journalists and the prime minister may have been right. It could have been the first minister's overzealous staff who had intervened on his behalf, without his prior approval. The other danger is that staff can become like a cocoon protecting a first minister from the harsh criticism of disgruntled voters, or from the critical but important advice from cabinet and caucus. There is a fine line between buoying up the spirits of an embattled politician and becoming a barrier shielding a first minister from difficult but vital truths.

As the first minister relies for advice more and more on staff, civil servants, and polls, a key dimension of the parliamentary system of government is undermined. The strength of the American system is that the president can appoint his cabinet, allowing him to choose highly qualified people. The strength of the Canadian system is that cabinet ministers are elected, which should mean that the first minister is more attuned to the public mood and that the system is more accountable to voters. However, as the proliferation of staff, pollsters, and advisers in the Canadian system resembles what occurs in the United States, Canadians end up getting the worst of both worlds. The first minister is not free to choose the very best people but has to be content with voters' choices. And as he gets more and more of his political wisdom from advisers, civil servants, and polls, the advantage of having an elected cabinet is diminished. Paul Martin has labelled this problem the "democratic deficit," by which he means the concentration of power in the Prime Minister's Office at the expense of elected members. The key to getting results in Ottawa, Martin claimed, was "Who do you know in the PMO?"[7]

At both the federal and provincial levels there are excellent examples of the pitfalls of relying on staff and polls. The 1999 Saskatchewan election was seen from the outside to have been an upset. Rather than coasting to victory, as had been assumed, the government received only a minority, because

it was literally wiped out in rural Saskatchewan. But for at least eighteen months our rural MLAs regularly stood up in caucus and warned us that there was a whirlwind of trouble in their constituencies, and they had beseeched us to change direction. Just as regularly there had been the standard response of releasing the latest polls, which showed the government with a commanding lead over the opposition. Only after all the rural members were defeated did we make the changes for which they had been pleading. What we were doing was using polls – valuable but blunt instruments – to override the judgment of elected people, our own foot soldiers, whose jobs depended on the fate of the government.

At the federal level, in the space of a few months the Chrétien government lost three powerful cabinet ministers: Herb Gray, Brian Tobin, and Paul Martin. In the case of the last two, negotiations about their departure were handled by the prime minister's staff. Why was it left to staff, no matter how senior, to discuss the fate of such key lieutenants as Tobin and Martin? Strong cabinet ministers should be seen as the first minister's executive team. In what other organization would the president have staff communicate with his or her vice-presidents about their future plans?

The power of the first minister and the archaic culture that surrounds the office help explain this seemingly bizarre scenario. First ministers, as Jeffrey Simpson has so aptly explained, wield tremendous power in the Canadian system. But reinforcing their power is the political culture of governments. Politics, it is assumed, is the highest calling, and being a cabinet minister is the pinnacle of success, with every caucus member aspiring to cabinet and waiting desperately for the call from the first minister. Cabinet ministers, it is also assumed, are so delighted to hold their positions that they will do almost anything to keep their jobs, to climb the ladder from junior to senior portfolios, and to get their policy decisions through cabinet. The first minister holds the key to all these opportunities, and he is accountable to no one for his decisions. It is this sense of being almost omnipotent that explains how a first minister can take for granted the important advice that can come only from the elected members of his team; and how vetting all major decisions through cabinet and caucus can fall by the wayside as the first minister relies more and more on staff to devise and execute decisions. But the shield that staff provide for the first minister to make his decisions with the minimum of hassle, can also be the sword that undoes him, as was shown in Saskatchewan during the nurses' strike.

In the spring of 1999 Saskatchewan nurses went on strike, disgruntled by stressful working conditions and demanding double-digit salary increases. Battling against nurses is like taking on Florence Nightingale, a contest especially troubling for an NDP government on the verge of an election. From the beginning, the premier's office played a major role in managing the crisis.

Before the strike was called, Romanow decided to invite the leadership of the nurses' union into his office to discuss the strike. I was one of several cabinet ministers who phoned and urged his staff not to put the premier in the middle of what could be an emotionally charged affair. Sure, he might be lucky and solve the problems, but what if he failed? In the middle of the night talks broke down, and the leader of the nurses' union left the premier's office and called a strike.

As house leader I was awakened by the premier's staff in the early hours of the morning and told that there was an emergency situation in which patient safety was at risk and that the house had to be called immediately to pass back-to-work legislation. Without even thinking I called the two opposition leaders, who quickly agreed to co-operate. This was the wrong decision. I should have spoken to the premier and asked him to reconvene the cabinet and maybe even the caucus, and look at the facts. What was the evidence that patient safety was at risk? Did we really have to act so quickly, or was there some latitude to wait until there was public pressure for back-to-work legislation? The answer to these questions can never be known, but it was a fatal mistake not to use the process that would have laid the facts on the table. By the time the house was convened the next morning, the opposition parties had come to their senses and were much more critical of the government's legislation. Nonetheless, within hours the back-to-work legislation was passed. But to our horror, the nurses defied it and refused to return to work.

The next morning, as Dwain Lingenfelter and I made our way into the regularly scheduled cabinet meeting, we noticed the premier on television giving a speech. The bewildered looks on our faces reflected the fact that neither he, as deputy premier, nor I, as house leader, had been asked for advice about the speech. As we listened, bewilderment turned to horror and a sense of doom, as we heard a man who is at heart conciliatory sound harsh and uncompromising. As a Liberal opposition member said later, "In that speech, the public saw a side of Romanow that they had never seen before and it was an image that was hard to erase." What saddened me, as well as Lingenfelter, was knowing that if Romanow had asked us, two of his key lieutenants, we would have been able to dissuade him from making the speech. We could have saved him if only he had given us the chance.

Although the circumstances were different, the same sort of factors would have led Prime Minister Chrétien to believe that he could fire his most able minister and get away with it. Relying on the advice of staff, not communicating directly with key lieutenants, being distant enough from caucus to misconstrue the facts, and the added dimension of the incredible power of the prime minister led Chrétien to make the biggest mistake of his political career. In firing Martin, Chrétien made a martyr of him while at the same

time freeing him from the strong constraints of cabinet solidarity so that he could openly campaign for the leadership. In the process, Chrétien revealed a harsh and mean-spirited side of his personality – which probably all of us have in some part of our being – that was totally at odds with his original image as the little guy from Shawinigan.

By the early years of the twenty-first century, time had taken its toll on both the Romanow and the Chrétien government. This is not to say that either was a bad government. Sure, there were problems, but both were still probably better than average and maybe a lot more typical of what most governments are really like. It's just that once you have been part of a government at the top of its game, it's hard to be satisfied with merely being in an average government doing a respectable job of running the people's business.

After the 1999 election – when the NDP's minority status led to a coalition with the Liberals – only three of the war cabinet remained: the premier and the two who allegedly aspired to be premier – Lingenfelter and me. By 1999 Lingenfelter and I had become closer. In the bizarre way that former political rivals cosy up to each other, we never talked on the phone or met for coffee, as normal people might. Instead, we sat next to each other in the legislature, and as the chaos of question period swirled around us we shared our deepest thoughts and feelings with each other, sometimes being caught totally off guard when a question came our way. By May 2000 a lot of our conversations were about the frustration of having a budget with income tax cuts that were important in making Saskatchewan competitive with Alberta, a budget that was neither placed within the context of a strategic game plan nor being sold to the public.

Ironically, on the day that a devastating poll was released showing that the public was against the budget and that the NDP was well behind the opposition in popular support, Lingenfelter and I were the most senior ministers in the legislature, to whom fell the task of selling the budget and raising the morale of the dispirited foot soldiers who sat behind us and looked to us for leadership. We joined forces and put on the show of our lives – the two leadership rivals, I the policy person and he the supreme politician – hammering the opposition, feeling once again for a few fleeting minutes what it was like to be part of a team at the top of its game. As the caucus members pounded their desks with approval, little did they know that they were saying goodbye to Lingenfelter. A few weeks later he left to become vice-president of an oil company.

Both Lingenfelter and I embraced the changes of the 1990s – strategic government, the reality of the market economy, and the virtues of mutual responsibility. Either of us would have had a shot at successfully leading the Saskatchewan people. But neither of us could lead the NDP. Too many New

Democrats in 2001 harked back to the 1970s. In politics there is no going backward, there is only going forward.

I stayed, even after Romanow left in the fall of 2000, because I had unfinished business and it was difficult for another senior minister to leave so soon after Lingenfelter and Romanow. I found humour in the comments of people willing to accept that it was okay for the two men to leave, but somehow it was my duty to hold the fort. My unfinished business included implementing the forestry strategy. The province's untapped forestry potential was being developed in a partnership between major forestry companies such as Weyerhaeuser (which brought capital and access to markets) and aboriginal people, who offered community involvement and support. The second piece of unfinished business was the synchrotron, a project for which I was the point person. I was always convinced that Saskatoon would become one of the fastest growing cities on the prairies and that research would be key to its success. A measure of its future prospects was the fact that the University of Saskatchewan won a national competition to become the site of Canada's only synchrotron, a massive research facility that would cost more than $170 million. Although the university had won the project, putting the funding in place was a major hurdle, and it was my highest priority in my last two years in cabinet. I had no intention of leaving the government until the synchrotron was landed.

I was willing to give the new government a chance and asked Premier Calvert to make me responsible for the Crown Investments Corporation (CIC) on the understanding that I would make changes in policies and people. My goal was to move out some of the wheeler-dealers who had lost their sense of accountability to cabinet and caucus, and to try one last bold stroke – to move the government out of making direct investments in companies.

Three weeks after the new government was sworn in, my son Alan and I were on a road trip to arrange for his graduate education. The malaise that I felt about the direction of the new government permeated our discussions. On my cellphone I got a call about the budget. The new government was going to increase spending by about 8 percent when revenues were declining, which meant that balancing the budget would require a major drawdown of reserves. So I would have to support a deficit budget after all the years I had spent fighting deficits. Then a call came about the lay of the land from deep within the government. As minister of CIC, I would not be able to make any major changes in the investment policies of the government, because this was a government attuned to the views of the party, with a heavy 1970s influence. In addition, I risked being the fall guy for managing the bad news from the crown corporations. The conversation ended with the great question: "Is this what you want to be doing with the next year of your life?"

My son Alan overheard the conversation, and at 10 o'clock at night he pulled

the car over to a restaurant in Revelstoke, British Columbia. When we were inside, he said: "This new government may have some very decent people on its team, but it's not your team. Your original war cabinet is all gone. It may very well have an agenda, but it's clearly not your agenda. Listen to those who care about you – you've done your time; you owe nothing more to anybody. Get out NOW." The next morning, as we headed back to Saskatoon for a hastily arranged meeting with the premier, I felt a sense of freedom that comes with having a burden lifted and knowing that you are moving forward.

The next day, I told the cabinet that I thought the 2001 budget was unsustainable. Then I met very briefly with the premier. I told him of my irrevocable intention to quit the next morning, gave him the press release that I would issue explaining my exit, and expressed my hope that he would attend the press conference. No fighting, no acrimony, no explanations. Just a sense of the parting of the ways. Before the press event I talked to Bob Mitchell and all my former deputies, but I did not tell Romanow. This was mainly because on his departure he had said to me, "Hang in there, kid, for the team." After the press conference I opened the door to my office in the cabinet building to find Romanow waiting. He had been alerted by Mitchell to what was afoot. After I briefly explained my decision, he said, "I understand. Now let's get down to refining the message for your last interviews so that your exit from politics can be as classy as your entry." It was a fitting way to end almost a decade in politics.

Less than two years later when Romanow released his report on the future of health care, I wrote an opinion piece that was critical of his work for the *Globe and Mail*. I made a decision to comment publicly on our long-standing differences of opinion only after several private meetings during which I tried to dissuade him from writing the report that he did and after informing him of my intention to write a critical review of his approach. The article symbolized the fact that although I had left government, I had not abandoned public policy. What I decided after ten years in the business was that although my time to be a partisan politician had come to an end, this in no way diminished my interest in public policy issues. On the contrary, freer to express my views, I welcome the opportunity to debate public issues. If the deficit crisis has taught us anything, it should be that voters and politicians should confront issues before they become crises and that no citizen should merely slough off government decisions as being the prerogative of either ministers or deputies. In the end, government decisions affect all of us, and minding the public purse involves more than just watching the dollars and cents. It means making the best public policy choices within the broad framework of the trade-offs required for us to live within our means. Minding the public purse is the responsibility of all of us, and each of us has an obligation to contribute what we can to the debate about Canada's future.

Notes

PREFACE

1 Interview with Paul Martin, 31 Mar. 2001.
2 Ibid.
3 Bricker and Greenspon, *Searching for Certainty*.

CHAPTER ONE

1 *Wall Street Journal*, 12 Jan. 1995; Jenish, *Money to Burn*, 126.
2 Clarkson and McCall, *Trudeau and Our Times*, 89–136.
3 Greenspon and Wilson-Smith, *Double Vision*, 126; Jenish, *Money to Burn*, 130–4.
4 Gass, *Report of the Saskatchewan Financial Management Review Commission*, 5.
5 Government of Saskatchewan, Budget Speech, 13 Mar. 1980, 13; Budget Speech, 19 Mar. 1982; the population statistics are from *The Saskatchewan Municipal Directory*, 1982.
6 Hayden, *Seeking a Balance*.
7 Bercuson, Granatstein, and Young, *Sacred Trust?*, 93–4.
8 Greenspon and Wilson-Smith, *Double Vision*, 238.
9 Conkin and Courchene, *Deficits*, 199–206; Carmichael, *Tackling the Federal Deficit*, 65–7.
10 Rae, *From Protest to Power*, 194.
11 Jenish, *Money to Burn*, 63; Bercuson, Granatstein, and Young, *Sacred Trust?*, 93–120.
12 Ibid., 11–72, esp. 12–13.
13 Fortin, "Slow Growth, Unemployment and Debt: What Happened? What Can We Do?" Paper presented at the second annual Bell Conference on Economic and Public Policy, Queen's University, Kingston, Ont., 15–16 Oct. 1993; Osberg and Fortin, *Unnecessary Debts* and *Hard Money, Hard Times*.

14 Curtis, "Canadian Fiscal and Monetary Policy and Macroeconomic Performance 1984–1993, 135–52.

15 Pierre Fortin, "The Canadian Fiscal Problem: The Macroeconomic Connection," in Osberg and Fortin, *Hard Money, Hard Times*, 26–38; Ronald D. Kneebone, "Four Decades of Deficits and Debt," in ibid., M.C. McCracken, "Recent Canadian Monetary Policy: Deficit and Debt Implications," in ibid.

16 McQuaig, *Shooting the Hippo*.

17 See, for example, Brown, Roberts, and Warnock, *Saskatchewan Politics from Left to Right '44 to '99*.

18 Jenish, *Money to Burn*, 165.

19 Ibid., 6–7.

20 Terence Corcoran, *Globe and Mail*, 17 Feb. 1993.

21 "Canada's Drift into Debt Worries Investors," *Euromoney*, January 1993.

22 Jenish, *Money to Burn*, 22.

23 Ip, Mendelsohn, and Robson, *Avoiding a Crisis*; *Maclean's*, 29 Mar. 1993.

24 Peter Nicholson, quoted in Greenspon and Wilson-Smith, *Double Vision*, 235.

25 Interview with Paul Martin, 31 Mar. 2001.

CHAPTER TWO

1 Jenish, *Money to Burn*, 177.

2 Ibid., 176–84.

3 Ibid., 200.

4 Cooper, *The Klein Achievement*, 42.

5 Robert L Mansell, "Fiscal Restructuring in Alberta: An Overview," in Bruce, Kneebone and McKenzie, *A Government Reinvented*, 16–72.

6 Jeffrey Simpson, *Globe and Mail*, 14 May 1993, quoted in Simpson, *The Anxious Years*, 32.

7 Gruending, *Promises to Keep*, 79–80.

8 Baron and Jackson, *Battleground*, 23.

9 See Pitsula and Rasmussen, *Privatizing a Province*.

10 Baron and Jackson, *Battleground*, 257; interview with Berny Wiens, May 2001.

11 Ibid., xiv.

12 Regina *Leader Post* (*LP*), 17 Oct. 1990.

13 See Lipset, *Agrarian Socialism*, and Friesen, *The West*.

14 Friesen, *The West*, 162.

15 See Blakeney and Borins, *Political Management in Canada*.

16 McLeod and McLeod, *Tommy Douglas*, 194–204; Shackleton, *Tommy Douglas*, 231–246.

17 Richards and Pratt, *Prairie Capitalism*.

18 See Friesen, *The West*, 105–6, Blakeney and Borins, *Political Management in*

Canada, 210–11, Gruending, *Promises to Keep*, 216, Richards and Pratt, *Prairie Capitalism*.

19 Richards and Pratt, *Prairie Capitalism*.

20 Gruending, *Promises to Keep*, 216.

21 Interview with Allan Blakeney, Sept. 2002.

22 Gruending, *Promises to Keep*, 191.

23 Ibid., 217.

24 Interview with Allan Blakeney, Sept. 2002.

25 Interview with Bob Andrew, Sept. 2002.

26 Friesen, *The West*, 100.

27 Dyck, *Provincial Politics in Canada*, 470.

28 Baron and Jackson, *Battleground*, 11.

29 Colin Thatcher, *Backrooms*, 43.

30 Grant Hodgins, "Statement by a member," Legislative Assembly of Saskatchewan, *Debates and proceedings*, 17 June 1992, 4058; interview with Grant Hodgins, Sept. 2002.

31 Interview with Bob Andrew, Sept. 2002.

32 Budget Speech, 30 Mar. 1989, 3; Budget Speech, 22 Apr. 1991, 8.

33 Budget Speech, 22 Apr. 1991, 4.

34 Interview with Colin Thatcher, 4 Dec. 2001.

35 "Devine Government Now Must Deal with Faltering Economy," *LP*, 14 Aug. 1982; Budget Speech, 29 Mar. 1983, 10; Budget Speech, 21 Mar. 1984, 12–13.

36 Dale Eisler, *LP*, 27 Mar. 1986.

37 Gass, *Report of the Saskatchewan Financial Management Review Commission*, 22–4.

38 Ibid., 35–7.

39 *LP*, 14 Aug. 1982.

40 Provincial Auditor of Saskatchewan, Auditor's Report, 17 July 1991, quoted in Gass, *Report of the Saskatchewan Financial Management Review Commission*, 17.

41 *Star Phoenix* [*SP*], 25 Sept. 1986.

42 O. Yul Kwon, "Saskatchewan: Provincial Public Finances," in McMillan, *Provincial Public Finances*, 209–38.

43 "Budget Chops Farm Purchase," *LP*, 18 June 1987.

44 Kwon, "Saskatchewan," 237.

45 Interview with George McLeod, Sept. 2002..

CHAPTER THREE

1 Dale Eisler, *LP*, 5 June 1982.

2 Michelmann and Steeves, "The 1982 Transition in Power in Saskatchewan," 16; Joe Jeerakathil, *LP*, 18 Oct. 1983.

3 Thatcher, *Backrooms*, 230, 214; Baron and Jackson, *Battleground*, 314–15.

4 Paul Jackson, *SP*, 14 Aug. 1989.

5 Thatcher, *Backrooms*, 230.

6 Michelman and Steeves, "The 1982 Transition in Power in Saskatchewan," 17.

7 Interview with Grant Hodgins, Sept. 2002; Gass, *Report of the Saskatchewan Financial Management Review Commission*, 77–8.

8 GST senators were appointed by Mulroney in 1990 to bolster Conservative numbers in the Senate so that the GST would pass.

9 Jones, *SaskScandal*, 175.

10 Legislative Assembly of Saskatchewan, *Debates and Proceedings*, 1 Dec. 1981, 99, 85–6, quoted in Michelmann and Steeves, "The 1982 Transition in Power in Saskatchewan," 4–5.

11 Ibid., 4.

12 Simpson, *Spoils of Power*, 259.

13 Ibid., 256–71.

14 Lipsett, *Agrarian Socialism*, 307–8, 316, 322.

15 Interview with Con Hnatiuk, 1 Sept. 2001.

16 Dale Eisler, *LP*, 26 May 1984, quoted in Simpson, *Spoils of Power*, 270.

17 Interview with Colin Thatcher, 4 Dec. 2001.

18 Ibid.

19 Ibid.

20 Thatcher, *Backrooms*, 191, 205–6, 197.

21 Dale Eisler, *LP*, 13 May 1982, quoted in Pitsula and Rasmussen, *Privatizing a Province*, 41.

22 *LP*, 7 June 1982, quoted in Michelman and Steeves, "The 1982 Transition in Power in Saskatchewan," 9.

23 "Former Government Employee Seeks Motives for his Dismissal," *LP*, 7 Aug. 1982.

24 Dale Eisler, *LP*, 4 Dec. 1982.

25 "Boredom, Frustration Led to Resignation," *LP*, 2 May 1983.

26 Eric Berntson, "Statement by Deputy Premier," Legislative Assembly of Saskatchewan, *Debates and Proceedings*, 23 Apr. 1986, 811–12.

27 *LP*, 7 Aug. 1986.

28 Interview with Grant Schmidt, Sept. 2002.

29 *LP*, 3 July 1991.

30 Interview with Schmidt.

31 "Hnatiuk Did Sask. Favor by Resigning: Schmidt," *SP*, 3 Sept. 1987.

32 Interview with Con Hnatiuk, May 2001.

33 Pitsula and Rasmussen, *Privatizing a Province*, 43.

34 "Sell Is On for Fair Share Sask," *Prince Albert Herald* (*PAH*), 22 Mar. 1991; "More Than Our Fair Share Should be P.A.'s Goal," ibid., 7 Mar. 1991; "REDA Wants Research Center," *LP*, 4 June 1991.

35 Ron Petrie, *LP*, 26 Mar. and 10 Apr. 1991; "Suggestion to Include U of S in Fair

Share Nets High Interest," *SP*, 18 Oct. 1991; John Gray, "A Letter to Prince Devine," *Western Civilization*, Sept. 1991, 103–4.

36 "Fear and Frustration," *LP*, 30 May 1991; "Move to Rural Areas 'Sick, Disgusting' Plan: Ag Worker," *SP*, 31 May 1991; "Couple Face Dilemma over Move," *SP*, 6 June 1991; "Devine's Doctrine Distorted," *LP*, 11 June 1991.

37 *SP*, 25 June 1988; *Globe and Mail*, 22 May, 1989; Pitsula and Rasmussen, *Privatizing a Province*, 271–6.

38 Gass, *Report of the Saskatchewan Financial Management Review Commission*, 76.

39 "The New Meddlers: Canada Has Already Had More Than Its Share of Industrial Strategy Disasters ... " *Canadian Business*, Jan. 1993, 21–32; Pitsula and Rasmussen, *Privatizing a Province*, 63; Cooper, *The Klein Achievement*, 43.

40 *LP*, 4 Sept. 1985; *Moose Jaw Time Herald* (*MJTH*), 23 Oct, 1985; *LP*, 23 Oct. 1984, 15 Sept. 1985, and 4 Sept. 1985; Paul Martin, "Regina's NewGrade Heavy Oil Upgrader is a Winner," *MJTH* 10 Sept. 1985.

41 *LP*, 27 June 1990.

42 Thatcher, *Backrooms*, 195.

43 Pitsula and Rasmussen, *Privatizing a Province*, 57.

44 Gass, *Report of the Saskatchewan Financial Management Review Commission*, 77.

45 Pitsula and Rasmussen, *Privatizing a Province*, 63–4; Stevie Cameron, "How the Gravy Train Went off the Rails," *Globe and Mail*, 2 June 1993; see also, Mark Stobbe, "The Selling of Saskatchewan," in Biggs and Stobbe, *Devine Rule in Saskatchewan*, 81–109.

46 Gass, *Report of the Saskatchewan Financial Management Review Commission*, 91, 89.

47 Ibid., 81, 82.

48 Stevie Cameron, "How the Gravy Train Went Off the Rails;" *Globe and Mail*, 2 June 1993; Gass, *Report of the Saskatchewan Financial Management Review Commission*, 81.

49 Ibid., 44.

50 *SP*, 7 Nov. 1992.

51 Harold Empey to provincial cabinet ministers, 27 June 1984.

52 *SP*, 7 Nov. 1992.

53 Ibid.

54 Jack McPhee to Harold Empey, 25 July 1985. Paragraphs 18 and 5, letter agreements, 3 Sept. 1985; Deputy Minister of Energy to Minister of Energy, 31 May 1985; Government of Saskatchewan, *New Grade Energy Inc.: An Historical Review*, Dec. 1991, 16, 12.

55 The Provincial Nominees to the NewGrade Board, in Government of Saskatchewan, *Stewardship Report Re: NewGrade Energy Inc.*, Sept. 1991, 5, 6, 8,

56 Ibid., 13, 15.

57 Ibid., 20.

58 Ibid., 22.

59 *LP*, 31 Oct. 1988; Thatcher, *Backrooms*, 196; *LP*, 13 and 30 Dec. 1985; Government

of Saskatchewan, *Assessment of the Bi-Provincial Upgrader at Lloydminster,*
51–2.

60 Ibid., 3, 100.

61 Thatcher, *Backrooms,* 208.

62 Government of Saskatchewan, *Assessment of the Bi-Provincial Upgrader at Lloyd-minster,* 77, 99, 2.

63 Gord Brock *LP,* 17 Dec. 1992.

64 Lee, *Frank,* 187.

65 Government of Saskatchewan, *The Investment in Crown Life by Haro Financial Corporation,* 31.

66 *Globe and Mail,* 19 Oct. 1991.

67 Jones, *SaskScandal,* 103.

68 Ibid., 179.

CHAPTER FOUR

1 *Leader-Post (LP),* 17 Apr. 1993.

2 *LP,* 22 Oct. 1991.

3 Ibid.

4 *Star Phoenix (SP)* and *LP,* 2 Nov. 1991.

5 *Moose Jaw Times Herald (MJTH),* 31 Mar. 1989; "What's Happening to Our Province ... A Look at the Facts," (an NDP election pamphlet), 1991, 7.

6 *SP,* 2 Nov. 1991.

7 Greenspon and Wilson-Smith, *Double Vision,* 280.

8 Government of Alberta, Budget Speech, 6 May 1993, 13.

9 See *LP,* 13 Nov. 1991; 27 Nov. 1991, *SP,* 26 and 27 Nov. 1991.

10 *SP,* 2 Nov. 1991.

11 "Who's New in Cabinet," *Briarpatch* 21 (Feb. 1992):5–9.

12 David Tickell, special adviser to the Minister of Social Services, to the Minister, 3 Dec. 1991.

13 *LP,* 2 Feb., 3 Jan. 1992 and 26 Nov. 1991.

14 *LP,* 3 Mar. 1992; *SP,* 6 Mar. 1992.

15 *LP,* 2 Nov. 1991.

16 *Financial Post,* 24 Apr. 1993.

17 Government of Saskatchewan, Budget Speech, Feb. 1995, 74–7.

18 Dale Eisler, *LP,* 23 Jan. 1996.

19 Interview with John Penner, 22 Nov. 2001.

20 *LP,* 13 Mar. 1996.

21 Ibid., 15 Feb. 1996.

22 Ontario Federation of Labour, *Unfair Shares;* O'Hara, "Corporate Wealthfare," 16; Brooks, *Left vs Right,* 26.

23 *Commonwealth,* Jan. 1993, 7.

24 Mr and Mrs W. Sudom, to Premier Roy Romanow, 18 Mar. 1996.

25 "Saskatchewan Emerges as Star of the nineties," *Globe and Mail*, 6 Nov. 2000.

26 Government of Saskatchewan, *Budget Speech*, Feb. 1995, 5.

27 These are based not on estimates but on actual revenues included in the budget addresses. See Government of Saskatchewan, *Budget Speeches*, May 1992, 54; Feb. 1995, 92; Mar. 1997, 66.

28 Friesen, *The West*, 29.

29 *Time*, 17 Sept. 2001.

30 Interview with Berny Wiens, May 2001.

31 *SP*, 10 May 1993, 18 Mar. 1994.

32 *SP*, 7 Nov. 1992.

33 *LP*, 16, 17 Dec. 1992; *SP*, 16 Dec. 1992; *Moose Jaw Times Herald*, 16 Dec. 1992.

34 Interview with Ned Shillington, 17 Jan. 2002.

35 Gass, *Report of the Saskatchewan Financial Management Review Commission*, 79.

36 *LP*, 18 Nov. 1992.

37 *LP*, 11 Mar. 1993.

38 *LP*, 23 Apr. 1993.

39 *SP*, 3 June 1993.

40 *SP*, 19 May 1993; *LP*, 26 May 1993.

41 *SP*, 5 June, 27 May 1993;

42 *SP*, 27 May 1993.

43 *Prince Albert Herald*, 30 June 1993.

44 *Western Producer*, 1 July 1993; *SP*, 13 Aug. 1993; *LP*, 20 July 1993.

45 *SP*, 22 May 1993; *LP*, 3 June 1993;

46 *LP*, 1 June 1993.

47 *LP*, 4 June 1993.

48 *SP*, 2 July 1993.

49 *Globe and Mail*, 16 June 1994.

50 *LP*, 13 Jan. 1996.

51 See, *SP*, 14 Feb., 7 May, and 1 Aug. 1996; *Prince Albert Herald*, 7 May 1997.

52 Murray Mandryk, *LP*, 25 Feb. 1998; *SP*, 29 June 1994; *LP*, 2 May 1995.

53 Murray Mandryk, *LP*, 25 Feb. 1998.

54 "Government Should Sell Holding," *SP*, 29 Oct. 1993.

55 Murray Mandryk, *LP*, 25 Feb. 1998.

56 *LP*, 31 July 1998.

CHAPTER FIVE

1 *Maclean's*, 29 Mar. 1993, 28.

2 Government of Saskatchewan, Department of Finance, "Calculated Cost of Fuel Tax Removal, Mortgage Protection Plan: The Home Program and Associated Interest from 1982–83 to 1996–97," 4 Nov. 1996.

3 *LP*, 2 Feb. 1993.

4 Terence Corcoran, "What a Debt Crisis Might Look Like," *Globe and Mail*, 17 Feb. 1993.

5 Government of Saskatchewan, Department of Finance, briefing note, 24 Nov. 1991, 4–5.

6 Government of Saskatchewan, Department of Finance, "Addressing Saskatchewan's Debt Problem," Saskatchewan Finance pre-budget consultations, Jan. 1993.

7 Gass, *Report of the Saskatchewan Financial Management Review Commission*, 2.

8 $700 million in write-offs for SPMC and $115 million in write-offs for Sask Water. See ibid., 23, 35.

9 Ibid., 35; Government of Saskatchewan, Department of Finance, "Charting the Course to Financial Freedom," 1993–94 pre-budget consultations, 1992, 5.

10 "Charting the Course to Financial Freedom," 5.

11 Gass, *Report of the Saskatchewan Financial Management Review Commission*, 2.

12 Government of Saskatchewan, Department of Finance, "Addressing Saskatchewan's Debt Problem," 12.

13 Government of Saskatchewan, Department of Finance, briefing note, 26 May 1992.

14 Savoie, *Governing from the Centre*; Ibbitson, *Promised Land*.

15 Premier Roy Romanow, "Building for Tomorrow," notes for remarks, SUMA Convention, 26 Jan. 1992.

16 *LP*, 16 Apr. 1992.

17 Interview with Colin Thatcher, 4 Dec. 2001.

18 "Rebuilding Saskatchewan Together," Budget Speech, May 1992, 1, 6, 7, 12.

19 *Globe and* Mail, 8 May 1992; *LP*, 7 May 1992.

20 *LP*, 7 May 1992.

21 *SP*, 7 May 1992; *LP*, 8 May 1992.

22 Speaking points for meeting with Standard and Poor's, 26 May 1992, MacKinnon papers.

23 See *Globe and Mail*, 12 Mar. 1993.

24 See "Debate Rages over Debt Cuts," *LP*, 2 Feb. 1993; McQuaig, *Shooting the Hippo*; Brooks, *Left vs Right*.

25 *LP*, 13 Nov. 1991.

26 *LP*, 7 May 1992.

27 *Globe and Mail*, 1 Mar. 1993.

28 "Charting the Course to Financial Freedom," *Commonwealth*, Jan. 1993, 13.

29 *LP*, 19 Mar. 1993.

30 *Prince Albert Herald (PAH)*, 14 Jan. 1993.

31 Interview with Paul Martin, 31 Mar. 2001.

32 Greenspon and Wilson-Smith, *Double Vision*, 208.

33 Interview with Paul Martin, 31 Mar. 2001.

34 *Globe and Mail*, 1 Mar. 1993.
35 "Securing Our Future," Budget Speech, March 1993, 35.
36 *PAH*, 19 Mar. 1993.
37 Rae, *From Protest to Power*, 207.
38 National Union of Public and General Employees, *If Pigs Could Fly*.
39 Interview with Paul Martin, 31 Mar. 2001.
40 *Globe and Mail*, 15 and 12 Mar. 1993.
41 *Globe and Mail*, 15 Mar. 1993.
42 *SP*, *LP*, and *PAH*, 19 Mar. 1993.
43 Street poll, *LP*, 19 Mar. 1993.
44 "Survey Indicates NDP is on Right Track," *LP*, 2 July 1993.
45 See, for example, CBC Radio interview, 4 Nov. 1993, Regina, Sask., 7:45 AM.
46 *Weyburn Review*, 24 Mar. 1993.
47 *LP*, 19 Mar. 1993.
48 "Kudos for Deficit Fight," *LP*, 17 Apr. 1993; *SP*, 27 Mar. 1993.
49 Salomon Brothers, *Canadian Provinces: An Outlook for Credit*, Aug. 1993, 5.
50 *LP*, 1 Oct. 1993, 8 Mar., 1994, 20 May 1994.
51 *LP*, 11 Nov. 1995.
52 *LP*, 10 July 1993.

CHAPTER SIX

1 *Financial Post*, 19 Nov. 1994; "To Tax or not to Tax," *Maclean's*, 13 Feb. 1995; *Edmonton Journal*, 12 Feb. 1997.
2 *Financial Post*, 19 Nov. 1994; Roger Gibbins, "Staying the Course?" in Boothe and Reid, *Deficit Reduction in the Far West*, 111–34.
3 Boothe and Reid, "Introduction," in *Deficit Reduction in the Far West*, x.
4 Gibbins, in ibid., 121.
5 Cristine de Clercy, " Policy Innovation and Deficit Reduction: Saskatchewan, Alberta and British Columbia," in ibid., 206; Mark O. Dickerson, Greg Flanagan, "Why Alberta Can't Export the Klein Budget-Cutting model," *Globe and Mail*, 31 Jan. 1995.
6 The figure is for operating spending, excluding interest payments; see Canada West Foundation, *Red Ink II: Deficits and Debt*, 16.
7 Government of Saskatchewan, Department of Finance, "Comparison between Saskatchewan and Alberta: Selected Statistics," 27 May 1996.
8 Bradford Reid, "Provincial Fiscal Positions: An Historical Perspective," in *Deficit Reduction in the Far West*, 108.
9 *Edmonton Journal*, 25 Feb. 1994.
10 "A New Day Dawning for Saskatchewan," Budget Speech, Feb. 1995, 83; "Investing in People," Budget Speech, Mar. 1997, 47.
11 See *Financial Post*, 25 Oct. 1994; Kierans and Robson, *The Courage to Act*.

12 Keith Archer and Roger Gibbons, "What Do Albertans Think? The Klein Agenda on the Public Opinion Landscape," in Bruce, Kneebone, and McKenzie, *A Government Reinvented*, 466.

13 *LP*, 2 Apr. 1993.

14 *LP*, 19 Mar. 1993.

15 cfib Research, May 1995.

16 Rae, *From Protest to Power*, 193–216.

17 Ibid., 207, 212.

18 Government of Alberta, Budget Speech, 1993, 7.

19 *SP*, 20 May 1993.

20 Ralph Klein, "Alberta Aims for Less Government, More Jobs," speech, May 1994, 4.

21 Bricker and Greenspon, *Searching for Certainty*.

22 *Globe and Mail*, 3 Dec. 1996.

23 *SP*, 3 May 1993.

24 Canada West Foundation, *Red Ink II: Understanding Government Finances, 1990–1995*, 21.

25 Government of Alberta, Budget Speech, 4–5.

26 Paul Boothe, "Slaying the Deficit Dragon? Anti-Deficit Policies in the West," in Boothe and Reid, *Deficit Reduction in the Far West*, 150–2.

27 Ibid.

28 Government of Alberta, Budget Speech, 7–8.

29 Richard H.M. Plain, "Health Reform, Health Care Spending, and Health Status," in Boothe and Reid, *Deficit Reduction in the Far West*, 167.

30 Ibid.; Lee, *Frank*, 218–20.

31 Boothe, "Slaying the Deficit Dragon?", 151–3.

32 Ibid.

33 Government of Saskatchewan, Department of Health, *Report on Comparative Healthcare Statistics*, 1996.

34 Government of Saskatchewan, News Release, 20 Aug. 1996.

35 Government of Saskatchewan, Budget Speech, 1993, 17.

36 Ralph Klein, "Alberta Aims for Less Government, More Jobs," speech, May 1994, 4.

37 Ibbitson, *Promised Land*, 120, 183.

38 *Globe and Mail*, 18 Jan. 2002.

39 See Potter, *The Liberty We Seek*.

40 Diana Ralph and Mark Stobbe, "Welfare Reform as Moral Reform in Saskatchewan," in Biggs and Mark Stobbe, *Devine Rule in Saskatchewan*, 268.

41 *Western Report*, 29 June 1987, quoted in Pitsula and Rasmussen, *Privatizing a Province*, 206.

42 Ibid., 201–15.

43 Quoted in Mark Stobbe, "Less Is More: Schmidtspeak," *Briarpatch* Dec. 1987/Jan. 1988.

44 Diana Ralph and Mark Stobbe, "Welfare Reform as Moral Reform," in Biggs and Mark Stobbe, *Devine Rule in Saskatchewan*, 277.

45 Ibid., 271.

46 *LP*, 28 June 1989, quoted in Pitsula and Rasmussen, *Privatizing a Province*, 212.

47 Ibid., 205, 207; *Moose Jaw Times Herald (MJTH)*, 21 Feb. 1992; *SP*, 13 May 1992.

48 *MJTH*, 21 Feb. 1992.

49 Government of Saskatchewan, Department of Social Services, "Changing Direction," Feb. 1992.

50 *SP*, 10 Dec. 1991, *LP*, 5 Dec. 1991.

51 *SP*, 28 Apr. 1992.

52 "Sask. Takes Better Care of its Poor, "*LP*, 7 June 2001.

53 *LP*, 16 Feb. 1995.

CHAPTER SEVEN

1 Seventh Annual Western Finance Ministers' Report, 1.

2 Fifth Annual Western Finance Ministers' Report, 11.

3 Ibid.

4 News Release, Western Premiers' Conference, Canmore, Alta, 25 Nov. 1993.

5 *LP*, 27 Feb. 1995.

6 *LP*, 1, 3, and 28 June 1993.

7 *LP*, 31 May 1993.

8 *SP*, 10 Feb. 1996; *Prince Albert Herald*, 10 Feb. 1996; *LP*, 13 Feb. 1996; *LP*, 14 Feb. 1996.

9 *LP*, 20 Mar. 1997.

CHAPTER EIGHT

1 Halifax *Daily News*, 2 Dec. 1993.

2 *SP*, 1 June 1993.

3 *Sixth Annual Western Finance Ministers' Report*, 11; *Seventh Annual Western Finance Ministers' Report*, 1, 2; *Toronto Sun*, 11 Apr. 1996; Ottawa *Citizen*, 29 Mar. 1996.

4 *SP*, 25 Nov. 1993.

5 *SP*, 9 Feb. 1994; *LP*, 18 Feb. 1994.

6 *Fifth Annual Western Finance Ministers Report*, 8.

7 *SP*, 22 Feb. 1994.

8 Greenspon and Wilson-Smith, *Double Vision*, 374.

9 *Globe and Mail*, 1 Feb. 1996.

10 *Globe and Mail*, 12 Aug. 1995.

11 Greenspon and Wilson-Smith, *Double Vision*, 8.

12 Ibid., 373.

13 Ibid., 371–86.

14 *Globe and Mail*, 12 Aug. 1995; *LP*, 24 Feb., 4 May, and 7 Mar. 1996.

15 *LP*, 25 Sept. 1993.

16 Ottawa *Citizen*, 29 Mar. 1996.

17 Finance Minister Paul Martin to provincial Finance Ministers, 18 Nov. and 20 Dec. 1993, MacKinnon papers.

18 *Toronto Star*, 29 Mar. 1996.

19 *SP*, 23 Mar. 1996; *Toronto Sun*, 11 Apr. 1996.

20 CKCK/CFQC TV news, Regina, 3 Feb. 1996, 18:00.

21 *SP*, 30 Mar. 1996; *Globe and Mail*, 1 Feb. 1996.

22 *LP*, 4 May 1996.

23 *LP*, 20 Apr. 1996.

24 *Prince Albert Herald*, 8 Mar. 1996; Charlottetown *Guardian*, 12 Mar. 1996; North Battleford, CJNB radio news, 15 Mar. 1996; *SP*, 23 Mar. 1996.

25 Rubin M. Baerg to Janice MacKinnon, 23 Mar. 1996, MacKinnon papers.

26 *Globe and Mail*, 18 May, 1996.

27 Charlottetown *Guardian*, 19 Sept. 1996; *Fredericton Daily Gleaner*, 5 Mar. 1997; Charlottetown *Guardian*, 9 Sept. 1996; *Saint John Telegraph Journal*, 12 Sept. 1996; *St John's Evening Telegram*, 11 Oct. 1996.

28 *Ottawa Sun*, 17 Apr. 1996.

29 *LP*, 4 May 1996.

30 *LP*, 24 Apr. 1996.

31 Seventh Annual Western Finance Ministers' Report, 1–2; News Release, 12 June 1996.

CHAPTER NINE

1 Jenish, *Money to Burn*, 91; Greenspon and Wilson-Smith, *Double Vision*, 137.

2 *SP*, 30 Nov. 1993.

3 For an excellent discussion of Martin and Massé and their relationship, see Greenspon and Wilson-Smith, *Double Vision*, 105–18.

4 Fourth Annual Western Finance Ministers' Report, 30.

5 Jenish, *Money to Burn*, 91.

6 Greenspon and Wilson-Smith, *Double Vision*, 82–3.

7 Although CAP was cost-shared, after the 1990 cap on CAP the three wealthiest provinces would have paid more than half the costs.

8 Interview with Paul Martin, 31 Mar. 2001.

9 Jenish, *Money to Burn*, 91.

CHAPTER TEN

1 Paul Martin, Budget Speech, 27 Feb. 1995 (hereafter Martin, Budget Speech, 1995), 27.

2 Ibid., 4.

3 *LP*, 27, Feb. 1995. Greenspon and Wilson-Smith, *Double Vision,* 274.

4 Martin, Budget Speech, 1995, 2.

5 See William MacKinnon, "The Relationship between the Government and the Bank of Canada," unpublished essay, 2002, 11–13, in MacKinnon papers.

6 Andrew Phillips, "Price Fighter: John Crow Leaves the Bank of Canada but His Successor Vows to Keep a Hardline in the Fight Against Inflation," *Maclean's*, 3 Jan. 1994, 38, quoted in William MacKinnon, 12.

7 *LP*, 25 Sept. 1993.

8 *LP*, 21 Oct. 1993.

9 Martin, Budget Speech, 1995, 2.

10 See Greenspon and Wilson-Smith, *Double Vision*, 153–70.

11 Frank Graves, Ekos Research Associates of Ottawa, quoted in Jenish, *Money to Burn*, 24.

12 Greenspon and Wilson-Smith, *Double Vision* , 262.

13 *LP*, 9 Dec. 1994.

14 Martin, Budget Speech, 1995, 5.

15 Ibid., 6.

16 Ibid., 8

17 Ibid., 14.

18 Ibid., 17.

19 Ibid., 17, 18.

20 *LP, SP,* 28 Feb. 1995.

21 *Prince Albert Herald*, 28 Feb. 1995.

22 *SP*, 28 Feb. 1995.

23 *SP, LP*, 15 Mar. 1995.

24 *SP*, 18 Jan. 1996.

25 *LP*, 5 Aug. 1995.

26 Sixth Annual Western Finance Ministers' Report, 8.

27 Hon. Janice MacKinnon, "The Crisis in Federal-Provincial Fiscal Relations," speech to IPAC National Forum, Regina, 29 August 1995.

28 *LP*, 9 Mar. 1995.

29 Ibbitson, *Promised Land*, 119.

30 Ibbitson, *Loyal No More*, 166.

31 Ibid., 167–8.

CHAPTER ELEVEN

1 *Globe and Mail*, 29 July 1996.
2 Porter and Monitor Company, *Canada at the Crossroads*.
3 *Canada's Innovation Strategy: Achieving Excellence*, section 2: 4.
4 Conference Board of Canada, *Performance and Potential 2002–03*, 5.
5 Ibid., 10.
6 I am greatly indebted to Rick August of the Saskatchewan Department of Social Services for providing me with a draft of a forthcoming document on social policy in Canada.
7 Pulkingham and Ternowetsky, *Remaking Canadian Social Policy*, 5.
8 Government of Canada, *Science and Technology for the New Century*, 3.
9 Ibid.
10 Government of Canada, Budget Speech, 1997, 11.
11 *Canada's Innovation Strategy: Achieving Excellence*, 5; Budget Speech, 1997, 8.
12 *Canada's Innovation Strategy: Achieving Excellence*, section 2: 10.
13 *SP*, 11 Apr. 2002.
14 Bricker and Greenspon, *Searching for Certainty*, 143, 140; *Canada's Innovation Strategy: Achieving Excellence*, "The Knowledge Performance Challenge," section 5: 9; ibid., *Achieving Excellence*, section 2: 9.
15 Ibid., *Achieving Excellence*, 2.
16 Ibid., 3.
17 Government of Canada, Budget Speech, 2000, 6.
18 Government of Canada, Budget Speech, 1997, 6.
19 *Canada's Innovation Strategy: Achieving Excellence*, "Knowledge Performance," Executive Summary.
20 Government of Canada, Budget Speech, 28 Feb. 2000, 7.
21 *Canada's Innovation Strategy: Achieving Excellence*, "Skills and Learning," Executive Summary.
22 I am indebted to Rick August of the Saskatchewan Department of Social Services for his ideas and analysis.
23 Ibid.
24 Government of Canada, Budget Speech, 18 Feb. 1997, 8.
25 Bricker and Greenspon, *Searching for Certainty*, 257.
26 Government of Canada, Budget Speech, Mar. 1997, 3.
27 Romanow, *Building on Values*; and "The Cost of Health Care: Is It Sustainable?" Speech at the Harvard Center for International Affairs, Cambridge, Mass., 16 Oct. 2002.
28 William Robson, "Will the Boomers Bust the Health Budget? Demographic Change and Health Care Financing Reform," quoted in David MacKinnon,

president of the Ontario Hospitals Association, presentation to the Romanow Commission on Health Care.

29 Conference Board of Canada, *The Future Cost of Health Care in Canada*, iii; Kirby, *The Health of Canadians*, 258; Conference Board of Canada, *Performance and Potential 2001–02: Charting a Canadian Course in North America*, 91.

30 Conference Board of Canada, *Performance and Potential 2001–02: Charting a Canadian Course in North America*, 91.

31 Canadian Institute for Health Information, National Health Expenditure Trends <http://seure.cihi.ca>; Government of Canada, Department of Finance, Public Accounts 2002, *Budgetary Revenues*, 11.

32 Fyke, *Caring for Medicare*, 75; Mazankowski, *A Framework for Reform*, 27.

33 Conference Board of Canada, *The Future Cost of Health Care in Canada*, 1.

34 Ronald J. Daniels, "Let's Reach for the Gold in Higher Education," *Globe and Mail*, 1 Mar. 2002; Association of Universities and Colleges of Canada, *Trends in Higher Education*, 64–5.

35 Conference Board of Canada, *Performance and Potential 2002–03*, 9; Bricker and Greenspon, *Searching for Certainty*, 136, provides an excellent discussion of this issue.

36 Mazankowski, *A Framework for Reform*, 32; *SP*, 16 Apr. 2002.

37 Bricker and Greenspon, *Searching for Certainty*, 136.

38 Canadian Medical Association, *A Prescription for Sustainability*, viii–ix.

39 Romanow, "The Cost of Health Care: Is It Sustainable?" Speech at the Harvard Center for International Affairs, Cambridge, Mass., 16 Oct. 2002.

40 Bricker and Greenspon, *Searching for Certainty*, 213–14.

41 Mazankowski, *A Framework for Reform*, 5.

42 Kirby, *The Health of Canadians*: Highlights, 30; Mazankowski, *A Framework for Reform*, 7.

43 Conversation with Mazankowski, Sept. 2002.

44 Kirby, *The Health of Canadians*, 260.

45 Government of Saskatchewan, Budget Speech, 1997, 84.

CHAPTER TWELVE

1 See Simpson, *The Friendly Dictatorship*, 82–96.

2 Bricker and Greenspon, *Searching for Certainty*, 45–86.

3 Interview with Gary Doer, Aug. 2002.

4 See Simpson, *The Friendly Dictatorship*, 9; Ibbitson, *Loyal No More*, 179–80.

5 See *Globe and Mail*, 15 July 2002.

6 Savoie, *Governing from the Centre*.

7 "Martin's Plan Gives Back Bench More Clout," *Globe and Mail*, 22 Oct. 2002.

Bibliography

PRIMARY SOURCES

Government Documents

Canada's Innovation Strategy: Achieving Excellence. Investing in People, Knowledge, and Opportunity. Ottawa, 2002

Fifth Annual Western Finance Ministers' Report. Gimli, Man., 1994

Fifth Annual Western Premiers' Report. Gimli, Man., 1994

Fourth Annual Western Premiers' Meeting. News Release. Canmore, Alta., 1993

Fourth Annual Western Premiers' Report. Canmore, Alta., 1993

Fyke, Kenneth J. *Caring for Medicare: Sustaining a Quality System.* Report of the Commission on Medicare (Fyke Commission). Regina, Sask., 2001

Gass, Don. *Report of the Saskatchewan Financial Management Review Commission* (Gass Commission). Regina, Sask., Feb. 1992

Government of Alberta. *Budget Speeches*, 1993–96

Government of Canada, *Budget Speeches*, 1994–2002

– *Science and Technology for the New Century.* Ottawa, 1994

– *Speech from the Throne*, 1994–2002

– Department of Finance. Public Accounts, Oct. 2002

Government of Saskatchewan. *Assessment of the Bi-Provincial Upgrader at Lloydminster, Saskatchewan.* Prepared for the Crown Investments Corporation, Oct. 1992

– *Auditor's Reports*, 1982–2002

– *Budget Speeches*, 1980–2002

– *NewGrade Energy Inc.: An Historical Review*, Dec. 1991

– *Stewardship Report Re: NewGrade Energy Inc.*, Sept. 1991

– *The Investment in Crown Life by Haro Financial Corporation. A Report Prepared for Crown Management Board*, 2 Dec. 1991

– Department of Finance. Papers and briefing notes

– Department of Health. Papers and briefing notes

– Department of Social Services. Papers and briefing notes

Kirby, Michael J. *The Health of Canadians: The Federal Role*. Vol. 6 of Government of Canada. *Recommendations for Reform*. Ottawa: Senate Standing Committee on Social Affairs, Science and Technology, Oct. 2002

Legislative Assembly of Saskatchewan. *Debates and Proceedings*, 1982–2002

Mackinnon, the Hon. Janice, Papers. Private Collection: Member of the Legislative Assembly for Saskatoon Westmount/Idylwyld. Correspondence, 1991–2001

– Associate Minister of Finance. Correspondence, memos, briefing notes, 1992–93

– Government House Leader. Correspondence, memos, briefing notes, 1997–99

– Chair/member of Treasury Board. Briefing notes, 1992–2001

– Chair/member, Crown Investments Corporation. Minutes and reports, 1992–2001

– Minister of Crown Investments Corporation. Correspondence, memos, briefing notes, 1992–93, 2001

– Minister of Economic and Co-operative Development. Correspondence, memos, briefing notes, 1997–2001

– Minister of Finance. Correspondence, memos, briefing notes, 1993–97

– Minister of Social Services. Correspondence, memos, briefing notes, 1991–92

– Minister responsible for the Saskatchewan Opportunities Corporation and Innovation Place. Correspondence, memos, briefing notes, 1997–2001

– Minister responsible for the Saskatchewan Trade and Export Partnership. Correspondence, memos, briefing notes. 1997–2001

Mazankowski, Donald A. *A Framework for Reform: Report of the Premier's Advisory Council on Health*. Edmonton, Alta, 2001

Romanow, Roy J. *Building on Values: Report of the Commission on the Future of Health Care*. Ottawa, Nov. 2002

Saskatchewan Municipal Directory

Seventh Annual Western Finance Ministers' Report. Dawson City, Yukon, 1996

Seventh Annual Western Premiers' Report. Dawson City, Yukon, 1996

Sixth Annual Western Finance Ministers' Report. Yorkton, Sask., 1995

Sixth Annual Western Premiers' Report. Yorkton, Sask., 1995

Interviews and Discussions

The book relies on discussions that occurred at provincial and federal-provincial meetings, 1991–2001, with a variety of federal and provincial cabinet ministers and premiers. The finance ministers include federal finance ministers Don Mazankowski and Paul Martin; British Columbia finance ministers Elizabeth Cull and Andrew Petter; Alberta treasurer, Jim Dinning; Manitoba finance minister, Eric Stefanson; Ontario finance ministers Floyd Laughren and Ernie Eves (who later became premier); Quebec finance ministers Gérard D. Lévesque, André Bourbeau, Jean Campeau, Pauline Marois, and Bernard Landry (who later became premier); New Brunswick finance minister, Alan Maher; Nova Scotia finance minister, Bernie

Boudreau; Newfoundland finance ministers Winston Baker and Paul Dicks; and Prince Edward Island finance minister, Wayne Cheverie. The premiers include Mike Harcourt and Glen Clark of British Columbia, Ralph Klein of Alberta, Roy Romanow and Lorne Calvert of Saskatchewan, Gary Filmon and Garry Doer of Manitoba, Bob Rae and Mike Harris of Ontario.

I also conducted interviews in 2001–2 with various federal and provincial cabinet ministers including former federal finance ministers Paul Martin and Don Mazankowski and Premier Garry Doer of Manitoba. I also interviewed the following cabinet ministers from the government of Premier Grant Devine: Minister of Finance Bob Andrew, Deputy Premier and Minister of Health George Mcleod, Minister of Energy Colin Thatcher, Government House Leader Grant Hodgins, and Minister of Social Services Grant Schmidt. There were also discussions with other ministers in the Devine government in the 1980s, and many with cabinet ministers and MLAS from the 1990s, on both the government and opposition benches. Some of these discussions are quoted in the text; most, however, are not cited at the request of those to whom I spoke

I also spoke with many civil servants, whose tenure in government spanned the period from the 1970s to the present. These people were especially valuable in documenting what occurred behind closed doors in the 1980s and in comparing the decision-making procedures and styles of governments from the 1970s to the present day. Some – like Con Hnatiuk, Saskatchewan deputy minister of social services and of health, and Harry Van Mulligen, an official in the housing department in the 1980s – agreed to have their interviews on the record. The rest have requested anonymity.

Newspapers and Magazines

Canadian Business
Citizen (Ottawa)
Commonwealth
Daily News (Halifax)
Edmonton Journal
Euromoney
Financial Post
Frederiction Daily Gleaner
Globe and Mail
Guardian (Charlottetown)
Leader Post (Regina) (*LP*)
Maclean's
Moose Jaw Times Herald (*MJTH*)
Ottawa Sun
Prince Albert Herald (*PAH*)
St John's Evening Telegram

Saint John Telegraph Journal
Star Phoenix (Saskatoon) (*SP*)
Toronto Star
Toronto Sun
Western Civilization
Western Producer
Wall Street Journal

SECONDARY SOURCES

Books

Allan, John, ed. *Public Enterprise in an Era of Change*. Regina: Canadian Plains Research Center, 1998

Armstrong, Pat. *Universal Health Care: What the United States Can Learn from the Canadian Experience*. New York: New Press, 1998

Association of Universities and Colleges of Canada. *Trends in Higher Education*. Ottawa, 2002

Auer, Ludwig, et al. *Cost-Effectiveness of Canadian Health Care: Research Report*. Ontario: Queen's–University of Ottawa Economic Project, 1995

Baron, Don, and Paul Jackson. *Battleground: The Socialist Assault on Grant Devine's Canadian Dream*. Toronto: Bedford House, 1991

Bégin, Monique. *The Future of Medicare: Recovering the Canada Health Act*. Ottawa: Canadian Centre for Policy Alternatives, 1999

Bercuson, David, J.L. Granatstein, and W.R. Young. *Sacred Trust? Brian Mulroney and the Conservatives in Power*. Toronto and New York: Doubleday, 1986

– eds. *Petrified Campus: The Crisis in Canada's Universities*. Toronto: University of Toronto Press, 1997

Biggs, L., and Stobbe, M., eds. *Devine Rule in Saskatchewan: A Decade of Hope and Hardship*. Saskatoon: Fifth House, 1991

Blake, Raymond B., et al., eds. *The Welfare State in Canada: Past, Present and Future*. Concord, Ont.: Irwin, 1997

Blakeney, Allan, and Sanford Borins. *Political Management in Canada: Conversations on Statecraft*. Toronto: University of Toronto Press, 1998.

Boan, John A., ed. *Proceedings of the Fifth Canadian Conference on Health Economics*. Regina: Canadian Plains Research Center, 1994

Boothe, Paul, and Bradford Reid, eds. *Deficit Reduction in the Far West: The Great Experiment*. Edmonton: University of Alberta Press, 2001

Bothwell, Robert, et al. *Canada Since 1945*. 2nd ed. Toronto: University of Toronto Press, 1989

Bricker, Darrell, and Edward Greenspon. *Searching for Certainty: Inside the New Canadian Mindset*. Toronto: Doubleday Canada, 2001

Brooks, Neil. *Left vs. Right: Why the Left is Right and the Right is Wrong.* Ottawa: Centre for Policy Alternatives, 1995

Brown, Douglas. *Market Rules: Economic Union Reform and Intergovernmental Policy-Making in Australia and Canada.* Montreal and Kingston: McGill-Queen's University Press, 2001

Brown, Lorne A., Joseph K. Roberts, and John W. Warnock. *Saskatchewan Politics from Left to Right '44 to '99.* Regina: Hinterland Publications, 1999

Brownsey, Keith, and Michael Howlett, eds. *The Provincial State in Canada: Politics in the Provinces and Territories.* Toronto: Broadview Press, 2001

Bruce, Christopher, Ronald D. Kneebone, and Kenneth J. McKenzie, eds. *A Government Reinvented: A Study of Alberta's Deficit Elimination Program.* Don Mills, Ont.: Oxford University Press, 1997

Canada West Foundation. *Red Ink II. Deficits and Debt: Staying on Track or Derailing.* Calgary: Canada West Foundation, 1994

– *Red Ink II: Understanding Government Finances, 1990–1995.* Calgary: Canada West Foundation, 1994

Canadian Medical Association. *A Prescription for Sustainability.* Ottawa: CMA, 2002

Carmichael, Edward A. *Tackling the Federal Deficit.* Toronto: C.D. Howe Institute, 1984

Clarke, Harold D. *A Polity on the Edge: Canada and the Politics of Fragmentation.* Peterborough: Broadview Press, 2000

Clarkson, Stephen and Christina McCall. *Trudeau and Our Times: The Heroic Delusion.* Toronto: McClelland & Stewart, 1994

Clement, Wallace. *Understanding Canada: Building on the New Canadian Economy.* Montreal and Kingston: McGill-Queen's University Press, 1996

Conference Board of Canada. *The Future Cost of Health Care in Canada, 2000 to 2020: Balancing Affordability and Sustainability.* Ottawa: Conference Board of Canada, 2001

– *Performance and Potential, 2001–02: Charting a Canadian Course in North America.* Ottawa: Conference Board of Canada, 2001

– *Performance and Potential, 2002–03: Canada 2010. Challenge and Choice at Home and Abroad.* Ottawa: Conference Board of Canada, 2002

Conkin, David W. and Thomas J. Courchene, eds. *Deficits: How Big and How Bad?* Toronto: Ontario Economic Council, 1983

Cooper, Barry. *The Klein Achievement.* Toronto: Centre for Public Management, University of Toronto, 1995

Crowley, Brian Lee, et al. *Definitely Not the Romanow Report: Consumer Empowerment in Canadian Health Care.* Halifax: Atlantic Institute for Market Studies, 2002

Dunn, Chris. *Provinces: An Introduction to Canadian Provincial Politics.* Peterborough: Broadview Press, 1996

Dyck, Rand. *Provincial Politics in Canada.* 2nd ed. Scarborough, Ont.: Prentice-Hall, 1991

Eager, Evelyn. *Saskatchewan Government: Politics and Pragmatism.* Saskatoon: Western Producer Prairie Books, 1980

Eisler, Dale. *Rumours of Glory: Saskatchewan and the Thatcher Years*. Edmonton: Hurtig, 1987

Finkel, Alvin. *Our Lives: Canada after 1945*. Toronto: Lorimer, 1997

Finlay, J.L,. and D.N. Sprague. *The Structure of Canadian History*. 4th ed. Scarborough, Ont.: Prentice-Hall, 1993

Francis, R. Douglas, and Howard Palmer, eds. *The Prairie West: Historical Readings*. Edmonton: University of Alberta Press, 1991

Francis, R. Douglas, et al. *Destinies: Canadian History since Confederation*. 4th ed. Toronto: Harcourt Brace, 2000

Friesen, Gerald. *Citizens and Nation: An Essay on Communication, and Canada*. Toronto: University of Toronto Press, 2000

– *The West: Regional Ambitions, National Debates, Global Age*. Toronto: Penguin, 1999

Frizzell, Alan, and Jon H. Pammett, eds. *The Canadian General Election of 1997*. Toronto: Dundurn Press, 1997

Gratzer, David., ed. *Better Medicine: Reforming Canadian Health Care*. Toronto: ECW Press, 2002

– *Code Blue: Reviving Canada's Health Care System*. Toronto: ECW Press, 1999

Greenspon, Edward, and Anthony Wilson-Smith. *Double Vision: The Inside Story of the Liberals in Power*. Toronto: Doubleday, 1996

Gruending, Denis. *Promises to Keep: A Political Biography of Allan Blakeney*. Saskatoon: Western Producer Prairie Books, 1990

Hayden, Michael. *Seeking a Balance: The University of Saskatchewan, 1907–1982*. Vancouver: University of British Columbia Press, 1983

Ibbitson, John. *Loyal No More: Ontario's Struggle for a Separate Destiny*. Toronto: HarperCollins, 2001

– *Promised Land: Inside the Mike Harris Revolution*. Toronto: Prentice-Hall, 1997

Ip, Irene K. *Big Spenders: A Survey of Provincial Government Finances in Canada*. Toronto: C.D. Howe Institute, 1991

Ip, Irene K., Josh Mendelsohn, and William B.P. Robson, eds. *Avoiding a Crisis: Proceedings of a Workshop on Canada's Fiscal Outlook*. Toronto: C.D. Howe Institute, 1993

Jenish, Darcy. *Money to Burn: Trudeau, Mulroney and the Bankruptcy of Canada*. Toronto: Stoddart, 1996

Jones, Gerry. *SaskScandal: The Death of Political Idealism in Saskatchewan*. Calgary: Fifth House, 2000

Kierans, Thomas E., and William B.P. Robson. *The Courage to Act: Fixing Canada's Budget and Social Policy Deficits*. Toronto: C.D. Howe Institute, 1994

Kneebone, Ronald A., and Kenneth McKenzie. *Past (In)discretions: Canadian Federal and Provincial Fiscal Policy*. Toronto: Centre for Public Management, University of Toronto, 1999

Laux, Jeanne Kirk, and Maureen Appel Molot. *State Capitalism: Public Enterprise in Canada*. Ithaca, N.Y.: Cornell University Press, 1988

Laycock, David H. *The New Right and Democracy in Canada: Understanding Reform and the Canadian Alliance*. Don Mills, Ont.: Oxford University Press, 2001

Lee, Philip. *Frank: The Life and Politics of Frank McKenna*. Fredericton: Goose Lane, 2001

Leeson, Howard A., ed. *Saskatchewan Politics*. Regina: Canadian Plains Research Center, 2001

Lipset, S.M. *Agrarian Socialism: The Co-operative Commonwealth Federation*. Garden City, N.Y.: Anchor Books, 1968

McLeod, Thomas H., and Ian McLeod. *Tommy Douglas: The Road to Jerusalem*. Edmonton: Hurtig, 1987

McMillan, Melville, ed. *Provincial Public Finances: Provincial Surveys*. Vol. 1. Toronto: Canadian Tax Foundation, 1991

McQuaig, Linda. *Shooting the Hippo: Death by Deficit and Other Canadian Myths*. Toronto: Viking, 1995

Melnyk, George. *Beyond Alienation: Political Essays on the West*. Calgary: Detselig Enterprises, 1993

– ed. *Riel to Reform: A History of Protest in Western Canada*. Saskatoon: Fifth House, 1992

Morton, Desmond. *A Short History of Canada*. 5th ed. Toronto: McClelland & Stewart, 2001

National Union of Public and General Employees. *If Pigs Could Fly: The Hard Truth about the "Economic Miracle" That Ruined New Zealand*. Ottawa: NUPGE, 1994

Naylor, C. David, ed. *Canadian Health Care and the State: A Century of Evolution*. Montreal: McGill-Queen's University Press, 1992

Norrie, K.H., and Douglas Owram. *A History of the Canadian Economy*. Scarborough, Ont.: Nelson Thomson Learning, 2002

Osberg, Lars and Pierre Fortin, eds. *Hard Money, Hard Times: Why Zero Inflation Hurts Canada*. Toronto: Lorimer, 1998

– *Unnecessary Debts*. Toronto: Lorimer, 1996

Owram, Douglas. *Born at the Right Time: A History of the Baby-Boom Generation*. Toronto: University of Toronto Press, 1996

– *A History of the Department of Public Works*. Ottawa: Department of Public Works, 1979

Paikin, Steve. *The Life: The Siren Song of Politics*. Toronto: Viking, 2001

Pitsula, James M., and Ken Rasmussen. *Privatizing a Province: The New Right in Saskatchewan*. Vancouver: New Star Books, 1990

Porter, Michael, and Monitor Co. *Canada at the Crossroads*. Ottawa: Business Council on National Issues and Government of Canada, 1991

Poschmann, Finn, and John Richards. *How to Lower Taxes and Improve Social Policy: A Case of Eating Your Cake and Having It Too*. Toronto: C.D.Howe Institute, 2000

Potter, Janice. *The Liberty We Seek: Loyalist Ideology in Colonial New York and Massachusetts*. Cambridge, Mass.: Harvard University Press, 1983

Pulkingham, Jane, and Gordon Ternowetsky. eds. *Remaking Canadian Social Policy: Social Security in the Late 1990s*. Halifax: Fernwood, 1996

Rae, Bob. *From Protest to Power: Personal Reflections on a Life in Politics.* Toronto: Viking, 1996

Richards, John, and Larry Pratt. *Prairie Capitalism: Power and Influence in the New West.* Toronto: McClelland & Stewart, 1979

Robertson, Heather-Jane. *No More Teachers, No More Books: The Concentration of Power in Canadian Politics.* Toronto: McClelland & Stewart, 1998

Savoie, Donald J. *Governing from the Centre: The Concentration of Power in Canadian Politics.* Toronto: University of Toronto Press, 1999

– *The Politics of Public Spending in Canada.* Toronto: University of Toronto Press, 1990

Sclar, Elliot D. *You Don't Always Get What You Pay For: The Economics of Privatization.* Ithaca, N.Y.: Cornell University Press, 2000

Shackleton, Doris French. *Tommy Douglas: A Biography.* Toronto: McClelland & Stewart, 1975.

Simpson, Jeffrey. *The Anxious Years: Politics in the Age of Mulroney and Chrétien.* Toronto: Lester, 1996

– *The Friendly Dictatorship.* Toronto: McClelland & Stewart, 2001

– *Spoils of Power: The Politics of Patronage.* Toronto: Collins, 1998

Smith, David E. *Building a Province: A History of Saskatchewan in Documents.* Saskatoon: Fifth House, 1992

Somerville, Margaret A., ed. *Do We Care? Renewing Canada's Commitment to Health.* Montreal: McGill-Queen's University Press, 1999

Swan, William R., and Patrick Taylor, eds. *Forward to Basics: Proceedings of the Seventh Canadian Conference on Health Economics,* held at Carleton University, Ottawa, August 21–3, 1997. Canada: Canadian Health Economics Research Association, 1997

Taft, Kevin. *Shredding the Public Interest: Ralph Klein and Twenty-Five Years of One-Party Government.* Edmonton: University of Alberta Press, 1997

Thatcher, Colin. *Backrooms: A Story of Politics.* Saskatoon: Western Producer, Prairie Books, 1985

Tremblay, Melville, trans. Fred A. Reed. *A Country Held Hostage: How the World Finances Canada's Debt.* Toronto: Stoddart, 1996

Van Herk, Aritha. *Mavericks: An Incorrigible History of Alberta.* Toronto: Matrix, 2001

Ward, John, ed. *Days of Reckoning: The Real Story Behind Canada's $600 Billion Debt.* Toronto: Warwick, 2000

Watson, William G., et al. *The Case for Change: Reinventing the Welfare State.* Toronto: C.D. Howe Institute, 1994

Workman, Thom. *Selling the Debt: The Discourse of Fiscal Crisis.* Halifax, Fernwood, 1996

Wotherspoon, Terry, ed. *Hitting the Books: The Politics of Educational Retrenchment.* Toronto: Garamond Press, 1991

Articles and Speeches

Abizadeh, Sohrab, and John A. Gray. "Government Spending in Canadian Prairie Provinces." *Prairie Forum* 18, no. 1 (1993): 117–36

Aldcroft, Derek H. "The Twentieth Century International Debt Problem In Historical Perspective." *Journal of European Economic History* 30, no. 1 (2001): 173–202

Barker, Paul. "Decision Making in the Blakeney Years." *Prairie Forum* 19, no. 1 (1994): 65–80

Bird, R.M., and A.T. Tassonyi. "Constraints on Provincial and Municipal Borrowing in Canada: Markets, Rules, and Norms." *Canadian Public Administration* 44, no. 1 (2001): 84–109

Boychuk, Gerard W. "Differences of Degrees: Higher Education in the American States and Canadian Provinces." *Canadian Public Administration* 43, no. 4 (2000): 453–72

Campbell, Colin. "The Future of Canadian Economic Nationalism." *British Journal of Canadian Studies* 13, no. 1 (1998): 97–111

Crichton, Anne. "Health Care in Canada and Australia: The Development of a Comparative Analytical Framework." *Australian-Canadian Studies* 13, no. 2 (1995): 59–72

Curtis, Douglas. "Canadian Fiscal and Monetary Policy and Macroeconomic Performance, 1984–1993: The Mulroney Years." *Journal of Canadian Studies* 32, no. 1 (1997): 135–52

James, Amanda M. "Closing Rural Hospitals in Saskatchewan: on the Road to Wellness?" *Social Sciences and Medicine* 49, no. 8 (1999): 1021–34

Johnston, Richard. "Business Cycles, Political Cycles, and the Popularity of Canadian Government, 1974–1998." *Canadian Journal of Political Science* 32, no. 3 (1999): 499–520

Klein, Ralph. "Alberta Aims for Less Government, More Jobs." Speech, May 1994

Kneebone, Ronald D., and John Leach. "The Accumulation of Public Debt in Canada." *Canadian Public Policy* 27, no. 3 (2001): 297–313

Kneebone, Ronald D., and Kenneth J. McKenzie. "The Characteristics of Fiscal Policy in Canada." *Canadian Public Policy* 25, no. 4 (1999): 483–502

Livine, Marc V. "Public Policies, Social Institutions, and Earning Inequality: Canada and the United States, 1970–1995." *American Review of Canadian Studies* 26, no. 3 (1996): 315–40

MacKinnon, Janice. "Balance: Fiscal Responsibility in Saskatchewan," In *How to Use the Fiscal Surplus*, ed. Herbert Grubel. Vancouver: Fraser Institute, 1999

– "The Crisis in Federal-Provincial Fiscal Relations," *IPAC* National Forum. Regina, 29 Aug. 1995

Maclellan, Duncan K. "Shifting from the Traditional to the New Political Agenda: The Changing Nature of Federal-Provincial Relations." *American Review of Canadian Studies* 25, no. 2–3 (1995): 323–46

Michelmann, Hans J., and Jeffrey S. Steeves. "The 1982 Transition in Power in

Saskatchewan: The Progressive Conservatives and the Public Service," *Canadian Public Administration* 25, no. 1 (1985): 1–23

Petry, Fracois, et al. "Electoral and Partisan Cycles in the Canadian Provinces." *Canadian Journal of Political Science* 32, no. 2 (1999): 273–92

Robson, William B.P. "Will the Baby Boomers Bust the Health Budget? Demographic Change and Health Care Financing Reform." *C.D. Howe Institute Commentary* no. 148, February 2001

Romanow, Roy. "The Cost of Health Care: Is It Sustainable?" Speech at the Harvard Center for International Affairs, Cambridge, Mass., 16 Oct. 2002

Savoie, Donald J. "The Rise of Court Government in Canada." *Canadian Journal of Political Science* 32, no. 4 (1999): 635–64

Smith, David E. "A Comparison of Prairie Political Developments in Saskatchewan and Alberta." *Journal of Canadian Studies* 4, no. 1 (1969): 17–26

Tollefson, Edwin A. "The Aftermath of the Medicare Dispute in Saskatchewan." *Queen's Quarterly* 72, no. 3 (1965): 452–65

Wiseman, Nelson. "The Direction of Public Enterprise in Canada." *Journal of the Commonwealth and Comparative Politics* 37, no. 2 (1999) 72–88

Web Site

Canadian Institute for Health Information, National Expenditure Trends <http://secure.cihi.ca>

Index